THE CRITICAL IMA

THE CRITICAL IMAGE

ESSAYS ON CONTEMPORARY PHOTOGRAPHY

EDITED BY CAROL SQUIERS

BAY PRESS · SEATTLE · 1990

Published in 1990. Printed in the United States of America.
95 94 93 92 91 5 4 3 2 1

Bay Press
115 West Denny Way
Seattle, WA 98119

Designed by Katy Homans
Set in Gill Sans and Century Expanded on an Apple Macintosh computer
Printed by Publishers Press

Library of Congress Cataloging-in-Publication Data
The Critical Image: essays on contemporary photography / edited by Carol Squiers.
 p. cm.
 Includes bibliographic references.
 ISBN 0-941920-14-3: $18.95. — ISBN 0-94120-15-1 (pbk.): $12.95
 1. Photography, Artistic. I. Squiers, Carol, 1948– .
 TR642.C74 1990
 770'.9—dc20 89-81357

To my father — C. S.

CONTENTS

INTRODUCTION

Carol Squiers

The announcement in 1839 of the invention of photography created a frenzy of excitement, perplexity, and outrage. Even before the official presentation of Louis Jacques Mandé Daguerre's process in the French Chamber of Deputies, news of the daguerreotype's capacity for startlingly detailed pictorial rendition was trumpeted in newspapers and feverishly passed by word of mouth. After attending a special viewing of daguerreotypes in Paris, the British astronomer Sir John Herschel wrote breathlessly about the pictures to another inventor of photography, William Henry Fox Talbot: "It is hardly too much to call them miraculous. Certainly they surpass anything I could have conceived as within the bounds of reasonable expectation... I cannot commend you better than to *come and see*. Excuse this ebullition!"[1]

1. Beaumont Newhall, *The History of Photography*, rev. ed. (New York: The Museum of Modern Art, 1982), p. 23.

But those who were less than enchanted by the new technology just as boldly voiced skepticism, poked fun, and even denounced the daguerreotype as the devil's work: "To fix fleeting images is not only impossible, as has been demonstrated by very serious experiments in Germany, it is a sacrilege," thundered one writer in a German newspaper. "God has created man in His image and no human machine can capture the image of God. He would have to betray all his Eternal Principles to allow a Frenchman in Paris to unleash such a diabolical invention upon the world."[2] Despite our greater understanding of photography, modern attitudes toward the medium are still substantially defined by those early polarities of wonder and contempt.

2. Gisèle Freund, *Photography & Society*, trans. Richard Dunn, Yong-Hee Last, Megan Marshall, and Andrea Perera (Boston: David R. Godine, 1980), p. 69.

In fact, for much of the one hundred and fifty years of its existence, photography has been haunted by critical disagreement as to its nature and by defensiveness about its cultural status. Despite intermittent outpourings of verbiage about photography, consensus about its importance, function, and effect has never been achieved. The reasons for this would require a lengthy analysis of the whole of photographic writing, an impossible task in this small space. Instead, we can point to some early perceptions that seem to presage the murky reasoning, questionable claims, and vehement criticism that photography has inspired.

From the beginning there was much confusion as to what, exactly, a daguerreotype was and what it did. It was compared to painting,

3. Louis Jacques Mandé Daguerre, "Daguerreotype," in *Classic Essays on Photography*, ed. Alan Trachtenberg (New Haven, Conn.: Leete's Island Books, 1980), p. 13.

4. Dominique François Arago, "Report," in *Classic Essays*, p. 19.

5. Robert Taft, *Photography and the American Scene: A Social History, 1839–1889* (New York: Dover Publications, 1964), p. 63.

6. Newhall, *History of Photography*, p. 129.

7. Helmut and Alison Gernsheim, *L.J.M. Daguerre: The History of the Diorama and the Daguerreotype* (London: Secker and Warburg, 1956), p. 92.

8. Josef Maria Eder, *History of Photography*, trans. Edward Epstean (New York: Dover Publications, 1978), p. 235. See also Gernsheim, *History of Diorama*, p. 92. The Gernsheims make clear Delaroche's more measured comments were written after his famous "painting is dead" exclamation.

referred to as engraving. Daguerre, the man who ostensibly knew the answer only complicated the issue with a claim that his invention gave nature "the power to reproduce herself."[3] That mistaken idea then evolved into a belief in the evidential or verisimilar character of photography, which survives today. Disagreement as to the relation between reality-out-there and reality-as-transcribed-in-a-photograph remains a central issue in debates about photography.

A kindred problem, which was early used as a selling point for the medium, was the potential ease with which photographs could be made. Scientist and pioneering patron of photography, Dominique François Arago, suggested that by following Daguerre's instructions "there is no one who cannot succeed" at making photographs.[4] The commercial potential expressed in his observation was taken up by untold numbers of would-be photographers, many of them with qualifications similar to those of Nathaniel Hawthorne's laughably versatile daguerreotypist, who had previously been a country schoolmaster, salesman, newspaper editor, peddler of cologne water, dentist, and lecturer on "mesmerism."[5] Arago's prediction was even further demonstrated when George Eastman marketed his "You Press the Button, We Do the Rest" Kodak camera to the masses.[6] Critics of the medium still use the comparative simplicity of the photographic process — and the ease with which it can be learned — to challenge its expressive and informational capabilities.

Perhaps the most woefully influential — and misunderstood — of all statements about photography is the oft-quoted declaration of history painter Paul Delaroche: "From this day painting is dead," he reportedly claimed after visiting Daguerre's studio.[7] With those words he seemed to endow photography with the capacity to replace painting, and thus to claim that photography itself was an art form. Although he moderated his opinion to the effect that Daguerre's invention was "a great service rendered to the Arts,"[8] thereby bringing photography down a notch from art form to helpmate, the implications of his initial declaration were seized upon by proponents of the new medium. For nearly one hundred years, the major battle that has been fought within both the photographic community and the more status-conscious art world has been over photography's standing as an art.

Probably the most important early insight about photography was made by Lady Elizabeth Eastlake, a writer who was married to neoclassical painter and president of the Royal Academy of Arts, Sir Charles Eastlake. In 1857 she wrote "photography has become a household word and a household want; is used alike by art and science,

9. Beaumont Newhall, *Photography: Essays & Images. Illustrated Readings in the History of Photography* (New York: The Museum of Modern Art, 1980), p. 81.

by love, business, and justice; is found in the most sumptuous saloon, and in the dingiest attic — in the solitude of the Highland cottage, and in the glare of the London gin-palace — in the pocket of the detective, in the cell of the convict, in the folio of the painter and architect, among the papers and patterns of the millowner and manufacturer, and on the cold brave breast on the battle-field."[9] Photography had in less than twenty years permeated every level of society. What Lady Eastlake seemed to realize was that the new medium was not simply a vehicle for artists but also a tool with endless potential uses — for commemoration, information-gathering, surveillance, and profit. It radically altered the terms of pictorial representation. Changed forever were ideas about what could be represented in pictures, how those pictures would look, and most important, who controlled their manufacture and dissemination.

But Lady Eastlake's prescient observations, which were born out even more fully by the later development of news, social documentary, and advertising photography, had seemingly little effect on subsequent writing about photography (or at least on the writing that has thus far been recognized as part of the official canon). Once Alfred Stieglitz began his fervent campaign for the recognition of photography as a valid art form in the late nineteenth century, his agenda helped shape much of the subsequent discourse on the medium.

Perhaps Stieglitz's hauteur and anger also set the tone for the writing of many photographers, which tried to prescribe and rationalize the proper attitudes, work habits, and concerns of the serious photographer (as opposed to the amateur snapshooter or the commercial hack). The photographers who were trying to express a private vision, either by making visual metaphors for their emotions and psychology or by seeking to reveal in pictures truths about the state of mankind, assiduously distanced themselves from the imagemakers who trafficked primarily in commercial rather than the purer realms of personal photography. Critics and journalists who championed the medium adopted a similar attitude and gave prominent place to the photographers' words and biographies.

In one way or another, the fight to validate photography as an art form dominated photographic debate in the United States until the 1970s. Around that time a variety of theoretical writings on art, film, popular culture, literature, feminism, and politics, especially by French and British thinkers, began influencing critical writing in the United States. The work of now-familiar figures such as Walter Benjamin, Roland Barthes, Jacques Lacan, Julia Kristeva, Louis Althusser,

Claude Lévi-Strauss, Michel Foucault, Jean Baudrillard, Juliet Mitchell, and Jacqueline Rose, among others, was introduced to an American audience in university classrooms and small, specialized journals. Semiotics, structuralism, Marxism, feminism, psychoanalytic theory, and poststructuralist thought all made their mark on a number of disciplines. Writing that was specifically about photography, however, largely escaped these influences, with the exception of certain pieces by a small number of people including Rosalind Krauss, Douglas Crimp, Martha Rosler, and Allan Sekula in the United States and Victor Burgin and John Tagg in Britain. The work of the latter two was not terribly well known in America and was certainly not well understood, and the writings of the others initially made only limited inroads into photographic discourse.

Among those early writings, however, there was one piece that resonated with a clear, angry defiance of accepted photographic wisdom: Allan Sekula's "On the Invention of Photographic Meaning," first published in an art magazine in 1975.[10] Rather than discussing the creative achievements of his photographer-subjects — Alfred Stieglitz and Lewis Hine — Sekula took an entirely different tack: he showed how the perception of Stieglitz's art images and Hine's sociological images was determined by the "discourse situation" within which they were made and presented.[11] Photographs, he proposed (after Barthes), had to be read as cultural messages, not simply as well-composed or badly composed artistic or documentary pictures. It wasn't the individual's private consciousness — which in the photography world, as in the art world, had been privileged above all else — that alone produced meaning in photographs. By making Stieglitz, the high priest of artistic aspiration, a major target of his essay, Sekula issued a challenge to the entrenched ideas of generations of artist-photographers and their supporters, from Stieglitz and his *Camera Work* to John Szarkowski and the Museum of Modern Art.

Since Sekula's essay appeared, much exemplary writing has been produced, by scholars such as Peter Hales, Krauss, Christopher Phillips, Sekula, Abigail Solomon-Godeau, Sally Stein, Alan Trachtenberg, and Jan Zita-Grover. But much of this writing has been on historical aspects of photography. The only contemporary photographic practice that has occasioned a parallel body of critical writing has been so-called postmodernist art. One reason for this is that the New York art world remains the major arena — and consumer — for critical writings on photography. And art is the only topic that is truly close to the art world's heart. Many critics, especially if they are in tenured, university-level positions

10. Allan Sekula, "On the Invention of Photographic Meaning," *Artforum* (January 1975). Reprinted in *Thinkng Photography*, ed. Victor Burgin (London: Macmillan, 1982).

11. Ibid., p. 36.

in art history departments, believe that art is the most worthwhile object of their attentions; in this they echo Stieglitz and his followers.

What is lacking, then, is a substantial body of writing on contemporary photography that treats the entire spectrum of photographic practice as a process of signification. This would include an examination of all institutional production of photography, from newspaper and magazine photojournalism to images taken for purposes of surveillance to commercial wedding photography and amateur snapshooting. Granted, writing on contemporary photography is problematic in certain ways: there is no readily accessible archive stored in a warehouse or a library awaiting scrutiny; practitioners are still alive and therefore able to exert control over their own output and the information that is available about their lives and careers; access to institutions that use photography — such as newspaper picture departments or the offices of corporate communications — is difficult to obtain, and reportorial skills are necessary in order to extract information. And judgments have to be made about subject matter that may prove to be faulty or uninteresting in the future: today's political photographer may in ten years not be nearly as significant as an Erich Salomon or a Robert Capa will continue to be.

The goal of this book is to bring together writings on contemporary practice in photography that address a number of issues, from why certain photographic images are made, and to what ends they are put by those who commission them, to the way that feminist theory is being rethought in relation to woman-as-viewer. One guiding principle in selecting essays to reproduce and authors to commission — nearly half the essays were specially written for the book — was to enlist a wide range of theoretical and critical approaches. This sometimes meant looking outside the immediate community of writers who specialize in photography to find people who had considered related issues of representation.

In the area of photojournalism, most writing has concentrated on the recognition and definition of photojournalists as heroes and artists. During the late 1970s and early 1980s, a penchant for exhibiting photojournalism in galleries and museums as discrete, artistic pictures, shorn of their original context and sometimes even of rudimentary captions, developed with a vengeance. The question of the relation between the photographer and his or her subject, or the relation between the photographer and the publication for which he or she worked was peripheralized or was engaged only in terms of the individual's battle against the media behemoth that sought to squelch creativity.

One issue affecting photojournalism that has emerged with great force in the 1980s is computer digitalization of photographic images, which enables anyone with access to such equipment to seamlessly alter still photographs. Fred Ritchin's contribution to this book is an update on his pioneering 1984 essay on the way the computer is challenging the efficacy of the news photograph and the implications of this Orwellian development. My essay examines the propagandistic uses to which the "photo opportunity" was put at the Reagan White House — and the relationship between photojournalists and the White House — focusing especially on the period immediately following the first revelations about the illegal sale of arms to Iran and the funneling of the proceeds to the U.S.-backed *contras* in Nicaragua.

As in photojournalism, all manner of commercial photographs, especially advertising and fashion images, have been conscripted in the last decade as purely aesthetic objects for display and journalistic appreciation. Although such images would seem to be ideal subjects of interdisciplinary scrutiny, little has been written about them in the United States from any theoretically informed perspective. Of the three essays commissioned for this book on this broad topic, those of Silvia Kolbowski and Victor Burgin employ psychoanalytic theory, the former to examine feminist attitudes toward fashion photography, the latter to address the exhibitionism and voyeurism central to Helmut Newton's work. In contrast, Kathy Myers analyzes individual advertisements to show the small but important role that photography plays in the commercialization and exploitation of "Green," or environmental, politics by British industry.

As indicated earlier, art photography is one area that has received much critical attention. Abigail Solomon-Godeau has produced a substantial body of writing on the works usually grouped under the contested rubric of postmodernism. In the essay reproduced here, she reviews the problematic transformation that "postmodernist" photography has undergone and, at the same time, questions the possibility of developing a truly critical practice as either an artist or a critic. Rosalyn Deutsche discusses artist Krzysztof Wodiczko's photographic project on homelessness and urban gentrification by placing it within a far-ranging, historically based explication of the class and economic interests undergirding the entire process of urban redevelopment. Andy Grundberg looks at the periodic revivals of surrealistic style within art photography, disputing both Susan Sontag's notion that photography is inherently surrealistic and various recent curatorial claims that position surrealism as a precursor to postmodernism.

One issue that overlaps territory covered in other essays is that of representation and sexual politics. Three authors address these issues directly, including Griselda Pollock, who reconsiders questions she had raised in an early essay on the problems inherent in feminist analyses of "images of women." Sexuality and government control are at the heart of Carole Vance's examination of the way Attorney General Edwin Meese's Commission on Pornography used still photographic images of pornography during its public hearings in the mid-1980s to "prove" its contentions about the deleterious effects of pornography. Simon Watney demonstrates how antihomosexual bigotry and a concurrent fatalism shape the way people with AIDS are portrayed in the mass media.

Finally, three critical essays examine what can broadly be termed the "nature" of the medium. Rosalind Krauss attacks the idea of photographic "originality" and argues the insufficiency of analyzing photography from a sociological point of view. Film theorist Christian Metz maps out some basic distinctions between film and photography to show the mechanisms by which still photography is more liable than film to become a fetish. In contrast to Krauss's and Metz's essays, which are "applied" theory, John Tagg examines his own critical practice in an interview with Joanne Lukitsh.

In summing up the intentions and content of this anthology, it is clear that large, important areas of concern have not been covered. The issue of representation of people of color, from African-Americans to citizens of the "Third World," has not been discussed at all. The influence of television on photography — and the possible effect of photography on television — was only touched upon. And the decision-making hierarchies within the mass media in regard to the reasons and manner in which pictures are chosen for publication deserve some close attention. Finally, a coherent methodology for considering photography as a cultural practice that cuts across all levels of society has yet to be articulated.

But even to suggest the development of such a methodology is a potentially dangerous proposition. For as salutary as the contributions of myriad theoretical writings have been in the field of cultural study, so too has theory been used to mystify and abstract. Rather than providing illumination, it has often been erected as a series of hurdles over which only the most determined athletes in academia have vaulted. To create a hermetic theory of photographic representation, which would inevitably remain ghettoized within a narrow, scholarly space, would be a futile exercise.

Yet, despite the limitations of theoretical or oppositional discourse, constructive avenues of inquiry into the field of photographic representation have already been made. The challenge now is to shape an eloquent, accessible communication that can expand beyond the scholarly precinct into the very institutions it critiques.

A NOTE ON PHOTOGRAPHY AND THE SIMULACRAL

Rosalind Krauss

This essay was originally published in *October* 31 (Winter 1981) and is reprinted here with permission of the author and MIT Press. A version of this essay was delivered as the keynote address for the National Conference of the Society for Photographic Education in Philadelphia, March 1983.

In 1983 French television launched *Une minute pour une image,* a program conceived and directed by Agnès Varda. True to its title the show lasted just one minute, during which time a single photograph was projected onto the screen and a voice-over commentary was spoken. The sources of these reactions to the given photograph varied enormously — from photographers themselves to writers like Eugène Ionesco and Marguerite Duras, or political figures like Daniel Cohn-Bendit, or art critics such as Pierre Schneider to a range of respondents that one could call the man-on-the street: bakers, taxi drivers, workers in a pizza parlor, businessmen.

This very gathering of response from a wide spectrum of viewers, including those who have no special expertise in either photography or the rest of what could be called the cognate visual arts, in its resemblance to an opinion poll and its insistence on photography as a vehicle for the expression of public reaction — this technique was a continuation, whether intentional or not, of a certain tradition in France of understanding photography through the methods of sociology, and insisting that this is the only coherent way of considering it. This tradition finds its most lucid presentation in the work of the sociologist Pierre Bourdieu, who twenty years ago published his study *Un art moyen.* This title uses the notion of *moyen,* or middle, to invoke the aesthetic dimension of middling or fair as a stage between good and bad, and to mean midway between high art and popular culture; it also employs *moyen* to call up the sociological dimensions of middle class as well as distributed middle or statistical average. But before looking into Bourdieu's argument about this art for the average man, it might be well to examine a few samples of Varda's photographic showcase, to which public response was vigorous enough to warrant a morning-after publication in *Libération,* where each day following the transmission, the photograph was reproduced, its commentary forming an extended caption.

Here, for example, is a photographer's response, as Martine Frank comments on a 1958 image by Marc Riboud:

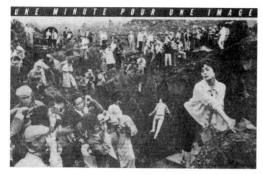

Marc Riboud

Are these workers from a camera factory who have been sent to amuse themselves in the country; is this a photo contest; or is it a photography class? I can't tell. In fact, as a photographer, I have always been intrigued by this image and struck by the fact that amidst all these men there is not a single woman taking a picture. What's interesting in this photo is that it puts the whole idea of photographic talent into question because in the end all these photographers find themselves in the same place, at the same moment, under the same light, before the same subject, and one could say that they all want to make the same photo. Yet, even so, among these hundreds of photos perhaps there will be one or two good ones.

Varda elicited these comments from Marguerite Duras in front of a Deborah Turbeville photograph:

Deborah Turbeville

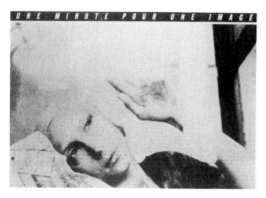

I think she's dead. I think she's fake. It's not a person; yet around the mouth there is something alive, a trace of speech. She is behind a windowpane. That's not blood in her hand, it's paint, perhaps it is the allegory of painting. No, she isn't dead. She's on top of a closed trunk or a door. There is a shipping label, perhaps it is her coffin. No, she isn't dead. No. I don't see her as a woman from my novels.

And Daniel Cohn-Bendit, faced with an image of three dancers made in Tokyo in 1961 by William Klein, began:

The first reaction anyway is: it's frightening, it's the devil, the devil without a face. I see this hand that…that denounces…that says, uh…don't go any further… stay there, uh, there where you are. At first I didn't understand. The man, in the end, I think that, yes, it's a man at the right who is in drag, with his little finger lifted as though he were drinking a cup of tea. It's very disturbing. By chance I came across the puddle of water that is one of the most luminous moments of this photo, brighter than all the rest of this view that has something so oppressive and fearful about it. It's really the abyss, the pits, it's….

In the *Libération* version of Cohn-Bendit's response, his comments broke off with this last "it's," this last attempt to say what it is that he's looking at, a last, though obviously not a final term to a potentially endless list of possible subjects, for this one-minute commentary contained seven candidates for what "it" is.

That, of course, does not distinguish the nature of Cohn-Bendit's

reactions from those of Marguerite Duras, who for her part enunciated eight possibilities for the identity of her subject. Nor does it differ generically from the way the photographer Martine Frank approached her image, again beginning with an attempt to specify the subject before breaking into a slight reflection on the problem that so many shutterbugs in the same place might raise for the aesthetic status of photography. But what is striking in her brief meditation is that it remains in the transparent, behind-the-surface space of "it's an x or a y" — because her little cough of photo criticism is really a speculation on the photographs that one or another of these eager men might make rather than a pictorial, aesthetic consideration that reflects on the success of the very image she is now looking at, and reflects as well on its capacity to account for its own structural conditions. This commentary by means of "it's" — in the very primitivism of its character as aesthetic discourse — is, not surprisingly, even more present in the response from the men on the street.

Thus an industrialist commented on an image by Marie-Paule Nègre taken in the Luxembourg Gardens in 1979, a photograph that, to say the very least, uses the conditions of atmosphere and place to reconstitute the limitations of surface and frame within the space of the photographic subject. The businessman's remarks have a certain monotonous relation to what one has already witnessed:

It's the arrival of a train, it's the arrival of a train in a dream, a woman waits for

Marie-Paule Nègre

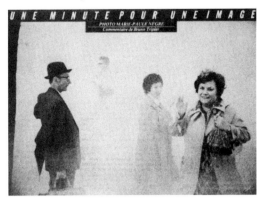

someone and obviously makes a mistake about the person; the man she was waiting for obviously is...he isn't in the shot, he has aged, and she was waiting for someone much younger, more brilliant than the little fellow we see there...She dreams and in her dream she is also much younger, at the time when her feelings developed as she would have liked to recover them there, now. It's a dream that doesn't work out.

And finally, here is a botanist commenting on a recent image by Edouard Boubat, an homage to the Douanier Rousseau, which specifically constructs a relationship between photography and painting based on imitation:

In front of this tree, which is obviously a quinquéliba, the Crotons are of the family Croton Tiglium, and in the back you have Cecilia leaves which would lead one to the idea that the woman is called that; it's a very beautiful woman from what one can see. She is alone. She is cold because she is on a marble slab and

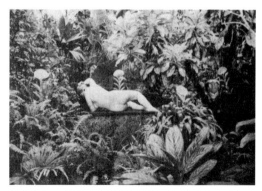

Edouard Boubat

François Hers

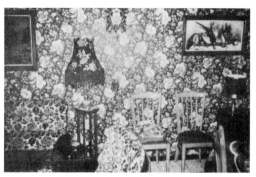

she is filled with anxiety by all this vegetation that runs riot and could possibly threaten her, submerge her, cover her over, such that she seems to look for refuge in this kind of vault that she glimpses into and stares at.

In fact, within all this monotony of approach to, or judgment of, the photographic object by means of "it's," in a potentially endless taxonomy of subjects, the one notable exception is the commentary of the art critic Pierre Schneider. Speaking of a work by François Hers, he said:

The wallpaper mural, with its motif of repeated flowers that one finds, for example, in hotel rooms, is an instant producer of insomnia. When I look at the decorations of this room I say to myself that all this, covered over by fabric printed with a repetitive, decorative motif, becomes surface; that is, if you take the paintings by Matisse from the 1920s where he paints many interiors in perspective, with heavy pieces of furniture completely modeled in three dimensions, well, their volume disappears and the picture becomes a play of colored surfaces that breathe because Matisse knows how to make them breathe.

This notion that the depicted object might be nothing but a pretext for the accomplishment of a formal idea — here, the play of colored surfaces — is, of course, second nature to the critic of modernist art, and so, as though by a reflex response, Pierre Schneider has recourse to this type of experience of a visual field in terms of its formal order when interrogating the photograph. But whether this makes his interrogation any more legitimate than the other, more possibly primitive responses — the judgments according to "it's" — is a question to which we will have to return.

It is the thesis of Pierre Bourdieu that photographic discourse can never be properly aesthetic, that is, can have no aesthetic criteria proper to itself, and that, in fact, the most common photographic judgment is not about value but about identity, being a judgment that reads things generically; that figures reality in terms of what sort of thing an x or a y is — thus the repetitive judgments in terms of "it's a so-and-so" that emerge from the Varda experiment. When the judgment backs up far enough to encompass the photograph as a whole and not just its separate components, then the assignment or judgment is

commonly by genre. "It's a landscape," "it's a nude," "it's a portrait." But, of course, a judgment of genre is completely transparent to the photograph's represented objects. If a photograph belongs to the type *landscape* or *portrait*, that is because the reading of its contents allows it to be recognized and classed by type. And it is the nature of these types — according to Bourdieu's assessment of photographic practice — to be ruled by the rigid constraints of the stereotype.

The experience of photography in terms of the stereotypical — which is what the "it's" judgment involves — is maintained almost without exception among the lower and less well-educated classes, whether urban or rural. Bourdieu's analysis, which begins by asking the question, "Why is photography within our culture so fantastically widespread a practice?" proceeds to the understanding that photography as an *art moyen*, a practice carried out by the average man, must be defined in terms of its social functions. These functions he sees as wholly connected to the structure of the family in a modern world, with the family photograph an index or proof of family unity, and, at the same time, an instrument or tool to effect that unity.

Simply put, families with children have cameras; single people, typically, do not. The camera is hauled out to document family reunions and vacations or trips. Its place is within the ritualized cult of domesticity, and it is trained on those moments that are sacred within that cult: weddings, christenings, anniversaries, and so forth. The camera is a tool that is treated as though it were merely there passively to document, to record the objective fact of family integration. But it is, of course, more active than that. The photographic record is part of the point of these family gatherings; it is an agent in the collective fantasy of family cohesion, and in that sense the camera is a projective tool, part of the theater that the family constructs to convince itself that it is together and whole. "Photography itself," Bourdieu writes, "is most frequently nothing but the *re*production of the image that a group produces of its own integration."[1]

From this conclusion Bourdieu naturally goes on to discredit any notion of photographic objectivity. If the photographic image is considered to be objective, that designation occurs within an entirely tautological or circular condition: the societal need to define something as fact leads to the insistence on the utterly objective factuality of the record that is made. But, says Bourdieu, "In stamping photography with the patent of realism, society does nothing but confirm itself in the tautological certainty that an image of reality that conforms to its own representation of objectivity is truly objective."[2]

1. Pierre Bourdieu, *Un art moyen. Essai sur les usages sociaux de la Photographie* (Paris: Editions de Minuit, 1965), p. 48.

2. Ibid., p. 113.

Given the narrow social functions that both promote and radically limit the photographic practice of the common man, the result is an insistent stereotyping of both photographic subjects and the way they are rendered. The photographic subject, the thing deemed worthy of being recorded, is extremely limited and repetitive. Its disposition is equally so. Frontality and centering, with their banishing of all signs of temporality or contingency, are the formal norms. Bourdieu continues:

The purpose of a trip (like the honeymoon) lends solemnity to the places passed through and the most solemn among them lends solemnity to the purpose of the trip. The truly successful honeymoon is the couple photographed in front of the Eiffel Tower because Paris is the Eiffel Tower and because the real honeymoon is the honeymoon in Paris. One of these [honeymoon] pictures in the collection of J. B. is split right down the middle by the Eiffel Tower; at the foot is J. B.'s wife. What might strike us as barbarous or cruel is in fact the perfect carrying out of an intention.[3]

3. Ibid., p. 60.

And Bourdieu muses, "Conscious or unconscious? Of all the photos, this and another representing the couple in front of the Arch of Triumph are their author's favorites."[4]

4. Ibid., p. 60, n. 34.

Stereotypy lends to this practice a quality of allegory or ideogram. The environment is purely symbolic, with all individual or circumstantial features relegated to the background. "In J. B.'s collection," remarks Bourdieu, "nothing is left of Paris except atemporal signs; it is a Paris without history, without Parisians, unless accidentally, in short, without events."[5]

5. Ibid., p. 61.

To all of those who are interested in serious or art photography or even in the history of photography with its cast of "great photographers," Bourdieu's analysis of the photographic activity of the common man must seem extremely remote. What can J. B.'s inept honeymoon snapshots, no matter how amusing their inadvertent play of sexual symbolism, have to do with serious photographic practice?[6] But this is precisely where Bourdieu's sociological approach becomes somewhat more painful, because it starts to cut closer to home. Sociologically speaking, Bourdieu claims, photography fills another function, namely that of a social index. The ubiquitous practice of these hicks with their Instamatics becomes an indicator of class or caste against which members of other classes react in order to mark themselves as different. One of the ways of expressing this difference is to abstain from taking pictures; another is to identify oneself with a special kind of photographic practice which is thought of as different. But the notion that there is really an art photography as opposed to a primitive photography of common usage is, for Bourdieu, merely the extension of the

6. Roland Barthes expresses irritation with Bourdieu's approach, denying its legitimacy as a means of discussing the nature of photography, but simultaneously denying the alternative of aesthetic categories: "What did I care about the rules of composition of the photographic landscape, or, at the other end, about the Photograph as family rite?... another, louder voice urged me to dismiss such sociological commentary; looking at certain photographs, I wanted to be a primitive, without culture" [Roland Barthes, Camera Lucida, trans. Richard Howard (New York: Hill and Wang, 1981)].

expression of social distinctions. His feeling that art photography's difference is a sociological *effect* rather than an aesthetic reality stems from his conviction that photography has no aesthetic norms proper to itself; that it borrows its caché from the art movements with which various serious photographers associate themselves; that it borrows certain aesthetic notions from the other arts as well — notions like expressiveness, originality, singularity, and so forth — but that these notions are utterly incoherent within what purports to be the critical discourse of photography; and that, finally, most photographic discourse is not inherently different from the judgment of the common man with his Instamatic. They reduce, on the one hand, to a set of technical rules about framing, focus, tonal values, and so on, that are in the end purely arbitrary, and, on the other hand, to a discussion of genre, which is to say the judgment "it's an x or a y." Agnès Varda's experiment does nothing, of course, to disprove all of this.

Bourdieu's insistence that photographic discourse borrows the concepts of the high arts in vain — because that borrowing only leads to conceptual confusion — is confirmed by the intellectual discomfort that is provoked by Pierre Schneider's comparison of the François Hers photo to Matisse's painting. And Bourdieu analyzes the various aesthetic unities of the other arts to demonstrate that the mechanical nature of photography makes them inapplicable. The specter raised by Martine Frank that those hundreds of Japanese men will in fact make hundreds of identical images, insofar as it is a theoretical possibility, explodes the grounds on which there might be constructed a concept of photographic originality and, for Bourdieu, reduces all critical discussions of such originality in the photography magazines to mere cant.

Photography's technical existence as a multiple thus joins the theoretical possibility that all images taken of the same object could end up being the same image and thus partake of sheer repetition. Together these forms of multiplicity cut deeply against the notion of originality as an aesthetic condition available to photographic practice. Within the aesthetic universe of differentiation — which is to say: "this is good, this is bad, this, in its absolute originality, is different from that" — within this universe photography raises the specter of nondifferentiation at the level of qualitative difference and introduces instead the condition of a merely quantitative array of differences, as in a series. The possibility of aesthetic difference is collapsed from within, and the originality that is dependent on this idea of difference collapses with it.

Now, this very experience of the collapse of difference has had an enormous impact on a segment of the very artistic practice that is

supposed to occupy an aesthetic position separate from that of photography: the world of painting and sculpture. For contemporary painting and sculpture has experienced photography's travesty of the ideas of originality, or subjective expressiveness, or formal singularity, not as a failed version of these values, but as a denial of the very system of difference by which these values can be thought at all. By exposing the multiplicity, the facticity, the repetition and stereotype at the heart of *every* aesthetic gesture, photography deconstructs the possibility of differentiating between the original and the copy, the first idea and its slavish imitators. The practice of the multiple, whether one speaks of the hundreds of prints pulled from the same negative or the hundreds of fundamentally indistinguishable photographs that could be made by the Japanese men — this practice has been understood by certain artists as not just a degraded or bad form of the aesthetic original. It has been taken to undermine the very distinction between original and copy.

From contemporary practice an obvious example would be the work of Cindy Sherman. A concatenation of stereotypes, the images reproduce what is already a reproduction — that is, the various stock personae that are generated by Hollywood scenarios, TV soap operas,

Harlequin Romances, and slick advertising. And if the subject of her images is this flattened, cardboard imitation of character, her execution is no less preordained and controlled by the culturally already-given. One is constantly confronted by formal conditions that are the results of institutional recipes: the movie still with its anecdotal suggestiveness, or the advertising image with its hopped-up lighting and its format dictated by the requirements of page layout.

Cindy Sherman,
Untitled, 1981.
Courtesy of Metro
Pictures.

That Sherman is both subject and object of these images is important to their conceptual coherence. For the play of stereotype in her work is a revelation of the artist herself as stereotypical. It functions as a refusal to understand the artist as a source of originality, a fount of subjective response, a condition of critical distance from a world which it confronts but of which it is not a part. The inwardness of the artist as

a reserve of consciousness that is fundamentally different from the world of appearances is a basic premise of western art. It is the fundamental difference on which all other differences are based. If Sherman were photographing a model who was not herself, then her work would be a continuation of this notion of the artist as a consciousness which is both anterior to the world and distinct from it, a consciousness that knows the world by judging it. In that case we would simply say that Sherman was constructing a critical parody of the forms of mass culture.

With this total collapse of difference, this radical implosion, one finds oneself entering the world of the simulacrum — a world where, as in Plato's cave, the possibility of distinguishing between reality and phantasm, between the actual and the simulated, is denied. Discussing Plato's dread of the simulacral, Gilles Deleuze argues that the very work of distinction and the question of how it is to be carried out characterizes the entire project of Plato's philosophy.[7] For Plato, difference is not a matter of classification, of properly separating out the various objects of the real world into genus and species, for example, but of knowing which of these objects are true copies of the Ideal Forms and which are so infinitely degraded as to be false. Everything, of course, is a copy; but the true copy — the valid imitation — is that which is truly resemblant, copying the inner idea of the form and not just its empty shell. The Christian metaphor rehearses this distinction: God made man in his own image and therefore at the origin man was a true copy; after man's fall into sin this inner resemblance to God was broken, and man became a false copy, a simulacrum.

But, Deleuze reminds us, no sooner does Plato think the simulacrum, in the *Sophist* for example, than he realizes that the very idea of the false copy puts into question the whole project of differentiation, of the separation of model from imitation. For the false copy is a paradox that opens a terrible rift within the very possibility of being able to tell true from not-true. The whole idea of the copy is that it be resemblant, that it incarnate the idea of identity — that the just man resemble Justice by virtue of being just — and in terms of this identity that it separate itself from the condition of injustice. Within this system, separations are to be made between terms on the basis of the particular condition of inner resemblance to a form. But the notion of the false copy turns this whole process inside out. The false copy takes the idea of difference or nonresemblance and internalizes it, setting it up within the given object as its very condition of being. If the simulacrum resembles anything, it is the Idea of nonresemblance. Thus a labyrinth

7. See Gilles Deleuze, *Logique du sens* (Paris: Editions de Minuit, 1969), pp. 292–307. This section on Plato appears in English as "Plato and the Simulacrum," trans. Rosalind Krauss, *October* 27 (Winter 1983), pp. 45–56.

is erected, a hall of mirrors, within which no independent perspective can be established from which to make distinctions — because all of reality has now internalized those distinctions. The labyrinth, the hall of mirrors, is, in short, a cave.

Much of the writing of poststructuralism, in its understanding of the Real as merely the effect of simulated resemblance, follows Nietzsche's attack on Platonism in which he insisted that there is no exit from this cave, except into an even deeper, more labyrinthine one. We are surrounded, it is argued, not by reality but by the reality *effect*, the product of simulation and signs.

As I have said, at a certain point photography, in its precarious position as the false copy — the image that is resemblant only by mechanical circumstance and not by internal, essential connection to the model — served to deconstruct the whole system of model and copy, original and fake, first- and second-degree replication. For certain artists and critics, photography opened the closed unities of the older aesthetic discourse to the severest possible scrutiny, turning them inside out. Given its power to do this — to put into question the whole concept of the uniqueness of the art object, the originality of its author, the coherence of the oeuvre within which it is made, and the individuality of so-called self-expression — given this power, it is clear that, with all due respect to Bourdieu, there *is* a discourse proper to photography; only, we would have to add, it is not an aesthetic discourse. It is a project of deconstruction in which art is distanced and separated from itself.

If Sherman's work gives us an idea of what it looks like to engage the photographic simulacrum in order to explode the unities of art, we might choose an example from serious "art" photography to look at the reverse situation — the attempt to bury the question of the simulacrum in order to produce the effect of art, a move that almost inevitably brings about the return of the repressed. As one of many possible examples, one might look at a recent series of still lifes by Irving Penn through which the domain of high art is self-consciously evoked by calling on the various emblemata of the *vanitas* picture or the *memento mori* — the skulls, the desiccated fruit, the broken objects that all

function as reminders of the swift flight of time toward death.

But beyond this iconographic system that is copied from the world of Renaissance and baroque painting — and one has the right to ask if this is a true or a false copy — there is another aspect of the aesthetic system that Penn wishes to annex for photography, or at least for this photography. This is the combined aspect of rarity and uniqueness that a pictorial original is thought to possess in the first degree and a print made after the painting would possess only in a degraded second degree. Again one is confronted with the question of whether or not Penn's strategy for acquiring these qualities only produces a simulation of them. His strategy involves the production of opulent platinum images, contact-printed from huge negatives. The platinum, with its infinite fineness of detail, provides the sense of rarity; and the process of contact-printing, with its unmediated connection between plate and paper, gives the work a sense of uniqueness not unlike that possessed by the photogram, which then implies the further system of uniqueness of the arts of painting and drawing.

In order to obtain the size negative needed to produce these prints without the use of an enlarger, Penn turned to a particular kind of camera — an antiquated instrument called a banquet camera — which with its bellows and enormous plates would allow him to enlarge the photographed object during the very process of making the negative. This camera, invented for the recording of groups of people — whether football teams or Elks Club dinners — was also the generator of the format we see in Penn's images: a horizontally splayed rectangle whose height/width ratio is very different from that of most cameras.

But what the format of these pictures is *not* different from is the peculiar shape of the double-page spread of the slick magazine: the most opulent of the typographic theaters of mass advertising, the most

Irving Penn,
Clinique advertisement.
Courtesy of Clinique.

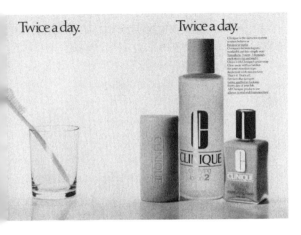

luxurious print screen of the Platonic cave of a modern consumer society. Now, the double-page spread, in sumptuous, seductive color photography, is something of which Penn is a master, and for the last several years he has produced a series of still lifes for this commercial context, a series that in format, disposition of objects, frontality of composition, and shallowness of space is identical to the *memento mori* images of his own aesthetically tagged platinum prints. The work Penn has done

for Clinique cosmetics, which month after month has filled facing pages in *Vogue*, *Harper's Bazaar*, and *Town and Country* with elegant, shallow, luminous still lifes of bottles and jars — creating a kind of centerfold of cosmetic promise — is the visual twin of its conceptual counterpart, the platinum work that speaks not of perpetual youth, but of death.

Penn's Clinique ads are photographs that are thoroughly open to the analysis by Bourdieu that we entertained earlier. They are posing as pictures of reality, marked by a straightforwardness that proclaims the supposed objectivity of the image. But they are, instead, the reality that is being projected by an advertising company, by a given product's imperative to instill certain desires, certain notions of need, in the potential consumer. The very determination to fill both facing pages with a single image and to close the visual space of the magazine against any intrusion from outside this image/screen is part of this strategy to create the reality effect, to open up the world of the simulacrum, which here means to present advertising's false copy as though it were innocently transparent to an originary reality: the effect of the real substituting for the real itself.

And if one pursues this analysis one step further, one sees how Penn's image of art — in his *memento mori* still lifes — is itself dependent upon the space of that photographic project that preceded this series for some years: the Clinique ad and its staging of visual reality. There is here no *direct* relation to a specific subject — whether one thinks of that as the eroticism of death, or the presence of art, or whatever else one determines as Penn's meaning in the platinum prints. There is, instead, an elaborate system of feedback through a network in which reality is constituted by the photographic image — and in our society that increasingly means the image of advertising and consumption — so that the art-effect is wholly a function of the photographically produced reality-effect.

Penn has turned to art undoubtedly as a means of escaping the world of commercial photography. This has happened at the same moment that the art world has turned to commercial photography as the description of the very limits of vision. Like many other photographers, Penn presumably believes that he can transcend those limits. But that belief is, clearly, tantamount to repressing the existence of the limits. And the burgeoning of Clinique's claims within Penn's "art" is the return of the repressed, one compromising the other within the system of the simulacrum.

Penn wishes to affirm photography as the proper object of criticism, which is to say, the photograph as a work of art. But, symptomatically we might say, Penn's "art photographs" are like screen-memories behind which lurk the forms and images of the primal scene: that moment — viewed with a shudder by Baudelaire in the 1850s — of art debauched by commerce.[8]

8. Baudelaire expresses his horror in terms that sound very familiar to contemporary critical thought; he invokes the supplement: "If photography is allowed to supplement art in some of its functions, it will soon have supplanted or corrupted it altogether, thanks to the stupidity of the multitude which is its natural ally" [*The Salon of 1859*, sec. 2, "The Modern Public and Photography," in *Baudelaire, Art in Paris*, trans. Jonathan Mayne (London: Phaidon, 1965), p. 154].

As distinct from Penn's, Sherman's work stands in an inverse relationship to critical discourse, Sherman having understood photography as the Other of art, the desire of art in our time. Thus her use of photography does not construct an object for art criticism but constitutes an act of such criticism. It constructs of photography itself a metalanguage with which to operate on the mythogrammatical field of art, exploring at one and the same time the myths of creativity and artistic vision, and the innocence, primacy, and autonomy of the "support" for the aesthetic image.

These two examples, we could say, operate at the two opposite poles of photography's relation to aesthetic discourse. But transecting the line that connects these two practices is the socio-discourse of the Varda experiment with which I began. *Une minute pour une image*, with its system of presenting the isolated photograph as an invitation for the viewer to project a fantasy narrative, and its abandonment of the notion of critical competence in favor of a kind of survey of popular opinion, occupies a position as far as possible from the rigors of serious criticism. But in taking that position it raises the possibility of the utter irrelevance of such criticism to the field of photography.

The specter of this possibility hangs over every writer who now wishes to consider the field of photographic production, photographic history, photographic meaning. And it casts its shadow most deeply over the critical project that has been engaged by a growing number of writers on photography as they try to find a language with which to analyze the photograph in isolation, whether on the wall of a museum, a gallery, or a lecture hall. For, they must ask themselves, in what sense can this discourse be properly sustained, in what sense can it, as critical reflection, be prolonged beyond the simple inanity of "a minute for an image"?

PHOTOJOURNALISM
IN THE AGE OF COMPUTERS

Fred Ritchin

The meaning, definition, and interpretation of photography has been the subject of vigorous debate for the last fifteen years. Among other issues, many critics have attacked photography's reputation for verisimilitude and objectivity. Yet photography is still popularly perceived as a virtually transparent medium. This claim, however mistaken, has been taken advantage of by the print media — in everything from reportage to advertising — in its presentation of the world.

In the last decade, another challenge to photography's putative capacity for reliable transcription has arisen. It has come not from the traditional avenue of critical discourse nor even from the increasing tendency of the news media to use the photograph to illustrate preconceived editorial ideas. Instead, it has emerged from a new direction: the application of computer technology to photography. For the first time, this technology allows the rectangle of the image — its very substance — to be easily entered and modified. The result of this electronic manipulation is a seamless, fast alteration of the photograph — and of its representation of "reality." The implications of this technology are now becoming clear. In fact, the new malleability of the image may eventually lead to a profound undermining of photography's status as an inherently truthful pictorial form.

Computerized pictorial alteration involves translating a photograph into digital information (a numerical code that can be read by the computer) by using a device called a scanner. An image then appears as the sum total of many tiny squares, called pixels, or picture elements, each of which represents information as to the brightness and color of that sector of the image. Once digitized, an image can be subtly modified pixel by pixel. The entire image can be altered in a variety of ways: colors can be changed, the apparent focus sharpened, some elements can be taken out, and others replicated. The process also allows for the original image to be combined with another.

Conventional retouching techniques have allowed many similar alterations to be made; yet, unlike computerized revamping of the photograph, older techniques could generally be detected — at least on the image itself, if not in its reproduction. Earlier retouching methods

frequently took a skilled craftsperson many hours or days to accomplish, and it wasn't apparent how the image would look until the end of a frequently expensive process. In contrast, the computer allows modifications that appear virtually seamless to be made within seconds or minutes. Increasingly, computers are also being used by large publications for their efficiency and speed in laying out and preparing text and pictures for printing.

The fact that photographic images are being digitally entered into these pre-press systems as a matter of course confronts editors with a new temptation: the image can quite easily be modified in its digital form. Too, the routine use of this technology makes it more accessible to a wide range of employees at a given publication, any of whom may become enamored with its image-altering possibilities. No comparable opportunity was offered by conventional printing techniques.

For some practitioners, such as artists and advertising designers, computer technology has obvious advantages that are less problematic, especially since neither art nor advertising ever claimed to be unmanipulated. A graphic designer, for example, can produce new images for a brochure by taking a single photograph of a car and digitally placing it into a photographic scene of snow-capped mountains, a quiet beach, or a busy metropolis. The computer can also be used to change the car's color, its orientation in the frame, and the number of doors on it. This type of computerized compositing represents a practical resolution to visual problems in situations where documentary considerations are not an issue.

The ethical or factual problem of computer alteration arises with the greatest urgency in photojournalism, or what more broadly and accurately should be labeled editorial photography. Traditionally it has been possible to crop a photograph for publication, cutting out parts of one or more of its edges, usually without damaging the image's integrity. But the computer allows much more extensive manipulation, introducing new practices that demand new terminology, such as what might be called "reverse cropping." Now, the edge of an image can be extended or cloned rather than cropped, a practice that appears to be gaining wide acceptance.

In essence, an editor now has the ability to reach into the guts of a photograph and manipulate any aspect of it, just as text editors are able to reach inside sentences or paragraphs and change the words of a writer. There is a big difference in the status of the writer and the photographer, however. Writers are considered to be the authors of their own words, to have an acknowledged point of view, and to be

responsible for what is printed under their bylines. Editorial photographers, on the other hand, have usually not been considered the authors of their images, but rather the talented operators of a neutral mechanical device. It is not by chance that the photographer's credit line is often printed in exceedingly small type and frequently can be read only by turning a book or magazine on its side.

In addition, the photographer is generally required to submit a large number of pictures taken on each assignment. Editors then choose which images are to be used; a writer, in comparison, is not required to turn in a variety of rough drafts for someone else to select from. Editors must consult with the writer, at least in principle, before making significant modifications in a text. At most major publications, a photographer's images are usually selected by someone other than the photographer, a process that often takes place without his or her knowledge and with little possibility of recourse.

In this climate, the computer provides the editor with yet another tool to aid in controlling the production of imagery. A notorious case of computer manipulation occurred in the February 1982 issue of *National Geographic*, a mainstream magazine dedicated to "straight" photography.

For that issue, the magazine's editors wanted to use a picture of the pyramids at Giza on the cover. But the photograph they chose was horizontal; what they needed was a vertical image. So they used a computer to visually shift the pyramids close to each other — close enough that they would fit on the cover. News of the *Geographic*'s deception was well publicized, causing considerable controversy in the photographic community. Several years after the fact, Wilbur E. Garrett, the magazine's editor, characterized the manipulated image as one that the photographer might have taken were he to have stood a few feet to the side. Garrett summarized what had been done as a kind of retroactive repositioning of the photographer.[1]

1. Wilbur E. Garrett, interview with author, Summer 1984.

Garrett's comment is yet another indication of how earlier conceptions about the nature of photography are no longer sufficient. His justification posits the idea that the accepted photographic convention of cropping and the newer reverse cropping, which are both space-related modifications, have been joined by the concept of "modification in time." In other words, the photographic image is no longer time-specific, the result of the momentary and privileged meeting of subject and photographer. Now, time is not fleeting. The editor's revisionist ability can extend to interfering even with the already completed relationship of the photographer to his or her subject.

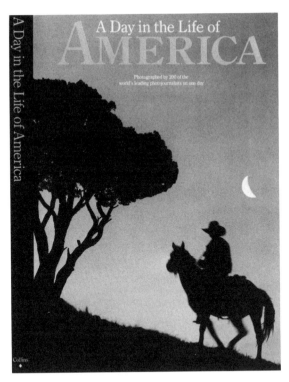

One can reach backward in time, repudiating the photographer's judgment, to "rephotograph."

National Geographic is not the only magazine to have used this technology. Many other publications have modified photographs, often because of the difficulty of fitting an image to the cover format, the cover being considered the publication's main newsstand selling point. *Rolling Stone*'s editors, for example, removed a shoulder holster and pistol from a photograph of "Miami Vice" television series star Don Johnson in order to achieve a less violent-looking image for the cover.[2] Editors of *A Day in the Life of America*, a book that is marketed as a photojournalistic look at the United States, also decided to computer-manipulate a horizontal image into a vertical one for use on the book's cover. (And they had more than 235,000 images to choose from.) So acceptable has this practice apparently become that the book's producers didn't even try to hide the manipulation: a horizontal image of the same scene was published on the front cover of their illustrated calendar, with the book's vertical cover image printed on its back. One of the "Day in the Life" producers, Rick Smolan, later explained at a conference on computer imaging that other books in this series contained computer-modified images and that the modifications had been done for marketing reasons.[3]

Perhaps the most interesting — and forthright — use of computer technology by a

A Day in the Life of America, Collins Publishers. Photo: Frans Lanting, © 1986.

2. *Rolling Stone,* 28 March 1985.

Science '84, August 1984.

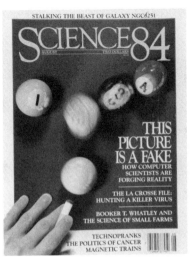

3. Smolan's remarks were made at the Electronic Photography and Digital Imaging Conference, Sunnyvale, California, February 1989, and reported in *News Photographer,* May 1989.

magazine was done for the cover of *Science 84* in 1984. Underneath a title that read "This Picture Is a Fake" was an image that showed a hand holding a billiard cue over the green felt-covered surface of a pool table, along with several pool balls that were apparently in motion. This still image, created by the magazine, represented the application of three major imaging techniques. The picture of the hand and billiard cue were taken from a conventional photograph. In turn, it was conjoined with the image of the billiard balls by using computer technology that can combine images. The green felt was also extended on top so that the magazine's title could be placed on it. The third technique was the computer genera- tion of a photographically realistic image of the pool balls in motion, which was created by Lucasfilm, Ltd., a San Rafael, California–based motion picture production company.

This last technique — creating a "realistic" image from scratch with a computer — is perhaps the most revolutionary in its implications because it allows the generation of imagery according to mathematical applications that simulate reality. To make this image, programmers working at Lucasfilm managed to create a program that visually simu- lates the look of objects in motion, in this case the pool balls, so that a realistic image could be made of moving objects that never existed. The balls cast shadows on the table, and some reflect what appear to be lights and windows. The image, which would have taken only about a second for a camera to record, required some one hundred hours of calculation on a computer as well as several months of work by scientists. It is still a prototype technique. Once developed, such techniques (in this case the simulation of blur caused by motion) can be applied to other computer- created imagery in which a similar effect is desired.

Of greater significance, however, is the possibility of mathematically generating images of human beings. This ability to simulate reality, as well as the capacity to explore new realities unavailable to conventional photography, make the computer-generation of imagery a particularly potent tool. Yet, synthesizing new images mathematically is a complex and time-consuming process, and it is likely that in the field of still photography, the bulk of computer-generated imagery will be made by compositing and otherwise manipulating extant imagery. Utilizing developments such as home scanners and the enormous supply of photographs stored in image banks, which will be retrievable by com- puter, artistic, editorial, and many other needs can be fulfilled without programming imagery from scratch. In principle, one will be able to telephone in a request for imagery and have the pictures appear on one's computer screen, charged to a private or business account. Home

scanners will afford virtually anyone the technical means to copy any image that appears in print, as well.

This methodology raises a variety of questions about the ownership of copyright. If a photographer's image is significantly manipulated by someone else, who owns the copyright to the new image? Who gets paid for it? On what basis would a fee be divided between the imagemaker and the image-manipulator? If one incorporates several other photographers' images into one, as I did in a demonstration I orchestrated for *The New York Times Magazine* in which photographs of the Eiffel Tower, Statue of Liberty, and TransAmerica Pyramid were added to a photograph of the New York City skyline, how much does each photographer get paid? By the amount of space each image takes up? How is one going to keep track of where images come from? When the producers are unscrupulous, how can an image be traced back to its original, unmanipulated source? One photograph of a full moon may be appropriated and used in a multitude of other images.

By extension, one can imagine a new market opening up for generic photographs. Photographers might be assigned at the outset to shoot raw visual material for others to manipulate, rather than being asked to make specific pictures. This might be the way that many photographers will begin to think of their own imagemaking: the original photograph will become as malleable as clay waiting to be shaped by artists or editors at some point in the future. Photography might also become a two-step process, in which the photographer makes generic images that he or she will alter or combine at a later date. In a "worst-case" scenario, many photographers won't be needed at all.

With the enhancement of video imagery and the advent of high-definition television, it may be possible to dispense with still photographers in many situations and simply allow editors to choose images stored on videotape. It may not be too farfetched to consider that robot video cameras will be placed at press conferences and courtrooms to simultaneously fulfill the needs of both television and the print media in the future.

When I wrote an early article on computerized image-manipulation, it seemed obvious to me that major publications would take heed of the dangers of computer retouching and exercise caution, if only because it seemed to be in their own best interest to guard the authoritative illusion of photography, untampered by human hands.[4] It was therefore surprising to see an article in the January 26, 1989, edition of the *Wall Street Journal*, in which the picture editor of *Newsweek* magazine, Karen Mullarkey, not only acknowledged using a computerized compositing of

4. Fred Ritchin, "Photography's New Bag of Tricks," *The New York Times Magazine*, 4 November 1984, pp. 42–56.

two photographs into one image, but averred that such retouching was an acceptable practice for feature and fashion photographs. In this case, the two stars of the feature film *Rain Man*, Dustin Hoffman and Tom Cruise, were photographed separately but composited together so that it appears that a laughing Hoffman was standing in front of a smiling Cruise in a single photograph.[5] The illusion was reinforced by the fact that the composite carried only one photo credit — Douglas Kirkland — who had photographed each star at a separate time and place.

5. The composite appeared in the January 16, 1989, issue of *Newsweek*. Photographer Kirkland discusses the making of the image in his book, *Light Years: Three Decades Photographing among the Stars* (New York: Thames & Hudson, Inc., 1989).

Looking at the image and thinking it a single photograph, I deduced that Hoffman was a more assertive and perhaps more self-involved man, while Cruise was somewhat shy and respectful of his older co-star. Yet they both seemed to get along rather well, each acting naturally in the other's presence. The text of the accompanying article, in fact, describes the two stars in approximately the same way that I interpreted this image. The use of the computer, then, allows the continual revision of photographic images so that they can now more precisely illustrate the point of view expressed in the text. Furthermore, photographs could be constructed to illustrate *anyone's* point of view in the publishing chain of command.

The implications of this technique being used at a mainstream magazine such as *Newsweek* are particularly alarming. Even though the picture editor is quoted as saying that computer manipulation would not be used on news photography because "you undermine your reputation," there is a growing sense that this kind of editorial illustration is occurring at a variety of publications with increasing frequency. But it remains largely unacknowledged. Now, the reader cannot rely upon his or her experience and sense of what is real, based upon photography's similar-ity to human sight, to decipher the veracity of these kinds of composites because they are too well done. Arnold Drapkin, the former picture editor of *Time* magazine, found this out when *Time'* s editors composited a picture of a United States Marine done in a studio and one of the American Embassy in Moscow, for a lead picture on a story about Marine espionage in the April 20, 1987, issue. He thought that the image was too obviously a montage, with two photo credits, to label it as such. But after the magazine received many letters concerning the use of the montage, Drapkin had to write directly to the readers who had complained, apologizing for the composite.

6. Guenther Cartwright, discussion with author, February 1989. Cartwright's demonstration was made at a seminar on electronic color imaging, held by the National Press Photographers' Association, at the Rochester Institute of Technology, Rochester, New York, 25 March, 1988.

Clearly, editors are using the computer in ways that they do not consider to be tampering with essential veracities. Yet as Guenther Cartwright, a professor at the Rochester Institute of Technology who has altered images in order to provoke discussions of ethics, has put it, "One person's enhancement is another person's alteration."[6]

7. *Life* magazine, February 1989, p. 4.

In its February 1989 issue on "the future," *Life* magazine's editors altered three photographs and acknowledged the modifications.[7] In the publisher's note, the magazine's director of design, Tom Bentkowski, predicted an increased use of the computer in the future: "We are accustomed to seeing a painting in expressionistic colors, but we think of photographs as being real and representational. As it becomes easier to manipulate the colors electronically, we will see more and more of that being done in the future."

After only a few years' experience with this new computer technology, one looks with some unease at the further development in electronics of still video cameras. These cameras do not use film but a small, reusable videodisc that can record up to fifty images. The images can be sent directly from a transmitter containing the disc to a computer in an editor's office, where the images appear on a screen. From there the image can be transmitted directly to the printing plant: it does not need to exist as a negative, transparency, or print before it appears in published form.

What makes this such a potentially problematic situation is that with the absence of both a permanent negative (the discs are made to be reusable) and a print, there is no archival document that can be with certainty called an "original" photograph. If the photographer reuses the disc and someone in the editor's office or printing plant decides to manipulate the now ephemeral image in the electronic system, it would be very difficult for a photographer to recall all the details of a situation and point out the changes. Or, conversely, a photographer may decide to significantly modify the image before transmitting or printing it, and the editor might then be unable to detect what has happened. The problems of image authentication become obvious not only in photojournalism, but also in a court of law, the enforcement of missile verification treaties, and other documentary uses of the photograph.

What can be done to safeguard the photograph's documentary authority in the age of the computer? It seems inevitable that the photograph will be thought of as both less reliable and more inventive in its public and private applications, extending from its use on the front page of a newspaper to snapshots of one's relatives. As home systems become more available, travel pictures may begin to say more about what one *wanted* to happen on a vacation than what one experienced. Social and cultural histories will not be able to rely so easily upon photographs, for

there will be less assurance that the details in the picture were reliably depicted. Artists, on the other hand, will benefit by having a wide array of imagery to play with, although the capacity of these images to portray "reality" may eventually be perceived as much less intense or may even be neutralized.

It does seem that much can be done to safeguard the photograph's ability to transcribe reality and its general sense of veracity. In the case of journalism, for example, editors have been able to rely upon a reporter's sense of honor; reporters are asked to stand by what they write. In the future, this attitude must also extend to a greater degree to photographers. The photographer will have to be considered to be the author of his or her images, responsible for the accuracy of what is in them. When the photograph is no longer thought of as simply a mechanical transcription, then it will have to be acknowledged as the product of individual interpretation. As such, the photographer would finally be thought of as having a point of view that would be violated by tampering with the photograph.

This trend may in fact encourage more editorial photographers to do work other than the "I was there" variety, work that would raise questions, assert opinions, and let the reader share more fully the complexity and depth of the photographer's vision. And while images will be made by robots in the future, perhaps there will also be a revival of the largely dormant photo essay taken by living, breathing, thinking photographers; the photograph, unchained from its simplistic role of authentication, will then be recognized for its linguistic subtlety and broader reach.

As photographs become more varied in their approach and execution, it will be important to define them just as text is defined, under categories such as fiction and nonfiction or editorializing and reportage. It may also be necessary to employ a specific terminology, such as "photo-illustration," to differentiate physically manipulated photographs from other images. Similarly, other kinds of staging and manipulation in editorial photography, such as the use of models as stand-ins, should also be indicated.

What is clear thus far is that before this process generally infiltrates journalism in the United States and elsewhere, and the public begins to perceive photography as unreliable, those who control its uses should clearly understand what they are doing to the photograph. They should address both the question of image manipulation by the computer and the more general tendency to use photographs to illustrate preconceived ideas and self-fulfilling prophesies. Similar questions

should also be addressed to television, as the videotaped image is certainly not immune to these same abuses. Whether this kind of soul-searching will ever take place in the media as a whole, though, is unclear.

As readers we must remain vigilant. Otherwise, what as a society, and among societies, are we going to be left with as a form of communication that can be trusted? What information will people be able to rely upon to make decisions? Or, most precisely, what will the role of the press in a democracy be worth?

If even a minimal confidence in photography does not survive, it is questionable whether many pictures will have meaning anymore, not only as symbols but as evidence. A government will be able to deny the veracity of images of torture victims, for example — and it may be difficult to prove otherwise. Undoubtedly, we will all be told that what has happened is the computer's fault, and we will then be even more isolated in our own media bubbles than ever before.

THE PLEASURES OF LOOKING

The Attorney General's Commission on Pornography versus Visual Images

Carole S. Vance

An early version of this paper was given at the Society for Photographic Education convention, Rochester, New York, 1989; thanks to the audience for a stimulating exchange and to the Women's Caucus for inviting me. Portions of this argument first appeared in "The Meese Commission on the Road," *The Nation*, 2–9 August 1986, pp. 65, 76–82.

1. Attorney General's Commission on Pornography, *Final Report*, 2 vols. (Washington, D.C.: U.S. Government Printing Office, July 1986).

Public hearings were organized around preselected topics in six cities: Washington D.C. (general), Chicago (law enforcement), Houston (social science), Los Angeles (production and distribution), Miami (child pornography), and New York (organized crime). Each public hearing typically lasted two full days. Commission executive sessions were held in each city, usually for two working days, in conjunction with the public hearings. Additional work sessions occurred in Washington, D.C., and Scottsdale, Arizona.

All the commission's executive sessions were open to the public, following the provision of sunshine laws governing federal advisory commissions. Commissioners were specifically enjoined from discussing commission business or engaging in any informal deliberations outside public view.

My analysis is based on direct observations of the commission's public hearings and executive sessions, supplemented by many interviews with participants.

2. Larry Madigan, "former consumer of pornography," testified at the Miami hearings. He was

The Attorney General's Commission on Pornography, a federal investigatory commission appointed in May 1985 by then-Attorney General Edwin Meese III, orchestrated an imaginative attack on sexual pleasure and desire. The chief targets of its campaign were sexually explicit images, dangerous, according to the logic of the commission, because they might encourage sexual desires or acts. The commission's public hearings in six U.S. cities during 1985 and 1986, lengthy executive sessions, and an almost two-thousand-page report[1] constitute an extended rumination about visual images and their power. Although the term *representation* was not in its vocabulary, the panel of commissioners tenaciously clung to and aggressively advanced implicit theories of visual representation. More important, the commission took every opportunity to show sexually explicit images during its public hearings, using them to promote its point of view, to document the alleged nature of pornography, to offer a compelling interpretive frame, and to intensify a climate of sexual shame that made dissent from the commission's viewpoint almost impossible.

To enter a Meese Commission public hearing was to enter a time warp, an inviolable bubble in which the 1950s were magically recreated. Women were virgins, sex was dirty, shame and secrecy were rampant. Consider the testimony of self-described "victim of pornography" Larry Madigan.[2] He testified earnestly that at age twelve he was a "normal, healthy boy and my life was filled with normal activities and hobbies," when his life was radically disrupted by exposure to a deck of pornographic playing cards: "These porno cards highly aroused me and gave me a desire I never had before." Soon after that, he started to masturbate. Later, he went on to have "promiscuous" sex with two women and almost ended up "a pervert, an alcoholic, or dead," until he found Christ and was born again. How can we explain that this testimony was received in 1985 by several hundred people in a federal courthouse in a major American city without a single, publicly audible laugh? The answer lies in the commission's use of visual images to create a logical and emotional climate in which such claims were not only plausible, but convincing.

Appointed during President Ronald Reagan's second term, the commission paid a political debt to conservatives and fundamentalists who had been clamoring for action on social issues, particularly pornography, throughout his term of office. Pornographic images are symbols of what moral conservatives want to control: sex for pleasure, sex outside the regulated boundaries of marriage and procreation. Sexually explicit images are dangerous, conservatives believe, because they have the power to spark fantasy, incite lust, and provoke action, as well as convey undesirable information. What more effective way to stop sexual immorality and excess, they reason, than to curtail sexual desire and pleasure at its source — in the imagination.

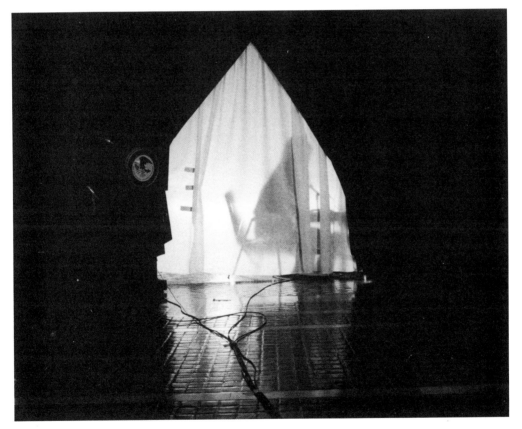

Witness testifying anonymously, Meese commission hearings, 1985–86. Courtesy of the Department of Justice.

Conservatives also project their intense feelings about sexuality and gender politics onto pornography. Pornography, to them, is a stand-in for destructive sexual impulses that, left uncontrolled, threaten to destroy the stability of the family, the authority of men over women, and the power of parents over children. Sexual pleasure is always suspect and usually dangerous, unless harnessed within marriage,

reproduction, and God's plan. Stirrings of desire, as well as individuals who would encourage or defend it, constitute a moral lapse and a personal threat. The battle against unruly sexual impulses is a never-ending struggle, even for those with strong convictions. Part of the charm of regulating pornography is that sexual images in the public arena can be banished more reliably than sexual impulses in the individual psyche.

The campaign against pornography comes at a time when moral conservatives' control over sexual behavior is shrinking. The past century has seen a relentless increase in the frequency and acceptance of sexual behavior outside the confines of marriage and even hetero-sexuality.[3] Contemporary controversies about sexuality — teen pregnancy, lesbian and gay rights, sex education in the schools, abortion, and AIDS — make it obvious that traditional moral standards no longer hold absolute sway. Sexuality is an actively contested terrain, where diverse constituencies struggle over definitions, law, and policy. Amid this flux, regulation of visual images gives the illusion of control: visual images can still be regulated, although the actual sexual behavior they depict usually cannot be. Visual images remain an easy target, since many who participate in sexual pleasure in private remain unwilling and ashamed to defend images of it in public.

The goal of the Meese Commission was to implement a repressive agenda on sexually explicit images and texts: vigorous enforcement of existing obscenity laws coupled with the passage of draconian new legislation. The commission's ninety-two recommendations continue to pose a serious threat to free expression.[4] They include appointing a high-powered Justice Department task force to coordinate obscenity investigations and prosecutions nationwide, developing a computer bank to collect data on individuals and businesses "suspected" (as well as convicted) of producing obscene materials, mandating high fines and long jail sentences for offenses, and using punitive RICO legislation (the Racketeer Influenced and Corrupt Organizations Act, originally developed to fight organized crime) to confiscate the personal property — cameras, darkroom equipment, computers, even homes and cars — of anyone convicted of the "conspiracy" of producing or distributing pornography. Performers and producers of sexually explicit photos and films should be prosecuted under existing prostitution and pimping laws, the panelists reasoned, since money changes hands in exchange for sexual services. They regretfully noted a large body of sexually explicit images beyond prosecutorial reach, since the images could not be judged obscene by current legal standards. The commission endorsed

3. For changes in sexual patterns in the last century, see (for England) Jeffrey Weeks, *Sex, Politics and Society: The Regulation of Sexuality Since 1800* (New York: Longman, 1981) and (for America) John D'Emilio and Estelle B. Freedman, *Intimate Matters* (New York: Harper and Row, 1988).

4. See *Final Report*, pp. 433–458, for a complete list of the panel's recommendations.

5. *Final Report*, p. 420. See *Final Report*, pt. 4, chap. 7, "Citizen and Community Action and Corporate Responsibility." These instructions are significant because they outline a powerful, extralegal strategy for eliminating materials that are "non-obscene but offensive," that is, normally immune from legal action under obscenity law. Suggestions include forming antipornography activist groups and collecting detailed information on sexually explicit materials available in local stores, movie theaters, hotels, and through video, cable, and computer channels. A detailed checklist is provided for citizens to conduct "a thorough survey of these establishments and media." Citizens are also encouraged to pressure police and public officials, conduct court watches, picket and boycott local stores, and monitor rock music heard by their children.

Commissioners also recommend that institutions that are taxpayer supported prohibit the "production, trafficking, distribution, or display of pornography on their premises or in association with their institution." Conservative politicians and right-wing decency groups used this strategy in 1989 to attack the National Endowment for the Arts for indirectly funding an exhibit of Robert Mapplethorpe's photographs, some of which were erotic, some sexually explicit, at the Corcoran Gallery, Washington, D.C. (For an account of the NEA-Mapplethorpe controversy, see Carole S. Vance, "The War on Culture," *Art in America*, September 1989, pp. 39–45.)

6. The children were returned home the next day, as social-service officials determined there was no evidence that the children were in danger. Charges were eventually dropped by the state of Virginia because of local protest, but the U.S. Postal Service has not officially closed the case. According to Sims, while searching her house agent Northrup told her, "Art is anything you can get away with," and referring to her work, "This is all filth." Later, in an

citizen action crusades, providing pages of detailed instructions for neighborhood watchdog groups to target and remove material in their communities that "some citizens may find dangerous or offensive or immoral."[5]

For imagemakers, the impact of the commission is significant in generating more aggressive prosecutions at the federal, state, and local levels, in encouraging passage of new legislation that implements the commission's recommendations, and in increasing caution and self-censorship among those who produce sexually explicit visuals. In 1988, officials arrested artist Alice Sims at her home in Alexandria, Virginia, for allegedly producing child "pornography," photographs of two naked little girls, one of them her one-year-old daughter. The photofinishing lab had reported her, as required by new laws, for developing "sexually explicit" material using children (a felony charge with a maximum penalty of ten years in jail). Officials — including U.S. Postal Inspector Robert Northrup, who testified before the Meese Commission — searched Sims's house, carted away three bags of "evidence" (her art), and removed her children, including the still breast-feeding daughter, to foster care.[6]

In another instance of the commission's impact, Congress passed, by an overwhelming majority, the 1988 Child Protection and Obscenity Enforcement Act, which contained several Meese Commission recommendations. Retroactive to 1978, the act would have required producers and distributors of material that depicted "frontal nudity" or "actual sexually explicit conduct" (not necessarily obscene) to obtain and maintain for an indefinite period of time proof of the model's age. Opponents challenged the law, arguing that such burdensome record-keeping provisions and severe forfeiture penalties would, in effect, ban constitutionally protected art books, photography, and motion pictures that have sexual content. The federal court agreed and struck down the legislation, though the government is considering redrafting the legislation or appealing.

The commission's unswerving support for aggressive obscenity law enforcement bore the indelible stamp of the right-wing constituency that brought the panel into existence. Its influence was also evident in the belief of many commissioners and witnesses that pornography leads to immorality, lust, and sin. But the commission's staff and the Justice Department correctly perceived that an unabashedly conservative position would not be persuasive outside the right wing. For the commission's agenda to succeed, the attack on sexually explicit material had to be modernized by couching it in more contemporary arguments,

interview with *Village Voice* art critic Elizabeth Hess, he said, "Artistic people are funny. Mrs. Sim's house was not like Ozzie and Harriet's." He asked, "How do you differentiate between an artist and a pedophile?" For a more complete account of the case, see "Snapshots, Art, or Porn?" *Village Voice*, 25 October 1988, pp. 31–32. Thanks to Jeff Weinstein for this citation.

arguments drawn chiefly from social science and feminism. So the preeminent harm that pornography was said to cause was not sin and immorality, but violence and degradation. In practice, the coexistence of these very different frameworks and languages proved uneasy, and modernized rhetoric at best disguised, but never replaced, the persistent bias of the commission.

I. Procedures and Bias

7. Alan Sears went on to become the executive director of Citizens for Decency through Law, a major conservative antipornography group. (The group has since changed its name to the Children's Legal Foundation.)

8. Besides Hudson, the commission panel included the following: James Dobson, head of the fundamentalist organization Focus on the Family; "I have a personal dislike for pornography and all it implies," he told *The Washington Post*. Judge Edward Garcia, recently appointed by then-President Reagan to the Federal District Court in California; Garcia prosecuted obscenity cases before becoming a judge. Diane Cusack, a member of the Scottsdale, Arizona, City Council; Cusack urged residents to take photographs and license numbers of patrons entering the local adult theater. Father Bruce Ritter, a Franciscan priest; Ritter directs Covenant House, a home for runaways in New York's Time Square area, and is an outspoken critic of pornography. Attorney Harold (Tex) Lazar; Lazar played an instrumental role in setting up the commission as an aide to Reagan's first Attorney General, William French Smith. Frederick Schauer, a law professor at the University of Michigan; Schauer has written extensively on obscenity.

The four members of the panel with no public positions on pornography included Park Elliott Dietz, a psychiatrist at the University of Virginia and a consultant to the Federal Bureau of

Appointed to find "new ways to control the problem of pornography," the panel was chaired by Henry Hudson, a vigorous antivice prosecutor from Arlington, Virginia, who had been commended by President Reagan for closing down every adult bookstore in his district. Hudson was assisted by his staff of vice cops and attorneys and by executive director Alan Sears, who had a reputation in the U.S. Attorney's Office in Kentucky as a tough opponent of obscenity.[7] Prior to convening, seven of the eleven commissioners had taken public stands opposing pornography and supporting obscenity law as a means to control it. These seven included a fundamentalist broadcaster, several public officials, a priest, and a law professor who had argued that sexually explicit expression was undeserving of First Amendment protection because it was less like speech and more like dildos.[8] The smaller number of moderates sometimes curbed the staff's conservative bent, but their efforts were modest and not always effective.

The commission had a broad mandate to examine a wide range of sexually explicit texts and images, including pornography as well as the much smaller category of obscenity. Obscenity, a legally meaningful term, had been defined by a series of court decisions determining that obscene expression fell outside normal First Amendment protection and thus could be regulated in a manner that most speech could not.[9] Laws that restrict sexually explicit speech may do so only if the material meets the definition of obscenity established by the courts, as interpreted by judges and juries. Pornography, on the other hand, has no legal definition, is not regulated by law, and comprises a much wider range of material. Material can be sexually explicit and even pornographic without being obscene. Thus, the panel's challenge: how to control or eliminate the large body of material called pornography, when the available legal weapons targeted only obscenity? (One solution was to encourage extralegal citizen action against material that was merely pornographic. A second was to invent a new category of

Investigation, who specialized in the subject of sexual deviations ("paraphilias"); Judith Becker, a Columbia University psychologist known for her research on rapists and rape victims; Ellen Levine, a vice president of CBS and editor of *Woman's Day*; and Deanne Tilton, head of the California Consortium of Child Abuse Councils.

9. A variety of state laws had resulted in prosecutions and convictions for obscenity in the nineteenth and twentieth centuries. In response to a challenge of one such law, the Supreme Court in 1957 articulated the First Amendment standard for what could be prosecuted as "obscene" in *Roth v. United States* [354 U.S. 476 (1957)]. The court decided that the normal protections given to constitutionally protected speech need not be given to legally obscene material.

The most recent attempt to define what is "obscene" in a constitutionally permissible manner is found in a 1973 case, *Miller v. California* [413 U.S. 15 (1973)]. According to *Miller*, material is obscene if all three of the following conditions are met:

1. The average person, applying contemporary community standards, would find that the work, taken as a whole, appeals to the prurient interest, and

2. the work depicts or describes, in a patently offensive way, sexual conduct specified by the statute, and

3. the work, taken as a whole, lacks serious literary, artistic, political, or scientific value.

10. Victims of pornography, as described in the *Final Report*, included "Sharon, formerly married to a medical professional who is a avid consumer of pornography," "Bill, convicted of the sexual molestation of two adolescent females," "Dan, former Consumer of Pornography [*sic*]," "Evelyn, Mother and homemaker, Wisconsin, formerly married to an avid consumer of pornography," and "Mary Steinman, sexual abuse victim."

pornography — "violent pornography," which was so pernicious, the panel argued, that it should be assimilated into the category of obscenity and subjected to its harsher penalties.)

The conservative bias continued for fourteen months, throughout the panel's more than three hundred hours of public hearings in six U.S. cities and lengthy executive sessions. The list of witnesses was tightly controlled: 77 percent supported greater control, if not elimination, of sexually explicit material. Heavily represented were law-enforcement officers and members of vice squads (68 of 208 witnesses), politicians, and spokespersons for conservative antipornography groups like Citizens for Decency through Law and the National Federation for Decency. Great efforts were made to find "victims of pornography" to testify,[10] but those reporting positive experiences were absent. Witnesses were treated unevenly, depending on whether the point of view they expressed facilitated the commission's ends. There were several glaring procedural irregularities, including the panel's attempt to withhold drafts and working documents from the public and its effort to name major corporations such as Time Inc., Southland, CBS, Coca-Cola, and K-Mart as "distributors of pornography" in the final report, repeating unsubstantiated allegations made by Rev. Donald Wildmon, executive director of the National Federation for Decency. These irregularities led to several lawsuits against the commission.[11]

The barest notions of fair play were routinely ignored in gathering evidence. Any negative statement about pornographic images, no matter how outlandish, was accepted as true. Anecdotal testimony that pornography was responsible for divorce, extramarital sex, child abuse, homosexuality, and excessive masturbation was entered as "evidence" and appears as supporting documentation in the final report's footnotes. Chairman Hudson's hope that social science evidence could provide the smoking gun linking pornography to violence was dashed by social scientists' testimony, which cautioned against drawing such hasty conclusions. When it became clear that social science would not provide the indictment of pornography that he wanted, the chair announced that harm should be evaluated according to two additional tiers of evidence: "the totality of the evidence," which included victim testimony, anecdotal evidence, expert opinion, personal experience, and common sense; and "moral, ethical, and cultural values." Pornography could thus still be convicted on two out of three tiers, despite the lack of more objective data.

The commission concentrated on sexually explicit images, although obscenity law applies to both texts and images. This marks a notable

11. In February 1986, the executive director of the commission announced that in the future no drafts or working papers could be released to the press or public. The American Civil Liberties Union sued the commission for violating access laws governing federal panels, and the commission settled before the case got to court, agreeing to release these documents to the public (see *The Washington Post*, 7 March 1986; 4 April 1986; 12 April 1986).

When some commissioners objected to repeating unsubstantiated allegations in the final report, the staff sent letters to the corporations on Department of Justice letterhead, noting that "the Commission received testimony alleging that your company is involved in the sale or distribution of pornography." The letter noted that the companies had thirty days to respond and that "a lack of reply would indicate they did not differ" with the allegations. Some corporations strenuously protested these methods. Others, however, caved in. Southland Corporation, which owns forty-five hundred 7-Eleven convenience stores, announced that it would no longer carry *Playboy*, *Penthouse*, and *Forum* magazines. Bob Guccione, *Penthouse* publisher, called the move "blacklisting" and launched lawsuits against the commission. The commission settled one by agreeing not to publish the allegations in the report, but Guccione's suit for economic damages against the commission and individual commissioners is still pending (*The New York Times*, 15 April 1986, p. B5; *Newsweek*, 26 April 1986, pp. 38–39).

12. For accounts of the history of regulating indecency and obscenity in the United States and England, see Edward J. Bristow, *Vice and Vigilance: Purity Movements in Britain since 1700*, (New Jersey: Rowman and Littlefield, 1977); David Pivar, *Purity Crusade: Sexual Morality and Social Control: 1868–1900* (Connecticut: Greenwood Press, 1972); Walter Kendrick, *The Secret Museum* (New York: Viking,

departure from the past century of obscenity regulation and moral crusades, when a significant part of censorship efforts were directed against written material.[12] During the period bracketed by 1933 (when the Supreme Court upheld the publication of *Ulysses*) and 1966 (when it ruled in favor of *Fanny Hill*), however, literary prosecutions became relatively unsuccessful, with all but the most zealous prosecutors losing interest in these doomed, and increasingly ridiculed, efforts. Conservatives like to explain their current emphasis on censoring sexually explicit images in terms other than the practical, maintaining that visual images have a special power to influence behavior. In addition, they argue that pornography has become increasingly visual and influential, due to the swelling numbers of hard-core magazines, new technologies like home-video and cable television, and more audacious content. They complain that "porn" is flooding the nation, and now everyone can see it, even illiterates. This alarm signals a concern about the availability of visuals across boundaries of class, youth, and gender. This same concern fueled nineteenth-century attempts to restrict literature, when reformers worried that cheap printing processes and penny-papers would put pornography, formerly available only to classically schooled aristocrats, within reach of the barely literate masses.[13] The arguments made against pornographic visuals today are virtually the same as those made against pornographic texts in the late nineteenth and early twentieth centuries, even though twentieth-century arguments against sexually explicit texts have fallen into total disrepute.

Despite their overriding concern with visual images, the commissioners invited few recognized experts on representation to testify. The small number included social psychologists reporting on their laboratory experiments on imagery and aggression, though their testimony concentrated on scientific questions and only briefly mentioned the stills or short video clips they had fashioned as experimental stimuli. More typical was a grandiosely titled lecture, "The History of Pornography," delivered by a vice detective. He provided a brief history of pornographic images in the twentieth century, illustrating his lecture with slides from adult magazines and films. No specialists were invited to discuss the history of representing nudity, the body, or eroticism. It proved easy for the commissioners to falsely claim that their efforts to regulate commercial pornography would have no impact on the fine arts: their refusal to consider artistic material made it difficult to see the connections between them.[14]

Although few experts were called to testify, most witnesses — particularly vice cops, politicians, and moral majoritarians — offered

1987); John D'Emilio and Estelle B. Freedman, *Intimate Matters* (New York: Harper and Row, 1988).

13. See Walter Kendrick, *The Secret Museum* (New York: Viking, 1987), for a discussion of the class concerns that motivated nineteenth-century obscenity regulation.

14. The falsity of this claim is made evident by the recent right-wing attack on the National Endowment of the Arts over the "blasphemy" and "obscenity" contained in the work of Andres Serrano and Robert Mapplethorpe.

15. In contrast to visual artists, print and literary groups turned out in force. The commission heard testimony from the National Writers Union, Writers Guild, Association of American Publishers, the American Library Association, the Freedom to Read Committee, Bantam Books, and Actors Equity Association.

clear statements about the effect of visual images and their mechanisms of influence. Most were adherents of the "monkey see, monkey do" school of representation: viewers simply imitated the sexual behavior they saw in pornography. Most important, visual images were presented as having the capacity to arouse sexual desire and fantasy in a visceral and immediate way. Bypassing logic and moral standards, explicit pictures stimulated lust, which then demanded immediate satisfaction through masturbation, perverted sex, or rape. The effect was cumulative and addictive, with viewers purportedly graduating from reading more socially acceptable men's magazines like *Playboy* and *Penthouse* to hard-core magazines depicting fetishism and child pornography. Soon, as the story went, viewers were dependent on pornography for the supercharged arousal it offered, causing ordinary sex to pale in comparison. The path could go only downhill, ending in sexual addiction, antisocial behavior, and personal ruin. Sexually explicit visuals also communicated information about unfamiliar behavior — anal sex, bestiality, group sex — which enterprising and curious viewers would be inclined to try for themselves, thus expanding the perverse forms desire might take. In this manner, pornography served to influence norms, suggesting that hedonism, sex for pleasure, and promiscuity were acceptable. The proof of this was easily seen, witnesses claimed, offering personal and professional anecdotes as evidence. The social scientists who testified about what they had discovered to be the thin connection between sexually explicit material and sexual violence were easily overwhelmed by melodramatic recitations of personal anecdote and assertions of moral certainty.

No visual artists or art groups were called to testify.[15] The absence of spokespersons for the visual arts community was striking, given the commission's intense preoccupation with images and the potentially serious impact of its restrictive recommendations on imagemakers. A moderate panelist, *Woman's Day* editor Ellen Levine, occasionally raised questions about the relationship between the images found in the photography of Bruce Weber, Robert Mapplethorpe, and Helmut Newton and the pornographic images under discussion, asking about the impact of new regulation on their work. Since most commissioners seemed unfamiliar with contemporary work, the discussion never developed. But unlike writers' groups who vigorously testified about the possible impact of censorship on their writing, visual and graphic arts groups, as well as individual artists, were silent. The only testimony given on behalf of groups connected to the actual production of visual images was offered by trade organizations (the Motion Picture

Association of America, the Adult Film Association of America, and the National Cable Television Association), a free-lance porn producer, and representatives of several men's magazines, but they rarely addressed issues of interpretation and meaning. It is unclear if visual groups were absent because of their unwillingness to testify or their ignorance of the proceedings, but their absence was a serious loss.

II. Interpreting Visual Images

The commission's campaign against sexually explicit images was filled with paradox. Professing belief in the most naive and literalist theories of representation, the commissioners nevertheless brilliantly used visual images during the hearings to establish "truth" and manipulate the feelings of the audience. Arguing that pornography had a singular and universal meaning that was evident to any viewer, the commission staff worked hard to exclude any perspective but its own. Insisting that sexually explicit images had great authority, the commissioners framed pornography so that it had more power in the hearing than it could ever have in the real world. Denying that subjectivity and context matter in the interpretation of any image, they created a well-crafted context that denied there was a context.

The foremost goal of the commission was to establish "the truth" about pornography, that is, to characterize and describe the sexually explicit material that was said to be in need of regulation. Pornographic images were shown during all public hearings, as witnesses and staff members alike illustrated their remarks with explicit, fleshy, often full-color images of sex. The reticence to view this material that one might have anticipated on the part of fundamentalists and conservatives was nowhere to be seen, though the anomaly was not lost on wags in the audience, who jokingly referred to "the federally funded peep show." The commission capitalized on the realistic representational form of still photos and movie and video clips, stating that the purpose of viewing these images was to inform the public and themselves about "what pornography was really like." Viewing was carefully orchestrated, and a great deal of staff time went toward organizing the logistics and technologies of viewing. Far from being a casual or minor enterprise, the selection and showing of sexually explicit images constituted one of the commission's major interventions.

In fact, visual images dominated the hearings at all times. During screenings, pornographic images consistently captured the audience's attention with a reliability that eluded the more long-winded witnesses.

The images were arresting, vivid, memorable, and, one had to suspect, not infrequently arousing. A rustle of excitement swept through the audience at the announcement of each showing. The chance to see forbidden material had obvious appeal. In between slide shows, the images of sex still loomed large, as witnesses testified under a blank projection screen whose unblinking, steady eye served as a reminder of the pornography whose nature had been characterized with seemingly documentary precision. Residual effects were palpable, too, in the aroused emotional state of the audience and commissioners, which made dissent not only unwelcome, but incomprehensible and personally discrediting as well.[16]

The structure of viewing was an inversion of the typical context for viewing pornography. Normally private, this was public, with slides presented in federal courthouse chambers before hundreds of spectators in the light of day. The viewing of pornography, usually an individualistic and libidinally anarchic practice, was here organized by the state — the Department of Justice, to be exact. The normal purpose in viewing, sexual pleasure and masturbation, was ostensibly absent, replaced instead by dutiful scrutiny and the pleasures of condemnation.

These pleasures were intense. Some had called the commission a show trial in which pornography was to be found guilty, but if so, it seemed scripted by the staff of "Saturday Night Live." The atmosphere throughout the hearings was one of excited repression: witnesses alternated between chronicling the negative effects of pornography and making sensationalized presentation of "it." Taking a lead from feminist antipornography groups, everyone had a slide show: the FBI, the U.S. Customs Service, the U.S. Postal Service, and sundry vice squads. At every "lights out," spectators would rush to one side of the room to see the screen, which was angled toward the commissioners. Were the hearing room a ship, we would have capsized many times.

Alan Sears, the executive director, told the commissioners with a grin that he hoped to include some "good stuff" in their final report, and its two volumes and 1,960 pages faithfully reflect the censors' fascination with the thing they love to hate. Although the commission stopped short of reproducing sexually explicit images in a government document, the enthusiastic voyeurism that marked the hearings is evident in the report. It lists in alphabetical order the titles of material found in sixteen adult bookstores in six cities: 2,370 films, 725 books, and 2,325 magazines, beginning with *A Cock between Friends* and ending with *69 Lesbians Munching*. A detailed plot summary is given for the book *The Tying Up of Rebecca*, along with descriptions of sex aids advertised

16. A number of potential witnesses told me that they were afraid to testify, in some cases declining actual invitations and in other cases deciding against requesting to speak. They feared hostile and humiliating cross-examination and, for producers of sexually explicit material, police retaliation in the form of harassment, investigation, and potential prosecution. Fear of reprisal was especially common among the free-lance, and often more innovative, producers of sexually explicit material, whether pornography or radical political graphics. As independent producers, they could not rely on large parent organizations to offer legal protection and financial backing (and, some implied, payoffs to corrupt vice cops). With only modest financial resources at hand, the prospect of disrupted business or costly legal battles (even if ultimately victorious) spelled financial disaster. Most small producers felt it was prudent not to testify, leaving the job to mainstream men's magazines not known for radical sex politics or innovative graphics.

17. Descriptions of magazine photographs can be found in the *Final Report*, pp. 1614–1646. Videos and movies are also described, though the narrative concentrates primarily on plot and dialogue. The narrative reproduces long sections of dialogue verbatim, arguably constituting a copyright violation.

18. *Final Report*, statement of Judith Becker and Ellen Levine, p. 199. In addition, they wrote: "We do not even know whether or not what the Commission viewed during the course of the year reflected the nature of most of the pornographic and obscene material in the market; nor do we know if the materials shown us mirror the taste of the majority of consumers of pornography…. While one does not deny the existence of this material, the fact that it dominated the materials presented at our hearings may have distorted the Commission's judgment about the proportion of such violent material in relation to the total pornographic material in distribution."

19. Recent empirical evidence does not support the often-repeated assertion that violence in pornography is increasing. In their review of the literature, social scientists Edward Donnerstein, Daniel Linz, and Steven Penrod conclude, "at least for now, we cannot legitimately conclude that pornography has become more violent since the time of the 1970 obscenity and pornography commission" [in *The Question of Pornography: Research Findings and Policy Implications* (New York: The Free Press, 1987), p. 91].

20. The only original research conducted by the commission examined images found in the April 1986 issues of best-selling men's magazines (*Cheri, Chic, Club, Gallery, Genesis, High Society, Hustler, Oui, Penthouse, Playboy, Swank*). The study found that "images of force, violence, or weapons" constituted less than 1 percent of all images (0.6 percent), hardly substantiating the

in the books, their cost, and how to order them. The report describes photographs found in ten sexually explicit magazines, for example, *Tri-Sexual Lust, Bizarre Climax No. 9, Every Dog Has His Day*, and *Pregnant Lesbians No. 1.* The interpretive approach may not be on the cutting edge of photographic criticism, but here it earnestly slogs along for thirty-three pages ("one photograph of the female performing fellatio on one male while the other male's erect penis rests on her cheek" and "one close-up photograph of a naked caucasian male with the testicles of another naked caucasian male in his mouth").[17]

The commission viewed a disproportionate amount of atypical material, which even moderate commissioners criticized as "extremely violent and degrading."[18] To make themselves sound contemporary and secular, conservatives needed to establish that pornography was violent rather than immoral and, contradicting social science evidence, that this violence was increasing.[19] It was important for the panel to insist that the images presented were "typical" or "average" pornography. But typical pornography — glossy, mainstream porn magazines directed at heterosexual men — does not feature much violence, as the commission's own research (quickly suppressed) confirmed.[20] Yet the slide shows did not present many carefully airbrushed photos of perfect females or the largely heterosexual gyrations (typically depicting intercourse and oral sex) found even in the more hard-core adult bookstores. The commission concentrated on atypical material, produced for private use or for small, special-interest segments of the market, or confiscated in the course of prosecutions. Slides featured subjects guaranteed to have a high shock value: excrement, urination, homosexuality, bestiality (with over twenty different types of animals, including chickens and elephants), and especially sadomasochism (SM). Child pornography was frequently shown (with no effort made to disguise the identity of the children), despite repeated testimony from the commission's own expert witnesses that severe penalties had made this material virtually unobtainable in the commercial market.

Predictably, the commission relied on the realism of photography to amplify the notion that the body of material shown was accurate, that is, representative. The staff also skillfully mixed atypical and marginal material with pictorials from *Playboy* and *Penthouse*, rarely making a distinction between types of publications or types of markets. The desired fiction was that extreme images were found everywhere and that all pornography was the same. Images existed in a timeless pornographic present, with little attention given to describing an image's date, provenance, conditions of production, intended market,

commission's claim that violent
imagery in pornography was com-
mon. Although the results of this
study are reported in the draft,
they were excised from the final
report.

The study found that the most
common acts portrayed were
"split beaver" poses (20 percent),
other imagery including touching
(19 percent), oral-genital activity
(12 percent), and activities
between two women (12 per-
cent). According to the Audit
Bureau of Circulation (ABC) the
thirteen top-selling mainstream
magazines sold 12 million copies
per month (4.2 million copies for
Playboy, 3.3 million copies for
Penthouse), with a monthly sales
value over $38 million (1984
data).

or producer. Although representatives from major men's magazines testified, taking pains to distance what they called the "healthy adult entertainment" in their publications from the sleazy and degraded images, which they agreed deserved censorship, the mud-slinging only reinforced the idea that sexual images were suspect.

The panel's effort to modernize the case against pornography led to complex symbolic and rhetorical gymnastics. The most successful effort was the appropriation of the term *degrading*. Used by some antipornography feminists to describe sexist images, the term was rapidly appropriated to cover images of all sexual behavior that might be considered immoral, since in the conservative worldview, immorality degraded the individual and society. "Degrading" was freely applied to visual images that portrayed homosexuality, masturbation, and even consensual heterosexual sex. Even images of morally approved marital sexuality were judged "degrading," since public viewing of what should be a private experience degraded the couple and the sanctity of marriage.

A more difficult enterprise for the commission was managing the contradiction between the heavy emphasis on "violent" or "degrading" pornography in the hearings and the commission's concerns about more typical sexually explicit images, that is, the *Playboy* problem. Strategically, the panel emphasized atypical material to build a strong case against pornography. But even successful attempts to restrict these images (child pornography, SM, bestiality) would in fact have little impact on pornography available, because they constitute such a small fraction of the market. This reality surfaced in panel discussions periodically, and members' frustration exposed the panel's enduring interest in restricting all sexually explicit material, including mainstream magazines that had never been judged obscene by the courts. Commissioners complained that the overemphasis on extreme material incorrectly implied that the worst harm of pornography was found at the edges of the porn industry. To the contrary, they stated, the real danger of pornography was in its most acceptable guise, the men's magazine, which endorsed hedonism, promiscuity, and sex without responsibility in homes throughout America.

The visuals, including commentaries, descriptions, and instructions about how to read them, were a crucial part of the commission's discourse. Yet the commission's strategic maneuvers and assertions about sexual images were covert and therefore exempt from argument. Many have commented on the way all photographic images are read as fact or truth because the images are realistic. This general phenomenon is true for pornographic images as well, but it is intensified when the viewer is confronted by images of sexually explicit acts that he or she has little

experience viewing in real life. Shock, discomfort, fascination, repulsion, arousal all operate to make the image have an enormous impact and seem undeniably real.

But any photographic image, of course, reflects choice, perspective, intention, and conventions of production. And any collection of images said to represent a body of work — say, a slide show — bears the mark of an editing hand and an organizing intelligence or intentionality. Yet the ritual showing of pornographic images with their accompanying voice-overs throughout the course of the hearings erased the commission's editing hand, guaranteeing that many images and their interpretations would be given the status of unassailable truth. It is difficult to argue with a slide show.

The commission's frame was always a literal one. The action depicted was understood as realistic, not fantastic or staged for the purpose of producing an erotic picture. Thus, images that played with themes of surrender or domination were read as actually coerced. A nude woman holding a machine gun was obviously dangerous, because the gun could go off (an interpretation not, perhaps, inaccurate for the psychoanalytically inclined reader). Images of obviously adult men and women dressed in exaggerated fashions of high school students were called child pornography. Although meaning was said to be self-evident, nothing was left to chance.

Sadomasochistic pornography had an especially strategic use in establishing that sexually explicit imagery was "violent." The intervention was effective, since few (even liberal critics) have been willing to examine the construction of SM in the panel's argument. Commissioners saw a great deal of SM pornography and found it deeply upsetting, as did the audience. Photographs included images of women tied up, gagged, or being "disciplined." Viewers were unfamiliar with the conventions of SM sexual behavior and had no access to the codes participants use to read these images. The panel provided the frame: SM was nonconsensual sex that inflicted force and violence on unwilling victims. Virtually any claim could be made against SM pornography and, by extension, SM, which remains a highly stigmatized and relatively invisible sexual behavior. Stigma and severe disapproval ensure that one normal channel of information about the unfamiliar, discussion with friends and peers about behavior they engage in, is closed, because the cost to participants is too high. As was the case for homosexuality until recently, invisibility reinforces stigma, and stigma reinforces invisibility in a circular manner.

The redundant viewing and narration of SM images reinforced

several points useful to the commission: pornography depicted actual violence; pornography encouraged violence; and pornography promoted male dominance and the degradation of women. Images that depicted male domination and female submission were often shown. An active editorial hand was at work, however, to remove reverse images of female domination and male submission; these images never appeared, though they constitute a significant portion of SM imagery. Amusingly, SM pornography elicited hearty condemnation of "male dominance," the only sphere in which conservative men were moved to critique it throughout the course of the hearing.

The commission called no witnesses to discuss the nature of SM, either professional experts or typical participants. Given the atmosphere, it was not surprising that no one defended it. Indeed, producers of more soft-core pornography joined in the condemnation, perhaps hoping to direct the commission's ire to more stigmatized groups and acts.[21] The commission ignored a small but increasing body of literature that documents important features of SM sexual behavior, namely consent and safety.[22] Typically the conventions we use to decipher ordinary images are suspended when it comes to SM images. When we see war movies, for example, we do not leave the theater believing that the carnage was real or that the performers were injured making the films. But the commissioners assumed that images of domination and submission were both real and coerced.

In addition, such literalist interpretations were evident in the repeated assertions that all types of sexual images had a direct effect on behavior. Witnesses provided the evidence: rapists who were said by arresting officers to have read pornography, and regretful swingers who said their careers were started by exposure to pornography. According to the commission, the danger in sexually explicit images was that they inspired literal imitation, as well as more generalized and free-flowing lust. The less diversity and perversity available for viewing, the better.

The commission downplayed the most common use of pornography — for arousal during masturbation. To fully acknowledge this use would put the entire enterprise dangerously close to seeming to attack masturbation, a distinctly nineteenth-century crusade that would seem to defy most forms of rhetorical modernization. The idea that sexual images could be used and remain on a fantasy level was foreign to the commission, as was the possibility that individuals might use fantasy to engage with dangerous or frightening feelings without wanting to experience them in real life. This lack of recognition is consistent with

21. The proclivity of mildly stigmatized groups to join in the scapegoating of more stigmatized groups is explained by Gayle Rubin in her discussion of the concept of sexual hierarchy ["Thinking Sex: Notes for a Radical Theory of the Politics of Sexuality" in *Pleasure and Danger: Exploring Female Sexuality*, ed. Carole S. Vance (Boston: Routledge & Kegan Paul, 1984) pp. 267–319].

22. For recent work on SM, see Gini Graham Scott, *Dominant Women, Submissive Men* (New York: Praeger, 1983); Thomas Weinberg and G. P. Levi Kamel, *S and M: Studies in Sadomasochism* (Buffalo: Prometheus Books, 1983); Gerald and Caroline Greene, *S-M: The Last Taboo* (New York: Grove Press, 1974); Michael A. Rosen, *Sexual Magic: the S/M Photographs* (San Francisco: Shaynew Press, 1986); Geoff Mains, *Urban Aboriginals* (San Francisco: Gay Sunshine Press, 1984); Samois, ed., *Coming to Power*, 2d ed. (Boston: Alyson Press, 1982).

fundamentalist distrust and puzzlement about the imagination and the symbolic realm, which seem to have no autonomous existence; for fundamentalists, imagination and behavior are closely linked. For these reasons, the commission was deeply hostile to psychoanalytic theory, interpretation, or the notion of human inconsistency, ambiguity, or ambivalence. If good thoughts lead to good behavior, a sure way to eliminate bad behavior was to police bad thoughts.

The voice-over for the visual segments was singular and uniform, which served to obliterate the actual diversity of people's response to pornography. But sexually explicit material is a contested ground precisely *because* subjectivity matters. An image that is erotic to one individual is revolting to a second and ridiculous to a third. The object of contestation *is* meaning. Age, gender, race, class, sexual preference, erotic experience, and personal history all form the grid through which sexual images are received and interpreted. The commission worked hard to eliminate diversity from its hearings and to substitute instead its own authoritative, often uncontested, frequently male, monologue.

It is startling to realize that many of the Meese Commission's techniques were pioneered by antipornography feminists between 1977 and 1984. Claiming that pornography was sexist and promoted violence against women, antipornography feminism had an authoritative voice-over, too, though for theorists Andrea Dworkin and Catharine MacKinnon and groups like Women Against Pornography, the monologic voice was, of course, female.[23] Although antipornography feminists disagreed with fundamentalist moral assumptions and contested, rather than approved, male authority, they carved out new territory with slide shows depicting allegedly horrific sexual images, a technique the commission happily adopted. Antipornography feminists relied on victim testimony and preferred anecdotes to data. They, too, shared a literalist interpretive frame and used SM images to prove that pornography was violent. It was not a total surprise when the panel invited leading antipornography feminists to testify at its hearings, and they cooperated.

In the Meese Commission's monologue, even dissenting witnesses inadvertently cooperated by handing over the arena of interpretation to the commission. Not a single anticensorship witness ever showed a slide, provided a competing frame of visual interpretation, or showed images he or she thought were joyful, erotic, and pleasurable.[24] All lost an important opportunity to present another point of view, to educate, and to interrupt the fiction of a single, shared interpretive frame. Visual images remained the exclusive province of the censors and the

23. Major works of antipornography feminism include Andrea Dworkin, *Pornography: Men Possessing Women* (New York: G. P. Putnam & Sons, 1979); Laura Lederer, ed., *Take Back the Night* (New York: William Morrow, 1980); Catharine A. MacKinnon, "Pornography, Civil Rights, and Speech," *Harvard Civil Rights – Civil Liberties Law Review* vol. 20 (Cambridge: Harvard University, 1985), pp. 1–70.

Opinion within feminism about pornography was, in fact, quite diverse, and it soon became apparent that the antipornography view was not hegemonic. For other views, see Varda Burstyn, ed., *Women Against Censorship* (Vancouver: Douglas & McIntyre, 1985) and *Caught Looking: Feminism, Pornography, and Censorship* (New York: Caught Looking, Inc., 1986).

24. These witnesses included legal scholars, representatives from the American Civil Liberties Union, the Freedom to Read Committee, and publishers' and authors' groups.

literalists. This further cemented the notion that the visual "evidence" was uncontested and indeed spoke for itself. Why did the anticensorship community not do better?

The Meese Commission was skilled in its ability to use photographic images to establish the so-called "truth" and to provide an almost-invisible interpretative frame that compelled agreement with its agenda. The commission's true genius, however, lay in its ability to create an emotional atmosphere in the hearings that facilitated acceptance of the commission's worldview. Its strategic use of images was a crucial component of this emotional management. Because the power of this emotional climate fades in the published text, it is not obvious to most readers of the commission's report. Yet it was and is a force to be reckoned with, both in the commission and, more broadly, in all public debates about sexuality that involve the right wing. Though the commission was not infrequently ridiculed by journalists for its lack of objectivity and its overzealous puritanism, logical objections to its manipulations often faded in the hearing room.

III. Creating a Climate of Sexual Shame

The commission relentlessly created an atmosphere of unacknowledged sexual arousal and fear. The large amount of pornography shown, ostensibly designed to educate and repel, was nevertheless arousing. The range and diversity of images provided something for virtually everyone, and the concentration on taboo, kinky, and harder-to-obtain material added to the charge. Signs were evident in nervous laughter, rapt attention, flushed cheeks, awkward jokes, throat clearing and coughing, squirming in seats, and a charged, nervous tension in the room. Part of the discomfort may have come from the unfamiliarity of seeing sexually explicit images in public, not private, settings, and in the company of others not there for the express purpose of sexual arousal. But a larger part must have come from the problem of managing sexual arousal in an atmosphere where it was condemned.

The rhetoric of the commission suggests that pornographic material is degrading and disgusting and that no decent person would seek it out or respond to it. Although it is obvious that millions of people buy pornography, none of them appeared in the hearing room to defend it. And, as the testimony elicited by the panel suggested that porn consumers are likely to be rapists, raving maniacs, and perverts easily detected by their flapping raincoats and drooling saliva, certainly no one present at the hearing was willing to admit to feeling sexually aroused.

As a result, anyone who experienced any arousal to the images shown felt simultaneously ashamed, abnormal, and isolated, particularly in regard to homosexual or SM imagery, which had been characterized as especially deviant.

The commission's lesson was a complex one, but it taught the importance of managing and hiding sexual arousal and pleasure in public, while it reinforced sexual secrecy, hypocrisy, and shame. The prospect of exposure brought with it fear, stigmatization, and rejection. Sexual feelings, though, did not disappear; they were split off as dangerous, alien, and hateful, projected onto others, where they must be controlled. Unacknowledged sexual arousal developed into a whirlwind of confused, repressed emotion that the Meese Commission channeled toward its own purpose.

Dissenting witnesses rarely attacked the commission's characterization of pornography. Although they made important arguments about censorship, they left the commission's description of pornography, interpretive frame, and account of subjectivity unchallenged. The commission's visual interventions and narrative voice-over remained powerful because no one pointed to their existence or the mechanisms through which they were created.

No one offered a deconstruction of the commission's visual techniques or offered images that would problematize its constructions. A counter slide-show might have included erotic images from the fine arts as well as from advertising, calling into question the neat category of "the pornographic." It could have historicized sexually explicit imagery by relating images to time, place, genre, audience, and conditions of production. It might have included images of similar bodies and body parts whose context made all the difference in meaning, or included viewers talking about the diversity of their responses to the same image. And it could have included artists talking about erotic creativity. To show positive images of sexual explicitness would have been a radical act.

To be fair, it was extraordinarily difficult to offer a dissenting perspective. The overwhelming emotional climate created by the hearings turned anyone who disagreed into a veritable monster, a defender of the most sensational and unpalatable images shown. The frame demonized pornography, but it also tarnished the reputation of anyone who questioned the commission's program. Most prospective dissenting witnesses correctly perceived that the atmosphere was closer to a witchcraft trial than a fact-finding hearing. Some declined to testify, and others moderated their remarks, anticipating a climate of intimidation.[25]

Indeed, an important aspect of the commission's work was the ritual airing and affirmation of sexual shame in a public setting, a practice that

was embedded in the interrogatory practices of the chair. Witnesses appearing before the commission were treated in a highly uneven manner. Commissioners accepted virtually any claim made by anti-pornography witnesses as true, while those who opposed restriction of sexually explicit speech were often met with rudeness and hostility. Visual images proved to be the Achilles' heel of anticensorship witnesses, since the witnesses were often asked if they meant to defend a particularly stigmatized image that had just been flashed on the screen, such as *Big Tit Dildo Bondage* or *Anal Girls*. The witnesses were often speechless, and their inarticulateness about images often undercut their testimony.

Sexual shame was also ritualized in how witnesses spoke about their personal experience with images. "Victims of pornography" told in lurid detail of their use of pornography and eventual decline into masturbation, sexual addiction, and incest. Some testified anonymously, shadowy apparitions behind translucent screens. Their first-person accounts, sometimes written by the commission's staff,[26] featured a great elaboration of the sexual damage caused by visual images. To counter these accounts there was nothing but silence: descriptions of visual and sexual pleasure were absent. The commission's chair even noted the lack and was fond of asking journalists if they had ever come across individuals with positive experiences with pornography. The investigatory staff had tried to identify such people to testify, he said, but had been unable to find any. Hudson importuned reporters to please send such individuals his way. A female commissioner helpfully suggested that she knew of acquaintances, "normal married couples living in suburban New Jersey," who occasionally looked at magazines or rented X-rated videos with no apparent ill effects. But she doubted that they would be willing to testify about their sexual pleasure in a federal courthouse, with their remarks transcribed by a court stenographer and their photos probably published in the next day's paper as "porn-users."

Though few witnesses chose to expose themselves to the commission's intimidation through visual images, the tactics used are illustrated in the differential treatment of two female witnesses, former *Playboy* Playmate Micki Garcia and former *Penthouse* Pet of the Year Dottie Meyer. Garcia accused Playboy Enterprises and Hugh Hefner of encouraging drug use, murder, and rape (as well as abortion, bisexuality, and cosmetic surgery) in the Playboy mansion. Her life was endangered by her testimony, she claimed. Despite the serious nature of her charges and the lack of any supporting evidence, her testimony was

26. Statement of Alan Sears, executive director, (Washington, D.C., transcript, 18 June 1985).

27. Los Angeles hearing,
17 October 1985.

received without question.[27] Meyer, on the other hand, testified that her association with *Penthouse* had been professionally and personally beneficial. At the conclusion of her testimony, the lights dramatically dimmed and large blowups of several *Penthouse* pictorials were flashed on the screen; with rapid-fire questions the chair demanded that she explain sexual images he found particularly objectionable. Another commissioner, prepared by the staff with copies of Meyer's nine-year-old centerfold, began to pepper her with hectoring questions about her sexual life: Was it true she was preoccupied with sex? Liked sex in cars and alleyways? Had a collection of vibrators? Liked rough-and-tumble sex?[28] His cross-examination was reminiscent of that directed at a rape victim made vulnerable and discredited by an image of her own sexuality.

28. New York City hearing,
22 January 1986.

The commission's success in maintaining and intensifying a climate of sexual shame depended on the inability of witnesses to address the question of sexuality and pleasure. Most witnesses who opposed greater restriction of sexually explicit material framed their arguments in terms of the dangers of censorship, illustrating their points by examples of literature that had been censored in previous, presumably less enlightened, times. Visual examples were rare. Speakers favored historical, rather than contemporary, examples around which a clear consensus about value had formed. Favored examples were the plays of Eugene O'Neill and D. H. Lawrence's *Lady Chatterley's Lover*. The frame was cultured and high-minded, calling on general principles like free speech and the Bill of Rights.

The motives behind this strategy differed. The small number of witnesses directly associated with the sex industry (producers of X-rated films, books, or magazines) believed that their disreputable image could be uplifted by associating themselves with higher, unassailable principles that had a minimal connection with sexuality. Although they had practical experience with visuals, they judged it a wiser course to say little about their real-world connection. The second group, a much larger number of witnesses representing literary, artistic, and anti-censorship organizations, was totally unprepared to talk about visuals. They had thought little about questions of representation or sexually explicit images, often shared the same unsophisticated premises as the commissioners, and appeared to feel that association with sexuality was potentially discrediting.

The second group was fair game for the chair. Relying on his well-honed prosecutorial abilities, he was selectively relentless. He went right to the heart of witnesses' reluctance to associate themselves with anything sexual, visual, or pleasure-filled. Pointing to the latest slide or

holding aloft the latest exhibit, he questioned them about their organization's position on *Hot Bodies* or *Split Beavers*. Did their members produce such images? Did their organization mean to defend such material? Did they think such material should be available?

Like vampires spying crosses and garlic cloves, witnesses shrank back. Having never seen the sexually explicit material or thought about it, having no well-developed position about sexuality or visual representation, and sensing the increasingly dangerous turf they were being lead into, they said, "No." They were unprepared, speechless, and unwilling to defend anything so patently sexual. The chair had proven his point: even anticensorship advocates would not defend visual pornography. He politely excused them, with bland, if inaccurate, assurances that antipornography efforts would target only indefensible sleaze, not worthy high culture. More important, he appeared to establish a consensus, which included even liberals, that sexually explicit visuals were beyond the pale. Despite their valiant effort, the testimony of anticensorship witnesses never succeeded in deconstructing or interrupting the Meese Commission's rhetorical and symbolic strategies. The right-wing's commitment, however, to controlling symbols means that there will be other times, other battles in which to elaborate a richer, more complex response.

IV. Speaking Sexual and Visual Pleasure

The antidote to the Meese Commission — and by extension all conservative and fundamentalist efforts to restrict sexual images, whether in pornography, sex education, or AIDS information — is a complex one, requiring vigorous response that goes beyond appeals to free speech. Free expression is a necessary principle in these debates because of the steady protection it offers to all images, but it cannot be the only one. We need to offer an alternative frame for understanding images, one that rejects literalist constructions and offers in their place multiplicity, subjectivity, and the diverse experience of viewers. We must challenge the conservative monopoly on visual display and interpretation. The visual arts community needs to employ its interpretive skills to unmask the modernized rhetoric conservatives use to justify their traditional agenda, as well as deconstruct the "difficult" images fundamentalists pick to set their campaigns in motion. Despite their uncanny intuition for choosing culturally disturbing material, their focus on images also contains many sleights of hand, even displacements, which we need to examine. Images even we allow to remain "disturbing" and unconsidered

put us anxiously on the defensive and undermine our own response. To do all this, visual artists and arts groups need to be willing to enter public debate and activism, giving up the notion that art or photography is somehow exempt from right-wing crusades against images.

The most robust and energetic response, however, must be to take courage and begin to speak to what is missing, both in the Meese Commission's monologue and in the anticensorship reply: desire, sexuality, and pleasure. Truly dissenting voices and speakers must start to say in public that sexual pleasure is legitimate and honorable, a simple statement that few witnesses in the commission's hearings dared to make. If we remain afraid to offer a public defense of sex and pleasure, then even in our rebuttal we have granted the right wing its most basic premise: sexuality is shameful and discrediting. The rigid, seemingly impenetrable symbolic and emotional façade constructed by the Meese Commission can, in fact, be radically undermined by insistently confronting it with what it most wants to banish — the tantalizing connection between visual and sexual pleasure.

I am grateful to many individuals for helpful discussions, comments on early drafts, and encouragement, especially Ann Snitow, Frances Doughty, Sharon Thompson, Lisa Duggan, David Schwartz, and Gil Zicklin. Special thanks to Frances Doughty for insightful and invaluable suggestions about writing. Thanks to Carol Squiers for editorial suggestions and to Gayle Rubin for last-minute help.

LIVING WITH CONTRADICTIONS

Critical Practices in the Age of Supply-Side Aesthetics

Abigail Solomon-Godeau

A version of this essay originally appeared in *Screen* (Summer 1987).

1. "Neo-geo," also referred to as "simulationism," the latest art package to blaze across the art-world firmament, is a good case in point. The artists involved (Ashley Bickerton, Peter Halley, Jeff Koons, Haim Steinbach, Meyer Vaisman — to name only the most prominent) were the subject of massive media promotion from the outset. See, for example, Paul Taylor, "The Hot Four: Get Ready for the Next Art Stars," *New York* magazine, 27 October 1986, pp. 50–56; Eleanor Heartney, "Simulationism: The Hot New Cool Art," *Artnews* (January 1987), pp. 130–37, and Douglas C. McGill, "The Lower East Side's New Artists, A Garment Center of Culture Makes Stars of Unknowns, *The New York Times*, 3 June 1986. The media blitz was subsequently ratified by a group exhibition at the Sonnabend Gallery and, on the museological front, by an exhibition at the Institute for Contemporary Art, Boston ("Endgame: Reference and Simulation in Recent Painting and Sculpture," 25 September–30 November 1986) with an accompanying catalogue featuring essays by prominent art historians and critics such as Yves-Alain Bois, Thomas Crow, and Hal Foster. For a less exalted and intellectualized view of this phenomenon, see "Mythologies: Art and the Market," an interview with Jeffrey Deitch, art advisor to Citibank, *Artscribe International* (April/May 1986), pp. 22–26. The interest of this interview lies in the way it clearly indicates the determinations and mechanisms in the fabrication and marketing of a new art commodity.

It should have become abundantly clear, especially during the Reagan years, that the function of criticism, for the most part, is to serve as a more or less sophisticated public relations or promotional apparatus. This is less a function of the critic's active partisanship (Diderot and Baudelaire, for example, are historically associated with the artists Greuze and Guys, whom they championed as exemplars) than a consequence of the fact that most contemporary art criticism is innocent of its own politics, its own interests, and its own ideology. In fact, the promotional aspect of most art criticism derives from the larger institutional and discursive structures of art. In this respect, the scholarly monograph, the temporary exhibition, the discipline of art history, and last but not least, the museum itself, are essentially celebratory entities. Further — and at the risk of stating the obvious — the institutions and discourses that collectively function to construct the object "art" are allied to the material determinations of the marketplace, which themselves establish and confirm the commodity status of the work of art.

Within this system, the art critic normally functions as a kind of intermediary between the delirious pluralism of the marketplace and the sacralized judgment seat that is the museum. But even this mediating process has now been bypassed; artists such as Julian Schnabel, to take one particularly egregious example, have been propelled from obscurity to the pantheon without a single serious critical text ever having been produced in support of their work. The quantum increase in the scale of the international art market, the unprecedented importance of dealers in creating (or "managing") reputations and manipulating supply and demand, the emergence of a new class of "art consultants," and the large-scale entry of corporations into the contemporary art market have all contributed to the effective redundancy of art criticism. Art stars and even "movements," with waiting lists of eager purchasers in their train, stepped into the spotlight before many art critics knew of their existence.[1] This redundancy of criticism, however, can hardly be understood as a consequence of these developments alone. Rather, the current state of most art criticism represents the

final dissolution of what was, in any case, only a fragile bulwark between market forces and their institutional ratification, a highly permeable membrane separating venture capital, so to speak, from blue-chip investment. As a result, art criticism has been forced to cede its illusory belief in the separateness or disinterestedness of critical discourse.

In this essay I am primarily concerned with the condition — and position — of critical practices within art criticism and artmaking in the age of Reagan. In contradistinction to business-as-usual art promotion and the atavistic, cynical, and mindless art production exemplified by pseudoexpressionism, critical practices, by definition, must occupy an oppositional place. But what, we must ask, is that place today? Within the map of the New York art world, where is that place of opposition and what is it in opposition to? Second — and integrally linked to the first set of questions — we must ask what defines a critical practice and permits it to be recognized as such. What, if anything, constitutes the difference between a critical practice and a recognizably political one? If artists as dramatically distinct as, for example, David Salle and Sherrie Levine can both say that their work contributes to a critique of the painterly sign, what common political meanings, if any, ought we attribute to the notion of critical practice? Last — and here is where I am most directly implicated — what is the nature, the terms, even the possibility, of a critical practice in art criticism? Is such a practice not inevitably and inescapably a part of the cultural apparatus it seeks to challenge and contest?

Postmodernist Photography: The Third Time Around
A Case History

When I think of it now, I don't think what Julian Schnabel was doing was all that different from what I was trying to do.
— Sherrie Levine[2]

2. Sherrie Levine, "Art in the (Re)Making," interview with Gerald Marzorati, *Artnews* (May 1986).

By way of exploring these questions, and in the interest of providing some specificity to the discussion, I want to concentrate primarily on the evolution and development of postmodernist photographic work from the late 1970s to the late 1980s, using it as a case history in which to explore the salient issues. This corpus of work, identified with its now fully familiar strategies of appropriation and pastiche; its systematic assault on modernist orthodoxies of immanence, autonomy, presence, originality, and authorship; its engagement with the simulacral; and its interrogation of the problematics of photographic mass media

3. See Hal Foster, "Postmodernism: A Preface," in *The Anti-Aesthetic: Essays in Postmodern Culture*, ed. Hal Foster (Port Townsend, Wash.: Bay Press, 1983), pp. ix–xvi. The conception of postmodernism in the visual arts as a critical practice was established in the following essays: Douglas Crimp, "Pictures," in *Art after Modernism: Rethinking Representation*, ed. Brian Wallis (Boston: David R. Godine, 1984), pp. 175–87; "On the Museum's Ruins," in Foster, *The Anti-Aesthetic*, pp 43–56; "The Photographic Activity of Postmodernism," *October* 15 (Winter 1980), pp. 91–101; "The End of Painting," *October* 16 (Spring 1981), pp. 69–86; "The Museum's Old, the Library's New Subject," *Parachute* 22 (Spring 1981), pp. 32–37. For a theorization of postmodernism as an allegorical procedure, see Craig Owens, "The Allegorical Impulse: Toward a Theory of Postmodernism, parts I and II, *October* 12 (Spring 1980), pp. 66–86 and *October* 13 (Summer 1980), pp. 59–80, and Benjamin H. D. Buchloh, "Allegorical Procedures: Appropriation and Montage in Contemporary Art," *Artforum* (September 1982), pp. 43–56. See, further, Rosalind Krauss's important essays "Sculpture in the Expanded Field," in Foster, *The Anti-Aesthetic*, pp. 31–42 and "The Originality of the Avant-Garde," in Krauss, *The Originality of the Avant-Garde and Other Modernist Myths* (Cambridge, Mass.: MIT Press, 1985) pp. 151–70. For a synopsis of the above essays, see Hal Foster, "Re: Post" in Wallis, *Art after Modernism*, pp. 189–201. See also my essay "Playing in the Fields of the Image," *Afterimage* (Summer 1982), pp. 10–13.

4. See Robert Venturi, Denise Scott Brown, Steven Izenor, *Learning from Las Vegas* (Cambridge, Mass.: MIT Press, 1972), and Charles Jencks, *The Language of Postmodern Architecture* (New York: Rizzoli, 1977).

5. Irving Howe and Harry Levin were using the term in the late fifties.

representation may be taken as paradigmatic of the concerns of a critical postmodernism or what Hal Foster has designated as "oppositional postmodernism."[3] The qualifier "critical" is important here, inasmuch as the conceptualization and description of postmodernism in architecture — chronologically anterior — was inflected rather differently.[4] There it signaled, among other things, a new historicism and/or repudiation of modernist architecture's social and utopian aspirations, and a concomitant theatricalization of architectural form and meaning. In literary studies, the term *postmodernism* had yet another valency and made its appearance in literary criticism at an even earlier date.[5] Within the visual arts, however, postmodernist photography was identified with a specifically critical stance. Critics such as Benjamin Buchloh, Douglas Crimp, and Rosalind Krauss, for example, theorized this aspect of postmodernist photographic work as principally residing in its dismantling of reified, idealist conceptions enshrined in modernist aesthetics — issues devolving on presence, subjectivity, and aura. To the extent that this work was supported and valorized for its subversive potential (particularly with respect to its apparent fulfillment of the Barthesian and Foucauldian prescriptions for the death of the author and, by extension, its subversion of the commodity status of the art object), Sherrie Levine and Richard Prince were perhaps *the* emblematic figures. For myself, as a photography critic writing in opposition to the academicized mausoleum of late-modernist art photography, part of the interest in the work of Vikkie Alexander, Victor Burgin, Sarah Charlesworth, Silvia Kolbowski, Barbara Kruger, Sherrie Levine, Richard Prince, Cindy Sherman, Laurie Simmons, and Jim Welling (to cite only those I have written about) lay in the way their work directly challenged the pieties and proprieties with which art photography had carved a space for itself precisely as a modernist art form.[6] Further, the feminist import of this work — particularly in the case of Kruger and Levine — represented a theoretically more sophisticated and necessary departure from the essentialism and literalism prevalent in many of the feminist art practices that emerged in the seventies.[7]

In retrospect, Levine's production in the late seventies to the mid-eighties reveals both the strength and weakness of this variant of critical postmodernism as a counterstrategy to the regnant forms of art production and discourse. The changes in her practice, and the shifts in the way her work has been discursively positioned and received, are themselves testimony to the difficulty and contradiction that attend critical practices that operate squarely within the framework of high-art production.

6. See my "Winning the Game When the Rules Have Been Changed: Art Photography and Postmodernism," *Screen* 25 (November/December 1984), pp. 88–102 and "Photography after Art Photography," in Wallis, *Art after Modernism*, pp. 75–85.

7. The occlusion of feminism from the postmodernist debate, re-marked upon by Andreas Huyssen, among others, is signifi-cant. It is by no means incidental that many, if not most, of the central figures within oppositional postmodernism in the visual arts, film, and video, have been women, and much of the work they have produced has been directly con-cerned with feminist issues as they intersect with the prob-lematics of representation. See note 16.

8. On the implications and ideol-ogy of the revival of pseudo-expressionism, see Benjamin H. D. Buchloh "Figures of Authority, Ciphers of Repression," in Wallis, *Art after Modernism*, pp. 107–36, and "Documenta 77: A Dictionary of Received Ideas," *October* 22 (Fall 1982), pp. 105–26; Rosalyn Deutsche, "Representing the Big City," in *German Art in the Twentieth Century*, ed. Irit Rogoff and Mary Anne Stevens, (Cam-bridge: Cambridge University Press, forthcoming), and with Cara Gendel Ryan, "The Fine Art of Gentrification," *October* 31 (Winter 1984), pp. 91–111; Craig Owens, "Honor, Power, and the Love of Women," in *Art in America* (January 1982), pp. 12–15. On the construction of photography as an "auratic" art, see Crimp, "The Photographic Activity of Post-modernism" and "The Museum's Old, the Library's New Subject," and Abigail Solomon-Godeau, "Winning the Game When the Rules Have Been Changed."

Levine's work first drew critical notice in the late 1970s, a period in which the triumph of the Right was as much manifest in the cultural sphere as in the political one. As one might well have predicted for a time of intense political reaction, symptoms of morbidity included the wholesale resurrection of easel painting exemplified by German, Italian, and American pseudoexpressionism, a wholesale retrenchment against the modest gains of minority and feminist artists, a repression (or distortion) of the radical art practices of the preceding decade, a ghastly revival of the mythology of the heroicized (white male) artist, and last, the institutional consolidation and triumphant legitimation of photogra-phy as a fully "auratic," subjectivized, autonomous fine art.[8]

Against this backdrop, one aspect of Levine's work consisted of directly rephotographing from existing reproductions a series of photographs by several canonized masters of photographic modernism (Edward Weston's nude studies of his son Neil, Eliot Porter's Techni-color landscapes, Walker Evans's Farm Services Administration pictures) and presenting the work as her own. With a dazzling economy of means, Levine's pictures deftly upset the foundation stones (author-ship, originality, subjective expression) on which the integrity and supposed autonomy of the work of art is presumed to rest. Moreover, her selection of stolen images was anything but arbitrary; the contents and codes of these purloined images — always the work of canonized male photographers — were chosen for their ideological density (the classical nude, the beauty of nature, the Depression poor) and then subjected to a demystifying scrutiny enabled and mobilized by the very act of (re)placing them within quotation marks. Finally, the strategy of fine-art-photography appropriations had a tactical dimension. For these works were produced in the wake of the so-called photography boom — meaning not simply the cresting of the market for photographic vintage prints, but the wholesale reclassification of all kinds of photography to conform with Kunstwissenschaft-derived notions of individual style and authorial presence.

It goes without saying that Levine's work of this period, consid-ered *as* a critical practice (feminist, deconstructive, and literally trans-gressive — the Weston and Porter works prompted ominous letters from their estate lawyers), could make its critique visible only within the compass of the art world; the space of exhibition, the market frame-work, art (or photography) theory and criticism. Outside of this special-ized site, a Sherrie Levine could just as well be a "genuine" Edward Weston or a "genuine" Walker Evans. This, in fact, was one of the arguments made from the Left with the intention of countering the

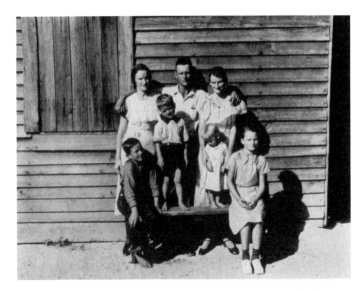

Sherrie Levine, *Untitled
(After Walker Evans: 2),*
1981. Courtesy of
Mary Boone Gallery.
Collection:
The Menil Foundation;
Houston, Texas.

9. Martha Rosler, "Notes on
Quotes," *Wedge* 3 (1982), p. 72.

claims for the critical function of work such as Levine's and Prince's (Prince at that period was rephotographing advertising images, excising only the text). The force of this criticism hinged on the work's insularity, its adherence to, or lack of contestation of, the art-world frame, and — more pointedly — its failure to articulate an alternative politics, an alternative vision.

In 1982, for example, Martha Rosler wrote an article entitled "Notes on Quotes" focusing on the inadequacies of appropriation and quotation as a properly *political* strategy:

"What alternative vision is suggested by such work? [She is referring here specifically to Levine.] We are not provided the space within the work to understand how things might be different. We can imagine only a respite outside social life — the alternative is merely Edenic or Utopic. There is no social life, no personal relations, no groups, classes, nationalities; there is no production other than the production of images. Yet a critique of ideology necessitates some materialistic grounding if it is to rise above the theological."[9]

Rosler's use of the term *theological* in this context points to one of the central debates in and around the definition — or evaluation — of critical practice. For Rosler, failure to ground the artwork in "direct social analysis" reduces its critical gesture to one of "highlighting" rather than "engaging with political questions that challenge...power relations in society." Moreover, to the extent that the artwork "remains locked within the relations of production of its own cultural field" and limited to the terms of a generic rather than specific interrogation of forms of domination, it cannot fulfill an educative, much less transformatory, function.

But "theological" in its opprobrious sense can cut both ways. It is, in fact, a "theological" notion of the political — or perhaps one should say a scriptural notion — that has until quite recently effectively occluded issues of gender and subjectivity from the purview of the political. Rosler's objections are to some degree moored in a relatively traditional conception of what constitutes the political in art ("materialistic

grounding," "direct social analysis"). Thus, Rosler's characterization of a purely internal critique of art as ineffective because it is theological can, from a somewhat different vantage point, be interpreted as a theologized notion of the political. It is, moreover, important to point out that while unambiguously political artists (unambiguous because of their choice of content) are rarely found wanting for their total exclusion of considerations of gender, feminist artists are frequently chastised by Left critics for the inadequacy of *their* political content. Nevertheless, the echoing cry of the women's movement — the personal is political — is but one of the remappings of political terrain that have engendered new ways of thinking the political and new ways of inscribing it in cultural production.

But perhaps even more important, to the extent that art is itself a discursive and institutional site, it surely entails its own critical practices. This has in fact been recently argued as the significance and legacy of the historical avant-garde.[10] For Peter Bürger, the Kantian conception of self-criticism is understood not in Greenberg's sense of a *telos* of purity and essence, but rather as a critical operation performed within and upon the *institution* of art itself. Thus, art movements like dadaism and constructivism and art practices such as collage, photomontage, and the Duchampian readymade are understood to be performing a specifically political function to the extent that they work to actively break down the notion of aesthetic autonomy and to rejoin art and life. Bürger's rigorous account of art *as* an institution in bourgeois culture provides a further justification for considering internal critiques such as Levine's as a genuinely critical practice. Cultural sites and discourses are in theory no less immune to contestation, no less able to furnish an arena for struggle and transformation than any other.[11] This "in theory" needs to be acknowledged here because the subsequent "success" of postmodernist photography as a *style* harkens back, as I shall argue, to problems of function, critical complicity, and the extreme difficulty of maintaining a critical edge within the unstable spaces of internal critique.

In the spring of 1982, I curated an exhibition entitled "The Stolen Image and Its Uses" for an alternative space in upstate New York. Of the five artists included (Alexander, Kolbowski, Kruger, Levine, and Prince), Levine was by far the most controversial and sparked the most hostility. It was, in fact, the very intensity of the outrage her work provoked (nowhere greater than among the ranks of art photographers) that appeared, at the time, to confirm the subversive effects of her particular strategies. But even while such exhibitions or lectures on

10. Peter Bürger, *The Theory of the Avant-Garde*, trans. Michael Shaw (Minneapolis: University of Minnesota Press, 1984).

11. The theorization of a localized "site specificity" for contestatory and oppositional practices is one of the legacies of Louis Althusser and, with a somewhat different inflection, Michel Foucault. See Michel Foucault, "The Political Function of the Intellectual," *Radical Philosophy* 12 (Summer 1977), pp. 12–15, and "Revolutionary Action: 'Until Now'," in *Language, Counter-Memory, Practice; Selected Essays and Interviews by Michel Foucault*, ed. Donald F. Bouchard (Ithaca, N.Y.: Cornell University Press, 1977), pp. 218–33.

Levine's works were received outside New York with indignation, a different kind of appropriation of existing imagery, drawn principally from the mass media, was beginning to be accorded theoretical recognition across a broad range of cultural production. It was less easy to see this kind of appropriation as critically motivated. Fredric Jameson, for ex-

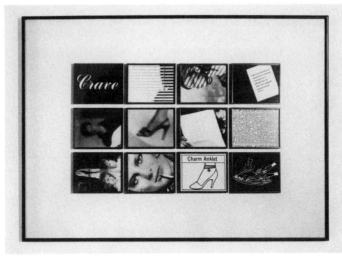

ample, could in part identify his conception of postmodernism with the strategies of appropriation, quotation, and pastiche.[12] That these strategies could then be said to unify within a single field of discourse the work of Jean-Luc Godard and the work of Brian DePalma constitutes a problem for critical practice. Not only did such an undifferentiated model suppress a crucial consideration of (political and aesthetic) difference, it also implied the impossibility of cultural opposition within a totalizing system, a dilemma accorded growing intellectual prestige within the art world through the later writings of Jean Baudrillard. Rooted in such a framework, an appropriative strategy such as Levine's (although Jameson does not mention the specific practice of appropriation) would figure only as a synecdochical symptom within a master narrative on postmodernism.[13]

By 1983, plundering the pages of glossy magazines, shooting advertisements from the television set, or "simulating" photographic tableaux that might have come from either of these media had become as routine an activity in the more sophisticated art schools as slopping paint on canvas. In January of that year the Institute of Contemporary Art in Philadelphia mounted an exhibition entitled "Image Scavengers." Included in the exhibition were representatives of the first wave of appropriators and pasticheurs (Kruger, Levine, Prince, Cindy Sherman) and several other artists whose work could be allied to the former only by virtue of their formal devices. Invited to contribute a

12. See Fredric Jameson, "Post-modernism, or the Cultural Logic of Late Capitalism," *New Left Review* 146 (July–August 1984), pp. 53–92. An earlier, less developed version of this essay, entitled "Post-Modernism and Consumer Society," is reprinted in Foster, *The Anti-Aesthetic*, pp. 111–25.

13. For various critiques of Jameson's arguments, see Mike Davis, "Urban Renaissance and the Spirit of Postmodernism," *New Left Review* 151 (May–June 1985), pp. 107–18; Terry Eagleton, "Capitalism, Modernism and Postmodernism, *New Left Review* 152 (July 1985), pp. 60–73; and Douglas Crimp, "The Post-modern Museum," *Parachute* (March, April, May, 1987), pp. 61–69.

14. Douglas Crimp, "Appropriating Appropriation," in *Image Scavengers*, exhibition catalogue, University of Pennsylvania, Institute of Contemporary Art, 8 December 1982–30 January 1983, p. 27.

catalogue essay, Douglas Crimp was clearly disturbed at the domestication of what he had himself theorized as the critical potential of photographic appropriation. Under the title "Appropriating Appropriation," his essay initiated a reconsideration of the adequacy of appropriation as a critical mode. "If all aspects of the culture use this new operational mode," he wrote, "then the mode itself cannot articulate a specific reflection upon that culture."[14] Thus, although appropriative and quotational strategies had now become readily identifiable as a descriptive hallmark of postmodern culture, the terms by which they might once have been understood to be performing a critical function had become increasingly obfuscated and difficult to justify.

By this time, Levine's practice had itself undergone various alterations. In 1982, she had largely abandoned photographic appropriations and was confiscating German expressionist works, either by re-photographing them from book reproductions or by framing the reproductions themselves. In 1983 and 1984, however, she began making handmade watercolor and pencil copies after artbook illustrations, extending her *oeuvre*, so to speak, to include nonexpressionist modern masters such as Malevich and El Lissitsky. Her copies after expressionist drawings, such as Egon Schiele's contorted and angst-ridden nudes, were particularly trenchant comments on the pseudoexpressionist revival; master drawings are, after all, especially privileged for their status as intimate and revealing traces of the artist's unique subjectivity. In 1985, Levine made what might, or might not, be considered a radical departure from her earlier work and began to produce quite beautiful small-scale paintings on wood panels. These were geometrical abstractions — mostly stripes — which, Janus-like, looked backward to late-modernist works or minimalism and forward to the most recently minted new wave in the art world — neo-geo. Additionally, she accompanied her first exhibition of this new work with unpainted panels of wood in which one or two of the knots had been neatly gilded.

15. Craig Owens, "The Discourse of Others: Feminist and Post-modernism," in Foster, *The Anti-Aesthetic*, pp. 57–82, is an important exception.

16. Quoted in Gerald Marzorati, "Art in the (Re)Making," *Artnews* 85 (May 1986), p. 97.

17. The activities, events, and objects produced under the rubric of "A Picture Is No Substitute for Anything" collectively and individually functioned to

Mutatis mutandis, Levine had become a painter, although I would argue, still a somewhat singular one. Her work, moreover, had passed from the relatively marginalized purview of the *succès d'estime* to a new visibility (and respectability), signaled, for example, by her cover article in the May 1986 *Artnews*. In several of the comments she made to her interviewer, Levine explained her need to distance herself from the kind of critical partisanship that had not only helped establish her reputation, but — more important — had also, to a great degree, developed its position and analysis in relation to her work. Levine's

foreground the mechanisms of cultural production, exhibition, and reception. Although the working title implicitly points to — by denying — the fetish status of paintings, the practices themselves (for example, inviting an art public to the studio of Dmitri Merinoff, a recently deceased expressionist painter; the mailing [and exhibition] of gallery announcements; one-night-only exhibitions in which Levine and Lawler exhibited and arranged each other's work; the production of embossed matchbooks bearing the legend "A Picture Is No Substitute for Anything") were constituted as tactical interventions within the structures of art. Inscribing themselves in the mechanisms of publicity, display, and curatorship served to focus attention on the framing conditions of art production, which are thereby revealed to be structurally integral, rather than supplemental, to the field as a whole. See, for example, Andrea Fraser, "In and Out of Place," Art in America (June 1985), pp. 122–28; Kate Linker, "Rites of Exchange," Artforum (November 1986), pp. 99–100; Craig Owens, review of Levine-Lawler exhibition, Art in America (Summer 1982), p. 148; Guy Bellavance, "Dessaisissement Re-appropriation," Parachute (January–February 1982/3); Benjamin H. D. Buchloh, "Allegorical Procedures"; Louise Lawler and Sherrie Levine, "A Picture Is No Substitute for Anything," Wedge 2 (Fall 1982), pp. 58-67.

18. That the official museum version of modernism we inherit is in every sense partial and, more important, founded on these exclusions and repressions is a recurring theme in Benjamin H. D. Buchloh's essays. See also Rosalyn Deutsche, "Representing the Big City," and Douglas Crimp, "The Art of Exhibition" and "The Postmodern Museum." In the last named essay, certain problems in Frederic Jameson's theorization of postmodernist culture are seen to derive from his acceptance of the official, museological, and auteurist version of modernism.

professed discomfort with a body of critical writing that positioned her as a critical, indeed an adversarial, presence hinged on two factors. In championing Levine's work as either a poststructuralist exemplum or a demolition derby on the property relations that subtend the integrity of the art object, the (mostly male) critics who had written about her had overlooked, or repressed, the distinctly feminist import of her work.[15] But Levine also took issue with the interpretation of her work that stressed its materialist critique. In this regard, Levine insisted that hers was an aesthetic practice that implied no particular quarrel with the economic determinations of cultural production. Consequently, insofar as her critical supporters had emphasized those aspects of her work that subverted the commodity status of the artwork and demolished those values Walter Benjamin designated as the "theology of art," Levine began to believe that her activity as an artist was itself being repressed: "I never thought I wasn't making art and I never thought of the art I was making as not a commodity. I never thought that what I was doing was in strict opposition to what else was going on — I believed I was distilling things, bringing out what was being repressed. I did collaborate in a radical reading of my work. And the politics were congenial. But I was tired of no one looking at the work, getting inside the frame. And I was getting tired of being represented by men."[16]

The repositioning of Levine's work, with respect to both its meaning (now presented as a form of troubled obsequy mourning "the uneasy death of modernism") and the nature of her activity (commodity making), is disturbing from a number of perspectives. First, it involves its own forms of historical repression. For example, nowhere in the article was any reference made to Levine's two-year collaboration with the artist Louise Lawler, enacted under the title "A Picture Is No Substitute for Anything."[17] What is troubling about such an omission is that it parallels — no doubt wholly unintentionally — the institutional and discursive repressions that construct partial and falsified histories of art in the first place and in which the exclusion of women and radical practices are particularly conspicuous.[18] Second, it represses the active support of women critics, such as myself and Rosalind Krauss. But, more ominously, it traces a move from a position of perceptible cultural resistance to one of accommodation with existing modes of production and an apparent capitulation to the very desires the early work put in question. Whether this move is to be understood strategically (the need to be visible, the need to survive) or developmentally (an internal evolution in the artist's work) is not in itself a useful question. Far more important to consider here are the material and discursive forces that

both exceed and bind the individual artist. Whether artists choose to define their positions publicly in opposition to, or in strategic alliance with, dominant modes of cultural production is important only insofar as such definitions may contribute to a collective space of opposition. But, in the absence of a clearly defined oppositional sphere and the extreme rarity of collaborative practice, attempts to clarify the nature of critical practice must focus on the artwork's ability to question, to contest, or to denaturalize the very terms in which it is produced, received, and circulated. What is at stake is thus not an ethics or a moral position but the very possibility of a critical practice within the terms of art discourse. And, as a fundamental condition of possibility, critical practices must constantly address those economic and discursive forces that perpetually threaten to eradicate their critical difference.

Some notion of this juggernaut can be obtained from a consideration of the parallel fortunes of Levine's earlier photographic appropriations and, indeed, postmodernist photography as a whole. In 1985, for example, three large group exhibitions featuring postmodernist photography were mounted: "Signs of the Real" at White Columns, "The Edge of Illusion" at the Burden Gallery, and most grotesque of all, "In the Tradition of: Photography" at Light Gallery. Not the least of the ironies attendant upon the incorporation of postmodernist photography into the now expanded emporium of photography was the nature of the venues themselves: the Burden Gallery was established in January 1985 to function as the display window of *Aperture*, the photographic

publication founded by Minor White and customarily consecrated to modernist art photography; Light Gallery, a veritable cathedral of official art photography, represents the stable of officially canonized modernist masters, living and dead. The appearance of postmodernist photography within the institutional precincts of art photography signaled that whatever difference, much less critique, had been attributed to the work of Levine and others, it had now been fully and seamlessly recuperated under the sign of art photography, an operation that might be characterized as deconstruction in reverse.

How had this happened? The Light Gallery exhibition title — "In the Tradition of: Photography" — provides one clue, elaborated in an essay that accompanied the show. Postmodernist photography is here understood to be that which follows modernist photography in the same fashion that postimpressionism is thought to follow impressionism. The first of the two epigraphs that introduced the essay was taken from Beaumont Newhall's *History of Photography* — a sentence describing the conservatism of pictorial, that is, premodernist, art photography (that which preceded the Light Gallery regulars). The second epigraph consisted of two sentences from one of my essays, "Photography after Art Photography," asserting that the stakes that differentiate the two modes are a function of their position in relation to their institutional spaces. In much the same way that the modernist hagiographer Beaumont Newhall and I were equally useful in framing the thesis that postmodernist photography is part of an evolutionary *telos* having to do only with the internal development of art photography, so too did the gallery space both frame and render equivalent the two practices. This reduction of difference to sameness (a shorthand description for the eventual fate of most, if not all, initially transgressive cultural practices) was emblematically represented by the pairing — side by side — of a Sherrie Levine rephotograph of a Walker Evans and — what else? — a "real" Walker Evans beneath the exhibition title. That postmodernist photographic work and art photography came to inhabit the same physical site (although with the exception of the Levine-Evans coupling, the two were physically separated in the installation) is, of course, integrally linked with the nature of commercial space in the first place. In the final analysis, as well as a Marxist analysis, the market is the ultimate legitimator and leveler. Thus, among the postmodernist work, one could also find excerpts from Martha Rosler's 1977 book project *The Bowery in Two Inadequate Descriptive Systems* (originally published by the Press of the Nova Scotia College of Art and Design). Variously an uncompromising critique of conventional humanist muckraking

documentary photography, a text/image artwork, and an examination of the structuring absences and ideological freight of representational systems, *The Bowery...* was exhibited at the Light Gallery amid the range of postmodernist photographs and bore a purchase price of $3,500 (purchase of the entire set was required). But what was finally even odder than the effect of going from the part of the gallery in which the works of Aaron Siskind, Cartier-Bresson, and Paul Strand hung to the part devoted to the postmodernists was the revelation that postmodernist photography, once conceived as a critical practice, had become a "look," an attitude, a *style*.

Within this newly constructed stylistic unity, the critical specificity of a Rosler, a Prince, a Levine could be reconstituted only with difficulty

Frank Majore, *Cocktails*, 1983. Courtesy of Marvin Heiferman.

(and only with prior knowledge). In this particular instance, this was in large part a consequence of the inclusion of a "second generation" of postmodernist photographers — Frank Majore, Alan Belcher, Stephen Frailey, and so forth — whose relation to the sources and significance of their appropriative strategies (primarily advertising) seemed to be predominantly a function of fascination. Insofar as stupefied or celebratory fascination produces an identification with the image world of commodity culture no different from the mesmerization of any other consumer, the possibility of critique is effectively precluded. Frank Majore's simulations of advertising tableaux — employing props such as Trimline telephones, champagne glasses, pearls, and busts of Nefertiti all congealed in a lurid bath of fiftieslike photographic color — are cases in point. By reproducing the standard devices of color advertising (with which Majore, as a professional art director, is intimately familiar) and providing enough modification to accentuate their kitschiness and eroticism, Majore succeeds in doing nothing more

than reinstating the schlocky glamour of certain kinds of advertising imagery within the institutional space of art. But unlike the strategies of artists such as Duchamp, or Warhol, or Levine, what is precisely *not* called into question is the institutional frame itself.[19] The alacrity with which this now wholly academicized practice was institutionally embraced by 1985 (in that year Majore had one-person shows at the International Center of Photography, the 303 Gallery, and the Nature Morte gallery) was possible precisely because so little was called into question.

19. My use of the term *institutional frame* is intended in its broadest, most inclusive sense. Thus, what is at issue is not simply the physical space that the artwork inhabits, but the network of interrelated discourses (art criticism, art history) and the sphere of cultural production itself as a site of ideological reproduction within the social formation.

Although this more recent crop of postmodernist artists could become visible — or saleable — only in the wake of the success of their predecessors, the shift from margin to center had multiple determinations. "Center," however, must be understood in relative terms. The market was and is dominated by painting, and the prices for photographic work, despite the prevalence of strictly limiting editions and employing heroic scale, are intrinsically lower. Nonetheless, the fact remains that in 1980, the work of Levine or Prince was largely unsaleable and quite literally incomprehensible to all but a handful of critics and a not much larger group of other artists. When this situation changed substantially, it was not *primarily* because of the influence of critics or the efforts of dealers. Rather, it was a result of three factors: the self-created cul-de-sac of art photography that foreclosed the ability to produce anything new for a market that had been constituted in the previous decade; a vastly expanded market with new types of purchasers;

Laurie Simmons, *Red Indians*, 1984. Courtesy of Metro Pictures.

and the assimilation of postmodernist strategies back into the mass culture that had in part engendered them. This last development may be said to characterize postmodernist photography the third time around, rendering it both comprehensible and desirable and simultaneously signaling its near-total assimilation into those very discourses (advertising, fashion, media) it professed to critique. The current spate of Dior advertisements, for example, featuring a black-and-white photograph from the fifties on which a

color photograph of a contemporary model has been montaged bears at least a family resemblance to the recent work of Laurie Simmons. But where Simmons's pictures derived their mildly unsettling effects from a calculated attempt to denaturalize an advertising convention, the reappearance of the same montage tactic in the new Dior campaign marks the completion of a circuit that begins and ends in the boundless creativity of modern advertising.

The cultural loop that can be traced here is itself part of the problematic of critical practice. The more or less rapid domestication and commodification of art practices initially conceived as critical have been recognized as a central issue at least since the time of the Frankfurt school. This means that irrespective of artistic intention or initial effect, critical practices not specifically calibrated to resist recuperation as aesthetic commodities almost immediately succumb to this process. In this respect, the only difference between the fate of postmodernist photography and previous practices is the rapidity of the process and the ease, if not enthusiasm, with which so many of the artists accommodated themselves to it.

As was the case with its pop-art predecessors, the first wave of postmodernist photography pillaged the mass media and advertising for its "subject," by which I include its thematics, its codes, its emblems.

Cindy Sherman, Untitled Film Still, 1979. Courtesy of Metro Pictures.

These were then variously repositioned in ways that sought to denaturalize the conventions that encode the ideological and, in so doing, to make those very ideological contents available to scrutiny and contestation. Thus, Cindy Sherman's black-and-white movie stills — always her and never her — aped the look of various film genres to underscore their conventionality, whereas her infinite tabulation of the "images of women" generates equally conventionalized signs producing a category (woman) and not a subject. Additionally, the cherished notion of the

artist's presence *in* the work was challenged by the act of literally inscribing the author herself and revealing her to be both fictional and absent.[20] Similarly, Richard Prince's rephotographs of the "Marlboro Man" advertisements, which he began to produce in the early years of the Reagan administration, pointedly addressed the new conservative agenda and its ritual invocations of a heroic past. Here, too, the jettisoning of authorial presence was a component of a larger project. By focusing on the image of the cowboy — the individualistic and masculine icon of American mythology — Prince made visible the connections between cultural nostalgia, the mythos of the masculine, and political reaction. Recropping, rephotographing, and recontextualizing the Marlboro men permitted Prince to unpack the menace, aggression, and atavism of such representations and reveal their analogical link to current political rhetoric.

20. This aspect of Sherman's work was of particular importance to critics such as Douglas Crimp. For an interpretation of Sherman's photographs that stresses their feminist critique, see Judith Williamson, "Images of 'Woman'," *Screen* 24 (November/December 1983), pp. 102–16.

Richard Prince, *Untitled (Cowboy)*, 1980–84. Courtesy of Barbara Gladstone Gallery.

In contrast to practices such as these, work such as Majore's abjures critique, analysis, and intervention on either its purported object — the seductiveness of commodity culture, the hypnotic lure of simulacra — or the material, discursive, and institutional determinations of art practice itself.

Not surprisingly, the disappearance of a critical agenda, however construed, has resulted in an apparent collapse of any hard-and-fast distinction between art and advertising. In pop art, this willed collapse of the aesthetic into the commercial function carried, at least briefly, a distinctly subversive charge. The erasure of boundaries between high and low culture, high art and commodity, operated as an astringent bath in which to dissolve the transcendentalist legacy of abstract expressionism. Moreover, the strategic repositioning of the images and objects of mass culture within the gallery and museum reinstated the investigation and analysis of the aesthetic as an ideological function of the institutional structures of art. Postmodernism as style, on the other hand, eliminates any possibility of analysis insofar as it complacently affirms the interchangeability, if not the co-identity, of art production and advertising, accepting this as a given instead of a problem.

Perhaps one of the clearest examples of this celebratory collapse was an exhibition mounted in the fall of 1986 at the International Center of Photography entitled "Art & Advertising: Commercial Photography by Artists."[21] Of the nine artists represented, four came from the ranks of art photography (Sandi Fellman, Barbara Kasten, Robert Mapplethorpe, and Victor Schrager), two from the first wave of postmodernist photography (Cindy Sherman and Laurie Simmons), and two from the second (Stephen Frailey and Frank Majore); the ninth, William Wegman, whose work has encompassed both video and conceptualism, fell into none of these camps. As in the numerous gallery and museum exhibitions organized in the preceding years, the new ecumenicism that assembles modernist art photography and postmodernist photography functions to establish a familial harmony, an elision of difference to the profit of all.

21. "Art & Advertising: Commercial Photography by Artists," International Center of Photography, 14 September– 9 November 1986.

Addressing the work of Frailey, Majore, Simmons, and Sherman, the curator Willis Hartshorn had this to say:

The art of Stephen Frailey, Frank Majore, Laurie Simmons and Cindy Sherman shares a concern for the operations of mass media representation. For these artists to work commercially is to come full circle, from art that appropriates the mass media image, to commercial images that reappropriate the style of their art. However, for the viewer to appreciate this transformation implies a conscious relationship to the material. The viewer must understand the functions that are being compared through these self-referential devices. Otherwise, the juxtapositions that parody the conventions of the mass media will be lost.[22]

22. Willis Hartshorn, gallery handout.

Now firmly secured within the precincts of style, postmodernist photography's marriage to commerce seems better likened to a love match than to a wedding of convenience. Deconstruction has metamorphosed into appreciation of transformation, whereas the exposure of ideological codes has mellowed into self-referential devices. And insofar as the museum can now institutionally embrace and legitimize both enterprises — art and commerce — Hartshorn is quite right in noting that a full circle has been described. For those for whom this is hardly cause for rejoicing, the history of postmodernist photography is cautionary rather than exemplary.

Working with Contradictions

The notion of a critical practice, whether in art production or criticism, is notoriously hard to define. And insofar as critical practices do not exist in a vacuum, but derive their forms and meanings in relation to

their changing historical conditions, the problem of definition must always be articulated in terms of the present. Gauging the *effectiveness* of critical practices is perhaps even more difficult. By any positivist reckoning, John Heartfield's covers for *A-I-Z* (*Arbeiter Illustriete Zeitung*) had no discernible effect on the rise of fascism, although he was able to draw upon two important historic conditions unavailable to contemporary artists (a mass audience and a definable Left culture). Still, the work of Heartfield retains its crucial importance in any consideration of critical practice insofar as it fulfills the still valid purpose of making the invisible visible and integrally meshing the representation of politics with the politics of representation. In other words, its critical function is both externally and internally inflected.

Although Heartfield was clearly a political artist, few contemporary artists concerned with critical practice are comfortable with the appellation *political:* first, because to be thus defined is almost inevitably to be ghettoized within a (tiny) art world preserve; second, because the use of the term as a label implies that all other art is *not* political; and third, because the term tends to suggest a politics of content and to minimalize, if not efface, the politics of form. It is for all these reasons that throughout this essay I have chosen to employ the term *critical practice* in lieu of *political practice.* That said, the immediate difficulty of definition must still be addressed, and it is made no easier by the fact that a spate of recent practices — so-called simulationism, or neo-geo, and postmodernist photography in all its avatars — lays claim to the mantle of critical practice. Whether one is to take such claims at face

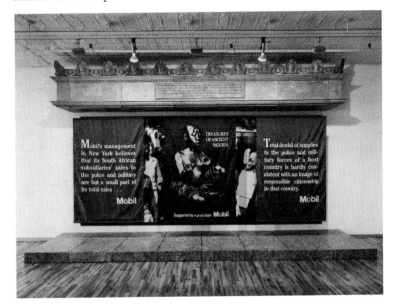

Hans Haacke, *MetroMobiltan*, 1985. Courtesy of John Weber Gallery. Photo: Fred Scruton.

value is another matter. But if we assume that critical practices conceptually assume both an activity and a position, the emphasis needs be placed on discursive and institutional function. In this regard, Walter Benjamin's rhetorical question of 1938 is still germane: "Rather than ask, 'What is the *attitude* of a work to the relations of production of its time?' I should like to ask, 'What is its *position* in them?' "[23] The relevance of this question is that it underscores the need for critical practices to establish a contestatory space in which the *form* of utterance or address speaks to otherwise unrecognized, or passively accepted, meanings, values, and beliefs that cultural production normally reproduces and legitimizes. Insofar as contemporary critical practices operate within a society in which, as Victor Burgin observes, "the market is 'behind' nothing, it is *in* everything,"[24] the notion of an "outside" of the commodity system becomes increasingly untenable. This would suggest that the definition or evaluation of a critical practice must be predicated on its ability to sustain critique from within the heart of the system it seeks to put in question.

If we are to grant that a range of postmodernist photographic work that emerged at the end of the 1970s did, in fact, initially function as a critical practice, it did so very much within these terms. First of all, unlike other contemporaneous critical practices that positioned themselves outside the art world and sought different audiences (for example, Fred Lonidier's *Health and Safety Game*, Jenny Holzer's *Truisms*, *Inflammatory Essays*, and *Survival* series, the London Docklands project, Mary Kelly's *Post-Partum Document*, and D. Art's *Form Follows Finance*, to mention only a few),[25] postmodernist photography for the most part operated wholly within the parameters of high-art institutions. As the photographic work of Sherrie Levine clearly demonstrates, the critical specificity of such practice is operative, can be mobilized, only within a particular context. Its instrumentality, in other words, is a consequence of its engagement with dominant (aesthetic) discourses whose constituent terms (and hidden agendas) are then made visible as prerequisites for analysis and critique. As circumstances change (for example, with the assimilation of appropriative strategies into the culture at large), so too does the position of the artwork alter.

But within the overarching category of immanent critique, it is important to distinguish between those practices that elucidate, engage with, or even contest their institutional frame and those that suspend or defer the institutional critique in the belief that such critique is already implied within the terms of their focus on the politics of representation.

23. Walter Benjamin, "The Author as Producer," in *Reflections*, ed. Peter Demetz (New York: Harcourt, Brace, Jovanovich, 1938), p. 222.

24. "In contemporary capitalism, in the society of the simulacrum, the market is 'behind' nothing, it is *in* everything. It is thus that in a society where the commodification of art has progressed apace with the aestheticisation of the commodity, there has evolved a universal rhetoric of the aesthetic in which commerce and inspiration, profit and poetry, may rapturously entwine." Victor Burgin, "The End of Art Theory" in Victor Burgin, *The End of Art Theory: Criticism and Postmodernity* (London: Macmillan, 1986), p. 174.

25. On Fred Lonidier's work and the London Docklands project, see *Cultures in Contention*, ed. Diane Neumaier and Douglas Kahn (Seattle: The Real Comet Press, 1985). On Jenny Holzer, see Bruce Ferguson, "Wordsmith: An Interview with Jenny Holzer," *Art in America* (December 1986), pp. 108–15. On Mary Kelly, see Mary Kelly, *Post-Partum Document* (London: Routledge & Kegan Paul, 1983). On "Form Follows Finance," see Connie Hatch, "Form Follows Finance," introduction by Jim Pomeroy, *Obscura* 2, no. 5, pp. 26–34.

Representation is, after all, itself contextually determined, and the meanings thereby produced and disseminated are inseparable from the discursive structures that contain and enfold them. Consistent with the terms of Peter Bürger's formulation, there is by now a lengthy history of art practices of the former type, ranging from those of the historical avant-garde through more recent production exemplified by Michael Asher, Daniel Buren, Marcel Broodthaers (d. 1976), Hans Haacke, Louise Lawler, and Christopher Williams. It is, I think, of some significance that the work of these artists has more or less successfully resisted the reduction to stylistics to which postmodernist photography so rapidly succumbed. This is in part due to the fact that, with the exception of Buren, these are all *protean* practices, whose changing forms are determined by the issues the work addresses, its venue, its occasion, the historical moment of its making. This formal flexibility not only militates against the fixity of a signature style but emphasizes the tactical and contingent aspect of critical practice that defines and redefines itself in response to particular circumstances. Working with contradictions entails not only a strategy of position as such but a degree of maneuverability as well.

This in turn suggests that art practices predicated on the production of signature styles rather than constantly modified interventions may be especially vulnerable to neutralization of their purported critique. The history of postmodernist photography overall would appear to confirm this analysis. As various theorists have argued, a position of resistance can never be established once and for all, but must be perpetually refashioned and renewed to address adequately those shifting conditions and circumstances that are its ground.[26]

It is one thing, however, for a critic to map out what she believes to be the necessary conditions for a critical practice and quite another to actively deal with, assess, or articulate a position in relation to the work she actually confronts. Here, both critic and artist, situated within the restricted realm of high culture, are from the very outset enmeshed within a particularly dense matrix of contradiction. Once the decision is made to operate within the institutional space of art rather than outside it, critical writing and critical art are alike caught up in and subject to the very conditions such work attempts to contest. This is particularly the case with critical advocacy. Critical practice, if it is not to reduce itself to the tedium (and moralism) of the jeremiad, must be equally concerned with advocacy and partisanship. My own critique of the triviality and conservatism of official art photography was integrally related to my support of alternative photographic practices. This

26. For an excellent discussion of these issues, see Victor Burgin, *The End of Art Theory* (Atlantic Highlands, N.J.: Humanities Press, 1986).

support, in turn, inevitably became part (a small part) of a cultural apparatus of undifferentiated promotion in the service of supply-side aesthetics. Critical advocacy, irrespective of the terms in which it is couched, is from the outset either part of the commodity system (for example, in the format of the museum or gallery exhibition catalogue or the commercial art magazine essay or review) or secondarily appropriated to it (as in the assimilation of critical writing into art journalism or the gallery press release). This means that critical writing, regardless of the writer's politics, can in no way consider itself as independent of the cultural apparatus it seeks to contest. This is not, however, to claim that there are no differences. Nor is this to suggest that critical writing is to be reduced to the opposite poles of partisanship or attack. On the contrary, ideally the work of the critic and the work of the artist — to the degree that they both conceive their practices critically — are theoretical, if not actual, collaborations. As is true of art practices with which such criticism collaborates, learns from, and shares its agenda, working with contradictions necessitates a practical sense of what those contradictions imply — what they enable and what they preclude.

Thus, although the prevailing conditions of cultural production are hardly cause for optimism, neither are they cause for unrelieved despair; it is, after all, the very existence of discernible contradictions that allows for the possibility of critical practices in the first place. That said, perhaps the most daunting of all the contradictions that critical practices must negotiate is the direct consequence of problematizing the concept of the political in art. In this regard, the writing of Brecht, the practice of Heartfield, and the prescriptions of Benjamin can no longer be looked to as the *vade mecum* of critical practice. For if we accept the importance of specificity as a condition of critical practice, we are thrown into the specifics of our *own* political conditions and circumstances in the sphere of culture. To the extent that these include a refusal of inside/outside dichotomies ("the market is *in* everything"), an interrogation of the notion of prescription itself (authoritative modes, practices, models), a recognition of the contingency and indeterminacy of meaning, and a general acknowledgment of the inescapable complicity of all practices within cultural production, it becomes increasingly difficult to say with any assurance what critical practices should actually or ideally seek to do. Needless to say, the putting in question of traditional conceptions of political correctness, of determinate and fixed positions of address, of exhortative or didactic modes of critique, has been exclusively the project of feminism and a part of the Left. The

regnant Right knows no such uncertainty as it consolidates its position with increasing authoritarianism, repressiveness, and certainty. To have thus problematized the conditions of political enunciation within cultural production at a moment of extreme political reaction is perhaps the most daunting contradiction of all.

I gratefully acknowledge the advice, suggestions, good counsel, and unstinting support of Rosalyn Deutsche in the writing of this essay.

ON THE DISSECTING TABLE

The Unnatural Coupling of Surrealism and Photography

Andy Grundberg

1. "L'Amour Fou," organized by Rosalind Krauss and Jane Livingston, appeared at the Corcoran Gallery of Art, Washington, D.C., September–November 1985; "Fashion and Surrealism," organized by Richard Martin, was seen at the Fashion Institute of Technology, October 1987–January 1988.

The late 1980s have seen an astonishing revival of interest in surrealism. This revival has been spearheaded in part by such historical exhibitions as "L'Amour Fou: Photography and Surrealism" and "Fashion and Surrealism,"[1] both of which argued for surrealism's relevance to our own times. Simultaneously, art photographers — Joel-Peter Witkin being the most noted example — have given surrealism's obsessive fascination with polymorphous sexuality, morbidity, and grotesquerie a new lease on life, creating an atmosphere of chic revulsive/compulsive shivering unseen since Diane Arbus's retrospective exhibition of the early 1970s.

This surrealist revival is only one of several to have coursed through the last fifty years of art photography; indeed, one could say that surrealism runs like a pulse or throb throughout art photography's modernist presence.[2] This repetition is inherently problematic, however, since it calls into question twentieth-century photography's claims as art. If surrealism is periodically recycled as a style, what constitutes photography's originality, or its own aesthetic field?

2. The notion of a modernist pulse or throb has been advanced by Rosalind Krauss, who uses it in a more literal sense. She traces an underlying on-off rhythm in the work of Duchamp, Ernst, Picasso, and in less exalted terms, the functioning of the zootrope. See "The Im/Pulse to See," in *Vision and Visuality*, (Seattle: Bay Press, 1988), pp. 51–75.

We might begin to answer that question by making a distinction between the photographs produced by the Parisian surrealists from 1924 (the date of André Breton's first surrealist manifesto) to 1939 (when the Nazi occupation effectively ended the surrealists' naughty daydreams) and the photographs of the last fifty years that have at one time or another been called "surrealist." Breton's call for an art of "psychic automatism in its pure state" was based in Freudian notions of the subconscious mind and in a belief that the irrational could be harnessed as an instrument of refusal directed against the prevailing culture. In effect, surrealist art in general and surrealist photography in particular tried to put the psychic life of the artist in the service of a broad social rebellion. Its conflicts and tensions are due precisely to this conflation of what today we would call the claims of autonomous authorship and the hopes of a critical, oppositional praxis.

The Parisian surrealists used the medium in distinctive ways, some of which we now consider commonplace. They assembled objects and arranged tableaux to present before the camera. They collaged images

and rephotographed them. They intervened in the photographic process during development and afterward. These methods distinguish them from "straight" modernist practitioners, as well as from their contemporaries with surrealist affiliations or leanings — Brassaï, Henri Cartier-Bresson, André Kertész — who have been more thoroughly integrated into the modernist pantheon we call the history of photography. But formal devices alone do not distinguish the surrealist practice of photography.

Like surrealist painting, surrealist photography alternated between strictly representational and "automatic" abstractionist styles. One can see both these opposing directions at play in the images of Man Ray, the artist whose work best exemplifies the potentials of surrealist photography. His 1930 portrait of a woman's face, called *Larmes*, which uses glass beads as stand-ins for tears, is a deliberate construction, while his Rayographs and solarized portraits rely on chance operations in the darkroom. His photographs of sculptural objects can be read in these same two ways: the image *Le Cadeau*, as a photograph, is simply a record of Man Ray's most famous sculptural incongruity, an iron with a row of tacks fastened to its soleplate, while *Dust Breeding*, an image of Marcel Duchamp's unfinished, dust-covered *Large Glass*, seems to have resulted from a capricious experiment in long exposure.

Like the other surrealists who used photography extensively — among them Hans Belmer, Georges Hugnet, Roger Parry, Maurice Tabard, and Raoul Ubac — Man Ray was fascinated by the female body, which he transformed, cropped, and refigured in an inventive variety of ways. But Man Ray's solarized and drawn-on nudes seem almost romantic compared to Belmer's series of images of discombobulated doll parts. Belmer's "poupées" are gnarled, frightening caricatures of women's bodies, rendered even more perverse and unsightly through the addition of hand-applied color to the black-and-white prints. This disfiguring tendency of surrealist photography is not its most enviable characteristic (one critic has remarked that "one would have to be blind" on this score "not to recognize the unconscious sexism that runs through the Surrealist movement from beginning to end"),[3] but it is, from the evidence of "L'Amour Fou," one of its most salient. All the cropping, distortion, and rearrangement of erogenous zones served as signifiers not only of unconventionality but also of untempered subconscious "thought."

3. Kathleen Campbell, "Ideology versus History: Deconstructing Surrealist Photography," *Exposure* 26:1 (Spring 1988), p. 46.

In the United States, the photographer who adopted the example of the Parisian surrealists with the greatest conviction and comprehension was Frederick Sommer. Directly influenced by Max Ernst, whom he met in 1941, Sommer combines an American modernist fixation with the finish of the print and a European surrealist penchant for odd juxtapositions, morbid subject matter, and the operations of chance. Unlike Clarence John Laughlin, the New Orleans autodidact whose gothic double exposures of cemeteries and ruins are often held up as models of American surrealism, Sommer's work is grounded in theoretical considerations every bit as abstruse, and internally inconsistent, as Breton's. It also incorporates virtually all the characteristic traits and tics of surrealist photography of the 1920s.

Sommer, who was raised in Brazil and trained as a landscape architect at Cornell, seems to have been an innate surrealist. His 1939 pictures of chicken parts, which predate his first encounter with Ernst by two years, are as disconcerting as Belmer's *Les poupées*, made only a few years earlier. In the 1940s he obsessively photographed dead animals, emphasizing both their state of decay and their almost literal flatness, and he made a series of horizonless landscapes of the Arizona desert. Shorn of the usual landscape photograph's orientation to the sky, these pictures seem to be cropped from an infinite pattern; they produce a vertiginous effect that is profoundly at odds with their descriptive fidelity. In the 1950s Sommer employed collage, putting reproductions of etchings, drawings, and other images together in the manner of Ernst's 1921 collage *Sambesiland*; he also painted on cellophane and made photographic prints from the resulting images, a technique akin to Ernst's practice of *frottage*.

Like Laughlin's, Sommer's photographs had an uneasy relation to the dominant postwar aesthetic of modernism, but they were sufficiently conventional (black-and-white, full toned, greatly detailed, abstractionist) to be accepted into its fold. (Sommer and Laughlin had their work published in *Aperture*, the bible of photographic orthodoxy during its early years.)[4] The modernist aesthetic imperative of so-called straight photography, which prohibited any manipulation of the transaction between the subject and the film, obviously was less omnipotent then than is now commonly believed. In Sommer's case, the common denominator with modernist practice was an extreme kind of print fetishism.

Nevertheless, it is possible to consider Sommer's photographs as a protest against or antidote to modern photography's concentration on the literal surfaces of things and on subject matter that seems to speak

4. See, for example, Jonathan Williams, "The Eyes of Three Phantasts: Laughlin, Sommer, Bullock," *Aperture* 9:3, 1961, pp. 96–123.

for itself. The same might be said of the throbs of "surrealistic" practice that have occurred regularly in American photography ever since. For example, the overt surrealist revival that occurred in the late 1960s, which centered around Jerry Uelsmann, Ralph Gibson, Les Krims, and Duane Michals, can be seen as a rebellious reaction to the strictures of straight, modernist practice. As with Sommer's photography, however, their work was quickly sanctioned by the guardians of the modernist tradition.

Uelsmann, who was a student of Minor White's at the Rochester Institute of Technology, became known for his seamless prints made from several discrete negatives. Gibson, Krims, and Michals were comparatively conventional in their use of materials, but like Uelsmann they constructed dreamlike narratives that are indebted to René Magritte, Paul Delvaux, and Salvador Dali, the most literal-minded of the European surrealists. Uelsmann, in particular, was recognized for daring to break the long-standing proscription against intervening between the negative and the print. All four were part of the photography-as-fine-art movement of the early 1970s.

The nod to surrealism in their work functioned to set off their images from both documentary photography and the abstract, expressive styles of White, Aaron Siskind, and others. In Uelsmann's images, uprooted trees float in skies, decrepit mansions appear mired in swamps, and female nudes seem to hover under the surface of the ocean. Sometimes these combinations are humorous — *Little Hamburger Tree* of 1971, for example, suggests the existence of a fast-food chain in the heavens — but others seem merely portentous, at least in retrospect. The "hook" in Uelsmann's work is its seamlessness: like any other modernist photographs, his are rendered in nearly microscopic detail, which makes their discontinuous tableaux seem only more unbelievable. If nothing else, this accounts for their being called surrealist.

Michals's "sequences" — narrative series of as many as ten individual pictures, frequently incorporating handwritten texts — are focused (again, sometimes humorously) on metaphysical questions relating to personal and sexual identity, urban life, and loss. What made them seem surrealist in the 1960s was their open debt to Magritte, whom Michals photographed at the beginning of his career, and their insistence on the primacy of the imagination over material reality. At the time, the idea that photographs could describe dreams and other states of the mind was itself virtually surrealist.

Gibson, who had been Dorothea Lange's assistant in the early 1960s and later worked with Robert Frank, produced a book called

The Somnambulist in 1970. With a layout based on the idea that the meaning of images grows out of their associations and contexts, *The Somnambulist* paired suggestive, fragmentary images of women's hands, handguns, and shadows. The narrative, such as it was, was left to the imagination of the viewer. Krims's collections of acted-out tableaux, most notoriously *The Incredible Case of the Stack O'Wheat Murders* (1972), acquired their "surrealist" edge by violating social norms regarding nudity. *The Stack O'Wheats* series purports to show the ravaged, lifeless victims of a murderer whose "signature" is a pile of pancakes, using naked young women as models. The real subject, however, is the equation of violence and voyeurism. As is true of Uelsmann, Michals, and Gibson, Krims's attempt to represent his imagination or fantasy life created imagery that lends itself to Freudian interpretation.

At the same time as these overt appeals to the surrealist heritage were being made, the photographer Diane Arbus was taking straight-forward, unmanipulated portraits of individuals outside the bounds of polite society. Susan Sontag was to observe in one of her influential essays on photography that these pictures seemed as surrealist as any images consciously wrought. Indeed, they led Sontag to the conclusion that photography needs no elaboration or veneer of intention to render the world uncanny. In her article on Arbus, Sontag wrote:

The mainstream of photographic activity has shown that a Surrealist manipulation or theatricalization of the real is unnecessary, if not actually redundant. Surrealism lies at the heart of the photographic enterprise: in the very creation of a dupli-cate world, of a reality in the second degree, narrower but more dramatic than the one perceived by natural vision.[5]

5. Susan Sontag, *On Photography* (New York: Farrar, Straus and Giroux, 1977), p. 52.

Much as the surrealists appropriated the work of Eugène Atget, Sontag used Arbus as an example of how photographs convert reality into another dimension. However, Arbus's work is surreal only in terms of its solicitation and evocation of the grotesque. Rendering the world uncanny is one of the side effects of a great many photographs, includ-ing those produced by the Parisian surrealists, but it is not equivalent to surrealism. Arbus's work has none of the self-conscious cropping, collaging, and refiguring of reality that mark surrealist photography, and little of the fixation on Freudian-defined eroticism, morbidity, and ironic juxtaposition. And it certainly has none of the surrealists' sense of humor. If Arbus's fascination with the grotesque has any precedent in surrealist photography, it is with Belmer's idiosyncratic, even dysfunctional (in surrealist terms) dolls. But then Arbus was dealing with real people.

Today we have Joel-Peter Witkin, who represents yet another pulse of "surrealist" photography, as well as a certain one-upsmanship of Arbus's interest in the freakish and the sexually ambiguous. Drag queens, hermaphrodites, corpses, and taxidermological specimens are the photographer's favorite playthings, and to elevate them to the plane of art, he arranges them in settings that recall well-known paintings and painters. *Harvest* (1984) mimics the fantastic compositions of the sixteenth-century Milanese painter Guiseppe Arcimboldi, whom the surrealists proclaimed a forebear; both *The Bra of Joan Miró* (1982) and *The Sins of Joan Miró* (1981) allude to the Catalan surrealist's work. Indeed, of all of the references to painting found in Witkin's images, those aimed at surrealism seem most pertinent, since he is interested in violating virtually the same sensibilities. But by now it is not these appeals to the surrealist heritage that shock us; what creates the revulsion to Witkin's pictures is the belief that photographs, no matter how scratched, toned, or otherwise manipulated, still have a one-to-one connection with reality.

Like Belmer, Witkin is preoccupied with sexual ambiguity, fetishism, and substitution. But his objectification of the female body — frequently dismembered, sometimes "teased" by his captions — has an unsavory aspect in our supposedly post-Freudian times. While scholars such as Rosalind Krauss have found a way to overlook, or excuse, the Parisian surrealists' fascination with the "forbidden" areas of the female body by interpreting it, and all surrealist gestures, as deconstructive, Witkin's efforts have no such redeeming aspect. Unlike the surrealists, Witkin is not challenging the realm of the social in his appeals to the subconscious; rather, he employs sexual horror as the sign of his own expressiveness. His shocked and titillated audience responds to his personal demons, not to the irrational aspects of life. In this sense one cannot consider Witkin's work surrealist, much less deconstructive.

But it is not only Witkin's photography that is considered *nouvelle* surrealist these days. Several recent group exhibitions have explicitly maintained that the leading edge of contemporary photography can be located within the surrealist legacy. Why should the tenets and prac- tices of an art movement more than fifty years old become allied with contemporary photography at this historical moment? What critical point is being made, and what critical advantage gained, by such a linkage? Gerard Roger Denson, the curator of a 1987 show called "Poetic Injury: The Surrealist Legacy in Post Modern Photography," has answered these questions quite bluntly: "Just as postmodernism does today, Surrealism sought in the 1920s and 30s to critique and

6. Gerard Roger Denson, "Grandchildren of the Storm," *Poetic Injury: The Surrealist Legacy in Post Modern Photography* (New York: the Alternative Museum, 1987), p. 8. The show included forty-three artists, ranging from Krims, Uelsmann, and Arthur Tress to Sarah Charlesworth, Barbara Ess, William Wegman, and Krzysztof Wodiczko.

transform the contents, logical operations, and objects of representation."[6]

In short, surrealism, as viewed through the lens of late twentieth-century theory, is seen as postmodernism's precursor. As an avatar of deconstructivist practice and theory, it supplies a rationale both for photography's position within the art world and for those photographic practices that seek to disorient and disrupt our conventional responses to images. Here is Krauss, co-curator of "L'Amour Fou," writing in the same catalogue as Denson:

If surrealism as a movement was collectively aware of anything, it was that reality and consciousness "produce" one another, that the operations of construction are everywhere.... Surrealist photography does not admit of the natural, as opposed to the cultural or made. And so all of what it looks at is seen as if already, and always, constructed, through a strange transposition of this thing into a different register. We see the object by means of an act of displacement, defined through a gesture of substitution.[7]

7. Rosalind Krauss, preface to *Poetic Injury*, p. 4.

This sounds itself like an act of displacement. The surrealists knew Freud and the psychological notion of substitution, but they were not acquainted with Jacques Derrida, Roland Barthes, Jean Baudrillard, or the semiotic conception of cultural construction that informs Krauss's assertions.

This is not to deny, however, that the *styles* of surrealism continue to circulate throughout photographic practice, in Europe as well as in America. As Kathleen Kenyon, organizer of the 1988 show "New Surrealism: or, the fiction of the Real," at the Center for Photography at Woodstock, has remarked, the surrealist spirit "keeps surfacing, submerging, and re-emerging...there seems to be a useful need it fills. It's not out of fashion, but in-and-out of fashion. A band of secret surrealists survives."[8]

8. Kathleen Kenyon, "Surrealism Is a Dirty Word," *Center Quarterly* (Summer 1988), p. 11. The ellipsis is the author's.

The survival of "a band of secret surrealists" constitutes a remarkable chapter within the photography and art of the twentieth century, not to mention a rupture with conventional art-historical thinking, which is founded in precepts of progressive evolution. (Aside from self-conscious remakes, like those of Mike Bidlo, cases of stylistic recurrence are rare in modern art.) But today's look-alike surrealist photography, as witnessed by Witkin, is only the hollowed-out shell of surrealism as Breton conceived it. The forms are maintained, as is the penchant for fragmented, cut-up nudity, but precious little of the spirit of social rebellion remains. The tension between the competing claims of autonomous authorship and a critical, oppositional praxis is no longer felt. Indeed, one could say that today's surrealist-inspired practice represents exactly what postmodernism sets out to repudiate.

Finally, what is there to say about Sontag's contention that photography by its very nature is surrealist? Only that the surrealists, who wrote

poetry, painted, put on performances, and utilized many other forms of expression besides photography, did not see it that way. Breton and the other surrealists never argued that photographs were surrealist in and of themselves; if they were, then there would have been no occasion for the sort of intentional disruption of lenticular description seen in the images collected in "L'Amour Fou." The valorization of Atget's work was an exception in the surrealist scheme of things, roughly equivalent to Breton's retrospective adoption of the nineteenth-century writer Isidore Ducasse, also known as Comte de Lautréamont. Both were "found" surrealists, in the same way that Duchamp's urinal was a found object. In short, inscribing photography as a whole within the rubric of surrealism does violence to both.

Today's photography is a response to living in a world in which what challenges reality is simulated reality, not surreality. Ours is quite a different situation from that of the surrealists, who saw reality as a screen or blockade that masked the irrational, chaotic, childlike, and presumably genuine arena of the subconscious. Today, the subconscious is no longer perceived as innocent of culture. There is no longer anything remarkable about the conjunction of a sewing machine and an umbrella on a dissecting table — for us, the image is as denatured, and as anesthetized, as any other. Surrealism no longer serves a critical or rebellious purpose, any more than photography serves as an infallible barometer of true experience, and its stylistic repetition within the tradition of American fine-art photography is at best a kind of mannerism and at worst a symbol of that tradition's exhaustion.

KRZYSZTOF WODICZKO'S HOMELESS PROJECTION AND THE SITE OF URBAN "REVITALIZATION"

Rosalyn Deutsche

A version of this essay was originally published in *October* 38 (Fall 1986) and is reprinted here with permission of the author and MIT Press.

In *The City Observed: A Guide to the Architecture of Manhattan,* Paul Goldberger, architecture critic of *The New York Times,* concluded his historical survey of Union Square with the following observation:

For all that has gone wrong here, there are still reminders within the square itself of what a grand civic environment this once was. There are bronze fountains and some of the city's finest statuary. The best of the statues are Henry Kirke Brown and John Quincy Ward's equestrian statue of Washington, with a Richard Upjohn base, and Karl Adolf Donndorf's mother and children atop a bronze fountain base. There is also an immense flagstaff base, $9^1/_2$ feet high and 36 feet in diameter, with bas-reliefs by Anthony de Francisci symbolizing the forces of good and evil in the Revolutionary War; *even if a derelict is relieving himself beside it, it has a rather majestic presence.*[1]

1. Paul Goldberger, *The City Observed — New York: A Guide to the Architecture of Manhattan* (New York: Vintage, 1979), p. 92 (emphasis added).

The cynicism inherent in the use of a homeless person as a foil for the aesthetic merits of a sculptural base and for the nostalgic visions evoked by civic monuments will hardly surprise anyone familiar with Goldberger's consistent apologies for the ruthless proliferation of luxury condominiums, lavish corporate headquarters, and high-rent office towers in New York City today. The dangers of this attitude have, however, become fully manifest only in the current period of architectural expansionism. For in his "appraisals" of new buildings — evaluations that appear, appropriately, juxtaposed to real-estate news and accompanying the incessant disclosures by public officials of private development plans — Goldberger also fails to reflect on the relation between horrifying social conditions and the circumstances of architectural production. Goldberger never mentions the fact that the architects of New York's construction boom not only scorn the flagrant need for new public housing but also relentlessly erode the existing low-income housing stock, thereby destroying the conditions of survival of hundreds of the city's poorest residents. By remaining detached from questions of housing and focusing on what he deems to be properly architectural concerns, he further impedes the more fundamental recognition that this destruction is no accidental by-product of such reckless building but is, along with unemployment and cuts in social

2. Reviewing an exhibition of Hugh Ferriss's architectural drawings held at the Whitney Museum's new branch at the Equitable Center, a building that, itself, represents a threat to the city's poor, Goldberger claims that Ferriss "offers the greatest key to the problems of the sky-scraper city that we face today," because he demonstrated "that a love of the skyscraper's power and romance need not be incom-patible with a heavy dose of urban planning" (Paul Goldberger, "Architecture: Renderings of Skyscrapers by Ferriss," *The New York Times,* 24 June 1986, p. C13).

3. Paul Goldberger, "Defining Luxury in New York's New Apartments," *The New York Times,* 16 August 1984, p. C1.

4. Observing the omissions of any social or economic history in Goldberger's "history" of the skyscraper, one reviewer wrote, "The building process is born of economics.... Some of these factors might be: the state of the national and regional economies; the nature of the local transpor-tation system; the conditions of local market supply-and-demand; the relationship to desirable local geographic features or elements, such as proximity to a park; the perceived or actual quality of building services and image; and the economies of new construc-tion techniques that reduce build-ing costs or enhance efficiency — *all of which are factors that cannot be seen simply by looking at the building's skin*" (Michael Parley, "On Paul Goldberger's *The Skyscraper*," *Skyline,* March 1982, p. 10 [emphasis added]). The factors Parley lists indicate some of the most serious problems with Goldberger's aesthetic history, although they, too, need to be set in a broader economic framework.

5. The designation appears in Department of City Planning, *Union Square Special Zoning District Proposal,* originally released November 1983, revised June 1984, p. 3.

services, a necessary component of the economic circumstances that motivate it in the first place. Moreover, the discourse that Goldberger represents blocks comprehension of the full urban context by simulating social responsibility in the form of a concern for the physical environ-ment of the city. Thus, Goldberger intermittently attempts to dispel doubts about the substantial threat this construction poses to New York's light, air, and open space by occasionally appealing to a mythical notion of planning which, in practice, is a considerable part of the problem itself.[2] By declaring the crucial issues in development projects to be the size, height, bulk, density, and style of individual buildings in relation to their immediate physical sites, Goldberger ignores architec-ture's political and economic sites. He is able to concede in passing that "architecture has now come to be a selling point in residential real estate as much as it has in commercial."[3] Nonetheless, he abets the destruction of housing and communities by aestheticizing the real-estate function of current construction, much as he did the commercial function of the early twentieth-century skyscraper.[4] In short, he makes common cause with contemporary development for the rich and privileged, using the same rationale that authorized his exploitative description of the sculptural treasures of Union Square: the exaltation of the essential power and romance of, in the first case, the skyscraper, and, in the second, the historical monument.

The City Observed appeared in 1979, only a few years before "derelicts," along with other members of a "socially undesirable population"[5] were, in fact, evicted from Union Square by a massive program of urban redevelopment. Like all such activities of the latest New York real-estate boom, this one forcibly "relocated" many of the area's lower-income tenants and threatens numerous others with the permanent loss of housing. The publication of Goldberger's guide coincided with the preparation of the redevelopment plan, and it shares prominent features of the planning mentality that engineered Union Square redevelopment and of the public relations campaign that legitimized it: aesthetic appreciation of the architecture and urban design of the neighborhood and sentimental appeals for restoration of selected chapters of its past history. The thematic correspondence between the book and the planning documents is no mere coincidence. It vividly illustrates how instrumental aesthetic ideologies are for the powerful forces determining the use, appearance, and ownership of New York's urban spaces and for the presentation of their activities as an illusory restoration of a glorious past. For Goldberger, "Union Square's past is more interesting than its present. Now the square is just a

6. Goldberger, *The City Observed*, p. 91.

7. Department of City Planning, *Union Square: Street Revitalization*, January 1976, p. 28.

8. For a history of the economic factors — the needs of business — that determined the development of Ladies' Mile, see M. Christine Boyer, *Manhattan Manners: Architecture and Style 1850–1900* (New York: Rizzoli International Publications, 1985).

9. "The making of compositions, the making of streets, and the making of theater — it is these things that define the architecture of New York far more than does any single style" (Goldberger, *The City Observed*, p. xv).

10. Krzsztof Wodiczko, "Public Projection," *Canadian Journal of Political and Social Theory 7* (Winter/Spring 1983), p. 186.

dreary park, one of the least relaxing green spaces in Manhattan."[6] Invariably, the reports, proposals, and statements issuing from New York's Department of City Planning, the City Parks Commission, and city officials regarding the various phases and branches of redevelopment also reminisce about the square's history and lament its sharply contrasting present predicament. As one typical survey put it, "For the most part, the park today is a gathering place for indigent men whose presence further tends to discourage others from enjoying quiet moments inside the walled open space."[7] These texts disregard the prospects for Union Square's displaced homeless or for the new homeless produced by mass evictions and the raised property values resulting from redevelopment. Instead, they conjure up a past that never really existed; narratives portraying vaguely delimited historical periods stress the late nineteenth-century episode in Union Square's history, when it was first a wealthy residential neighborhood and then a fashionable commercial district: part of the increasingly well-known — due to a wave of museum exhibitions, media reports, and landmark preservation campaigns — "Ladies' Mile."[8] The redevelopers are most eager to revive this purportedly elegant and genteel era. A principal value of the aesthetic discourse for those seizing control of Union Square lies in this discourse's ability to construct a distorted architectural and design history of the area, one that will produce the reassuring illusion of a continuous and stable tradition symbolized by transcendent aesthetic forms. The history of Union Square, it is said, lies in its architectural remains. Using the same methods that cleared the path for the design and execution of redevelopment, reconstructed histories such as Goldberger's conduct their readers on a tour of the area's buildings, monuments, and "compositions."[9]

Krzysztof Wodiczko's *Homeless Projection* interrupts this "journey-in-fiction."[10] Although it employs the same Union Square terrain and the same "significant" architectural landmarks, the work aligns itself with radically different interests within the politics of urban space. Its form: site-specific, temporary, collaborative with its public; its subject: the capitulation of architecture to the conditions of the real-estate industry; the contents of its images: the fearful social outcome of that alliance. All of these qualities render *The Homeless Projection* useless to those forces taking possession of Union Square in order to exploit it for profit; they militate, also, against the work's neutralization by aesthetic institutions. Instead of fostering an unreflective consumption of past architectural forms to oil the mechanism of urban "revitalization," the project attempts to identify the system of economic power

11. Ibid.

operating in New York City beneath what the artist once called "the discreet camouflage of a cultural and aesthetic 'background,'"[11] Eroding the aura of isolation that idealist aesthetics constructs around architectural forms, it also — by virtue of its rigorous attention to a broad and multivalent context — dismantles the terms of an even more obscurantist urban discourse that relates buildings to the city conceived only as a physical environment. Wodiczko's project reinserts architectural objects into the surrounding city understood in its broadest sense as a site of economic, social, and political processes. Consequently, it contests the belief that monumental buildings are stable, transcendent, permanent structures containing essential and universal meanings; it proclaims, on the contrary, the mutability of their symbolic language and the changing uses to which they are put as they are continually recast in varying historical circumstances and social frameworks. Whereas the architectural and urban discourses promoted in journalism such as Goldberger's and in the documents produced by New York's official urban-planning professionals manufacture an aesthetic disguise for the brutal realities of "revitalization," *The Homeless Projection*, if realized, would dramatically interfere with that image, restoring the viewer's ability to perceive the essential connections that these discourses sever, exclude, or cosmeticize — the links that place the interrelated disciplines of architecture, urban design, and, increasingly, art in the service of those financial forces that determine the shape of New York's built environment. Moreover, the clear ethical imperative that informs the work's engagement in political struggles markedly contrasts with the dominant architectural system's preferred stance of "corporate moral detachment."[12]

12. Krzysztof Wodiczko, *The Homeless Projection: A Proposal for the City of New York*, New York, 49th Parallel, Centre for Contemporary Canadian Art, 1986. See also Krzysztof Wodiczko, *October* 38 (Fall 1986), pp. 63–98.

Wodiczko entered the arena of New York housing politics when he took advantage of the opportunity offered him for an exhibition at a New York art gallery. *The Homeless Projection* exists only as a proposal presented at 49th Parallel in the winter of 1986. Consisting of four large montaged slide images projected onto the gallery's walls and a written statement by the artist distributed in an accompanying brochure, it outlined a plan for the transformation of Union Square Park. The exhibition coincided with the unfolding of the redevelopment scheme that is transforming Union Square in actuality, occurring several months after the completion of the first phase of the park's restoration — the ideological centerpiece and economic precondition for the district's "revitalization." Drastic changes in the built environment, such as this "revitalization," are effected through conventional and institutionalized planning forms. "What has been of fundamental

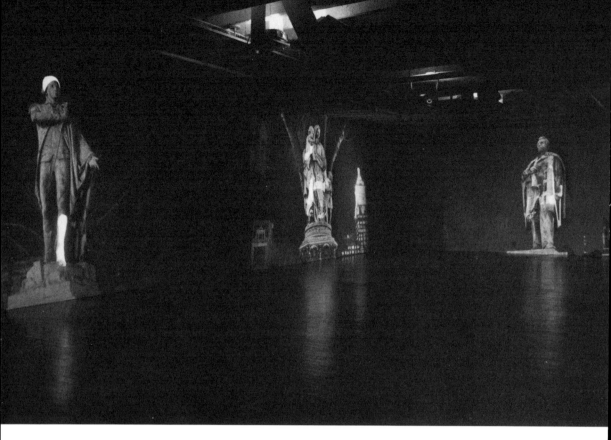

13. Bernardo Secchi, "La forma
del discourse urbanistico,"
Casabella 48 (November 1984),
p. 14 (emphasis added).

importance," writes a critic of the history of town planning, "is the role
of the project, that is of *imagination*."[13] Such projects entail activities of
sight and memory. No matter how objective their language, they are,
by virtue of their selective focuses, boundaries, and exclusions, also
ideological statements about the problems of and solutions for their
sites. Given the fact that *The Homeless Projection*'s potential site is the
site of the pervasive and calculated urban process of redevelopment,
Wodiczko's photographic and textual presentation in the space of
aesthetic display — the gallery — appears to echo and critically
intervene in the visual and written presentational forms of city plan-
ning. Like the official proposals generated by the teams of engineers,
landscape architects, designers, demographers, sociologists, and
architects who actually shaped Union Square's renovation, Wodiczko's
presentation envisioned imagined alterations to its location and set
forth the principles and objectives governing his proposal. Unlike such

documents, however, it offered no suggestions for enduring physical changes to the area under study. Instead, the artist disclosed a plan to appropriate temporarily the public space of Union Square Park for a performance, in the course of which he would project transient images onto the newly refurbished surfaces of the four neoclassical monuments that occupy symmetrical positions on each side of the park. Yet this impermanence does not represent the core of the difference between the two. Whereas mainstream planning discourse legitimates its proposals through the notion that they will restore a fundamental social harmony, Wodiczko's intervention illuminates the existing social relations of domination which such planning disavows.

The Image of Redevelopment

While *The Homeless Projection* is a proposal for a work to be situated in Union Square, the work's subtitle, "A Proposal for the City of New York," explicitly announces that Union Square represents a determinate location of urban phenomena extending far beyond the immediate area. Indeed, the transformation of Union Square from a deteriorated yet active precinct consisting of a crime-ridden park, low-rent office buildings, inexpensive stores,[14] and single-room occupancy hotels into a luxury "mixed-use" neighborhood — commercial, residential, and retail — is only an individual manifestation of an unprecedented degree of change in the class composition of New York neighborhoods. The concluding phases of such metamorphoses — those that follow the preliminary and calculated stages of abandonment, neglect, and deterioration caused by landlords and financial institutions — are identified by a constellation of inaccurate, confusing, and distorting terms. Overtly falsifying, however, is the overarching rubric *revitalization*, a word whose positive connotations reflect nothing other than "the sort of middle-class ethnocentrism that views the replacement of low-status groups by middle-class groups as beneficial by definition."[15] The word *revitalization* conceals the very existence of those inhabitants already living in the frequently vital neighborhoods targeted for renovation. Perhaps the most widely used term to designate current changes is *gentrification*, which, coined in London in the 1960s, implies the class interests at work in the phenomenon. It identifies the gentrifying classes incorrectly, however, suggesting that they represent some fictional landed aristocracy.

Explanations for "revitalization" and gentrification, where they exist, are generally formulated out of the concepts, values, and beliefs

14. The shops along Fourteenth Street from First to Eighth avenues, including Mays department store facing Union Square, make up the largest shopping district south of Spanish Harlem for Manhattan's Hispanic residents. Some of these stores' sites have already been purchased for future redevelopment. Known as La Calle Catorse, this street has traditionally provided the link between the concentrations of Hispanics on the Lower East Side and Chelsea, both of which neighborhoods have recently been redeveloped, resulting in large displacements of those populations.

15. Bruce London and J. John Palen, "Introduction: Some Theoretical and Practical Issues Regarding Inner-City Revitalization," in *Gentrification, Displacement and Neighborhood Revitalization*, ed. J. John Palen and Bruce London (Albany: State University of New York Press, 1984), p. 10.

espoused by those financial institutions, politicians, corporations, real-estate developers, landlords, and upper-middle-class residents who benefit from the process. At their most reactionary and self-serving — and most widely disseminated in the mass media — such "explanations" repress the social origins, functions, and effects of gentrification in order deliberately to thwart the apprehension of its determining causes and present it, instead, as the heroic acts of individuals. New York's former housing commissioner has, in this fashion, asserted,

When an area becomes ripe for gentrification, a condition that cannot be rigorously identified in advance but seems to depend on the inscrutable whims of an invisible hand, the new purchasers face monumental tasks. First the building must be emptied. Then layers of paint must be scraped from fine paneling; improvised partitions must be removed; plumbing must be installed and heating ripped out and replaced. Sometimes the new buyers spend years under pioneering conditions.[16]

16. Roger Starr, *The Rise and Fall of New York City*, (New York: Basic Books, 1985), p. 36.

Not all accounts are so blatantly misleading. But even those explanations that identify and criticize some of the real effects of gentrification tend to be superficial, impressionistic, or eclectic rather than based in an understanding of the specific forces that govern patterns of city growth and change.

Recently, however, efforts have been made to "identify rigorously" the structural factors that prepare the conditions for gentrification and to ascertain precisely whose needs and interests regulate the restructuring of urban space within which gentrification plays a role. These theories rest on the fundamental premise that the physical form of the cityscape is inseparable from the specific society in which it develops. The wholesale reorganization of that space represents, then, no mere surface phenomenon; rather it participates in a full-scale restructuring within that larger society. Compelled by the imperative to place gentrification within the context of this broader restructuring, Neil Smith and Michele LeFaivre produced in 1984 a detailed and urgently needed "Class Analysis of Gentrification."[17] In contradistinction to notions of "inscrutable whims" and "invisible hands," the essay examines a systematic combination of economic processes — a "devalorization" cycle of declining real-estate values — whereby inner-city neighborhoods have been historically and concretely "developed" into deteriorated areas in order to produce the prerequisites for gentrification. Occurring within the wider periodicity of capitalist expansion, this devalorization cycle — consisting of new construction, landlord control, blockbusting, redlining, and abandonment — terminates in a situation in which a developer's investment can result in a maximization

17. Neil Smith and Michele LeFaivre, "A Class Analysis of Gentrification," in *Gentrification, Displacement and Neighborhood Revitalization*, pp. 43–63.

of profit. The ability to produce profitable investments depends on the existence of a substantial gap between the current capitalization of real estate in a specific location and the potential return on investment. "When this rent gap becomes sufficiently wide to enable a developer to purchase the old structure, rehabilitate it, make mortgage and interest payments, and still make a satisfactory return on the sale or rental of the renovated building, then a neighborhood is ripe for gentrification."[18]

The analysis of this devalorization cycle is, by the authors' own admission, schematic; it requires readjustment to accommodate the variations among development procedures in diverse cities and to account for the variables of conflicting capital interests, forms of state intervention, the emergence of community movements, and other factors. Nonetheless, the analysis is indispensable in destroying the myth that arbitrary, natural, or individual actions produce neglect and abandonment, which can then be "corrected" by gentrification. Rather it ties the stages of abandonment and gentrification together within the "logic" of an economic system and reveals them to be the product of specific decisions by the primary and powerful actors in the real-estate market — financial institutions, developers, government, and landlords.

In their description of the real-estate devalorization cycle, Smith and LeFaivre emphasize the commodity function of city neighborhoods under capitalism. They further stress this function when they situate gentrification within the larger transformations taking place in central cities. In so doing they closely follow David Harvey's pioneering analyses of capitalist urbanization, in which Harvey endeavors to discover the constituent elements that propel the flow of capital into the built environment of the city during particular economic periods.[19] His conclusions depend on an application to urban processes of Marx's analysis of the contradictions within capitalist accumulation and how capitalism attempts to ensure its survival. Harvey emphasizes the tendency toward overaccumulation, in which the production of capital in certain sectors of the economy exceeds opportunities to employ it at the average rate of profit. Manifested in falling rates of profit, overproduction, surplus capital, surplus labor, or greater exploitation of labor, overaccumulation crises can be temporarily solved by switching investment into other sectors of the economy. Harvey views extensive investment in the built environment as a symptom of such a crisis, "a kind of last-ditch hope for finding productive uses for rapidly over-accumulating capital."[20] Due to the long-term, large-scale projects this investment entails, the success of the attempt — its short-lived success — requires the mediation of financial and state institutions.

18. Ibid., p. 50.

19. See in particular, David Harvey, "The Urban Process Under Capitalism: A Framework for Analysis," in *Urbanization and Urban Planning in Capitalist Society*, ed. Michael Dear and Allen J. Scott (London and New York: Methuen, 1981), pp. 91–121. Other works by Harvey include *Social Justice and the City* (Baltimore: The Johns Hopkins University Press, 1973), and *The Urbanization of Capital: Studies in the History and Theory of Capitalist Urbanization* (Baltimore: The Johns Hopkins University Press, 1985).

20. Harvey, "The Urban Process Under Capitalism," p. 108. For another analysis of the contemporary construction boom as a response to the capitalist economic crisis, see Mike Davis, "Urban Renaissance and the Spirit of Postmodernism, *New Left Review* 151 (May/June 1985), pp. 106–116.

Smith and LeFaivre apply Harvey's conclusions to the processes of contemporary central-city development and gentrification, which they evaluate as a component of this switching process: in order to counteract falling rates of profit, capital moves into areas such as real estate and construction. Characterizing gentrification as "the latest phase in a movement of capital back to the city,"[21] the authors offer another crucial argument against the prevailing vision that gentrification represents a spontaneous "back-to-the city" movement by individuals eager for the excitement of cosmopolitan life.

21. Smith and LeFaivre, "A Class Analysis of Gentrification," p. 54.

The use of the city neighborhood as a commodity to be exploited for profit represents, however, only one of its purposes in a capitalist economy. Traditionally, it has also provided the conditions for reproducing necessary labor power. Smith and LeFaivre interpret gentrification as a phenomenon representing a definitive replacement of this function by the neighborhood's alternative service as a commodity: "The economic function of the neighborhood has superseded the broader social function."[22] It is possible, however, to interpret gentrification as a means for the reproduction of labor power in a way that does not exclude the neighborhood's commodity function. In New York today, the two uses might signal conflicts within the capitalist class itself between those interests that require the conditions to maintain the labor force — the lower paid and part-time service workers in particular — and those that can profit from their destruction. Seen in this light, the current situation represents a specific historical instance of a more general contradiction between the imperatives of accumulation and reproduction in the late capitalist city. Writing in 1984 about the new commercial art scene that was then unfolding on New York's Lower East Side, Cara Gendel Ryan and I situated gentrification within the shifts taking place in the composition of the late capitalist labor force.[23] Citing heavy losses in manufacturing jobs in New York City, unemployment in the industrial sector due to the automatization of labor power, and the concomitant steady growth in jobs in the financial, business, and service sectors, we reasoned that gentrification was a crucial part of a strategy for restructuring the work force. Together with the loss of jobs and cuts in basic services, it has helped to impoverish and disperse the traditional, now largely redundant, work force and has allocated urban resources to fill the needs of the city's white-collar, corporate workers.

22. Ibid., p. 46.

23. Rosalyn Deutsche and Cara Gendel Ryan, "The Fine Art of Gentrification," October 31 (Winter 1984), pp. 91–111.

The general changes taking place in the nation's labor force are conditioned and modified by a global reorganization of labor which has accelerated since the 1970s. This global restructuring has had profound ramifications for urban spatial organization on a variety of levels. As a

system for arranging production on a world scale, the new international division of labor entails the transfer by multinational corporations of their labor-intensive and productive activities elsewhere, often to third-world countries and the intense concentration of their corporate headquarters in a few international centers. Allowing for enhanced flexibility and control over vastly extended operations, strategies are formulated, managerial decisions made, and financing administered from the global cities. To qualify as such an international center of business a city must possess, first, a high proportion of headquarters of corporations doing the majority of their business in foreign sales and, second, a centralization of international banks and international corporate-related services: law, accounting, and advertising firms.[24] By the late 1970s in the United States, only New York and San Francisco had emerged as such international centers, so that "even the international activities of firms headquartered outside these cities were increasingly linked to financial institutions and corporate services located within them."[25] But in addition to transforming relationships among international and national cities, the new international division of labor affects the work force within the corporate center itself. These centers present limited opportunities for blue-collar jobs, further "'marginalizing' the lower class which has traditionally found job mobility extremely difficult."[26]

As an arm of broader governmental policy, urban planning in New York City has, since the 1970s, focused its energies on the needs of the city's new economy — its corporate-linked activities and workers — and on the maximization of real-estate profits, engineering the dispersal of that "immobile" population with no place in this economy. Bureaucratic procedures and programs of planned development execute the task. Union Square "revitalization" is just such a program. The coincidence between the pattern of its evolution and the contours of deeper economic trends is clear. The area became the target of City Planning Commission attention in 1976, and the final redevelopment plan was approved in 1984. During this same period, New York lost more than 100,000 blue-collar jobs and gained over twice that many in the finance, insurance, and other business industries. These changes, accelerating since the 1950s, were reflected within the Union Square area itself. In that period, especially between 1970 and 1980, there had been an exodus of light manufacturing companies from the district's lofts, which were subsequently converted to more profitable residential and commercial uses compatible with the city's new economic base. Although it is difficult to furnish accurate figures for Union Square proper, since it comprises portions of four separate census tracts, the neighborhood's

24. R. B. Cohen has devised a "multinational index" for quantifying the status of cities in the United States as international business centers. See his "The New International Division of Labor, Multinational Corporations and Urban Hierarchy," in *Urbanization and Urban Planning,* pp. 287–315.

25. Ibid., p. 305.

26. Ibid., p. 306.

27. Department of City Planning, Manhattan Office, *Union Square Special Zoning District Proposal*, p. 17.

28. Thomas J. Lueck, "Rich and Poor: Widening Gap Seen for Area," *The New York Times*, 2 May 1986, p. B1.

29. "How Many Will Share New York's Prosperity?," *The New York Times*, 20 January 1985, p. E5.

30. Lueck, "Rich and Poor," p. B1.

middle-class residential population substantially increased; 51 percent were employed in the service industries, 43 percent in wholesale and retail businesses, while other employment sectors showed "less growth."[27] This disparity in employment possibilities illustrates the fact that New York's period of economic prosperity and resurgent business expansion is, more truthfully, an era of intense class polarization. According to a report prepared by the Regional Plan Association and based on 1980 census data, 17 percent of the New York area's upper-income households accounted for more than 40 percent of the area's total income, while 42 percent — those with incomes under $15,000 — accounted for only 14 percent of that income.[28] (By 1983, those with incomes under $15,000, were, in New York City itself, over 46 percent of the population.)[29] The report surmised that "the economic outlook for hundreds of thousands of poorly educated, low-income residents throughout the New York area, stretching from Trenton to New Haven, is growing more bleak."[30]

Only within the overarching framework of this larger urban development can the functions and effects of New York's recent redevelopment programs be assessed with any comprehensiveness. Nevertheless, throughout this period, the City Planning Commission began to restrict its vision using a technique that would eventually be codified by the Board of Estimate under the misnomer *contextual zoning*. Further, this time of extreme class polarization, wrenching restructuring of the economy, and social dislocation of the poor — most evident in the enforced mobility of the displaced homeless — was, to the commission, the interval when the city finally began to be conserved, stabilized, and protected from radical change as well as from the radical impositions of modernist architectural concepts. Advised by the architects, urban designers, planners, and engineers who staff the Department of City Planning, the commission modified its zoning regulations, bureaucratic methods, and physical design orientations in order to "guide" development according to the principles of responsiveness to the needs of distinct city environments. They pursued a design path directed toward the historical preservation of existing circumstances. With relief, one architect and urban planner for the city approvingly wrote, regarding this "preservationist" outlook,

The urban aesthetic of associational harmony is reasserting itself under the banner of *cultural stability*. The mercurial rise to prominence and power of the urban preservationist movement has helped to fuel this change in direction. Preservation of both our most valued urban artifacts, whether they be the conventionalized row houses of Brooklyn Heights or the sumptuous dissonance

31. Michael Kwartler, "Zoning as Architect and Urban Designer," *New York Affairs* 8:4 (1985), p. 118 (emphasis added).

32. This fact can been seen in the role that architecture and urban design are playing in the creation of Battery Park City, one of the largest real-estate developments in the country. The project has undergone several permutations since it was first conceived in the early 1960s, but a single one overshadows all the rest in significance. In 1969, the City Planning Commission accepted a plan for the development of Battery Park that called for two-thirds of the new housing units to be subsidized and divided equally between the poor and the middle class. When, however, the project was refashioned in the late 1970s, after the municipal fiscal crisis, it provided subsidies, instead, in the form of tax abatements, for the World Financial Center and plans for luxury apartments requiring incomes greater than $75,000. The fate of this project encapsulates the solution to the fiscal crisis adopted by the city. To Mayor Koch the change was justified by the fundamental necessity that "we continue to be the financial center of the world" (quoted in Martin Gottlieb, "Battery Project Reflects Changing City Priorities," *The New York Times*, 18 October 1985, p. C3). Whereas the chronicle of Battery Park City's growth illuminates important changes in the city's economic and political priorities over the past fifteen years, the design mentality governing its creation increasingly conformed during the course of that growth to the preservationist branch of contemporary planning. Speaking about the traditional street furniture reproduced for the public esplanade of the $4.5 billion project, a *New York Times* article noted that it makes the area "seem like a long-established section of New York — a natural and inevitable part of the city rather than a newly designed environment." And one of the architects who worked out the master plan for Battery Park said,

of the New York Public Library is an important, if not vital, contribution to our sense of emotional well-being.[31]

This "redevelopment" — the resurgence of tradition and emergence of a severely restricted and spectacularized notion of cultural preservation — helps paper over violent disturbances in the urban social fabric.[32]

From its inception the agenda of Union Square redevelopment was conceived and executed under the aegis of historical preservation, restoration of architectural tradition, and reinforcement of the existing urban context. These concepts dominated the massive ideological campaign accompanying the scheme and the narrower aspects of its decision-making process. The bronze monuments in Union Square Park — refurbished and newly visible — embody with particular efficacy the attempt to preserve traditional architectural appearances in order to deliver the Union Square territory into the hands of major real-estate developers and expedite luxury development. In fact the patriotic statues became a useful symbol to the forces of "revitalization" themselves as early as 1976, when the Department of City Planning received from the National Endowment for the Arts a $50,000 "City Options" grant, part of a "New York City Bicentennial Project." The intention of the grant was "to produce designs that would improve city life." After consulting with the community board, elected officials, businessmen, "civic leaders," and other city agencies, the Planning Department published a report entitled *Union Square: Street Revitalization*, the first exhibit in the case history of Union Square redevelopment. This document became the basis for the *Union Square Special Zoning District Proposal*, which was originally released in November 1983, revised in June 1984, and, after passing the city's review procedure, adopted later that year. The final redevelopment plan fulfilled the primary objectives and many of the specific recommendations of *Union Square: Street Revitalization*. When requesting the City Options grant, the Planning Department chose four "historic" neighborhoods for study and design proposals; its application announced that its goal in these neighborhoods was preservation: "Cities contain many centers and communities rich in history and a sense of place. We seek to develop prototypical techniques by which the particular character of these areas can be reinforced so as to assist in their preservation through increased safety, use and enjoyment."[33] Among the strategies developed to "capitalize on existing elements worthy of preservation"[34] was the first proposal for improving the park: "Restore the centerpiece flagpole, a memorial to the 150th anniversary of the United States, which features the Declaration of Independence engraved in bronze."[35]

"We wanted to make it look as though nothing was done" (Esplanade Recalls Old New York," *The New York Times*, 3 July 1986, p. C3). For a more detailed account of Battery Park City's housing and design history, see Rosalyn Deutsche, "Uneven Development: Public Art in New York City," *October* 47 (Winter 1988), pp. 3–52.

33. Victor Marrero, Chairman, Department of City Planning, "Preface," *Union Square: Street Revitalization.*

34. *Union Square: Street Revitalization*, p. 33.

35. Ibid., p. 37.

36. Benson J. Lossing, *History of New York City*, in I. N. Phelps Stokes, *The Iconography of Manhattan Island 1498–1909* (1926; reprint, New York: Arno Press, 1967), p. 1896.

37. Robert H. Wiebe, *The Search for Order 1877–1920* (New York: Hill and Wang, 1967), pp. 11–12.

The cover of *Union Square: Street Revitalization* "capitalized" on another Union Square monument and patriotic event. It reproduced an engraving from a nineteenth-century copy of *Harper's Weekly* captioned "The Great Meeting in Union Square, New York, To Support the Government, April 20, 1861." The print depicts a crowd of New Yorkers gathered at the base of the colossal equestrian statue of George Washington, now ceremonially located at the southern entrance to the park, but at that time situated on the small island at the park's eastern perimeter. The illustration evoked a brief era during the Civil War when Union Square became a gathering place for a public believed to be unified by nationalist sentiment. Loyal citizens repeatedly rallied around the Washington statue listening to speeches by Mayor Opdyke and letters of endorsement from the governor, president, and other officials; newspapers recounted the patriotic, unified spirit of these crowds:

The great war-meeting at Union Square effectually removed the false impression that the greed of commerce had taken possession of the New York community, and that the citizens were willing to secure peace at the sacrifice of principle.... The patriotism of the citizens was also indicated by the wrath which that meeting excited at the South. The Richmond *Dispatch* said: "New York will be remembered with special hatred by the South, for all time."[36]

The name of the square, originally referring only to its physical position at the juncture of Broadway and the Bloomingdale Road, now implied national unity and a shared public history, dreams believed for some time to have come true as a result of the war.[37] The placard displaying the word UNION in the *Harper's Weekly* print affirms these new connotations.

The survival of this myth helped repress beneath high-minded notions of communal harmony the more disquieting memories of class conflict that characterized modern urban society, conflict that was also insistently visible in Union Square. The park, for instance, was the scene of some of America's earliest labor demonstrations, including the New York segment of the first May Day celebration in 1886. This class division would reemerge conspicuously in the 1930s when the square became the conventional New York site for communist rallies and militant demonstrations of the unemployed and homeless. At that time its name was linked with trade-union movements. In a book entitled *Union Square*, Albert Halper, a "proletarian novelist" of the period, employed the park's heroic monuments as a conceit to underscore the contradictions between, on the one hand, idealized representations symbolizing spiritual ideals and reassuring authority and, on the other,

38. Albert Halper, *Union Square* (New York: Viking, 1933).

present-day realities of starvation and police brutalization of demonstrators. In this way, he described Donndorf's mother-and children fountain on the west side of the square — a position it still occupies — as "a dreamy piece of work" facing Broadway right near the "Free Milk for Babies Fund hut."[38] With similar irony, he juxtaposed the "big history" represented by the great men and deeds memorialized in the park's other statues with the historical class struggle, whose skirmishes were being waged in the square itself.

The original intention of monuments such as these, however, when they were erected in American cities in the late nineteenth century was more congruent with their use by the apparatus of Union Square redevelopment. Neoclassical imitations were meant, as M. Christine Boyer observes, to conceal such social contradictions by uplifting "the individual from the sordidness of reality" through illusions of order, timelessness, and moral perfection that neoclassicism was supposed to

39. M. Christine Boyer, *Dreaming the Rational City: The Myth of American City Planning* (Cambridge: MIT Press, 1983), p. 50.

represent.[39] Although they never constituted a planned or unified sculptural program, the Union Square monuments exemplify the type of sculpture and its strategic positioning promoted by the nineteenth-century municipal art movement — copies of Parisian copies of Greek and Roman landmarks of art and architectural history. These decontextualized forms, reinvested with new meanings about America's emerging economic imperialism and national pride, were products of the decorative offshoot of the municipal art movement, itself a branch of the attempt in the late nineteenth and early twentieth centuries to produce order and tighten social control in the American city.[40] Inspired by fears of the unplanned chaos of urban industrialization, squalor and disease in the slums, extensive immigration, and a wave of labor disturbances, the notion of urban planning and design as a vehicle to counteract these threats appeared in nascent form in the ideas of the civic art crusaders.

40. See Wiebe, *The Search for Order*; Paul Boyer, *Urban Masses and Moral Order in America 1820–1920* (Cambridge: Harvard University Press, 1978); Mario Manieri-Elia, "Toward an 'Imperial City': Daniel H. Burnham and the City Beautiful Movement," in Giorgio Ciucci et al., *The American City: From the Civil War to the New Deal* (Cambridge: MIT Press, 1979); M. Christine Boyer, *Dreaming the Rational City*.

Their activities are, then, only one aspect of an effort, as David Harvey puts it, "to persuade all that harmony could be established around the basic institutions of community, a harmony which could function as an antidote to class war."

The principle entailed a commitment to community improvement and a commitment to those institutions such as the Church and civil government, capable of forging community spirit. From Chalmers through Octavia Hill and Jane Addams, through the urban reformers such as Joseph Chamberlain in Britain, the "moral reformers" in France and the "progressives" in the United States at the end of the nineteenth century, through to model cities programmes and citizen participation, we have a continuous thread of bourgeois response to the problems of civil strife and social unrest.[41]

41. Harvey, "The Urban Process Under Capitalism," p. 117.

As part of this network, municipal art advocates aimed to produce a sense of order and communal feeling through spatial organization and decorative beauty. Public open spaces, such as Union Square Park, were targeted as prime locations for forming the desired community, a public realm characterized by cohesive values conjured up through moral influence. "Modern civic art," wrote one of its foremost advocates, "finds in the open space an opportunity to call [the citizens] out-of-doors for other than business purposes, to keep them in fresh air and sunshine, and in their most receptive mood to woo them by sheer force of beauty to that love and that contentment on which are founded individual and civic virtue."[42] In this regard, municipal art specialists in New York consistently lamented that Union Square was a missed opportunity. One of the few public squares provided in the 1811 Commissioner's Map that established the rectilinear grid plan for "upper" Manhattan above Washington Square, Union Square almost failed to materialize. In 1812 it was recommended that plans be dropped since they would require the use of land and buildings with high real-estate values. Although the square survived these threats and was finally opened to the public in 1839, greatly enhancing land values in the immediate vicinity, civic art reformers regretted that the park was never properly utilized to create a physically — and therefore, socially — cohesive public space. One critic proposed that it be turned into the civic center of New York;[43] another suggested that a proper and elaborate sculptural program be organized there around the theme and images of liberty secured by the War of Independence. "Could anything influence more forcibly the national pride of our coming generations?"[44] Public statues, embodying social ideals, would, it was hoped, "commemorate in permanent materials the deeds of great citizens, the examples of national heroes, the causes for civic pride, and the incentives to high resolve which are offered by the past."[45] As instruments for the pacification of an unruly populace, the sculptures, as well as street layouts devised by the municipal art movement, "searched not to transform the contradictions between reality and perfection but for the norms that moral perfection must follow."[46] Indeed, when Charles Mulford Robinson, systematizer of municipal art concepts, directed his attention to conditions in the metropolitan slums, he ignored the problem of poverty itself, declaring, "With the housing problem civic art, its attention on the outward aspect of the town, has little further to do."[47]

This resigned abandonment of the most troubling facts of city life and neglect of the motive forces determining the city's social structure could, in the end, only contribute to the persistence of the housing

42. Charles Mulford Robinson, *Modern Civic Art or, The City Made Beautiful* (New York and London: G. P. Putnam's Sons, 1903).

43. J. F. Harder, "The City's Plan," *Municipal Affairs* 2 (1898), pp. 25–43.

44. Karl Bitter, "Municipal Sculpture," *Municipal Affairs* 2 (1898), pp. 73–97.

45. Robinson, *Modern Civic Art*, p. 170.

46. Boyer, *Dreaming the Rational City*, p. 50.

47. Robinson, *Modern Civic Art*, p. 262.

problem. Today, the uses of New York's civic sculptures — and the architectural and urban design system they represent — have *everything* to do with the housing problem. This contention is amply supported by examining the fate of the Union Square monuments. The appearance of a nineteenth-century American imitation of a Roman equestrian statue on the cover of a late twentieth-century city-planning proposal for redevelopment during a period of fiscal crisis can demonstrate nothing other than the extreme pliability of the monument's meanings and functions. Nevertheless, the architects of redevelopment (together with the copywriters of real-estate advertisements) attempt to bolster the illusions of cultural stability, universal values, and gentility connoted by such architectural forms. By so doing, they fail to realize that their own acts of preservation are ideologically motivated, determined by particular interests and investments, and present them instead as neutral deeds of cultural rescue.[48] With the words *Union Square: Street Revitalization* parading across it, the nineteenth-century print and the George Washington monument are appropriated to incarnate a false impression of urban redevelopment as restoration. The small but clearly visible and centrally placed "UNION" placard in the engraving seems to promise that the values it connotes — coherence and harmony in the public realm — will adhere to the Union Square created by the redevelopment program. Similarly, the monuments themselves, their dirty images cleaned up, layers of crime and graffiti removed from their surfaces as part of the park renovation, have been enlisted to project an image of redevelopment as an act of benign historical preservation. Suffusing all the official accounts of Union Square's metamorphosis, this aura has become the classic image of gentrification, an image that secures consent to and sells the larger package of redevelopment. In this way, the aesthetic presentation of the physical site of development is indissolubly linked to the profit motives impelling Union Square's "revitalization."

This image of redevelopment can be contested by reconstructing the calculated moves made by the city in creating the new Union Square. The perception of Union Square redevelopment as a beautification procedure was reinforced by the fact that the first visible sign of change in the area came in the form of the park's renovation. Similarly, media reports focused on the park for almost a full year before there was any public indication of more comprehensive activities. This sequence of reported events and appearance of visible signs corresponds to the terminological inaccuracies surrounding urban restructuring. Misidentifying the new residents of "new" neighborhoods as a lost

48. Kurt W. Forster has examined current architectural attitudes toward history and preservation using Alois Riegl's 1903 essay on monuments, undertaken to direct the Austrian government's policy in protecting the country's historic monuments. Riegl's efforts to determine the nature of what he called the unintentional monument — the landmark of art or architectural history — led him to the understanding that relative and changing values determine the course and management of programs of preservation. Much of Riegl's essay is devoted to an attempt to identify and categorize these conflicting values. The act of establishing unintentional monuments as landmarks entails extracting art and architecture from its original context and assigning it new roles in new circumstances. Relating Riegl's insights to current architectural attitudes, Forster has designated the unintentional monument as "the homeless of history, entrusted to public and private guardians." He points out the fact that Riegl's study fundamentally undermines the notion that architectural monuments possess stable meanings. See Kurt W. Forster, "Monument/Memory and the Mortality of Architecture," and Alois Riegl, "The Modern Cult of Monuments: Its Character and Its Origins," *Oppositions* 25 (Fall 1982), pp. 2–19 and 21–51 respectively.

aristocracy, for example, the term *gentrification* participates in the prevalent nostalgia for genteel and aristocratic ways of life that returned during the Reagan state, a nostalgia fully exploited and perpetuated by prestigious cultural institutions. The term also yields erroneous perceptions of inner-city change as the rehabilitation of decaying buildings. Redevelopment, on the contrary, clearly involves rebuilding, usually after buildings have been razed and sites cleared. In these aggressive acts, the power of the state and corporate capital is more obvious.

In Union Square's redevelopment the illusion that the park restoration preceded redevelopment plans produced an equally distorted picture. The actual sequence and coordination of events differed considerably from surface appearances. Documents generated during the process indicate the extent to which planning in the area served as part of the comprehensive policy adopted by the city government following the fiscal crisis. The initial survey of Union Square, financed by the City Options grant, was issued during the period when austerity measures had been imposed on city residents. *Union Square: Street Revitalization* was informed by a full acceptance of the popular explanations offered by politicians and financiers about the origins of the crisis — overborrowing, corruption, greedy workers and welfare recipients — and of the "solutions" justified by these explanations — cuts in basic services and deferred wage increases. Thus the report asserted, in a practical, businesslike tone, that "public financing of new [housing] projects must be ruled out" in the development of Union Square's housing "frontier."[49] Instead, private development of housing, as well as of office and retail space, was viewed as a panacea, and the authors of the report hoped that efforts could be made to "enlist the real-estate industry in effort [*sic*] to market new or rehabilitated housing units."[50] Framed in objective language, the document adopted superficial, received notions about city policy. It was party, though, to the execution of a more brutal solution to a more basic problem — the incompatibility between the city's new economy and its traditional work force. That solution lay in "attempting to get rid of the poor and take away the better situated housing stock to reallocate to the workers needed by corporate New York."[51] The same year that *Union Square: Street Revitalization* was published, Roger Starr, who had been the city's housing and development administrator during the fiscal crisis, advocated the "resettlement" of those residents no longer needed in the corporate-oriented economy. Referring to deteriorated neighborhoods that would, he hoped, be completely vacated by such "relocation," Starr

49. *Union Square: Street Revitalization*, p. 30.

50. Ibid., p. 40.

51. William K. Tabb, "The New York City Fiscal Crisis," in *Marxism and the Metropolis: New Perspectives in Urban Political Economy*, ed. William K. Tabb and Larry Sawers (New York and Oxford: Oxford University Press, 1984), p. 336.

asserted that "the role of the city planner is not to originate the trend of abandonment but to observe and use it so that public investment will be hoarded for those areas where it will sustain life."[52] Adopting Starr's "empirical" method, the Planning Department complied. It was hardly, then, a question of the city's enlisting the real-estate industry in order to fulfill the needs of residents. Rather, real estate and other capital interests enlisted the city government to supply the conditions to guarantee profits and reduce risks.

The extent of the city's intervention into the housing market on behalf of corporate profits emerges in its clearest outlines in the 1983 proposal for redevelopment. It acknowledged that "Manhattan-wide market changes in the manufacturing, commercial, and residential sectors"[53] had effected changes in the population and land-uses of its wider study area: the territory bounded by Twelfth Street to the south, Twentieth Street to the north, Third Avenue to the east and Fifth Avenue to the west. It discovered, however, that Fourteenth Street and Union Square proper had benefited little from prevailing trends in the area. That pivotal center needed infusions of government support. "The Square continues to have a poor image,"[54] the report maintained, affirming that a principal barrier to the desired development had been the "social problems" plaguing Union Square Park, particularly its use by a "socially undesirable population (e.g., drug peddlers)."[55] By this time, however, the park had been "fenced off for reconstruction,"[56] a project that had been publicly announced in 1982.

The obstacle that the park's image represented had already been anticipated in the 1976 study, but the full force of the city's class-biased response to the problem and of its rationale for current urban policy is demonstrated by a difference between the 1976 and 1983 documents. In 1976, the surveyors deduced that "high income households...are more likely to be attracted to the Upper East Side or other established prestigious neighborhoods"[57] than to the shabby area around Union Square. While, admittedly, it contained no suggestions for providing low-income housing, the report made some pretense of formulating strategies for furnishing moderate-cost housing. The later proposal totally disregarded both. By that time, the implications of the original report had become clearer and hardened into policy. At the moment when services to the poor were cut and the assumption made that no thoughts of public financing of housing could even be entertained, the government, acting through the Parks Commission and Planning Department, was, in fact, directing its funds toward subsidizing the rich.

The $3.6 million restoration of the park constitutes such a public

52. Roger Starr, "Making New York Smaller," *The New York Times Sunday Magazine*, 14 November 1976, p. 105.

53. *Union Square Special Zoning District Proposal*, p. 2.

54. Ibid., p. 3.

55. Ibid.

56. Ibid.

57. *Union Square: Street Revitalization*, p. 30.

subsidy. Both Union Square plans indicate the degree to which the triumph of redevelopment depended on cleaning up the park's image and transforming it into an external housing amenity. An indication of the correctness of this prediction is the fact that by the time the restoration was planned and publicized, and, significantly, during the preparation of the final Planning Department proposal, the destiny of the most important development parcel in the area — the entire city block occupied by the abandoned S. Klein department store — was being decided. In July 1983, a two-year option to buy the property had been acquired by William Zeckendorf, Jr., New York's most active real-estate developer, particularly in speculation in poor neighborhood lots that become catalysts for gentrification. The Planning Department map labeled the property the "S. Klein/Zeckendorf Site." Zeckendorf intended to develop it for luxury commercial and residential use, but his plans were contingent on the fulfillment of various city plans. One such plan was already under way, however, as the hindrance that the park's image represented to the gentrifying classes was in the process of being removed. The restoration of the park, then, can be viewed only as that crucial stage of gentrification in which the poor are dislodged in order to make a neighborhood comfortable for high-income groups.

Typically, this stage of displacement is legitimized under the auspices of crime prevention and the restoration of order; the park was being reclaimed from thieves and drug dealers. This goal, primary in determining the urban design principles that governed the park's renovation, reveals the actual limits of the ideological program of historical preservation and the attempt to create a false congruence between the past and the present. While existing nineteenth-century structures — the park's monuments — were refurbished and sham ones — lights and kiosks — constructed, the park was also thoroughly bulldozed in preparation for the first phase of its "restoration" to its "original" condition. Phase I completely reorganized the park's layout and spatial patterns in order to permit full surveillance of its occupants. This was accomplished through design precepts that have been dubbed "defensible space." The popularizer of this appellation considered as "defensible" that space which allowed "people" to control their own environments.[58] In actuality it describes the application of the disciplinary mechanism that Foucault termed "panopticism" to state-controlled urban surveillance. By producing "defensible space," architecture and urban design become agents of the discreet and omnipresent disciplinary power that is "exercised through its invisibility; at the same time it imposes on those whom it subjects a principle of compulsory visibility."[59] Based in

58. Oscar Newman, *Defensible Space: Crime Prevention through Urban Design* (New York: Collier, 1972).

59. Michel Foucault, *Discipline and Punish: The Birth of the Prison* (New York: Vintage, 1977), p. 187. M. Christine Boyer analyzes urban planning as a disciplinary technology in *Dreaming the Rational City.*

notions of natural human territorial instincts, the principles of "defensible space" assign architecture the role of policing urban space:

Architectural design can make evident by the physical layout that an area is the shared extension of the private realms of a group of individuals. For one group to be able to set the norms of behavior and the nature of activity possible within a particular place, it is necessary that it have clear, unquestionable control over what can occur there. Design can make it possible for both inhabitant and stranger to perceive that an area is under the undisputed influence of a particular group, that they dictate the activity taking place within it, and who its users are to be.... "Defensible space" is a surrogate term for the range of mechanisms — real and symbolic barriers, strongly defined areas of influence, and improved opportunities for surveillance — that combine to bring an environment under the control of its residents.[60]

60. Newman, *Defensible Space*, pp. 2–3.

That the private corporate and real-estate interests represented by the new Zeckendorf Towers, its future residents, and other wealthy beneficiaries of Union Square redevelopment should exercise "unquestionable control" over the public space of Union Square Park was assured by a few decisive changes in the park's physical appearance and circulation system. An open expanse of lawn with two walkways cutting directly across the park replaced the original radical pattern of six paths converging on a circle in the park's center; a pathway encircling the entire periphery of the park provided the major circulation route; trees were removed and thinned out; removal of walls and trees created an open plaza at the park's southern entrance. According to the Police Department in St. Louis, this is the precise configuration of a safe park, because it permits "natural" surveillance by a long periphery that can be easily patrolled.[61] A statement by the design office of the New York City Parks Commission applauded the success of Phase I:

61. Ibid., p. 114.

With design emphasis on improved accessibility, visibility and security to encourage its optimal use, the park has once again recaptured its importance as a high quality open space amenity for this community. Since Phase I began, the area around the park has changed quite dramatically. It is felt that the park redesign has contributed greatly to the revitalization of the Union Square area, and regained the parkland so needed in this urban environment.[62]

62. "Union Square Park Phase I," statement by the design department of the City Park Commission, 1986.

The manipulation of New York's high level of street crime has proved instrumental in securing public consent to redevelopment, to the wholesale restructuring of urban space, and to a planning logic of social control through the kind of spatial organization exemplified in Union Square Park's sophisticated new security system. On April 19, 1984, at the inaugural ceremony for the restoration, the existing landscape had already been demolished. Mayor Koch told an assembled crowd: "First

63. Quoted in Deirdre Carmody, "New Day Is Celebrated for Union Square Park," *The New York Times*, 20 April 1984, p. B3.

64. Edward I. Koch, "The Mugger and His Genes," *Policy Review* 35 (Winter 1986), pp. 87–89. For alternative reviews by scientists condemning the authors' methods and conclusions, see Leon J. Kamin, "Books: *Crime and Human Nature*," *Scientific American* 254 (February 1986), pp. 22–27; and Steven Rose, "Stalking the Criminal Chromosome," *The Nation* 242 (May 24, 1986), pp. 732–736.

65. Koch, "The Mugger and His Genes," p. 89.

66. *Union Square Special Zoning District Proposal*, p. 23.

67. Friedrich Engels, *The Housing Question* (Moscow: Progress Publishers, 1979), p. 71. First published as three newspaper articles in *Volksstaat*, Leipzig, Germany, in 1872–73.

the thugs took over, then the muggers took over, then the drug people took over, and now we are driving them out."[63] To present the developers' takeover as crime prevention, however, the social and economic causes of crime are repudiated as thoroughly as the real causes and aims of redevelopment itself are obscured. Koch, for example, fully endorses the current resurgence of biologistic notions about the origins of "predatory street crime." Reviewing *Crime and Human Nature*, a recent book by sociobiologists James. Q. Wilson and Richard J. Herrnstein, in the pages of the neoconservative *Policy Review*, he reiterates the authors' explanations of such crime in terms of biological and genetic differences that produce unreformable delinquents.[64] This piece of self-serving journalism is used to justify New York's methods of crime control and its continuing attack on the poor: higher levels of indictments and convictions of felons, an increased police force, the imposition of criminal law for the purposes of "moral education,"[65] and, by implication, redevelopment projects that, employing architecture as a disciplinary mechanism, transform city neighborhoods into wealthy enclaves in order to facilitate the movement of "undesirables" and "undesirable market activities"[66] out of the immediate vicinity.

These tactics of urban restructuring are not entirely new; neither is the erasure of the less appealing signs of its manufacture or the denial of its social consequences. Over a hundred years ago, Friedrich Engels described these procedures for transforming the city to meet the needs of capital. At that time disease, even more effectively than crime, sanctioned the violent dislocation of the poor and the exacerbation of their problems that the process entails. Engels referred to this process by the word Haussmann, employing the name of Napoleon III's architect for the reconstruction of Paris. His description is still relevant:

By "Haussmann" I mean the practice, which has now become general, of making breaches in the working-class quarters of our big cities, particularly in those which are centrally situated, irrespective of whether this practice is occasioned by considerations of public health and beautification or by the demand for big centrally located business premises or by traffic requirements, such as the laying down of railways, streets, etc. No matter how different the reasons may be, the result is everywhere the same: the most scandalous alleys and lanes disappear to the accompaniment of lavish self-glorification by the bourgeoisie on account of this tremendous success, but — they appear again at once somewhere else, and often in the immediate neighborhood.[67]

About the housing question, Engels continued, "The breeding places of disease, the infamous holes and cellars in which the capitalist mode of

68. Ibid., p. 74.

production confines our workers night after night, are not abolished; they are merely *shifted elsewhere!*"[68]

That bourgeois solutions only perpetuate the problem is indicated by the growing numbers of homeless who no longer live inside Union Square Park but on the streets and sidewalks surrounding it. Furthermore, crime has, in the words of *The New York Times,* "moved into Stuyvesant Square," only a few blocks away, having "migrated from nearby areas that have been the focus of greater police surveillance."[69] Parks Commissioner Henry J. Stern concurs: "It's clear some of the problems of Union Square Park, and maybe Washington Square Park, have migrated to Stuyvesant Square."[70] By subsuming all of New York's social ills under the category of crime, the rationale for "revitalization" reproduces and heightens the real problems of poverty, homelessness, and unemployment. Simultaneously, it attempts to eradicate their visible manifestations. Aiding the appropriation of Union Square for the real-estate industry and corporate capital, architecture joins this endeavor. Embodied in the restored park and its monuments, architectural efforts to preserve traditional appearances merely repress the proof of rupture.

69. Keith Schneider, "As Night Falls, Crime Moves into Stuyvesant Square," *The New York Times,* 12 October 1985, p. 29.

70. Ibid., p. 31.

The Homeless Projection
Counter-Image of Redevelopment

"Behind the disciplinary mechanisms," Foucault wrote, "can be read the haunting memory of 'contagions,' of the plague, of rebellions, crimes, vagabondage, desertions, people who appear and disappear, live and die in disorder."[71] Similar repressions inhabit the controlled urban space that Wodiczko selected as the site of *The Homeless Projection.* The work stimulates an aggressive public reading of this Haussmannian arena of beautified surfaces, suppressed contradictions, relocated and unsolved problems. If the forms of Wodiczko's proposal at 49th Parallel can be viewed in relation to the presentational modes of contemporary city planning, the project's realization would critically scrutinize — *re-present* — the city environments that such planning produces. For this purpose, Union Square provides a fully equipped, well-arranged, and strategically located theater of urban events and social processes. The present "fake architectural real estate theater," as Wodiczko calls it, was brought into existence by a series of well-calculated strategies in an urban "revitalization" campaign. Conducted in the name of history — the Zeckendorf Towers are advertised as "The Latest Chapter in the

71. Foucault, *Discipline and Punish,* p. 198.

History of Union Square" — that campaign simultaneously attempts to consign its own brutal history to oblivion.

Utilizing the Union Square site, still possessed of memories of recent changes and the forced marginalization of people, *The Homeless Projection* seeks to wrest the memories of alterations and social conflicts from the very spaces and objects whose surface images deny them. In order to activate these memories — to liberate suppressed problems and foster an awareness of architecture's current social relations — Wodiczko takes advantage of the spectacle created by the park's restoration and the benefits its physical appearance offers. The numerous lamps — reproductions of nineteenth-century Parisian streetlights — and the platform on which the park is elevated — a legacy of alterations to the Fourteenth Street subway station in the 1930s — furnish him with a public stage accessible to a ready-made, collective city audience. The setting contains tangible evidence of social reorganization in the park's spatial reorganization — redirected pathways, newly sodded lawns, thinned-out foliage. Since Wodiczko's work inserts the restoration of the park into the context of more extensive architectural activities, the signs of urban change that ring the park's boundaries crucially complete his site, although most were not in existence when his proposal was made. Scaffolding, cranes, building foundations, demolished structures, fenced-off construction areas, emptied buildings all verify the extensive restructuring of the city and juxtapose signs of destruction with the signs of preservation in the park itself. The huge, luxury Zeckendorf building rising across the street (and since completed) — "The Shape of Things to Come" as its billboard announces — identifies the principal beneficiaries of this activity.

In addition to lighting, stage, audience, and sets, Union Square Park provides Wodiczko, most importantly, with actors for his own theatrical presentation in the form of its figurative monuments. By temporarily appropriating these statues, he stimulates an awareness of the role they are already playing in the gentrification of New York. Evoking memories different from those the monuments were originally meant to conjure up and associations contrary to the ones their official restorers hope to awaken today, *The Homeless Projection* probes the less exalted purposes that underlie reverential acts of faithful preservation. Sculptures once placed in "open spaces" in the hope of pacifying city residents are appropriated by Wodiczko to construct and mobilize a public. In opposition to the incursion of private interests, the space is restored as a site of public debate and criticism. Using the monuments in their contemporary incarnation — mediums for repressing the changed conditions of urban life — Wodiczko makes them his own vehicles for illuminating those conditions.

In this way he assimilates to the built environment of the city itself the techniques and purposes of Brechtian theater, about which Walter Benjamin wrote, "To put it succinctly: instead of identifying with the characters, the audience should be educated to be astonished at the circumstances under which they function."[72]

72. Walter Benjamin, "What Is Epic Theater," in *Illuminations*, trans. Harry Zohn (New York: Schocken, 1969), p. 150.

Despite energetic exertions by the mass media, the city, real-estate advertisements, and segments of the cultural community to present the bronze statues as representatives of eternal and universal values — aesthetic or symbolic — the monuments have, indeed, been recast in compromising situations and positions. Haphazardly produced, the sculptural program of Union Square is commonly considered to symbolize concepts of liberty and individual freedom. This assessment originated in the nineteenth century when two of the sculptures fortuitously shared a common subject: heroes of the revolution. The George Washington statue was erected in 1856 and, although it adopts the codes of Roman imperial form, it is generally characterized as a symbol of the freedom secured by the War of Independence. Lafayette, on the park's eastern edge, by Frédéric Auguste Bartholdi, sculptor of the Statue of Liberty, was presented to New York by its French residents in 1873 to commemorate French-American relations. Inscriptions on its base commemorate two instances of solidarity: mutual inspiration and support during the American Revolution and the sympathy offered by the United States to France during the "difficult" period of the Franco-Prussian War and Paris Commune. The other two nineteenth-century statues — Abraham Lincoln, erected three years after the death of the Civil War president and author of the Emancipation Proclamation, and the fountain located on the western side of the park, a "heroic bronze group," of a mother and children — do not strictly conform to the Revolutionary War theme but are easily incorporated into the patriarchal motif and atmosphere of eclectic classicism. On July 4, 1926, however, Tammany Hall bolstered the thematic coherence by donating a huge flagpole base, which was placed at the center of the park. It complemented the theme of freedom, containing the full text of the Declaration of Independence, a relief depicting an arduous struggle for liberation, a quotation from Thomas Jefferson that encircled the base, and a plaque stating, "This monument setting forth in enduring bronze the full text of the immortal charter of American liberty was erected in commemoration of the 150th Anniversary of the Declaration of Independence."

Originally, the park's six wide pathways converged on this monument; as a result of "revitalization," the hyperbolic tribute to individual

freedom stands alone in the middle of the large expanse of lawn created to render the public accessible to surveillance and to prevent any illicit activities taking place at the park's center — the most distant point from the policing on its perimeter. The restored structure's new position suggests that in the act of commemorating individual freedom the "enduring bronze" simultaneously represents the unfettering of those financial forces in whose interests the renovation was undertaken. The circumstances of that presentation demonstrate the monument's lack of symbolic stability and the extreme mutability of architecture's function. Unequivocal evidence of the nature of its current metamorphosis — what Wodiczko terms architecture's "real-estate change" — is provided by the presentation of the park's monuments in the Zeckendorf Towers sales office, which opened in the spring of 1986. Here, framed Cibachrome photographs of the statues hang next to pictures representing Union Square's history and photographs of mounted park police on a wall behind a model of the new condominiums, whose prices approach half a million dollars. The fact that a substantial number of the apartments were sold in the first week of business corroborates the testimony of the 1984 *Times* editorial which, urging support for Union Square redevelopment, seconded the City Planning Commission's belief that "the location of the public square and its handsome lines and *great statuary* will attract investment from builders."[73]

Nonetheless, the dogma persists that monumental architecture can "survive" overt changes in presentation and the contingencies of history with its dignity and power intact. Successful monuments, this discourse asserts, transcend the "trivialities" of commercialism. Such assertions "logically" extend the argument that successful monuments also transcend the "trivialities" of social conditions — poverty and homelessness, for example. Thus, expressing faith in the enduring power of architecture, Goldberger, who, as we have seen, shielded the Union Square flagpole base from the "degrading" actions of a homeless bum, recently rhapsodized the "essential dignity" of the Statue of Liberty. This defense was not occasioned by a desire to fortify the monument's purported meaning against the present virulent wave of anti-immigrant sentiment and attempts to enact repressive legislation against Hispanics and Asians in the United States. Rather, he applauded the Statue's ability to fulfill a monument's fundamental role in the urban environment: "The city that is too large and too busy to stop for anyone seems, through this statue, to stop for everyone. Suddenly its intense activity becomes background, and the statue itself becomes foreground: we cannot ask of a monument that it do anything more."[74]

73. "Speaking Up for Union Square," *The New York Times*, 16 August 1984, p. A22.

74. Paul Goldberger, "The Statue of Liberty: Transcending the Trivial," *The New York Times*, 17 July 1986, p. C18.

Unwittingly, Goldberger summarizes with remarkable clarity not the real workings of monuments but the ideological operations of his own idealist aesthetic and urban principles. Stretching the tenets of aesthetic autonomy far enough to embrace the city that surrounds the monument, he fetishizes the city environment, too, at the level of its physical appearances. In the article from which the passage is cited, he describes the Statue of Liberty's compositional relationship, by virtue of its permanent position in New York Harbor, to a city that is, through that relationship, made more physically coherent. Utterly neutralizing and drastically restricting the notion of context, Goldberger indeed employs architecture to push into the background the city's "intense activity" — which is, in fact, its social processes, its intense real-estate activity, for one. This blurring of the broader urban context renders it less disturbing; in this originates its usefulness as a weapon of power, for the aestheticization of the city has the most far-reaching implications for the urban environment.

Defining architecture as an institutionalized social system rather than as a collection of permanent aesthetic or narrowly utilitarian objects, and addressing urban space as a terrain of social processes, *The Homeless Projection*, on the contrary, appropriates the Union Square monuments not to depreciate the significance of either the city's activities or the architectural objects but to foreground and illuminate their relationships. Wodiczko plans to project onto the surfaces of four figurative monuments in Union Square Park — representatives of architecture's attempt to "preserve its traditional and sentimental appearances"[75] — images of the attributes of New York's homeless population — the group most noticeably dispossessed by the results of that attempt. Magnified to the scale of the buildings — although not heroicizing or representing the poor themselves — the images would remain, as they did in the gallery installation, unchanging for the duration of the artist's performance. The photographed images consist of the familiar objects and costumes of the homeless, their means of travel — occasioned by enforced mobility — and the gestures they adopt to secure an income on the streets. Far from transcending the "trivial" facts of city life, Wodiczko's monuments are forced to acknowledge the social facts they produce. Trivial objects form the content of his images, and while such monumentalized commonplace items as a shopping cart, wheelchair, or can of Windex seem to clash absurdly with the heroic iconography of the neoclassical monuments, their placement is also carefully calibrated and seamlessly joined to the formal language of the sculpture. This appearance of continuity, achieved in some cases

75. Wodiczko, *The Homeless Projection*.

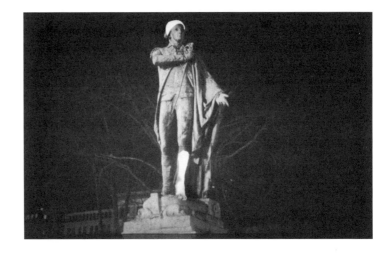

Krzysztof Wodiczko, *The Homeless Projection: A Proposal for the City of New York*, 1986. Courtesy of 49th Parallel, Centre for Contemporary Canadian Art.

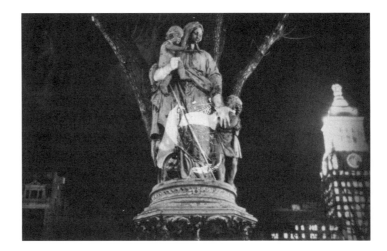

by superimposing a photograph of a hand over the statue's bronze surface so that it merges imperceptibly with the figure's anatomy, only renders the presence of the images more astonishing and the statues more uncanny in their mixture of strangeness and familiarity. Disengaging spectators from their usual disregard of the monuments as well as from their seduction by the restoration program's presentation — both of which shield the monuments from surrounding social conditions — *The Homeless Projection* allows viewers to perceive those objects *only* in relation to those conditions. This primary reading is ensured by the subject of the images as well as by Wodiczko's montage techniques, the relations he establishes between image and architecture. The effect of his formal accommodation of an unchanging image to the appropriated surface of an existing architectural structure is twofold. The viewer's attention is actively focused on the structure — its physical stability as well as it mythical symbolic stability: the images of inevitability and power that it normally projects. Second, however, the projection uses the structure's forms to disrupt its seemingly unshakable homogeneity and authoritative permanence. In a sense, the montage operation symbolically *moves* the object so that its actual instability can be recognized. Consequently, Wodiczko's method of projection destabilizes the monuments in a fundamental way. *The Homeless Projection*'s images, depicting the current social outcome of relations of private property, are integrated into symbolic forms commemorating political emancipation and the freedom of the individual. The bourgeois concept of the "rights of man" memorialized in the Union Square statues is, however, as Marx observed, that of the "rights of the *member of civil society*, i.e., of egoistic man, of man separated from other men and from the community."[76] The practical effect of this individualist conception of democracy has been, largely, to ensure the freedom of private property. The monuments, then, can only connote communal harmony and idealized political authority if this sphere of self-interest is constituted, through repression, as a separate domain. By forcing the effects of this private sphere to reappear within the public monuments themselves, *The Homeless Projection* revolutionizes the statues, which, in their altered form, "acknowledge" the contradictions they embody.

Thus, Wodiczko manipulates the statues' own language to challenge the apparent unity of its signification, transforming the classical gestures, poses, and attitudes of the sculpted figures into those used by people begging on the streets. George Washington's left forearm, for example, presses down on a can of Windex and holds a rag, so that the imperial gesture of his right arm is transformed into a signal used by

76. Karl Marx, "On the Jewish Question," in *Karl Marx: Early Writings*, trans. Rodney Livingstone and Gregor Benton (New York: Vintage, 1975), p. 229.

the unemployed to stop cars, clean windshields, and obtain a street donation. The "proud but humble" bearing of Lincoln becomes, through the addition of a crutch and beggar's cup, the posture of a homeless man standing on a street corner; the graceful stance and friendly extended arm of Lafayette takes on the added identity of a vagrant asking for alms; and the mother sheltering her children becomes a homeless family appealing for help. In addition, Wodiczko projects a continuously fading and reemerging image onto the front of the Lincoln monument: an emptied building whose surface is partially renovated.

This "style" of building — visibly empty at a time of a manifest need for housing — is a familiar New York spectacle. Its surface, like the surface of the monuments, has been partially restored as part of a presentation to encourage neighborhood speculation. By infiltrating the previously unbroken surfaces of the Union Square monuments — the images of gentrification — with images of this building and of the mechanisms by which the homeless survive, *The Homeless Projection* concretizes, albeit in a temporary antimonumental form, the most serious contradiction that New York architecture embodies: that between capital's need to exploit space for profit and the social needs of the city's residents. Mapping these images onto the surfaces of monuments in a public square, Wodiczko forces architecture to reveal this repressed contradiction and, thereby, its identity with the activities and actors in New York's real-estate market. By virtue of its attention to these contradictions, Wodiczko's intervention in the space of Union Square "revitalization" addresses the single issue ignored by the city throughout the long and complicated course of redevelopment: the question of displacement. During *The Homeless Projection*, and afterward in viewers' memories, Union Square's monuments, diverted from their prescribed civic functions, commemorate this urban event — mass eviction and development-caused homelessness.

Real-Estate Aesthetics

The indifference to and concealment of the plight, even the existence, of the displaced is entirely predictable. To foster development, the city encourages a suppression of data on displacement and homelessness. Whereas *The Homeless Projection* placed this issue at the center of the urban context, official architecture and urban disciplines, sanctioned by aesthetic considerations, actively participated in its cover-up in Union Square. To appreciate the extent of this collusion fully, it is necessary to

understand the crucial role played by "contextual aesthetics" at a key phase of "revitalization."

Government subsidies to real-estate developers are not confined to direct financial outlays or to tax abatements and exemptions. Benefits also accrue from the city's administration of institutional allowances for building, especially through its bureaucratic procedures and the power of zoning regulations. The development of Union Square hinged on a specialized proceeding through which the Planning Commission permits zoning constraints to be waived or altered. The vehicle for this alteration is called the "special zoning district," defined in the Planning Department Dictionary as a section of the city designated for special

77. "Glossary: Selected planning terms applicable to New York City real estate development," New York Affairs 8:4 (1985), p. 15.

78. Kwartler, "Zoning as Architect," p. 115.

treatment "in recognition of the area's unique character or quality."[77] Permitting changes in the use, density, or design of buildings in the specified area, the creation of a special zoning district is construed to represent a flexible response to "perceived needs."[78] Its flexibility is frequently underscored by comparing it to the rigidity of the 1961 Zoning Resolution, whose rules the special zoning district, since the 1970s, has been used to modify or circumvent. Thus, the 1961 zoning code is characterized as based on the principles of European modernist architecture of the 1920s and therefore "utopian," "anti-tradition," "anti-urban," and "unresponsive to context." Only within the terms of this simplistic "critique of modernism" and by portraying urban problems as aesthetic problems can current manipulations for the purposes of redevelopment be presented as responsive to the environment or to the city's needs. These distortions can be gleaned from the following assessment of the problems which lead to the frequent utilization of the special zoning district:

Less than ten years after the adoption of the 1961 Zoning Resolution, disaffection with the results of the utopian vision set in.... The prevailing view was that the new zoning was incompatible with the best efforts of architects and urban designers to produce high-quality architecture and good city form. This belief, while most often heard from architects and urban designers was also expressed with great regularity by the developers, bankers, and community representatives, and other professional, lay, and governmental constituencies. They posited that zoning was legislating esthetics, and that a single vision was too restrictive, leaving little room for genuine architectural design quality. The result is a cookie-cutter building that is ugly and sterile, set in an ill-considered and barely usable public open space that is often neglected, or used by the seedier elements of New York's street-corner society. These same buildings appear to be insensitive to the existing buildings around them, creating dissonance in urban form.[79]

79. Ibid., p. 113.

The special zoning district, then, is perceived as another means to conserve tradition, restore coherence and stability, and ensure architectural diversity. But it has other functions as well.

The Zeckendorf Company's plans in Union Square directly depended on the creation of a special district for sites fronting directly on the park. After purchasing the option to build on the Klein site, Zeckendorf announced that the realization of his project was contingent on the rezoning already being proposed by the Planning Department. The change put forward would increase the allowable density for buildings around the square, providing additional space bonuses for the Klein property in return for the developer's renovation of the Fourteenth Street subway station. The justification for the special zoning district was contained in the 1983 summary of the Planning Department's two-year study undertaken to "guide" redevelopment so that it would reflect the "existing urbanistic context."[80] In recognition of the historic architectural uniqueness of Union Square and to foster "compatibility between any new construction and the existing significant architectural buildings,"[81] the proposal suggested not only increased density allowances for new buildings to match those of the late nineteenth- and early twentieth-century structures, but also created special "bulk distribution regulations": no plazas or groundfloor setbacks were allowed — the park made plazas unnecessary — and the facades of all buildings on the square were required to be built to the property line and to rise straight up for a minimum of eighty-five feet. Light and air would be ensured, according to the proposal, by a system of mandated setbacks and a restriction on any towers within one hundred feet of the square. Zeckendorf's architects had already designed his mixed-use building to conform to these "contextualist" principles. Four seventeen-story apartment towers would rise from a seven-story base occupying the entire building site. They would begin at a point furthest from the park and terminate in cupolas to "echo" the historic tower of the Con Edison building behind them. According to Zeckendorf, the building plan "addresses the concerns we've heard from the community about not overshadowing the park and fitting in with the rest of the structures there."[82] The key point in the zoning rationale and in Zeckendorf's compliance was that the new buildings would not merely harmonize with the existing environment but recapture its history as an elegant neighborhood. A *Times* editorial stated:

To understand fully what the rescue of Union Square would mean, the observer has to imagine how it once resembled London's handsome Belgravia and Mayfair residential districts. By insisting on the eight-story rise directly from the sidewalk,

80. *Union Square Special Zoning District Proposal*, p. 1.

81. Ibid., p. 6.

82. Quoted in Lee A. Daniels, "A Plan to Revitalize Union Square," *The New York Times*, 1 July 1984, p. 6R.

the planners hope that modern apartment house builders will produce a contemporary echo of the walled-in space that gives the small squares of London and America's older cities their pleasing sense of order and scale.[83]

Before their ultimate approval (with slight modification) in January 1985, both the rezoning proposal and the design of the Zeckendorf Towers had to pass through a public review process. Over a period of seven months, each project was debated at public hearings, first before the community boards, then before the City Planning Commission, and finally before the Board of Estimate. The city and the developer submitted obligatory and highly technical Environmental Impact Statements in which they were required to show "the potential environmental effects of a proposed action on noise level, air and water quality and traffic circulation."[84]

The supreme measure of the city's alignment with corporate interests in the area was the neglect in any of their reports of the socio-economic impact of the redevelopment plan on the area's low-income population. Displacement of these residents, the most obvious effect of the literal demolition of housing and the more extensive effect of "revitalization" — raised property values, was virtually unremarked in the hundreds of pages of documents generated throughout the planning and review processes. The unquantifiable numbers of homeless who "find shelter out of the public view"[85] in city parks were driven from the newly visible Union Square, their numbers augmented by the homelessness caused by the larger redevelopment plan. Also unmentioned was the single-room-occupancy hotel directly on the Klein site whose demolition was required by the Zeckendorf project and whose address — 1 Irving Place — is now the address of the luxury towers. Similarly, the Planning Department surveyors who, in the proposal, applauded the increasingly residential character of the neighborhood due to middle-class loft conversions and who examined the quality of existing residential buildings, failed to survey the thirty-seven single-room-occupancy hotels and rooming houses in the area around the special district, buildings containing six thousand housing units for residents on fixed or limited incomes.[86] The relationship between current levels of homelessness and single-room-occupancy displacement in New York City is well known, however:

This shrinkage of housing options is nowhere more visible than in the long-time staple housing source for low-income single persons — the single-room-occupancy (SRO) hotel. Across the country the number of units in SROs is declining. In some areas they are being converted to luxury condominiums, while in others they are abandoned by owners unable to afford taxes and maintenance

83. "Speaking Up for Union Square," p. A22.

84. "Glossary," *New York Affairs*, p. 13.

85. New York State Department of Social Services, *Homelessness in New York State: A Report to the Governor and the Legislature*, October 1984, p. 3.

86. See the statement of Nancy E. Biberman, Director, Eastside Legal Services Project, MFY Legal Services, Inc., to the City Planning Commission, 17 October 1984.

87. Ellen Baxter and Kim Hopper, *Private Lives/Public Spaces: Homeless Adults on the Streets of New York* (New York: Community Services Society, Institute for Social Welfare Research, 1981), pp. 8–9, cited in Michael H. Schill and Richard P. Nathan, *Revitalizing America's Cities* (Albany: State University of New York Press, 1983), p. 170, n. 120. Schill and Nathan's book provides a rationale for governmental policy of encouraging redevelopment. It concludes that resulting displacement does not justify stopping this process. The authors' credibility is compromised by the fact that their methodology included "an effort…to avoid neighborhoods that contained high concentrations of SROs or transient accommodations" and that "the survey of outmovers does not describe the rate of displacement among the most transient households or examine the problems faced by the homeless."

88. *Homelessness in New York State,* p. 33.

89. Nancy Biberman, a lawyer from MFY Legal Services now doing private hou ʾng consulting, represented the tenants of 1 Irving Place and was able to obtain a good settlement for these victims of direct displacement. Since Zeckendorf was eager to begin construction before December 1985 in order to be eligible for 421-a tax abatements, and since legal problems could have held him up past the deadlines, he was pressured into offering these tenants the option of living in the Zeckendorf Towers themselves at the price of the tenants' old rents. For the victims of secondary displacement Zeckendorf assumed little responsibility. He was required only to purchase and renovate forty-eight units of SRO housing.

90. Ernest Mandel, *Late Capitalism* (London: Verso, 1975), p. 509.

costs. In New York City, SROs have disappeared at an alarming rate. Because of this — and other forces at work — it is estimated that as many as 36,000 of the city's most vulnerable residents, the low-income elderly, now sleep in the streets.[87]

Despite the fact that the number of lower-priced SRO units in New York declined more than 60 percent between 1975 and 1981,[88] the burden of surveying the area and determining the consequences of Union Square redevelopment on the occupants of these dwellings fell to the housing advocates who argued against the development plans at the Board of Estimate hearing. The impact of either primary displacement — the direct consequence of the demolition of the SRO on the Zeckendorf site — or the more significant secondary displacement — that caused by higher rents, enhanced property values, real-estate speculation, legal warehousing, and, temporarily, illegal conversion of neighboring rooming houses — were not included in the Environmental Impact Statements.[89]

Throughout, this concealment was facilitated by the notion of aesthetic contextualism and the cultural sentiments informing all three phases of Union Square "revitalization": the park restoration, the creation of the special zoning district, and the approval of the Zeckendorf project. Thus, the architects and designers who minutely calculated the physical effects of rezoning and of the towers on the shadows and air in Union Square or the aesthetic effects on the cornice lines of the square's buildings exemplify that "real idol of late capitalism," "the 'specialist' who is blind to any overall context."[90] Today, the ranks of the city's technocrats also include artists, critics, and curators who are asked to fulfill the task, as recently defined in a Mobil advertisement, of encouraging, through art, residential and commercial real-estate projects and "revitalizing" urban neighborhoods. One example of compliance with these corporate demands by sectors of the art establishment is that type of public art placed in "revitalized" spaces and applauded as socially responsible because it contributes, functionally or aesthetically, to the "pleasures" of the urban environment. Such work is based on the art-world equivalent of official urban planners' constricted version of contextualism. Knowing the real social consequences of this "contextualism" underscores the urgency of creating alternative art practices such as *The Homeless Projection*, whose reorientation of vision disturbs the tightly drawn borders secured by New York's contextual zoning.

PICTURING SCANDAL

Iranscam, the Reagan White House, and the Photo Opportunity

Carol Squiers

I. Among the most informative news items about Reagan's relationship to still photography are the following: Phil Gailey, "Photographers Finding Reagan Picture-Perfect," *The New York Times*, 4 November 1981, sec. I. A. O. Sulzberger, Jr., "Portrait of Personal Photographers to the President," *The New York Times*, 18 April 1981, sec. I. Irvin Molotsky, "Of Presidential Image and Presidential Focus," *The New York Times*, 15 March 1985, sec. I. David E. Rosenbaum, "Photographic Travels with the President," *The New York Times*, 24 December 1985, sec. I.

During the eight years of Ronald Reagan's presidency, the term "photo opportunity" became a household word. Evening talk show hosts and television newscasters made jokes and sly remarks about "photo ops." Photographs of eager news photographers elbowing each other for a shot of President Reagan appeared in newspapers and magazines. And news stories detailed myriad aspects of "picturing" this president, from pop analyses of his campaign imagery and chronicles of the activities of his personal photographer to the way "news" images of Reagan taken on foreign trips were thoroughly preplanned.[1] Rather than exposing the baneful effects of the photo op, the jokes and news items served to naturalize and domesticate it without providing a true picture of its visual and political manipulation.

In part, the photo op remained highly visible but essentially unexplained because journalists and other political specialists who trafficked in words treated it as a poor relation: it was as if the triumphant visuals that shaped and promoted the Reagan presidency were too pedestrian, too anti-intellectual, too simplistic to be dealt with seriously. It was also difficult to demystify so pervasive an institutionalized practice. Most of all, the White House staff and many members of the news media had a professional stake in maintaining and protecting this ritual, upon which rode livelihoods, perquisites, and the thrill of working close to the center of the most powerful government in the world.

When the Iran-*contra* scandal began in early November 1986, however, the presidential photo op became a problematic battleground for the administration. As one revelation after another made headlines, the White House lost control of the news photographers who covered it — and the usually upbeat, devil-may-care president as well — for a few crucial weeks. During that time a public opinion disaster was exacerbated by unusually unflattering pictures of a confused, ill-prepared president under fire, an image that could have helped undermine his presidency for the remainder of his term. Although Reagan was able to recover — thanks in great part to a compliant news media — the irritations of Iranscam for a brief time helped reveal the inner workings of the White House public-relations machine in relation to pictures as nothing else had.

The story of the Reagan administration's co-opting of the American news media — by image, sound, printed word — is long and complex. Chronicled in a variety of news articles and commentaries, the entire story was told most thoroughly and astutely by Mark Hertsgaard in his 1988 book, *On Bended Knee: The Press and the Reagan Presidency.*[2] Although Hertsgaard clearly delineates the crucial position that the visual image occupied in the Reagan White House, he treats political visuals, in general, in a somewhat dismissive way. During a PBS special on the 1988 presidential campaign, for instance, he referred to the prevailing dependence on pictorial material to illustrate national issues as "the tyranny of the visual."[3] Yet it is undeniable that visuals, both still and video, provide the American public with a significant part of its news.

Recognizing this basic fact, Reagan's media handlers purposefully set out to build a mythicizing image of a successful, high-spirited, archpatriotic president that would help sell the president's "message." By creating Reagan as a lovable, avuncular bumbler who approached the job of president with a joking inattention to the whys and wherefores of his own policies — a figure who could easily have been a character in a situation comedy — his aides hit upon a breathtakingly efficient method of promoting the pro–big business, anti–working class, and antiminority agenda of his administration that, at the same time, would override whatever negative media attention he got.

The manner in which they went about this combined the tantalizing blandishments of advertising and public relations with an insider's knowledge of dramatic presentation. Their game plan exploited three important elements: Reagan-the-prime-time-entertainer, Reagan-the-president-in-reality, and Reagan-the-straight-talking-guy. It wasn't Reagan's ability to read his lines that made his presidential persona so effective: it was the creation of him as a nearly fictional, prime-time president. He was fashioned to be as likeably familiar as a television character such as *All in the Family*'s Archie Bunker or *Star Trek*'s Captain Kirk, and to be as believably unbelievable as they were, too. Thus, the American public was drawn into a media-induced blending of "reality" and theatrics. Reagan was an actor, but he was also "really" the president; the American public watched his performance on TV in their role as audience, but because Reagan was "real" they were in some sense really in the drama, too. Just as the laugh track in a sitcom seeks to bring the at-home audience into a you-are-there illusion, the laughing reporters and appreciative audiences Reagan was seen addressing on TV were positioned as surrogates for folks all across the

2. Mark Hertsgaard, *On Bended Knee: The Press and the Reagan Presidency* (New York: Farrar, Straus and Giroux, 1988).

3. Mark Hertsgaard, "Campaign: The Prime Time President," Bill Moyers' Special: Show #1. New York: Public Affairs Television, 3 October 1988, transcript, p. 15.

land. And just as noisy studio audiences seem more like participants than mere viewers, the American public in effect became audience-participants, indeed, even extras, for Reagan's long-running political sitcom. The more "real" and unthreatening Reagan could be made to seem, the greater the intimacy one seemed to have with him. The combination of his sketchy knowledge of policies and his belligerently America-first orations bridged the gap between daily life and the silver screen and television as nothing and no one had before.

Certainly, Reagan's staff never aimed to create this complicated interplay of "reality" and illusion; it was an unexpected by-product of the dangerous political oversimplifications they meted out every day. Luckily for the White House, the news media proved to be all too willing both to unquestioningly carry the President's message at the expense of informing the American public about what it meant and to suture "reality," fantasy, and propaganda together into a seamless, highly polished fabric that could easily be unreeled on the evening news. After an initial bout of skepticism — in an article on Reagan's first hundred days, *The New York Times Magazine* slightly character-ized him as a "one-time baseball announcer, B-movie actor and televi-sion pitchman"[4] — the news media embarked on a long-term reportage that was mostly uncritical of the true substance of Reagan administra-tion policies while at the same time they poked good-natured fun at the fumbles and foibles of the media-genic head of state. In return, this White House courted, coddled, and spoon-fed the press as no admini-stration had before.

4. Steven R. Weisman, "Reagan's First 100 Days," *The New York Times Magazine*, 26 April 1981, pp. 51, 53.

Geared especially to television, Ronald Reagan's image was created in advertisements for both the 1980 election and 1984 reelection campaigns and, after his election, in daily news "events" designed for the maximum positive exposure on the evening news. Although it often occupied second place, the still news photograph was clearly of consid-erable importance to the White House. Former Reagan chief of staff Donald Regan makes repeated references in his autobiography to the political consequences of newspaper and newsmagazine pictures, both of himself and the Reagans, and to reactions provoked both inside and outside the White House by some of these pictures. In one anecdote he related a White House rumor that Robert McFarlane, Reagan's national security advisor and a key player in one of the most scandal-ous but silly incidents of the Iran-*contra* affair (the secret trip to see Iranian "moderates," bearing a Bible signed by Ronald Reagan and a key-shaped cake as presents), was angered by what he perceived as Regan's self-seeking hubris during the 1985 Geneva arms summit

between Reagan and Soviet Leader Mikhail Gorbachev. Regan related the incident thus:

I had heard that McFarlane was upset over a photograph taken by a White House photographer that Larry Speakes had released to the press without consulting me. (There was no reason why Speakes should have consulted me — it was a good picture that was sure to make the papers, and getting pictures into the papers was an important part of Speakes's job.) It showed me whispering to the President while he sat on the sofa with Gorbachev at the Soviet Mission.... I had stuck my head between Reagan's and Gorbachev's so that the President could hear me in a crowded room. It seemed impossible that this photo of a spontaneous moment should cause jealousy and suspicion, but I was assured that this was the case.

In other words, Regan was thought to have purposely inserted himself between the two world leaders for the express purpose of being photographed, thus appearing to be a major player in summit politics. At other points in his memoir, Regan discussed Nancy Reagan's obsession with staging flattering photo ops after her husband had surgery and how, after the Iran-*contra* scandal broke, Regan worried that he looked too "cross" in pictures taken during a media stakeout of a Thanksgiving dinner.[5]

However trivial all of this may seem, there is no doubt that Reagan aides considered pictures to be a serious matter. "Pictures are one of the most important ways of communicating and are the basis on which a number of people form their opinions of the president," Mark Weinberg, an assistant press secretary to Ronald Reagan solemnly proclaimed. "So we're naturally concerned about and interested in generating the most favorable and policy-goal consistent pictures we can. They [the American public] don't always read the story, but they always see the pictures."[6] Along similar lines, Gary Foster, the director of press advance at the White House during Reagan's second term, provided an overtly propagandistic point of view when he characterized the pictorial arrangements made for presidential appearances outside the White House, saying: "The whole reason we are there is to promote Ronald Reagan."[7]

During Reagan's first term in office, the man who orchestrated the presidential image — and who had honed Reagan's image since his successful gubernatorial campaign in 1966 — was Deputy Press Secretary Michael K. Deaver. In his autobiography, Regan succinctly described Deaver's function as he observed it:

It was Deaver's job to advise the President on image, and image was what he talked about nearly all the time. It was Deaver who identified the story of the day at the eight o'clock staff meeting and coordinated plans for dealing with it, Deaver who created and approved photo opportunities, Deaver who alerted the

5. Donald T. Regan, *For the Record: From Wall Street to Washington* (New York: Harcourt Brace Jovanovich, 1988), p. 324. Other citations that show Regan's preoccupation with photographs can be found on pages 13, 21–22, 46–47, 87, 237–238, 288, 302, 303, 308–310, 314–315.

6. Mark Weinberg, interview with author, Washington, D.C., 17 December 1986.

7. Gary Foster, interview with author, Washington, D.C., 17 December, 1986.

President to the snares being laid by the press that day. Deaver was a master of his craft. He saw — and designed — each Presidential action as a one-minute or two-minute spot on the evening network news, or a picture on page one of *The Washington Post* or *The New York Times*, and conceived every Presidential appearance in terms of camera angles. . . .

Every moment of every public appearance was scheduled, every word was scripted, every place where Reagan was expected to stand was chalked with toe marks. The President was always being prepared for a performance. . . .[8]

News photographers who regularly covered Reagan, and who voiced varying degrees of disgruntlement with this state of affairs, concurred with Regan's assessment: "You're on a movie stage. It's a set. Take one. Take two. You don't do it right, we'll do it again. No problem. The piece of tape is down, you know exactly where the president's going to be."[9]

Discussing the role of Reagan's media advisors in fabricating news events, ABC White House correspondent Sam Donaldson noted that they understood "a simple truism about television: the eye always predominates over the ear when there is a fundamental clash between the two."[10] CBS White House correspondent Leslie Stahl gave the following example of how this worked even when the news media were trying to critique the president:

During the 1984 campaign I did one major campaign story on Reagan for the evening news. It was five and one-half minutes long, which is unbelievable — most pieces run a minute and a half. The piece was very tough and very negative. Basically it said that Reagan was trying to create amnesia about policies of his that had become unpopular. So we'd show him standing in front of a [new] nursing home cutting the ribbon and I'd say, but he tried to cut the budget for nursing home construction. Then you'd see him at the Olympics for the handicapped and I'd say, but he tried to cut the budget for the handicapped. . . . He kept hitting all these places where he himself had tried to cut the budgets. . . .

I was very, very nervous about going back to the White House the next day. The piece ran and my phone rang — it was a senior White House official. And he said: *"great piece."* I said, wait a minute, that's probably one of the most negative pieces that's ever been done on Ronald Reagan. And he said: "You guys haven't figured it out yet, but when you run five minutes of pictures of Ronald Reagan looking energetic, patriotic, smiling and sweet, the public doesn't care about what you're saying. If your message is negative but the pictures are positive, the positive will totally override the message and cancel it out."[11]

Similarly, the visual always predominated over the *printed* word. No matter how problematic a government policy might be, it could be given an upbeat spin by an attractive visual that showed a beaming, likable president.

8. Regan, *For the Record*, pp. 247–248.

9. Larry Downing, interview with author, Washington, D.C., 18 December 1986.

10. Hertsgaard, *Bended Knee*, p. 25.

11. Leslie Stahl, speaking at "Projecting the Image: The White House and the Media," 1 November 1987, 92nd Street YMCA, New York City.

To that end, Reagan's press people made it almost impossible for photographers to make any unflattering or negative images of the president. They thought about not only how to achieve positive television images of Reagan, but how to achieve pleasing still images as well. "They understood what our needs were as opposed to TV's needs," said John Ficara, a White House photographer for *Newsweek*, describing the way Reagan aides set up pictures during Reagan's 1980 campaign. "They were very precise in what they wanted and they were very good. In the Carter campaign you had to scratch and claw to get anything. You got more candid pictures, but it was really left up to you.…But with the Reagan campaign it was very slick and packaged very neatly for you. They went out of their way to help you achieve that as much as they could."[12] This practice was continued and refined in the Reagan White House and was even commented on by the mass media before they simply caved in to administration machinations.

Early in Reagan's first term, for instance, *The New York Times* ran an article entitled "Photographers Finding Reagan Picture-Perfect." In it the reporter described how Reagan pretended to be giving an address on his economic plans while posing for photographers, even altering his stance to strike "a perfect two-column pose" at one photographer's request. "If you tell President Reagan what you need, he knows exactly what to do to make sure you get it," a longtime White House photographer was quoted as saying. Still, the "photographers said their chief frustration in covering Mr. Reagan was that he was always smiling and joking, no matter how serious the occasion. Some said they had received complaints from their editors who wanted to know why they kept shooting a smiling President every time he proposed more budget cuts." Whatever their initial misgivings might have been, newspaper and magazine editors quickly became accustomed to printing pictures of the frolicsome president, the general justification being that the American public just loved Ronald Reagan.[13]

The administration's meticulous staging of all pictures initially delighted the photographers, who were tired of contending with the Carter White House's casual and even hostile attitude toward the press. Eventually, though, the happy-faced events that the photographers confronted on a regular basis began to take a toll.[14] They knew that what they were photographing was a sham, but taking pictures of the president was what they were getting paid for. Therefore, they had constantly to try and wring some moment of "reality" out of the set-up situations with which they were confronted. Inevitably, the farcical conditions under which the photographers worked began to produce

12. John Ficara, interview with author, Washington D.C., 18 December 1986. Although the relationship between a presidential candidate and the press is usually different from the relationship between a president and the press, that difference was negligible in Reagan's case. White House aide Michael Deaver shaped Reagan's image both as a candidate and as president.

13. Gailey, "Photograhers Finding Reagan Picture-Perfect."

14. The artificiality of these events might be explained in part by Reagan's alleged discomfort with still photographers. Deaver claims that while Reagan was comfortable with movie and television cameras, a still camera "made him stiffen in a visible way." See Michael Deaver with Mickey Herskowitz, *Behind the Scenes: In Which the Author Talks About Ronald and Nancy Reagan… and Himself* (New York: William Morrow and Company, 1987), p. 43.

distortions of expectation and perspective in them about their own activities.

A typical, and typically ridiculous, example of these distortions occurred when Reagan went on tour during his first term to promote his tax-cut package; the usual road show of journalists went along to observe him. At one event, held in a civic center, the president sat down with his local supporters for a dinner of fried chicken. Ficara related what happened:

They allowed photographers to shoot him [Reagan] eating his fried chicken. The White House photographers were very excited to get the picture. He wasn't going to be staged, he was going to eat this chicken.... What was amazing afterwards was [listening to] the photographers [talking] on the way back to the bus, saying that it was a great shot. "I got a great one! Did you get him when he passed the mashed potatoes? When he had the potatoes remember that the old lady looked at him?" [They had] a heated discussion over the mashed potatoes and when he passed them, what frame was better![15]

15. Ficara, interview, 18 December 1986.

By rigidly controlling and preplanning every bit of access to the president, White House aides were able to make photographers feel grateful for any moment of spontaneity they were allowed to observe, no matter how absurd it was. Worse, these kind of trivial incidents took on an exaggerated importance. *Newsweek*'s Arthur Grace summed it up: "As a photographer you started losing your sense of reality, because you began to imagine that the chicken was better when it was *here* than when it was *there*."[16]

16. Arthur Grace, interview with author, Washington, D.C., 18 December 1986.

So it was that the Reagan administration became infatuated with its own ability to orchestrate news photographs that could often be counted on to function as public relations rather than reportage. But when the first revelations about the covert (and illegal) U.S. arms sales to Iran emerged in November 1986, the potentially negative pictures that the scandal might generate became an enormous threat to the administration. The one man who might have been able to deal with the impending crisis of imagery was Michael Deaver. But he had left the White House in May 1985 to set up a consulting business; by the time Iranscam broke, he was deeply immersed in his own troubles with Congress on charges of influence peddling.[17] Although the public-relations mechanism Deaver had created was still firmly in place, the people running it had little of the foresight or sensitivity to the visual that he did. Perhaps no one could have saved Reagan's face during this period, but the clumsy attempts by the White House to do just that revealed much about the machinations of the White House's use of the photo op, which Deaver probably would have been able to suppress.

17. Evan Thomas, "Influence Peddling: Lobbyists Swarm over Capitol Hill," *Time*, 3 March 1986, pp. 26–36. Deaver was pictured in the cover photo for the story talking on the telephone in what appeared to be a plush limousine. The cover line read, "Who's This Man Calling? Influence Peddling in Washington." In his autobiography, Deaver notes Nancy Reagan's disapproval of the photo. As soon as it appeared she called him and told him she thought posing for it was "a big mistake." See Deaver, *Scenes*, p. 216.

The Iran-*contra* affair broke on November 4, 1986. In the preceding few months, the White House had already suffered some disturbing diplomatic, political, and public-relations defeats: A U.S.-backed supply plane for the *contras* had been shot down in Nicaragua, and free-lance mercenary supplier Eugene Hasenfus had been taken prisoner, inspiring the White House to issue a series of unbelievable disclaimers and untruths about official U.S. involvement in the mission; news stories reported a National Security Council campaign to spread "disinformation" against Libya; U.S. journalist Nicholas Daniloff, charged with spying by the Soviets, was exchanged for an accused Soviet "spy"; the Reykjavík arms-control summit went down in flames, with efforts to patch up Soviet-U.S. differences continuing to produce nothing but disagreement; and, as the Iran-*contra* allegations emerged, the Democrats regained control of the Senate despite avid campaigning for Republican contenders by Reagan himself. Reagan's handlers, who were so used to successfully promoting a pre-scripted, positive image of Reagan, were having an increasingly difficult time rewriting events in their favor. By the time Reagan made his first speech on the Iran-*contra* debacle, Chief of Staff Regan had been told by White House officials that "the Administration faced 'a serious perceptual problem' because of revelations about United States dealings with Iran."[18] Even in times of extreme crisis, the Reagan White House thought of problem-solving in terms of how a situation *looked* to the American public rather than what the crisis actually meant.

18. Bernard Weinraub, "Reagan Confirms Iran Got Arms Aid; Calls Deals Vital," *The New York Times*, 13 November 1986, sec. I.

Borrowing a leaf from the Nixon administration's book on relations with the press, Reagan officials tried to stonewall for several weeks after the first allegations came to light, keeping Ronald Reagan away from the press. It was over a week before Reagan met with key Congressional leaders to "brief" them, that is, to "personally acknowledge sending military supplies to Iran."[19] But the initial reactions of Reagan's staff during this time were in keeping with long-standing administration policy, which Leslie Stahl later illuminated:

19. Ibid.

One of the things Ronald Reagan did in managing his presidency was to avoid visual connection with disaster. When there *was* something that wasn't going well, he would *absolutely* disappear. We would not see him, we would not hear from him. So that there was no *picture* for the public to remember connecting Ronald Reagan with the disaster. When the Marine barracks were blown up in Beirut and hundreds of Americans died, do you know how the President reacted? He handed the press a piece of paper and got on a airplane and went to California.[20]

20. Stahl, "Projecting the Image," 1 November 1987.

Unlike crises such as the Beirut bombing, where Reagan could resurface in time to be photographed comforting grieving widows, Iranscam had no sentimental finale that he could turn to his benefit.

Reagan was finally forced to make a speech about the arms sale on November 13. Full of inaccuracies and outright lies, the speech did little to reassure either political observers or the American people. Still, *The New York Times* assessed his performance in these ambivalently admiring words: "But the President's message went beyond his words. *As he warmed to the camera in his masterly style*, he seemed to exude confidence that the public, wanting to trust him, would engage in what Coleridge called 'the willing suspension of disbelief.'"[21] *Newsweek*'s reporter saw things differently and wrote that the November 13 appearance revealed "a Ronald Reagan never before seen on national TV. His jauntiness had turned to strained sarcasm, his easy charm to defensiveness."[22] The Iran arms sale had created a genuine rarity — a Ronald Reagan whose guard was down and who *looked bad*. Wanting to record a situation they didn't often see, White House news photographers did not hesitate to show an uncomfortable, confused, and sometimes angry president. The picture that ran with *Newsweek*'s story spoke reams about the president's predicament: his lips pursed in anger, Reagan looked as if he were ready to explode. But it was *Time*'s photograph of the President during his speech, taken by Dirck Halstead, that roused the ire of anxiety-ridden White House staffers.

"When the president is on top and the world is right, you're going to love my pictures," Halstead, *Time* magazine's senior White House photographer once told Reagan aides. "But when things go sour, I'll be the first person to show it."[23] That might have seemed an idle boast, given *Time*'s generally sympathetic coverage of the Reagan years — sympathetic enough that Ronald Reagan named Time Inc.'s editor-in-chief, Henry Anatole Grunwald, ambassador to Austria upon his retirement from *Time* in 1987. But Halstead remembered how powerful and controversial David Hume Kennerly's close-up images were of an exhausted, Watergate-plagued Nixon, images that had been taken for *Time* magazine near the end of Nixon's presidency. Although it was less than two weeks into the unfolding Iran-*contra* story by the time of Reagan's November 13 speech, Halstead was looking for a similarly revealing image. He considered how he might make a picture to show the palace intrigue at the beleaguered Reagan White House. At the same time, the "Nation" section picture-editor for *Time*, Peter Kellner, asked Halstead to "bring back something different — a wide view of the

21. David K. Shipler, "The Iran Connection: Skirting Credibility's Border in Search of a Mideast Deal," *The New York Times*, 16 November 1986, "The Week in Review," sec. 4. (emphasis added).

22. Larry Martz, et al., "Reagan's Iran Fiasco," *Newsweek*, 24 November 1986, pp. 50–54.

23. Dirck Halstead, interview with author, New York City, 10 December 1986.

scene" or anything else that portrayed a visually boring subject — the president sitting at his desk — in a more provocative and telling way than it was usually seen.[24]

24. Peter Kellner, telephone interview with author, 30 June 1989. There is some confusion about whose idea this picture was — Kellner's or Halstead's. What the situation does illustrate, however, is one of the endless ways that "news" pictures are previsualized, both by photographers and editors.

Like any good White House photographer, Halstead was privy to a steady stream of information and rumor supplied by his White House contacts, other photographers, and journalists. Early on, he knew that Donald Regan was the target of heavy criticism from Washington insiders and from Nancy Reagan, among other things for "manipulating" the president and not protecting him from this kind of disgrace. Halstead decided to try for a picture that would show Regan's reputedly devious behind-the-scenes maneuvering.

For a television speech delivered from the Oval Office, the President is normally seated at his desk, with one "pool" television camera televising the speech. (The networks and Cable News Network take turns televising these kind of limited-access events, sharing the videotape with other members of the pool.) No other cameras are allowed during the televising of the speech itself. News photographers line up in the long hallway that leads from the briefing room past the press secretary's office to the Oval Office. The photographers are arranged in an unwritten pecking order, with the two major wire services first — Associated Press and United Press International— the newsmagazines second — *Time, Newsweek*, and *U.S. News and World Report* — and everyone else, including the French wire service, Agence France-Presse, the big American newspapers — *The Washington Post, The New York Times, The Los Angeles Times* — local newspapers, stringers from photo agencies, and extra photographers from organizations with regular members already represented, at the end of the line.

When the president is finished delivering his address, the assistant press secretary in charge of stills leads the photographers down the hall, past the president's Secret Service detail and into the Oval Office. According to Halstead, the photographers usually kneel in front of the president's desk, where the television camera has been, and take pictures of the president mouthing the words of his speech. The pictures taken at this kind of event, then, can hardly be considered to be candid, journalistic images.

Because a photo op lasts a very short period of time — anywhere from a mere forty-five seconds to perhaps five minutes — photographers have to carefully plan their strategies ahead of time if they want to get a picture that is different from the routine photo op shot. For Halstead this meant quickly checking to see where Regan was standing in the Oval Office and then positioning himself to get the appropriate

Dirck Halstead,
Time magazine,
November 24, 1986.

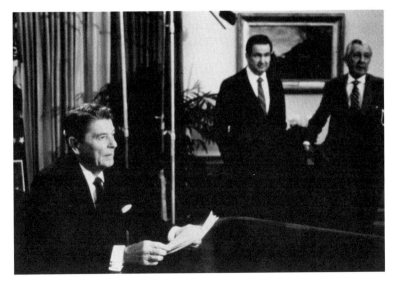

25. George J. Church, "Unraveling Fiasco," *Time*, 24 November 1986, pp. 18–22.

26. John Hinckley's attempted assassination of Reagan was the reason cited by White House staffers and Secret Service for their tight control over press access to Reagan during both his terms of office. Hinckley worked himself into a crowd of news reporters and camera people standing outside the supposedly secure VIP exit of the Washington Hilton Hotel in Washington, D.C., on March 30, 1981. From that vantage point he shot Reagan, presidential press secretary James Brady, Secret Service agent Timothy J. McCarthy, and Washington police officer Thomas K. Delahanty. In the wake of the shooting, the press's access to the president was systematically curtailed, beginning with limits on the number of reporters who could travel on presidential trips. See Kathryn Livingston, "The Shooting of the Shooting of the President," *American Photographer*, June 1981, pp. 69–73. Also see Francis X. Clines and Bernard Weinraub, "Washington Talk: Briefing," *The New York Times*, 2 October 1981, sec. 1.

27. Michael Baruch Grossman and Martha Joynt Kumar, *Portraying the President: The White House and the News Media* (Baltimore: The John Hopkins University Press, 1981), pp. 27–28.

photo. He spotted Regan and another aide who was also the subject of criticism, Director of Communications Patrick Buchanan, standing off to one side of the office. Halstead forsook the customary front-of-the-desk position and went to the side of Reagan's desk. From there he photographed a scene in which an uncertain-looking president gazed numbly ahead, while Buchanan and Regan stood next to him looking like two smug backroom power brokers. *Time* ran it as the lead photo in its "Nation" section with a story entitled "Unraveling Fiasco."[25] The picture caused a furor at the White House, and the press office handed down an edict: no photographing from the side of the president's desk.

To outsiders it seems inconsequential whether a photographer stands three feet to one side of a desk or the other. Indeed, pictures of photo opportunity scenes make it look as though still photographers are an unruly mob who will push to any place to get whatever picture they want. But photo op protocol, especially in the Reagan White House, was (and still is) rigid and formal. In the tightly controlled environment around the president, access and movement could easily be circumscribed by presidential aides.[26]

How photographers conduct themselves and what they may do during photo opportunities is defined by a series of unwritten rules, which were first scripted by Franklin Delano Roosevelt's press secretary, Stephen T. Early, in order to hide Roosevelt's handicap from the American public.[27] Among numerous unwritten rules, these were some of the most important during the Reagan administration: the president is the main subject of any presidential photo op; it is forbidden to take photographs of anyone standing in the hallway on the way to the Oval

28. Gary Kieffer, John Ficara, Barry Thumma, taped conversation with author, Washington, D.C., 17 December 1986. Significantly, the photographers often refer to government officials as "players" or "characters," terminology that reinforces the wholly theatrical nature of news events at the White House.

29. Mike Sargent, interview with author, Washington, D.C., 18 December 1986.

30. Denny Brisley, interview with author, Washington, D.C., 17 December 1986.

31. Wally McNamee, interview with author, Washington, D.C., 18 December 1986.

32. Kieffer, interview, 17 December 1986.

Office; the photo op starts when the president walks into the room. Even if the photographers are in the Oval Office with key players in a controversial story, they can't photograph anyone until the president arrives.[28] The photographers internalize and abide by the unwritten rules and often remind one another about the permissible limits of their activities. This is the way one photographer described what happens when inexperienced photographers from outside the Washington circuit unwittingly violate White House code: "They don't care about the rules," said Mike Sargent, the first photographer from Agence France-Presse to serve as a White House regular. "We police our own, too, because if they do something out of line it hurts everyone concerned. Photographers as a group are penalized when somebody steps out of line…it just makes the whole group look bad."[29] White House assistant press secretary Denny Brisley concurred: "They really regulate each other very well."[30] Any discussion of photographing at the White House with people who take pictures there is invariably peppered with references to the rules and the necessity of obeying them.

The precept that Halstead violated is the one that defines the president as the only viable subject of the photo op. This is normally enforced only during a tense situation, though, as photographers will often photograph other government figures in the Oval Office if they know their publications or news organizations have a particular interest in them. (This practice is buttressed by another rule: if the White House doesn't want something photographed, it shouldn't let the photographers see it.) As *Newsweek* photographer Wally McNamee pointed out: "Photographers always take these kinds of pictures,… but they're not of any interest until you have a story."[31]

Ignoring any of the rules laid down by the press office, especially when working in a sensitive situation, could result in a variety of punishments for photographers. At the least, they could be called into an assistant press secretary's office and reprimanded. If an offense was deemed serious enough, the photographer's editor might get a complaint about his or her behavior from the White House. At the extreme, taking a strictly forbidden picture, such as one of important government figures conversing with one another in the hallway outside the Oval Office, would be grounds to "rip" the photographer's White House credentials — that is, take away his or her access to the White House — perhaps for the remainder of that president's term of office.[32] Even if the situation didn't reach such calamitous proportions, photographers are obviously made to think twice about doing anything too far out of the ordinary. The psychological controls exercised on the photographer's

ideas about representation are as daunting as any physical controls might be. "It gets to the point where you have to decide whether breaking that rule is to your long-term benefit," said UPI photographer Vincent E. Mannino. "Is it big enough to be worth getting into bad relations with these people on an everyday basis?"[33]

33. Vincent E. Mannino, interview with author, Washington, D.C., 17 December 1986.

The answer to that question in most cases is "no." In effect, any journalist who works at the White House is there at the pleasure of the White House. The photographers must balance that reality with the fact that they are journalists; it is their job to get pictures that accurately represent the president at any given time, which is what Halstead was trying to do. But when his irritating side-of-the-desk picture was published, he set off fears of a previous Presidential crisis that lurked not too far beneath the surface of official Washington.

Parallels between Iranscam and Watergate were drawn early in the arms-sale scandal; the toll that Watergate took on Richard Nixon was shown all too clearly in pictures. Indeed, when one of David Kennerly's pictures of an embattled Nixon was published in *Time*, the White House was enraged. Even the UPI vice president for news pictures took the unusual step of sending letters to all UPI clients labeling the published picture as "out of context" and implying that Kennerly had purposely made Nixon look bad, based on his review of the pictures UPI photographers had taken of Nixon during the same photo session. (This seems to have been a case of professional competition masquerading as ethics: UPI had simply been badly scooped by Kennerly.) This unusual criticism, coming from a news organization official, brought Kennerly's integrity into question and forced him to defend himself to his editor at *Time*.[34] Although he survived the controversy, Kennerly was made an example of for the other photographers who might have been thinking of straying from accepted pictorial conventions.

34. David Hume Kennerly, *Shooter*, (New York: Newsweek Books, 1979), p. 119. Halstead also defended Kennerly's picture of Nixon in a letter to *Time's* picture editor, John Durniak.

During the Watergate scandal, *Newsweek*'s McNamee also took some equally disquieting close-ups of Nixon, one of which ran on *Newsweek*'s cover. The day after it came out, he was called into the office of an assistant press secretary, who chastised him by saying: "We let you go into the Oval Office to do photo opportunities, not to do portraits."[35] In a crisis situation, any kind of deviation from the norm — in this case using a long lens so that Nixon's face filled the entire picture frame, rather than using a normal or wide-angle lens to photograph the entire scene — can be labeled as out of bounds. By similarly berating photographers when less than flattering imagery of Reagan appeared in the press while Iranscam continued to make headlines, the White

35. McNamee, interview, 18 December 1986.

36. Ronald Reagan's public-relations team had clearly studied Richard Nixon's handling of the press. See Thomas Whiteside, "Annals of Television: Shaking the Tree," *The New Yorker*, 17 March 1975, pp. 41–91; Joe McGinnis, *The Selling of the President 1968* (New York: Trident Press, 1969); Hertsgaard, *Bended Knee*, pp. 20, 39, 324–325.

37. Bernard Weinraub, "President Orders Sales of Weapons to Iran Stopped," *The New York Times*, 20 November 1986, sec. 1.

38. Jonathan Fuerbringer, "Lawmakers Find Reagan Misleading," *The New York Times*, 29 November 1986, sec. 1.

39. Diana Walker, interview with author, Washington, D.C., 19 December 1986.

40. See Jeff Gerth, "Shipments to Iran: The Legal Issues," *The New York Times*, 12 November 1986, sec. 1.

41. Paul Hosefros, *The New York Times*, 26 November 1986, sec. 1, and Bob Daugherty, *Time*, 8 December 1986, pp. 16–17.

House apparently hoped to dampen their ardor for revealing reportage.[36]

Reagan's second public attempt to explain the arms sales to Iran took place on November 19, 1986. It was one of his rare news conferences, and it was a public-relations flop for the president. The next day he was characterized by *The New York Times* as looking "grim, even testy, at times."[37] His remarks to the press were called "confusing" and "misleading," and members of Congress reportedly felt that his comments "further hurt his credibility."[38] Until his next press conference four months later on March 19, 1987, he did not open himself to reporters' questions again.

But White House aides knew that the president couldn't disappear completely. Although staffers began restricting reporters more radically than ever, at the same time they made sure that photographers got access to the president — but only still photographers, not television crews. Network correspondents always accompany television crews going into the Oval Office for a photo op, which was too risky a situation to expose this president to while he was under fire. The separation between word and picture, however, is much stricter in the print media. Taking still photographers in to see the president did not automatically allow access for the reporters from their respective news organizations. And photographers can neither ask questions nor — according to another unwritten rule — tell anyone, including their editors or reporters, what was said during a stills-only photo op. "Photographers see, they don't hear," is a time-honored maxim.[39]

Unfortunately for the White House, even this attempt to protect the presidential image failed. On November 25, 1986, the president spent four disastrous minutes in the press briefing room stuttering out excuses that he was not "fully informed" about secret arms deals with Iran before he abdicated responsibility and turned the podium over to Attorney General Edwin Meese, who then widened the scandal by admitting that Iran's arms payments were diverted to the Nicaraguan *contras* in what seemed a clear violation of the Boland Amendment prohibiting such support.[40] The painful awkwardness of the scene as Reagan turned tail and ran was captured by news photographer Paul Hosefros of *The New York Times*, who showed a confused-looking Reagan backing away from the podium as he gestured to Meese, and the Associated Press's Bob Daugherty, who took a dramatic tight shot of a crestfallen Reagan, his lips pursed and hearing aid visible, ceding the floor to Meese.[41] For all their ability to stop reporters from questioning the president, aides could not prevent these images, which made the president look worse than he ever had. After six years of photographing prepackaged photo ops of

Ronald Reagan, photographers were able to penetrate the theatricalizing barrier so carefully erected by the White House. Finally it seemed that a "true" picture of Ronald Reagan was going to be revealed.

By this time the White House realized its error in allowing the photographers, and the rest of the press, any candid view of Reagan at all. Once Reagan aides announced in mid-December that the president had to undergo prostate surgery, his medical problems provided a handy excuse for completely keeping him away from the news media. Photo ops became even more innocuous than before, with the result that the photographs from them were usually not used by the national media. On occasion Reagan was caught in an unguarded moment; in one instance he was photographed walking to the White House with eyes averted under an umbrella, a man seemingly isolated by his own delusions and lies.[42] Mostly, the president was seen doing what he was

42. Both *Time* and *Newsweek* used versions of this image: Cynthia Johnson, *Time*, 22 December 1986, p. 14; John Ficara, *Newsweek*, 22 December 1986, p. 20.

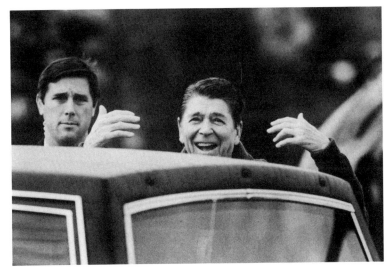

Doug Mills, 1987.
UPI/Bettman
Newsphotos.

best at: departing the White House for one vacation or retreat or another, Nancy in tow, with him waving and smiling or pointing and smiling or gesturing to his ears to indicate that he couldn't hear a reporter's shouted question. By continuing to pretend that nothing was wrong, administration aides began to close the rupture in the fabric of Reagan's presidency.

While four separate government investigations of the scandal were under way, the White House formulated a strategy that eventually helped exonerate the president, one which included confessing that administration actions were wrong, casting the blame for them on underlings Oliver North and John Poindexter, and "pledging to do everything possible to find out how it had happened and to make sure it never happened again."[43] Although the media displayed moments of skepticism about the way things were shaping up, they buried their own criticisms of Reagan in a barrage of commentary that implied and even stated outright that the American people did not want Reagan to be disgraced.

43. Hertsgaard, *Bended Knee*, p. 324.

So after two months of generally critical coverage of Iranscam and the president's role in it, the mainstream press decided to back off. By the time of Reagan's State of the Union address at the end of January 1987, the press had begun acting as if Iranscam were over and Reagan needed to get on with the business of governing, although there were months of Congressional testimony still to come. According to *Newsweek*'s report, Reagan "dispelled fears about his health and mental sharpness but conspicuously lacked either the old fire or a new agenda."[44] *Time* called the address "an important chance to demonstrate that he was taking charge of the Iranscam mess and to advance new goals that might help him recapture the initiative."[45] In the press's mind, Ronald Reagan seemed to be innocent, nonculpable for illegal acts in which his administration was involved. The Iran-*contra* incident was reduced to a "mess," a domesticated concept that any parent could understand.

Along with this willingness to let the Great Communicator off the hook came a change in the pictures with which the print media decorated its articles. *Newsweek*, usually a scintilla more critical of Reagan than *Time*, chose to run an image of Reagan looking strained and uncertain during his State of the Union speech. At *Time*, however, the renovation of the president was proceeding at a more rapid pace. Editors there chose a State of the Union picture of a chipper, smiling Reagan.

By the time Reagan gave a television address on March 4 to respond to the findings of the Tower Commission,[46] the media restoration of the president was in full swing. *Time* magazine called Reagan's speech, in which he took "full responsibility" for his own actions and those of his administration in the Iran-*contra* debacle "a masterly performance," thus revealing its readiness to go back to a style-over-substance portrayal of this president. *Time*'s White House photographer Diana Walker was granted a picture session with the president, his new chief of staff, Howard Baker, and his new national security advisor, Frank Carlucci. In her full-page color portrait, the three of them posed in a sober, dignified manner. The picture caption guided the reader's perception of the image with an unambiguous message: "Starting Over: The President flanked by Howard Baker and Frank Carlucci."[47] This was not a president who had been caught participating in illegal schemes for which he would be taken to task. He was merely the victim of a bad staff that exercised faulty judgment; after sweeping the bad apples out, he was ready to proceed with a gaggle of new advisors. The whitewashing of the president was evident especially in the last

44. Larry Martz, "Going Nowhere Fast," *Newsweek*, 9 February 1987, p. 24.

45. George J. Church, "The State of Reagan," *Time*, 9 February 1987, p. 16.

46. Democratic Senator John G. Tower of Texas, former secretary of state Edmund S. Muskie, and former national security advisor Brent Scowcroft were constituted by Reagan as a "special review board" to investigate Iran-*contra* allegations. On February 26, 1987, they issued a more than 300-page report that portrayed Reagan as "a confused and remote figure." See Steven V. Roberts, "Inquiry Finds Reagan and Chief Advisers Responsible for 'Chaos' in Iran Arms Deals," *Newsweek*, 27 February 1987, sec. 1.

47. Jacob V. Lamar, Jr., "Trying a Comeback," *Time*, 16 March 1987, p. 19.

paragraph of *Time*'s story, in which the writer said that although many Americans were "uneasy about Reagan's grip on his job," he was "still popular." *Time* went on to issue a prim Yankee scolding: "But if he is to recoup, he will have to resist his tendency to rely on theatrics rather than hard work."[48] Reagan, then, was just lazy and too enamored of the camera's loving eye.

So after all the scandal, allegations, illegalities, cover-ups, and lies, the Reagan administration ended on a high note, with the news media indulging in one last orgy of adulation for the Gipper. "Reagan's Final Rating Is the Best of Any President Since 40's" sang a *New York Times* headline on January 18, 1989. That same day, NBC News aired its cloying presidential portrait: "Ronald Reagan: An American Success Story," which was heralded by full-page newspaper ads. *Newsweek* fell in line with a cover story by conservative columnist and Nancy Reagan–confidant George Will on "How Reagan Changed America," replete with a six-page picture section of Reagan-era highlights and missteps, including the famous and quite bizarre scene of Nancy waving to the president's image projected on a gigantic screen at the Republican National Convention in 1984.[49]

Even more frightening and potentially dangerous than the whitewash of the Reagan administration was the legacy of information manipulation and image-fabrication that the administration left behind. Former Reagan press aide David Gergen was quoted as saying that he was so proud of what the Reagan press apparatus had accomplished that it would be "worthwhile to institutionalize some of the approaches Reagan has taken toward press events" so that future presidents could benefit.[50] Alarmingly, the press itself seemed to agree with this point of view. Certainly, George Bush's successful campaign for the presidency was exemplary, with its use of simple, emotional themes delivered in a dramatic, visual manner, relying on Reaganesque images of patriotism, nationalism, and fetishization of the nuclear family, along with a brutal, overt appeal to racist fears.[51]

Once in office, however, Bush had a hard time reducing the business of government to a few heart-warming themes. Newspeople who had grown accustomed to the steady diet of manufactured news items from the Reagan White House didn't find the same cleverly predigested material available to them in the Bush administration. Editors who had welcomed the jocular antics of a Hollywood-trained Ronald Reagan during photo ops were let down by the duller visuals provided by a former CIA spookmaster. After less than two months in office, the Bush administration was characterized by *Time* magazine as

48. Ibid., p. 23.

49. "Goodbye to the Gipper," *Newsweek*, 9 January 1989, pp. 18–23.

50. Hertsgaard, *Bended Knee*, p. 7.

51. One of the most successful and frequently broadcast ads of George Bush's 1988 presidential campaign featured an African-American convict named Willy Horton. Incarcerated in Massachusetts for murder, he raped a white woman while he was out of jail on a prison furlough program; the pro-Bush ad attributed Horton's action to the soft-on-crime liberalism of Democratic opponent Michael Dukakis, then the governor of Massachusetts and the Democratic party's 1988 nominee for president. For information on the ad and the way the Bush campaign tried to distance itself from its obvious racism, see Stephen Engleberg, et al., "Bush, His Disavowed Backers and a Very Potent Ad Attack," *The New York Times*, 3 November 1988, sec. 1.

52. Dan Goodgame, "Rude Awakening," *Time*, 20 March 1989, p. 22 (emphasis added).

53. Lucy Howard, "Tired of Bush," *Newsweek*, 10 April 1989, p. 7 (emphasis added).

54. A photograph entitled *Piss Christ* was one of eight photographs by Andres Serrano chosen for a traveling exhibition sponsored by the Southeastern Center for Contemporary Art in 1988. A conservative group called the American Family Association (AFA) began a direct-mail campaign to exhibition sponsors — including the Rockefeller Foundation, the Equitable Foundation, and the National Endowment for the Arts (NEA) — and to members of Congress, protesting Serrano's picture. This began a protracted battle in which the NEA was threatened with funding cuts for supporting "blasphemous" art. Then in mid-June 1989, the director of the Corcoran Gallery of Art in Washington, D.C., abruptly canceled a traveling retrospective of Robert Mapplethorpe's photographs organized by the Institute of Contemporary Art in Philadelphia, citing the possibly detrimental effect the show could have on NEA appropriations, especially to the Corcoran. For a general outline of the battle, see Robert Atkins, "Stream of Conscience," *The Village Voice*, 30 May 1989; Barbara Gamarekian, "Corcoran, to Foil Dispute, Drops Mapplethorpe Show," *The New York Times*, 14 June 1989, sec. 3; Barbara Gamarekian, "Artists Protest Corcoran Cancellation," *The New York Times*, 15 June 1989, sec. 3; William H. Honan, "Congressional Anger Threatens Arts Endowment's Budget," *The New York Times*, 20 June 1989, sec. 3; Grace Glueck, "A Congressman Confronts a Hostile Art World," *The New York Times*, 16 September 1989, sec. 1.

55. Hertsgaard, *Bended Knee*, p. 326. John Chancellor's comment was broadcast February 26, 1987.

suffering from "drift" and "malaise." Even worse was an accusation in *Time* that eight years earlier would have been impossible to imagine: "The White House has also been inattentive about *managing the news* and delivering its message to the public, especially when compared with skills of the Reagan administration or even with the 'theme-of-the-day' Bush campaign."[52] Not to be left behind, *Newsweek* chimed in a few weeks later: "Reporters now talk longingly of the Reagan presidency. The Gipper may have been remote, but *he made news*, they grumble."[53]

This addiction to prefabricated news was one of the most egregious accomplishments of the Reagan Revolution. Like kidnap victims suffering from Stockholm Syndrome, in which the captives sympathize with the plight of their captors and even actively defend their actions, the American news media grew to love their subjection at the hands of the President. Once they were brought back into line — after their "excesses" in reporting the Vietnam War and Watergate — the media were ripe for further bullying into total submission. The far-right's lust for social control — and its empowerment by the Reagan and then the Bush administrations — produced waves of official censorship, from the attacks on the Supreme Court for its decision upholding the burning of the American flag as a form of free speech to Congressional savaging of the National Endowment of the Arts because of grant monies given to a show of Robert Mapplethorpe's (homosexual, erotic) photographs and to (blasphemous) artist Andres Serrano.[54] In all of this, the way was paved by the Reagan White House's coercive handling of the press, its insistence on dictating the "proper" behavior of the people who covered it and its intolerance of any deviation.

In tandem with the right wing's repressive triumph, the Iran-*contra* affair reemphasized another dispiriting fact: the American news media's stake in maintaining the status quo. "Nobody wants him to fail," intoned John Chancellor on the NBC Nightly News, speaking about Reagan's tattered presidency. "Nobody wants another Nixon. He should be able to rebuild on that as he reshapes his image and his administration."[55] The Reagan White House wrote the book on shaping and reshaping the presidential image and the actor-president escaped scot free. When push came to shove, neither the studio audience nor the presidential production team could fathom an unhappy ending to the Ronald Reagan White House Hour. And the damaging pictures of a compromised, confused president, which once could have contributed to a president's downfall, ended up as mere footnotes to a picaresque episode in the annals of American media politics.

PLAYING WITH DOLLS

Silvia Kolbowski

Enter the major university library in which some of the research for
this article was carried out, and look for the section on photography.
Situated between *Human Nutrition* and *Industrial Chemistry*, it
contains a narrow assortment of books, titles such as *The Photographic
Lab Handbook, Image Science, Autoradiography in Biology and
Medicine, Overexposure: Health Hazards in Photography*, and *Theory
of Development*, as well as a variety of coffee-table monographs,
histories of the "evolution" of the medium and its techniques, "styles,"
and genres. Critical theory does not seem to have made much of an
incursion into these shelves; a book identified on its spine as *Introduc-
tion to Photographic Theory* turns out to be a technological thesis on
the silver halide process. Books on media, Marxist and feminist theo-
ries, psychoanalytic theories of sexuality and the gaze, critical art
histories, as well as those on the philosophy of history, or race and
representation, are to be found on different floors, which makes writing
on photography from a cross-cultural perspective a physical affair.
Even the library's computerized catalogue, able to traverse shelves at
the touch of a button, stubbornly refuses cross-referencing.

The titles listed above were intended to be a representative
register, a cross section. But all of the titles I chose contain words that
make associative references to medical science or the body: *lab, science,
image, radiography, biology, medicine, overexposure, health, develop-
ment*. These choices were overdetermined, perhaps, by the context of
my first encounter with the subject of this text — fashion photography
— as an adolescent in the waiting room of a doctor's office. There, to
allay my anxiety about the impending unveiling of my body to a strange
man (who would discover what?) whose gaze could not be contained
within professional parameters, I directed my own gaze to, touched the
surface of, photographic images of feminine "perfection." An image
from a recent fashion-magazine layout comes to mind: it is of a Cauca-
sian model standing in naked profile on a beach, her arms sinuously
caressing her own body, which suntan oil has made into a gloss of unin-
terrupted surface. There are no clothes or makeup being peddled in this
image — just perfection. Where the unstable territory of my own body
would be partitioned into zones of exposure (following the nurse's

directives, this part must be covered with a gown, that part must be left uncovered), the bodies that my gaze would capture and that captured my gaze, looked stable, imperturbable, self-sufficient. Those bodies, like my body on the examining table, were there to be looked at. Unlike my body, the models' bodies were contracted to appear to be comfortable objects of a gaze.

Through the creation of meaning, the advertisement works to simultaneously create identities for both the product and the reader, who will be addressed as a potential consumer. In order to engage the reader's attention, both text and image must be capable of offering certain forms of interest and pleasure. Crucially, for the image to fulfil its advertising function, it must not offer satisfaction in its own right. The advertisement works to displace satisfaction, promising fulfilment upon purchase of the commodity, at which point the reader becomes a consumer. It then articulates meaning and pleasure through a complex relationship which it establishes between reader, advertising image and commodity. This relationship is orchestrated by the overall marketing considerations, which determine not only where the advertisement will appear, but also where the commodity advertised will be distributed, retailed etc.... The image of woman is used as a complex signifier to associate the advertised product with other aspects of the cultural and ideological system: art, status, wealth, etc.

I. Kathy Myers, "Fashion 'N' Passion," Screen 23, no. 3/4 (1982), pp. 90, 94, 96.

— Kathy Myers, "Fashion 'N' Passion"[1]

...what is there to prevent [the woman]... from appropriating the gaze for her own pleasure? Precisely the fact that the reversal itself remains locked within the same logic. The male striptease, the gigolo — both inevitably signify the mechanism of reversal itself, constituting themselves as aberrations whose acknowledgement simply reinforces the dominant system of aligning sexual difference with a subject/object dichotomy.

2. Mary Ann Doane, "Film and the masquerade: theorizing the female spectator," Screen 23, no. 3/4 (1982), p. 77.

— Mary Ann Doane, "Film and the masquerade: theorizing the female spectator"[2]

The meager critical writing that exists on fashion photography either implicitly or explicitly poses the female spectator of such images as a consumer, part of a targeted market, a "user" who gets used through the manipulative seduction of an advertising/fashion/publishing complex. By implication, the female spectator is a passive, masochistic statistic who attains that status through an identification with images of fashion models in the service of a market construct, through the lures of photographic codes. Such descriptions of or allusions to this identificatory process underplay the contradiction inherent in any "passive" identification, that is, the active role of looking. All identificatory looks presuppose fluctuating subject/object positions. Even the woman's

identificatory gaze at a fashion model frozen into an image by the camera involves an active process of looking. In his discussion of maternal identification, Freud saw a *one-way* identification of the girl with her mother. The young girl's game of playing with dolls, Freud wrote, "... served as an identification with her mother with the intention of substituting activity for passivity. *She* was playing the part of her mother and the doll was herself: now she could do with the baby everything that her mother used to do with her."[3] In Freud's analysis of the scene, the girl assumes an active role as mother within a dualistic logic where only active *or* passive positions are available. But identification, as French psychoanalyst and theorist Luce Irigaray writes, is a multifaceted game: "a game — even of dolls — is never simply active or passive, but rather frustrates that opposition by the economy of repetition that it puts 'into play.'"[4] That is, the girl never *exclusively* assumes the part of her mother, or herself, or the doll in such a game. Instead, the process of identification could be referred to through metaphors of, for example, layering, simultaneity, fluctuation, nonlinear density.

My point in juxtaposing the two quotations at the beginning of this section is not to render the kind of primarily economic determination being argued in the first quote by Kathy Myers invalid or irrelevant but to indicate the dangers of its determination and to argue that whenever it is used in isolation it is bound to be *over*determined. For what such fundamentally paranoid scenarios tend to reduce to effects of economic motives are the unconscious and sexual difference. These scenarios suggest that those who advance advertising/photographic/editorial/ fashion industry interests exercise total understanding and control of their own motives. Through the deployment of images, they are then thought to exercise a similar power over their targeted objects. That is to say, such an argument implies that the meanings produced by these images are fully determined before they are viewed by the female spectator and that they produce a narrowly defined subject/audience/ consumer. Following this logic, opposition to such manipulation (which is to be desired on the part of an "enlightened" spectatorship?) would be theorized as an equally conscious function. That is, both processes, manipulation and resistance, are understood as fully conscious events, put into effect by an undivided "self" that is invulnerable to the vicissitudes of the unconscious and the imaginary. Contradictorily, such an argument must implicitly recognize the unconscious as a function that allows for manipulation to achieve its effects and is implicitly dependent on the enlisting of the faculty of fantasy. But fantasy cannot be so easily enlisted to a single aim, not only on the part of a persuasive strategy, but

3. Sigmund Freud, "Femininity" (1933), quoted by Luce Irigaray in *Speculum of the Other Woman*, trans. Gillian C. Gill (Ithaca: Cornell University Press, 1985), p. 77

4. Irigaray, *Speculum of the Other Woman*, p. 77.

5. Jean Laplanche and Jean-Bertrand Pontalis, *The Language of Psycho-Analysis*, trans. Donald Nicholson-Smith (New York: W. W. Norton and Company, 1973), p. 318.

also on the part of the desiring subject herself. As Jean Laplanche and J. B. Pontalis point out "[fantasy] is not an *object* that the subject imagines and aims at, so to speak, but rather a *sequence* in which the subject has his own part to play and in which permutations of roles and attributions are possible."[5] Laplanche and Pontalis then refer the reader to Freud's analysis of the fantasy "A Child Is Being Beaten," where the patients' recountings resist singular identifications, with no exact parallel between the identifications of the male and female patients. Freud writes: "Who was the child that was being beaten? The one who was himself producing the phantasy or another? Was it always the same child or as often as not a different one? Who was it that was beating the child? A grown-up person?… Or did the child imagine that he himself was beating another one?… In these circumstances it was impossible at first even to decide whether the pleasure attaching to the beating-phantasy was to be described as sadistic or masochistic."[6]

6. Sigmund Freud, "A Child Is Being Beaten," in *The Standard Edition of the Complete Psychological Works of Sigmund Freud*, ed. and trans. James Strachey (London: Hogarth Press, 1953–74), vol. 17 (1919), p. 181; hereafter cited as S.E.

In fantasies, identification resists rigidity. The feminine gaze at the fashion photograph's image of feminine perfection could be described as engaged in a one-way prescriptive identification (I become the object of my gaze); it could also be seen as simultaneously taking on a number of other forms: the embodied gaze of the spectator that is never in full disavowal of the schism between subject and object of the look (I see myself, or know myself to be, gazing at the image), the gaze that is aligned with that of the photographer/camera/frame, the gaze positioned "behind" the photographer. Pleasure, therefore, could be said to reside as much in the slippages of positions, the misalignments, as in the masochistic alignment with an unattainable object of perfection that is culturally reinforced. As opposed to the permutability of the identificatory gaze of fantasy, closed systems constructed through scenarios of full intentionality and control make even consciously willed or differing looks difficult to theorize or define. In fact, any theorization of a purely oppositional stance within such systems would not only have to deal with the intransigence of systemic structure, but would also fall within the dualistic logic to which Doane refers: opposition can be perceived as an aberration that reinforces a dominant subject/object hierarchy. That is, resistance can be read only as the exception to the social rule of hierarchic dichotomy, thus at the same time reinforcing it: if female spectatorship is willed an exclusively active gaze, it is at the expense of sustaining a strict active/passive division, of playing by the conventional rules of the game.

It is to the breaking down of such a division that Irigaray's comment is directed. For in Irigaray's psychoanalytic critique of identification,

"identity" never fully coheres, is never circumscribed by a finite moment. This proposition therefore leaves room for the theorization of an identificatory relationship between a female spectator and a photographic image that is not purely dichotomous and hierarchic, not predictably defined and determined. While there is very clearly an identificatory process at work in the interplay between the feminine gaze and the product of a photographic language, which creates images of idealized femininity, idealized female bodies, it could not be said that this look is fully manipulated by the persuasion tactics that work on such a fantasized identification.

What this text will attempt to do is inquire into whether there is something in the nondichotomous structure of identification that exceeds the parameters of masochism in relation to fashion images, something in the nonstatic gaze directed at static images that might allow for the theorization of another, perhaps coexistent, gaze. It will also question what it is about the specifically photographic language of fashion images that might assist in the exercise of what might be typified as a more resistant gaze, while at the same time assisting in the replication of manifestly conventional codes of femininity.

Without underestimating the significance of economic forces, I would argue for a morphology of the sites of representation constructed by fashion photographs (argued here in a very partial way) that accommodates the heterogeneous complexity of most social/psychical scenarios, the reciprocity of effect, and the (in)coherency of "identity." Issues of class and consumption are of crucial significance in analyzing mass media images, but making these issues predominant can screen out other, significant, albeit more "silent," issues that play a role in the construction of feminine subjectivity and pleasure.

"Pleasure" takes shape in the overlap of the social and the psychical and is not an innate response to outside stimuli. So how would one talk about the pleasurable stakes for women in the fascination with fashion photographs of women? (What do they "see" in these images?) By fashion photographs I mean, in this case, the overwhelming majority of contemporary fashion photographs as they appear in the west, those banal images of models — in magazines that target women of different classes and colors — posed so as to be caught by the camera in the midst of action, work, play, and repose, as well as those of figures facing the camera/reader/photographer head on, silhouetted against backdrops, or in cropped close-ups. Those images that do not make use of an overtly theatricalized sadism or sadomasochism (a phenomenon of fashion photography that appears, disappears, and reappears, but is by

no means predominant) are nonetheless "eroticized." To isolate "erotic" images of women is to misunderstand the way in which images are accorded meaning, through the sexualized nature of any gaze. Is there something in the spectatorship of these images that strains the readings favored by a logic of economic determination and exceeds the logic of a subjugation of woman? Is there something that could instead inscribe a type of feminine spectatorship that creates a field of tension occupied not only by oppressive demands made attractive through the lure of goods promising satisfaction, but also by an attraction that is given meaning through a look different from the ones described above? And, if so, what are the implications of such "excesses" or tensions? What are the academic/critical/popular props that lend support to the conventional construction of the female spectator as masochist? Is the demand for slavishness built into these images? Such a reading would be dependent on a notion of inherency, a notion that critical writing on photography has worked to challenge. In an example of this writing Alan Sekula writes:

The photograph is imagined to have a primitive core of meaning devoid of all cultural determination. It is this uninvested analogue that Roland Barthes refers to as the *denotative* function of the photograph. He distinguishes a second level of invested, culturally determined meaning, a level of *connotation*. In the real world no such separation is possible. Any meaningful encounter with a photograph must necessarily occur at the level of connotation. The power of this folklore of pure denotation is considerable. It elevates the photograph to the legal status of document and testimonial. It generates a mythic aura of neutrality around the image.[7]

7. Alan Sekula, "On the Invention of Photographic Meaning," *Artforum* (January 1975). Reprinted in *Thinking Photography*, ed. Victor Burgin (London: Macmillan, 1982), p. 87.

Is a reading that sees fashion photographs as, for example, unequivocally responsible for the replication of an oppressive social definition of femininity, not too dependent on a (somewhat repressed) realist (or denotative) reading? Instead of pursuing this line of reasoning, it could be argued that these images are representations that gain meaning in relation to a myriad of factors, events, and processes that shape subjectivity, meanings that are never graspable in isolation, never even serially singular.

I will now introduce three psychoanalytic, feminist critiques — of masquerade, narcissism, and identification — in an attempt to theorize a more complex feminine gaze. These critiques are not formulated along the same lines. In fact, when placed side by side they will diverge from and collide with one another. My purpose in bringing them together is not to develop a singular, determinative reading of fashion photography, but rather to indicate the possibility of how some differently positioned readings unsettle the more manifest narratives of such images. I will also look at how realist readings of the photographic medium tend to obscure the subtle fluctuations of such an identificatory gaze.

The Masquerade: The Missing Look

It seems significant that the bodies in the magazines that were gazed at in the doctor's waiting room were not only objects of the gaze, but were also physically handled. Mary Ann Doane has noted (after Christian Metz and Noël Burch) that the voyeuristic gaze of the cinematic spectator is dependent on a physical distance in the viewing situation: "The cinephile *needs* the gap which represents for him the very distance between desire and its object." Metz writes: "It is no accident that the main socially acceptable arts are based on the senses at a distance, and those which depend on the senses of contact are often regarded as 'minor' arts (culinary arts, arts of perfumes, etc.)." Those arts that are dependent on proximity and tactility are, not surprisingly, commonly associated with women and femininity and can be related to Doane's theorization that the female gaze at the screen lacks the gap necessary for the representation of sublimated desire: "…the female look [at/from the screen] demands a becoming"[8] due to the imaging of the woman's beauty, the adoration of her body through the cinematic codes of framing, lighting, camera movement, and angle, that keep her "more closely associated with the surface of the image than its illusory depths."[9] These codes repeatedly narrativize her as desirable body and close the distance between desire and object through an "over-identification" between woman and image, creating one in the image of the other, leaving the female spectator vulnerable to the cinematic codes that promote conventional "feminine" values. Because woman is narrativized and pictured as a desired and desirous *body*, as identifying spectator she lacks that gap that is the distance necessary for assuming a position productive of knowledge, of *re*-presentation rather than replication. "More so than men," Doane writes citing Helene Cixous, "who are coaxed toward social success, toward sublimation, women are body." "In opposition to this 'closeness' to the body (of the woman) a spatial distance in the male's relation to his body rapidly becomes a temporal distance in the service of knowledge."[10] In Freud's castration scenario, the girl sees the penis and knows in the same instant that she does not have it and wants it; the boy, (upon "seeing" the girl's genitals), however, undergoes a process of disavowal, irresolution, lack of interest, rereading, the endowment of meaning in relation to subjectivity — in short a "re-vision of earlier events…which invests the events with a significance which is in no way linked to an immediacy of sight." Although Doane does not explicitly frame it as such, her use of Freud's "observation" of the castration scenario situates it as a kind of textual

8. Doane, "Film and the masquerade," p. 78.

9. Ibid., p. 76.

10. Ibid., p. 79.

phenomenon, as an event given meaning by larger cultural encodings. Following this argument, the female spectator must gain access to the "gap between the visible and the knowable" denied to her by the cinematic institution if she is to participate in the process of her representation, the sublimation from body to "knowledge."[11]

11. Ibid., p. 80.

For Doane, psychoanalyst Joan Riviere's concept of the masquerade opens the way for the production of the gap necessary for the re-presentation of woman in relation to a dominant logic, for the achievement of distance from the body narrativized by cultural forms.[12] In her text of 1929, Riviere describes the case of a patient who appears to compensate for her public-speaking successes (which situate her as "masculine" subject) by engaging, after such events, in exaggerated feminine behavior — flirtation, coquetry, seductive deployment of the body. Riviere saw these gestures as "womanliness worn as a mask" in the service of camouflage (the woman's "masculinity" is hidden by the gestures) and relieving anxiety (staving off the expected reprisals directed at her by the men from whom she had stolen masculinity). By not distinguishing between "genuine womanliness" and the feminine masquerade, Riviere, at least in part, theorized femininity as a condition formulated in response to and through the dense material of the psychical *and* social.

12. Joan Riviere, "Womanliness as a Masquerade," in *Formations of Fantasy*, eds. Victor Burgin, James Donald, Cora Kaplan (London: Methuen, 1986). First published in *The International Journal of Psychoanalysis* 10 (1929).

According to Doane, "The masquerade, in flaunting femininity, holds it at a distance.…The masquerade's resistance to patriarchal positioning would therefore lie in its denial of the production of femininity as closeness, as presence-to-itself.…The effectivity of masquerade lies precisely in its potential to manufacture a distance from the image, to generate a problematic within which the image is manipulable, producible, and readable by the woman."[13] In this text Doane raises questions about, but stops short of defining the female spectator's distancing masquerade, or of specifying what its relation would be to the masquerade of femininity that the cinema itself makes use of. Perhaps these issues should remain questions. Her conclusion suggests, through the emphasis on the manipulability and readability of all images, a productive refusal to label certain images of women as inherently and irrefutably negative.

13. Doane, "Film and the masquerade," pp. 81, 87.

According to the logic of the masquerade, distance can be achieved through an exaggerated closeness to the socially determined codes of femininity, but not to a femininity that is essential, natural. (For if I am overtly playing a role, then it cannot also be a "natural" condition.) Cosmetics and the elaborateness of feminine fashion codes are often regarded as elements of the manipulation of and prescription for a

feminine look, or as serving a compensatory function for feminine "lack." But it could also be argued that some women take refuge in the material "layering" of femininity that they afford. For where there is layering, there is no absolute substance.

A consideration of masquerade in regard to fashion photography of/for women indicates several things. One is that a fascination with the image of feminine perfection can be seen as drawing on an identification with a masquerade. The very changeability, repetitiveness, and excessiveness of/in images that pass through one's hands with relative ease undeniably serve the marketplace. But in their proliferation, they also give form to the superficiality of that which is considered proper to femininity. If the cinema demands a becoming of the female spectator, closeness could be said to be literalized in the case of fashion photography in magazines, where bodily proximity is a precondition of viewing. (This is perhaps one of the things that gives commercial photography a "minor" status as opposed to the higher ranking achieved for "art photography," which can be seen — at a distance — on gallery and museum walls.) But it is perhaps the fashion photograph's status as a still image, its arrest of narrative, that makes it possible to theorize a gaze that achieves distance through access to masquerade and fantasy. What we have in fashion photographs is *frozen* masquerade unexasperated by the movement and narrative that "exasperate" masquerade in the cinema.[14] Fascination can be seen to lie in such an arrest, such a making of a mask. In this sense, the simple transmission of socially coded femininity cannot be fully relied on.

Photographic meaning has been rhetoricized through discourses of verisimilitude and illusion. Umberto Eco has pointed out that "the only property that the true object (of the photographic image) *does not have* is the representation of a body in a continuous outline" as it is portrayed in a photograph.[15] It then follows that a disavowal must take place in the viewer in order for the incongruence between image and referent to be smoothed over. But the fantasized look that is necessary for such a disavowal is not narrowly circumscribed. Identificatory entry into the elaborate "real-life" settings often used for fashion shots produced "on location" rather than in the studio, is dependent on a capacity for fantasy that is rooted in an ability to imagine a multitude of "realities." Identificatory entry is also dependent on the continuing dominance of belief in photography's verisimilitude — a belief that seems to accommodate (perhaps on the level of fantasy) the contradictory discourses surrounding photography.

14. Stephen Heath, "Joan Riviere and the Masquerade," *Formations of Fantasy*, pp. 57–58. "The masquerade is obviously at once a whole cinema, the given image of femininity. So it is no surprise that cinema itself can be seen as a prime statement of the masquerade....Cinema has played to the maximum the masquerade, the signs of the exchange femininity, has ceaselessly reproduced its — their — social currency: from genre to genre, film to film, the same spectacle of the woman, her body highlighted into the unity of its image, this cinema image, set out with all the signs of its femininity (all the 'dress and behavior')....Spectacle *and* narrative, image *and* movement, cinema in its films exasperates the masquerade and also tries to get women right, know her identity as reassurance — which rightness itself can only be masquerade..." (emphasis added).

15. Umberto Eco, "Critique of the Image," *Thinking Photography*, p. 33.

The Double Discourse: Verisimilitude and Illusion

There are two kinds of documents, or two tendencies within the documentary genre. The first, the more common, gives information to the intellect. The second informs the emotions.

16. William Stott, *Documentary Expression and Thirties America* (New York: Oxford University Press, 1973), p.12.

— William Stott, *Documentary Expression and Thirties America*[16]

150 years ago a language was invented that everyone understood.
— Kodak Advertising Board, Grand Central Terminal, New York, April 1989

Photography has many stories of origin. In one, Joseph Nicéphore Niépce, a retired French army officer who fooled around with lithography, comes to the "invention" of photography by reproducing a seventeenth-century engraving not with a camera but through the employment of photographic means: the production of a negative of sorts, light sensitivity, and so forth. In effect, a light-sensitive substance was applied to a metal plate onto which was placed an oiled — and thereby translucent — engraving. These were than exposed to light, which caused the areas of the light-sensitive substance that were exposed to adhere to the plate; the other areas dissolved when placed in an appropriate solvent. The resulting image on the plate was then engraved more deeply by a traditional engraver, and "copies" of the original engraving were pulled.[17]

17. Beaumont Newhall, *The History of Photography*, rev. ed. (New York: The Museum of Modern Art, 1982), p.14.

This production of verisimilitude has been cited by historians of the medium as a forerunner of the "first" photograph, Niépce's famous view from the window of his home near Chalon-sur-Saône. The collapsing of the engraving reproduction, which in fact produced only a direct imprint of a two-dimensional original, and the very differently conceived view from the window taken with a simple camera, seems to arise from a desire to grant the quality of verisimilitude, of a "reality stripped bare" to the photograph. The legacy of the medium's invention includes the fact that Niépce formed a partnership with Louis Daguerre, a showman who needed the exactitude of the photographic process to create "absolute illusion" in his performances of historical scenes. However, the photograph's fidelity to an immediate "reality," its truth, is still loudly proclaimed in the mass media and many areas of the academy.

Academic discourses sustain the concept of the photograph's truth or reality through the production and maintenance of official categories and genres, such as documentary and photojournalism, genres that compartmentalize their messages to appeal to such pseudocategories as "the emotions" or "the intellect." The photograph's potential for fantasy has also been accorded labels such as art photography, or manipulated

photography (as though all photographs were not manipulated). To put it another way, dichotomized discourses — illusion and reality, fantasy and verisimilitude, emotion and intellect — framed, legitimate(d), and explain(ed) the medium. But these dichotomized discourses are rarely allowed to function in tandem, in which case their conflicting interests would threaten the assumed neutrality of those discourses. More often, the discourses function through the repression or dominance of one or the other of them. There are particular social/historical contingencies that draw on one or another discourse, or ways in which the discourses feast on contingent factors, with a multiplicity of effects. I pose this material here in order to ask whether the arguments that hold fashion photography of/for women responsible for the replication of ideological femininity rely primarily and inadvertently on one of the dichotomized discourses: that of the "reality" of the image or of an instrumental illusionism of fantasy that always meets its aim?

"On Narcissism": A Different Look

In most of Freud's writings on femininity, woman is rendered as an enigma, a dark continent created by the veils that cover and compensate for her "natural deficiency," her "castration." Veils such as beauty, charm, modesty, coquetry are thought to aid in the cover-up of a frightening absence. Woman's ability to seduce is in direct proportion to her use of these veils. French psychoanalyst Sarah Kofman reads Freud's "On Narcissism: An Introduction," as deviating from this path in that it locates woman's enigma in her self-sufficiency.[18] I quote the passage from Freud's "On Narcissism" that Kofman focuses on in full so that the reader may have the benefit of Freud's own words (albeit in translation):

18. Sarah Kofman, *The Enigma of Woman*, trans. Catherine Porter (Ithaca: Cornell University Press, 1985).

A comparison of the male and female sexes... shows that there are fundamental differences between them in respect of their type of object-choice, although these differences are of course not universal (complete object-love of the attachment type is, properly speaking, characteristic of the male. It displays the marked sexual overvaluation which is doubtless derived from the child's original narcissism and thus corresponds to a transference of that narcissism to the sexual object).... A different course is followed in the type of female most frequently met with, which is probably the purest and truest one. With the onset of puberty the maturing of the female sexual organs which up till then have been in a condition of latency, seems to bring about an intensification of the original narcissism, (of the infant), and this is unfavourable to the development of a true object choice with its accompanying sexual overvaluation. Women, especially if

they grow up with good looks, develop a certain self-contentment which compensates them for the social restrictions that are imposed upon them in their choice of object.... The importance of this type of woman for the erotic life of mankind is to be rated very high. Such women have the greatest fascination for men, not only for aesthetic reasons, since as a rule they are the most beautiful, but also because of a combination of interesting psychological factors. (It seems very evident that another person's narcissism has a great attraction for those who have renounced part of their own narcissism and are in search of object-love.) The charm of a child lies to a great extent in his narcissism, his self-contentment and in accessibility, just as does the charm of certain animals which seem not to concern themselves about us, such as cats and the large beasts of prey. Indeed, even great criminals and humourists, as they are represented in literature, compel our interest by the narcissistic consistency with which they manage to keep away from their ego anything that would diminish it. It is as if we envied them for maintaining a blissful state of mind — an unassailable libidinal position which we ourselves have since abandoned.[19]

19. Sigmund Freud, "On Narcissism: An Introduction," S.E. vol.14, pp. 88–89.

In Freud's "On Narcissism," Kofman argues, beauty is no longer conceived of as covering or compensating for a natural deficiency, but rather compensating for what Freud calls "social restrictions imposed upon [women] in their choice of object."[20] What makes the narcissistic woman attractive and enigmatic is that she "has managed to preserve what man has lost." Or at least, Kofman's argument suggests, it could be said that this is what the man fantasizes about the woman. Women have "been able to preserve their narcissism, their terrifying inaccessibility, their independence, their indifference," Kofman writes, and although they have been compared to cats and beasts of prey before ("a 'Nietzschean' animal *par excellence*") she finds less common Freud's analogy to criminals and humorists. The criminal, as a type, is the great skeptic, whose position articulates a socially buried secret: "'Nothing is true, everything is allowed'"; criminals "keep away from their ego anything that would diminish it"[21] (and would therefore threaten their narcissism). As for the humorist, he "fend[s] off everything that might debase him... such as fear or terror: humor is particularly suited for freeing and exalting the ego. 'Look! [Kofman quotes Freud on humor] here is the world, which seems so dangerous! It is nothing but a game for children — just worth making a jest about.'"[22] Kofman does not set up a rhetorical spectacle to determine the accuracy or plausibility of a Freudian "explanation" of the enigma of woman in her examination of Freud's text. Freud's assertion of woman's "enigma" due to her recuperation of a primary narcissism is treated by Kofman as a radical theorization and re-presentation of femininity, not as a biologically or

20. Ibid.

21. Kofman, *The Enigma of Woman*, pp. 52–55.

22. Sigmund Freud, "Humour" (1927), in Kofman, *The Enigma of Woman*, p. 55.

empirically rationalized truth. Freud's conceptualization of woman's privileged relation to narcissism is regarded as discursive rather than diagnostic.[23]

I discuss Kofman's text here in order to ask again, in a different way, whether it is the accordance of a conventional reality/truth status to fashion photography that prevents us from seeing or perceiving these images as games, images "just worth making a jest about" (albeit images that are serious enough to be played with). Could it be that what women "see" in these images, among other things, is a representation of femininity that exceeds the "lack" of sexual organ that is generally imposed on them by the culture? Without discarding the Lacanian theorization that *both* men and women assume sexualized subjectivity as a lack-in-being in relation to the privileged status of the phallus, the other-presumed-to-know, the Name-of-the-Father, the paternal metaphors, a subjectivity formed through the gap that exists between any formulation of "self" and lack in the place of the Other, the question remains of how to respond critically to the "vast social connivance" that makes of the woman a "privileged site of prohibitions"[24] and renders her a "symptom" for the man by her construction as "the place onto which lack is projected, and through which it is simultaneously disavowed."[25]

Is it possible that the idealizations formulated through photography, the narcissistic identification with a representational plenitude that the fullness of fashion photographs solicit from the female spectator, play a part in contradicting the more explicit scenario of a superiority/deficiency dichotomy or the function of economic determination. This is not to imply that the reading I suggest here is in fact the "truth" of these photographs, but rather that it can exist alongside and also complicate the other meanings produced. The closeness of an identification with a narcissistic object such as a fashion photograph could be seen as affording the female spectator the distance of an imaginary self-sufficiency that separates her from a rhetoric of insufficiency. In the reverie of this identification (encouraged by the capacity of photography to created unbroken contours, to thus render bodies "whole" even in cases of cropped imagery), her "sexual organs" are no longer subject to a logic of masculine/feminine or phallic/castrated comparison. The question remains as to the relationship between this illusionary sufficiency and the loss of distance between desire and object that Doane and others have identified as necessary for representation and access to *revision*. But the strength of Kofman's argument remains its insistence on textuality as a way of rethinking femininity, of femininity produced through retextualization, rather than femininity as the effect of biological drives.

23. This encapsulation of Kofman's text cannot do justice to the subtlety of her argument. But it is important to note that in the end Kofman contends that Freud abandons the path toward the conception of a less conventional femininity opened up by "On Narcissism" because he is scared off by what he sees as the immoral character of narcissistic love, and he rescues the woman by collapsing femininity and motherhood. The narcissistic woman can, he suggests, direct her love out to an object which was a part of her body, and is also separate from her — the baby. Additionally, in Kofman's reading, Freud's rivalrous eagerness to oppose Jung's monism at the time of writing his text, and Freud's moralism, obscure the fact that, his alternative dualism — narcissistic love and object-love — does not hold up to inquiry, for Freud "tends to reduce object-love to narcissistic love… since [the man's] sexual overvaluation of the love-object results from the simple transference to woman of one's overvaluation of oneself.…" p. 56.

24. Jacques Lacan, *Seminar XVIII* (1969–70), quoted by Jacqueline Rose, "Introduction II," *Feminine Sexuality* (London: Macmillan, 1982), p. 39.

25. Rose, *Feminine Sexuality*, p. 48.

The Third Woman: Identification

The writer who "returns" to Freud has the methodological option of evading the intratextuality, symptomatological contradictions, and nonteleologic turns in his work, of acknowledging only a *solid*, logically unfolded body of work, or of reading and writing against, as well as with, the already variegated grain of his hypotheses and declarations.

French psychoanalyst Luce Irigaray has chosen to psychoanalyze Freud's writings, to insist on the symptomatic nature of his, and any, texts. For Irigaray, Freud himself supplies, in his methodological approaches, the tools necessary for questioning the investedness of his own writing, his own historical blind spots. Irigaray sees Freud as a "prisoner of a certain economy of the logos, of a certain logic, notably of 'desire,' whose link to classical philosophy he fails to see — he defines sexual differences as a function of the *a priori* of the same, having recourse, to support this demonstration, to the age-old processes: analogy, comparison, symmetry, dichotomic oppositions" and elaborates on the blind spot of sexual difference in Freud's writings by questioning those "age-old processes" of classical philosophy.[26] She attempts to find representational economies that do not fully depend on analogy, comparison, symmetry, and dichotomic oppositions.

26. Irigaray, *Speculum of the Other Woman*, p. 28.

To Freud's question: "What exactly is it that the little girl demands of her mother?" and his response that it is to get her mother with child (preferably with a boy) in order to produce evidence of her own fantasized phallism *and* to get the phallus from the (therefore phallic) mother, thus disavowing her own "castration," Irigaray addresses the following speculation:

One might advance the hypothesis that the child who is desired in the relationship [of the girl] with the mother must be a girl if the little girl herself is in any degree valued for her femaleness. The wish for that girl child conceived with the mother would signify for the little girl a desire to *repeat and represent* her own birth and separation of her "body" from the mother's. Engendering a girl's body, bringing a third woman's body into play would allow her to identify both herself and her mother as sexuate women's bodies. As *two* women, defining each other as both like and unlike, thanks to a third "body" that both by common consent wish to be "female." This would attenuate the lack of differentiation between the daughter and the mother or the maternal function which is inevitable when the desire for origin is not referred back to a relation between a man and a woman, a relation that in turn implies a positive representation of femininity (not just maternity) in which the little girl can inscribe herself as a woman in the making.[27]

27. Ibid., pp. 35–36.

The conceptualization of a "third body" that by common wish is

made female allows for a breaking down of strict hierarchy. The condition of being *both* like and unlike undermines any notion of a one-way identification and could be seen as allowing the female gaze to gain the distance of representation, distance from replication, from simple reproduction. The "woman-in-the-making" effected by the represent-ability of the "third woman" is more readily able to establish distance from the closure of an essential image of femininity. Representation is then seen as a process, rather than an unchangeable chain of images.

How could one conceive the location of the "third woman" in fashion photography? First, in the very obvious sense of the invisible triangle that is set up between the place of the maternal, the female subject's gaze, and the "third woman" of the image. The fashion photography genre creates this "third woman" as a plenitudinous ideal that can be seen as encouraging both "overidentification" in Doane's sense of the term, *and*, from Irigaray's perspective, a process of "repeating and representing" birth and separation from a mother's body that is socially encoded and biologically reinforced (or vice versa) as a sameness from whose replication the woman does not escape. Thus "overidentification" is also at the same time "exasperated" by separation and distance. What I am suggesting is that the aim of an economy of repetition can be seen as getting women to buy things, to buy a code of femininity. But there is also an economy of repetition at play that "exasperates" such aims at the same time.

Realism

Though the parade of models is constantly changing, the gut-level reaction from their audience stays the same: women always sneak a self-comparison to a beautiful ideal. The appeal is that today's models make that critical measuring-up less of a stretch.
— Jody Shields, "Facing the Future," *Vogue*, January 1989

The fact is, the primal scene story about the doctor's waiting room that I opened this text with is not true. Had it been, the fact that the images I would have been looking at would have been implausible objects of my identification, according to a realist schema of measurability, is irrelevant. The "self-comparison" of the above quote is described as a less than direct, but uncomplicated and achievable look. Popular arguments such as the one from *Vogue* are unmindful of the psychical/social overlap that constitutes such a look. They also, symptomatically, treat the medium as transparent. In these popular arguments, it is the models that are constantly changing and the models that are paraded in front of a

purportedly definable and predictable audience, to be looked at. It is the
unself-conscious assumption of a realist discourse about photography
that allows for the mediation of the medium to recede. Such a discourse,
of course, elides the issue of the photograph's illusionism, investedness,
socially naturalized status. It is disengaged from a discourse that would
seek to question the way in which photographic codes produce looks, as
well as the way in which socially/psychically/historically situated looks
produce photographic meaning. While fashion photographs have not
been elevated to what Alan Sekula refers to as the "legal status of docu-
ment and testimonial," the industry itself, along with certain theoretical,
critical, and journalistic discourses, trades on an implied realist dis-
course of naturalized referentiality, even when describing these pictures
with a vocabulary of fantasy (the images as dreamlike, otherworldly,
and so forth). It is not solely a question of taking less seriously the codes
at play in fashion photographs, or of whether this in fact can be accom-
plished. It is a question of considering the complexity of interrelated
looks and objects in a social context. To argue that such images can be
simultaneously oppressive and enabling raises more questions than can
be answered in this text. But it poses the possibility of an *in*effective-
ness of intended aims, a falling short that allows for the possibility of
interventionary looks that would not depend on alternative truths.

Inconclusion

There are not only unanswered questions raised by this text, there are
also significant unasked questions. Questions about how these argu-
ments would be inflected by an address to a panoply of differences and
contingencies: race, class, politics, object-choice, geography, and so on.
My insistence on developing an argument for a kind of resistance-in-the
making in the regard of such images would seem to downplay the
significance of their manifest "content." Instead, it is to emphasize that
the assumption that a resistant stance can be formulated only through
the imposition of knowledge achieved from either empirical data or that
which can be theorized through a social realm that lies *outside* or irre-
spective of the psychical is a weak one.

For resistance or intervention to become something other than
an aberration that confirms in its exclusiveness that which is dominant,
we need to look for fissures in the existing morphology of representa-
tion, rather than overestimate the efficacy of cultural or economic deter-
minations, an overestimation that ironically sometimes results in an
overidentification with such systems.

PHOTOGRAPHY AND FETISH

Christian Metz

This essay was originally published in *October* 34 (Fall 1985) and is reprinted here with permission of the author and MIT Press. An earlier version was delivered at a conference on the theory of film and photography at the University of California, Santa Barbara, in May 1984.

To begin I will briefly recall some of the basic differences between film and photography. Although these differences may be well known, they must be, as far as possible, precisely defined, since they have a determinant influence on the respective status of both forms of expression in relation to the fetish and fetishism.

First difference: the spatio-temporal size of the *lexis*, according to that term's definition as proposed by the Danish semiotician Louis Hjelmslev. The lexis is the socialized unit of reading, of reception: in sculpture, the statue; in music, the "piece." Obviously the photographic lexis, a silent rectangle of paper, is much smaller than the cinematic lexis. Even when the film is only two minutes long, these two minutes are *enlarged*, so to speak, by sounds, movements, and so forth, to say nothing of the average surface of the screen and of the very fact of projection. In addition, the photographic lexis has no fixed duration (= temporal size): it depends, rather, on the spectator, who is the master of the look, whereas the timing of the cinematic lexis is determined in advance by the filmmaker. Thus on the one side, "a free rewriting time"; on the other, "an imposed reading time," as Peter Wollen has pointed out.[1] Thanks to these two features (smallness, possibility of a lingering look), photography is better fit, or more likely, to work as a fetish.

Another important difference pertains to the social use, or more exactly (as film and photography both have many uses) to their principal legitimated use. Film is considered as collective entertainment or as art, according to the work and to the social group. This is probably due to the fact that its production is less accessible to "ordinary" people than that of photography. Equally, it is in most cases fictional, and our culture still has a strong tendency to confound art with fiction. Photography enjoys a high degree of social recognition in another domain: that of the presumed real, of life, mostly private and family life, birthplace of the Freudian fetish. This recognition is ambiguous. Up to a point, it does correspond to a real distribution of social practices: people do take photographs of their children, and when they want their feature film, they do go to the movies or watch TV. But on the other side, it happens that photographs are considered by society as works of art, presented in exhibitions or in albums accompanied by learned commentary. And

1. Peter Wollen, "Fire and Ice," *Photographies* 4 (1984).

the family is frequently celebrated, or self-celebrated, in private, with super-8 films or other nonprofessional productions, which *are* still cinema. Nevertheless, the kinship between film and collectivity, photography and privacy, remains alive and strong as a social myth, half true like all myths; it influences each of us, and most of all the stamp, the look of photography and cinema themselves. It is easy to observe — and the researches of the sociologist Pierre Bordieu,[2] among others, confirm it — that photography very often primarily means souvenir, keepsake. It has replaced the portrait, thanks to the historical transition from the period when long exposure times were needed for true portraits. While the social reception of film is oriented mainly toward a show-business-like or imaginary referent, the real referent is felt to be dominant in photography.

There is something strange in this discrepancy, as both modes of expression are fundamentally *indexical*, in Charles Sanders Pierce's terms. (A recent, remarkable book on photography by Philippe Dubois is devoted to the elaboration of this idea and its implications.)[3] Pierce called indexical the process of signification (*semiosis*) in which the signifier is bound to the referent not by a social convention (= "symbol"), not necessarily by some similarity (= "icon"), but by an actual contiguity or connection in the world: the lightning is the index of the storm. In this sense, film and photography are close to each other, both are *prints* of real objects, prints left on a special surface by a combination of light and chemical action. This indexicality, of course, leaves room for iconic aspects, as the chemical image often looks like the object (Pierce considered photography as an index *and* an icon). It leaves much room for symbolic aspects as well, such as the more or less codified patterns of treatment of the image (framing, lighting, and so forth) and of choice or organization of its contents. What is indexical is the mode of production itself, the principle of the *taking*. And at this point, after all, a film is only a series of photographs. But it is more precisely a series with supplementary components as well, so that the unfolding as such tends to become more important than the link of each image with its referent. This property is very often exploited by the narrative, the initially indexical power of the cinema turning frequently into a realist guarantee for the unreal. Photography, on the other hand, remains closer to the pure index, stubbornly pointing to the print of what *was*, but no longer *is*.

A third kind of difference concerns the physical nature of the respective signifiers. Lacan used to say that the only materialism he knew was the materialism of the signifier. Whether the only one or not,

2. Pierre Bordieu, *Un art moyen. Essai sur les usages sociaux de la photographie* (Paris: Editions de Minuit, 1965).

3. Philippe Dubois, *L'acte photographique* (Paris and Brussels: Nathan and Labor, 1983).

in all signifying practices the material definition is essential to their social and psychoanalytic inscription. In this respect — speaking in terms of set theory — film "includes" photography: cinema results from an addition of perceptive features to those of photography. In the visual sphere, the important addition is, of course, movement and the plurality of images, of shots. The latter is distinct from the former: even if each image is still, switching from one to the next creates a *second movement*, an ideal one, made out of successive and different immobilities. Movement and plurality both imply *time*, as opposed to the timelessness of photography which is comparable to the timelessness of the unconscious and of memory. In the auditory sphere — totally absent in photography — cinema adds phonic sound (spoken words), nonphonic sound (sound effects, noises, and so forth), and musical sound. One of the properties of sounds is their expansion, their development in time (in space they only irradiate), whereas images construct themselves in space. Thus film disposes of five more orders of perception (two visual and three auditory) than does photography, all of the five challenging the powers of silence and immobility which belong to and define all photography, immersing film in a stream of temporality where nothing can be *kept*, nothing stopped. The emergence of a fetish is thus made more difficult.

Cinema is the product of two distinct technological inventions: photography, and the mastering of stroboscopy, of the ø-effect. Each of these can be exploited separately: photography makes no use of stroboscopy, and animated cartoons are based on stroboscopy without photography.

The importance of immobility and silence to photographic *authority*, the nonfilmic nature of this authority, leads me to some remarks on the relationship of photography with death. Immobility and silence are not only two objective aspects of death, they are also its main symbols, they *figure* it. Photography's deeply rooted kinship with death has been noted by many different authors, including Dubois, who speaks of photography as a "thanatography," and, of course, Roland Barthes, whose *Camera Lucida*[4] bears witness to this relationship most poignantly. It is not only the book itself but also its position of enunciation which illustrates this kinship, since the work was written just after (and because of) the death of the mother, and just before the death of the writer.

Photography is linked with death in many *different* ways. The most immediate and explicit is the social practice of keeping photographs in

4. Roland Barthes, *Camera Lucida*, trans. Richard Howard (New York: Hill and Wang, 1981).

memory of loved beings who are no longer alive. But there another real death which each of us undergoes every day, as each day we draw nearer our own death. Even when the person photographed is still living, that moment when she or he *was* has forever vanished. Strictly speaking, the person *who has been photographed* — not the total person, who is an effect of time — is dead: "dead for having been seen," as Dubois says in another context.[5] Photography is the mirror, more faithful than any actual mirror, in which we witness at every age, our own aging. The actual mirror accompanies us through time, thoughtfully and treacherously; it changes with us, so that we appear not to change.

5. Dubois, *L'acte photographique*, p. 89.

Photography has a third character in common with death: the snapshot, like death, is an instantaneous abduction of the object out of the world into another world, into another kind of time — unlike cinema, which replaces the object, after the act of appropriation, in an unfolding time similar to that of life. The photographic *take* is immediate and definitive, like death and like the constitution of the fetish in the unconscious, fixed by a glance in childhood, unchanged and always active later. Photography is a cut inside the referent, it cuts off a piece of it, a fragment, a part object, for a long immobile travel of no return. Dubois remarks that with each photograph, a tiny piece of time brutally and forever escapes its ordinary fate, and thus is protected against its own loss. I will add that in life, and to some extent in film, one piece of time is indefinitely pushed backwards by the next: this is what we call "forgetting." The fetish, too, means both loss (symbolic castration) and protection against loss. Peter Wollen states this in an apt simile: photography preserves fragments of the past "like flies in amber."[6] Not by chance, the photographic art (or acting, who knows?) has been frequently compared with shooting, and the camera with a gun.

6. Wollen, "Fire and Ice."

Against what I am saying, it could of course be objected that film as well is able to perpetuate the memory of dead persons, or of dead moments of their lives. Socially, the family film, the super-8, and so forth, to which I previously alluded, are often used for such a purpose. But this pseudosimilarity between film and photography leads me back, in a paradoxical way, to the selective kinship of photography (not film) with death, and to a fourth aspect of this link. The two modes of perpetuation are very different in their effects, and nearly opposed. Film gives back to the dead a semblance of life, a fragile semblance but one immediately strengthened by the wishful thinking of the viewer. Photography, on the contrary, by virtue of the objective suggestions of its signifier (stillness, again) maintains the memory of the dead *as being dead*.

7. Sigmund Freud, "Mourning and Melancholia," in *The Standard Edition of the Complete Psychological Works of Sigmund Freud*, trans. James Strachey (London: Hogarth Press and the Institute of Psycho-Analysis, 1953–1974), vol. 14.

Tenderness toward loved beings who have left us forever is a deeply ambiguous, split feeling, which Freud has remarkably analyzed in his famous study, "Mourning and Melancholia."[7] The work of mourning is at the same time an attempt (not successful in all cases: see the suicides, the breakdowns) to survive. The object-libido, attached to the loved person, wishes to accompany her or him in death, and sometimes does. Yet the narcissistic, conservation instinct (ego-libido) claims the right to live. The compromise which normally concludes this inner struggle consists in transforming the very nature of the feeling for the object, in learning progressively to love this object *as dead*, instead of continuing to desire a living presence and ignoring the verdict of reality, hence prolonging the intensity of suffering.

Sociologists and anthropologists arrive by other means at similar conceptions. The funeral rites which exist in all societies have a double, dialectically articulated signification: a remembering of the dead, but a remembering as well *that they are dead*, and that life continues for others. Photography, much better than film, fits into this complex psycho-social operation, since it suppresses from its own appearance the primary marks of "livingness," yet nevertheless conserves the convincing print of the object: a past presence.

All this does not concern only the photographs of loved ones. There are obviously many other kinds of photographs: landscapes, artistic compositions, and so forth. But the kind on which I have insisted seems to me to be exemplary of the whole domain. In all photographs, we have this same act of cutting off a piece of space and time, of keeping it unchanged while the world around continues to change, of making a compromise between conservation and death. The frequent use of photography for private commemorations thus results in part (there are economic and social factors, too) from the intrinsic characteristics of photography itself. In contrast, film is less a succession of photographs than, to a large extent, a destruction of the photograph, or more exactly of the photograph's power and action.

8. Freud, "Fetishism," *S.E.*, vol. 21.

At this point, the problem of the space off-frame in film and in photography has to be raised. The fetish is related to death through the terms of castration and fear, to the off-frame in terms of the look, glance, or gaze. In his well-known article on fetishism,[8] Freud considers that the child, when discovering for the first time the mother's body, is terrified by the very possibility that human beings can be "deprived" of the penis, a possibility which implies (imaginarily) a permanent danger of

castration. The child tries to maintain its prior conviction that all human beings have the penis, but in opposition to this, what has been seen continues to work strongly and to generate anxiety. The compromise, more or less spectacular according to the person, consists in making the seen retrospectively unseen by a disavowal of the perception, and in *stopping the look*, once and for all, on an object, the fetish — generally a piece of clothing or underclothing — which was, with respect to the moment of the primal glance, near, just prior to, the place of the terrifying absence. From our perspective, what does this mean, if not that this place is positioned off-frame, that the look is framed close by the absence? Furthermore, we can state that the fetish is taken up in two chains of meaning: metonymically, it alludes to the contiguous place of the lack, as I have just stated; and metaphorically, according to Freud's conception, it is an equivalent of the penis, as the primordial displacement of the look aimed at replacing an absence by a presence — an object, a small object, a part object. It is remarkable that the fetish — even in the common meaning of the word, the fetish in everyday life, a re-displaced derivative of the fetish proper, the object which brings luck, the mascot, the amulet, a fountain pen, cigarette, lipstick, a teddybear, or pet — it is remarkable that it always combines a double and contradictory function: on the side of metaphor, an inciting and encouraging one (it is a pocket phallus); and, on the side of metonymy, an apotropaic one, that is, the averting of danger (thus involuntarily attesting a belief in it), the warding off of bad luck or of the ordinary, permanent anxiety which sleeps (or suddenly wakes up) inside each of us. In the clinical, nosographic, "abnormal" forms of fetishism — or in the social institution of the striptease, which pertains to a collective nosography and which is, at the same time, a progressive process of framing/deframing — pieces of clothing or various other objects are absolutely necessary for the restoration of sexual power. Without them nothing can happen.

Let us return to the problem of off-frame space. The difference which separated film and photography in this respect has been partially but acutely analyzed by Pascal Bonitzer.[9] The filmic off-frame space is *étoffé*, let us say "substantial," whereas the photographic off-frame space is "subtle." In film there is a plurality of successive frames, of camera movements, and character movements, so that a person or an object which is off-frame in a given moment may appear inside the frame the moment after, then disappear again, and so on, according to the principle (I purposely exaggerate) of the *turnstile*. The off-frame is taken into the evolutions and scansions of the temporal flow: it is

9. Pascal Bonitzer, "Le hors-champ subtil," *Cahiers du cinéma* 311 (May 1980).

off-frame, but not off-film. Furthermore, the very existence of a sound track allows a character who has deserted the visual scene to continue to mark her or his presence in the auditory scene (if I can risk this quasi-oxymoron: "auditory" and "scene"). If the filmic off-frame is substantial, it is because we generally know, or are able to guess more or less precisely, what is going on in it. The character who is off-frame in a photograph, however, will never come into the frame, will never be heard — again a death, another form of death. The spectator has no empirical knowledge of the contents of the off-frame, but at the same time cannot help imagining some off-frame, hallucinating it, dreaming the shape of this emptiness. It is a projective off-frame (that of the cinema is more introjective), an immaterial, "subtle" one, with no remaining print. "Excluded," to use Dubois's term, excluded once and for all. Yet nevertheless present, striking, properly fascinating (or hypnotic) — insisting on its status as *excluded* by the force of its absence *inside* the rectangle of paper, which reminds us of the feeling of lack in the Freudian theory of the fetish. For Barthes, the only part of a photograph which entails the feeling of an off-frame space is what he calls the *punctum*, the point of sudden and strong emotion, of small trauma; it can be a tiny detail. This *punctum* depends more on the reader than on the photograph itself, and the corresponding off-frame it calls up is also generally subjective; it is the "metonymic expansion of the *punctum*."[10]

10. Barthes, *Camera Lucida*, p. 45.

Using these strikingly convergent analyses which I have freely summed up, I would say that the off-frame effect in photography results from a singular and definitive cutting off which figures castration and is figured by the "click" of the shutter. It marks the place of an irreversible absence, a place from which the look has been averted forever. The photograph itself, the "in-frame," the abducted part-space, the place of presence and fullness — although undermined and haunted by the feeling of its exterior, of its borderlines, which are the past, the left, the lost: the far away even if very close by, as in Walter Benjamin's conception of the "aura"[11] — the photograph, inexhaustible reserve of strength and anxiety, shares, as we see, many properties of the fetish (as object), if not directly of fetishism (as activity). The familiar photographs that many people always carry with them obviously belong to the order of fetishes in the ordinary sense of the word.

11. Walter Benjamin, "A Short History of Photography," trans. Phil Patton, in *Classic Essays on Photography*, ed. Alan Trachtenberg (New Haven, Conn: Leete's Island Books, 1980).

Film is much more difficult to characterize as a fetish. It is too big, it lasts too long, and it addresses too many sensorial channels at the same time to offer a credible unconscious equivalent of a lacking part-object. It does *contain* many potential part-objects (the different shots,

the sounds, and so forth), but each of them disappears quickly after a moment of presence, whereas a fetish has be to kept, mastered, held, like the photograph in the pocket. Film is, however, an extraordinary activator of fetishism. It endlessly mimes the primal displacement of the look between the seen absence and the presence nearby. Thanks to the principle of a *moving cutting off*, thanks to the changes of framing between shots (or within a shot: tracking, panning, characters moving into or out of the frame, and so forth), cinema literally *plays* with the terror and the pleasure of fetishism, with its combination of desire and fear. This combination is particularly visible, for instance, in the horror film, which is built upon progressive reframings that lead us through desire and fear, nearer and nearer the terrifying place. More generally, the play of framings and the play with framings, in all sorts of films, work like a striptease of the space itself (and a striptease proper in erotic sequences, when they are constructed with some subtlety). The moving camera caresses the space, and the whole of cinematic fetishism consists in the constant and teasing displacement of the cutting line which separates the seen from the unseen. But this game has no end. Things are too unstable, and there are too many of them on the screen. It is not simple — although still possible, of course, depending on the character of each spectator — to stop and isolate one of these objects, to make it able to work as a fetish. Most of all, a film cannot be *touched*, cannot be carried and handled: although the actual reels can, the projected film cannot.

12. Octave Mannoni, "Je sais bien mais quand même...," *Clefs pour l'imaginaire; ou, L'autre scène* (Paris: Seuil, 1969).

I will deal more briefly with the last difference — and the problem of belief-disbelief — since I have already spoken of it. As pointed out by Octave Mannoni,[12] Freud considered fetishism the prototype of the cleavage of belief: "I know very well, *but*... ." In this sense, film and photography are basically similar. The spectator does not confound the signifier with the referent, she or he knows what a *representation* is, but nevertheless has a strange feeling of reality (a denial of the signifier). This is a classical theme of film theory.

But the very nature of *what* we believe in is not the same in film and photography. If I consider the two extreme points of the scale — there are, of course, intermediate cases: still shots in films, large and filmlike photographs, for example — I would say that film is able to call up our belief for long and complex dispositions of actions and characters (in narrative cinema) or of images and sounds (in experimental cinema), to disseminate belief; whereas photography is able to fix it, to concen-

trate it, to spend it all at the same time on a single object. Its poverty constitutes its force — I speak of a poverty of means, not of significance. The photographic effect is not produced from diversity, from itinerancy or inner migrations, from multiple juxtapositions or arrangements. It is the effect, rather, of a laser or lightning, a sudden and violent illumination on a limited and petrified surface: again the fetish and death. Where film lets us believe in more things, photography lets us believe more in one thing.

In conclusion, I should like to add some remarks on the use of psychoanalysis in the study of film, photography, theater, literature, and so on. First, there are presentations, like this one, which are less "psychoanalytic" than it might seem. The notion of "fetish," and the word, were not invented by Freud; he took them from language, life, the history of cultures, anthropology. He proposed an *interpretation* of fetishism. This interpretation, in my opinion, is not fully satisfactory. It is obvious that it applies primarily to the early evolution of the young *boy*. (Incidentally, psychoanalysts often state that the recorded clinical cases of fetishism are for the most part male.) The fear of castration and its further consequence, its "fate," are necessarily different, at least partially, in children whose body is similar to the mother's. The Lacanian notion of the *phallus*, a symbolic organ distinct from the penis, the real organ, represents a step forward in theory; yet it is still the case that within the description of the human subject that psychoanalysis gives us, the male features are often dominant, mixed with (and as) general features. But apart from such distortions or silences, which are linked to a general history, other aspects of Freud's thinking, and various easily accessible observations which confirm it, remain fully valid. These include: the analysis of the fetishistic nature of male desire; in both sexes the "willing suspension of disbelief" (to use the well-known Anglo-Saxon notion), a suspension which is determinant in all representative arts, in everyday life (mostly in order to solve problems by half-solutions), and in the handling of ordinary fetishes; the fetishistic pleasure of framing-deframing.

It is impossible to *use* a theory, to "apply" it. That which is so called involves, in fact, two aspects more distinct than one might at first believe: the intrinsic degree of perfection of the theory itself, and its power of suggestion, of activation, of enlightenment *in another field* studied by other researchers. I feel that psychoanalysis has this power in the fields of the humanities and social sciences because it is an acute and profound discovery. It has helped *me* — the personal coefficient of each researcher always enters into the account, despite the ritual

declarations of the impersonality of science — to explore one of the many possible paths through the complex problem of the relationship between cinema and photography. I have, in other words, used the theory of fetishism as a fetish.

Psychoanalysis, as Raymond Bellour has often underscored, is contemporary in our western history with the technological arts (such as cinema) and with the reign of the patriarchal, nuclear, bourgeois family. Our period has invented neurosis (at least in its current form), *and* the remedy for it (it has often been so for all kinds of diseases). It is possible to consider psychoanalysis as the founding myth of our emotional modernity. In his famous study of the Oedipus myth, Lévi-Strauss has suggested that the Freudian interpretation of this myth (the central one in psychoanalysis, as everybody knows) could be nothing but the last variant of the myth itself.[13] This was not an attempt to blame: myths are always true, even if indirectly and by hidden ways, for the good reason that they are invented by the natives themselves, searching for a parable of their own fate.

After this long digression, I turn back to my topic and purpose, only to state that they could be summed up in one sentence: film is more capable of playing on fetishism, photography more capable of itself becoming a fetish.

13. Claude Lévi-Strauss, chap. 11, "La structure des mythes," in *Anthropologie structurale*, (Paris: Plon, 1958); translated as *Structural Anthropology* (New York: Basic Books, 1963).

NEWTON'S GRAVITY

Victor Burgin

Sex is deadly serious.
— Helmut Newton, *Portraits*

I have a friend in New York. An Australian. A photographer. We're in his loft, and he pulls a print from down under a pile on a metal shelf. Hands it to me with a crazy giggle he has when he's enjoying himself but a bit embarrassed about it. I have to assume that the self-conscious-looking kid in the photograph is him. Dolled up by his parents for some high-street photographer. Long ago. Far away. "Look on the back," he says. I turn the print over. There's the name of the studio: *Helmut Newton.*

Helmut Newton Portraits, New York: Pantheon Books, 1987

Plates 1–22: Helmut; June; doctors; models... 1934–1986:
June on the *métro* in 1957, alongside a much older woman; June in Paris twenty-five years later, looking down at a fresh postoperative scar which starts well above her navel and ends just above her pubis. June in Melbourne in 1947. June in Monte Carlo thirty-five years later.

Helmut adolescent, sprawled on a Berlin beach, a girl in each arm and one between his knees. Helmut fifty-two years later, on his back for the doctors — Paris, San Francisco. *Self-portrait in Yva's studio, Berlin 1936:* all hat and overcoat and gloves and camera-case. *Self-portrait during an electrocardiogram, Lenox Hill Hospital, New York 1973:* all naked and wired up, with dangling leads and penis; arms akimbo, elbows bent, raised away from his body; one behind his head; a newly taken prisoner.

All naked (except for high-heeled shoes), arms akimbo, elbows bent, raised away from her body; one behind her head; alongside an older woman; the woman is June; Helmut appears between them, reflected in the mirror which reflects the model — *Self-portrait with wife June and models, Vogue studio, Paris 1981.*

We see both the model's back and her reflection in the mirror. The rectangle of the mirror, in which her image appears full length, fits the

165

Helmut Newton,
*Self-portrait with wife
June and models,
Vogue studio, Paris
1981.* Courtesy of
the artist.

space beneath her right elbow. Helmut's reflection, also full length, fits the space beneath her reflected elbow. June, just to the right of the mirror, sits cross-legged in a director's chair. Her left elbow on her left knee, chin propped on her left hand, mouth tense. Her right hand makes a fist. Helmut is wearing a raincoat, his face hidden as he bends over his Rolleiflex.

Caught looking

CS: One of your self-portraits shows you wearing a trench coat with a nude model, and your wife sitting off to one side. Does your wife sit in on photo sessions?

HN: Never. Ever. She had just come by for lunch that day.

— Newton talking to Carol Squiers, *Portraits*

Here I am, bent over the keyhole; suddenly I hear a footstep. I shudder as a wave of shame sweeps over me. Somebody has seen me.

— Sartre, *Being and Nothingness*

I am a voyeur!… If a photographer says he is not a voyeur, he is an idiot!

— Newton, *Portraits*

Every active perversion is…accompanied by its passive counterpart: anyone who is an exhibitionist in his unconscious is at the same time a *voyeur.*

— Freud, *Three Essays on the Theory of Sexuality*

There are certain clubs here and in Paris where people just watch other people fuck.

— Newton, *Portraits*

Anyone who desires to witness the sexual activities of a man and woman really always desires to share their experience by a process of empathy, generally in a homosexual sense, i.e., by empathy in the experience of the partner of the opposite sex.

— Fenichel, *Collected Papers*

The mirror is there so the model can see herself; the photographer would normally have his back to the mirror; a "correct distance" would divide their supposedly incommensurable roles: exhibitionist, voyeur. But Newton has invaded her space, planted his feet on her paper desert island — that Light Continent inhabited by Big Nudes. From this position, he now receives the look he gives. By entering the model's space he has, in a sense, taken her place — identified himself with her. June, his wife, has taken his place. Newton reveals himself to her, and to us, as a voyeur — the raincoat is his joke at his own expense. A voyeur in a raincoat? The photographer is here both a voyeur *and* an exhibitionist: a flasher, making an exposure. The raincoat opens at the front to form a shadowy delta, from which has sprung this tensely erect and gleamingly naked woman, this *coquette*. The photographer has flashed his prick, and it turns out to be a woman. Who else wears a raincoat? A detective — like the one who, in all those old B-movies, investigates all those old dangerously mysterious young women. Following her, watching her until, inevitably, the *femme* proves *fatale*. Where am I in all this? In the same place as Newton — caught looking.

Keep looking

Newton has made an indiscernible movement of the tip of one finger. The shutter has opened and paused. In this pause the strobe has fired, sounding as if someone had clapped his hands together, once, very loud. The light has struck a square of emulsion. Out in the street a driver in a stationary car has perhaps glimpsed, illuminated in this flash of interior lightning, the figure of a naked woman. Perhaps not. In the future (now past) the shutter will close. Newton will put down the camera. Helmut and June will go to lunch. The models will put on their clothes; perhaps they will go to lunch together. Perhaps not. I know nothing of this woman who is now "showing everything"; nor of the other woman whose stiletto-heeled legs project from the left into the mirrored space. It is difficult to decide where, precisely, these legs are to be located (with the result that the space of the mirror seems curiously apart from the real space of the room, almost as if the disembodied legs, and Newton, existed *only* in the mirror). Ridiculously, the legs can be "read" as an awkward appendage to the out-of-focus foreground figure — bringing to my mind (more ridiculously) an old woodcut in which the Devil is depicted with a forked penis. Such provision of a substitute penis for the one the woman "lacks" is what motivates fetishism. The fetish allays the castration anxiety which results from the little boy's

discovery that his mother, believed to lack nothing, has no penis. The contradictory function of the fetish is to deny the perception it commemorates. It is a particular example of a general form of defense against disquieting knowledge of the world which Freud termed "disavowal" — which takes the form "I know very well, but nevertheless…" Other defensive moves are possible. If the penis is not here, then it clearly must be elsewhere, in space or in time. One has only to keep looking. (*All* of this, of course, is ridiculous; but the unconscious is far less sensible about such things than we are.)

…whatever uneasiness he may have felt was calmed by the reflection that what was missing would yet make its appearance: she would grow one (a penis) later.
— Freud, "*Splitting of the Ego in the Process of Defense*"

That form of masculine behavior we call *Don Juanism* is popularly understood as motivated by an insatiable thirst for conquest. As I wrote some years ago, "…we can interpret Don Juan's behavior another way: the most poignant moment for Don Juan takes place…between the bedroom door and the bed — it's the moment of undressing."

CS: When you photographed yourself nude in 1976, your clothes were very neatly folded on a chair in the picture. But when you photograph women who are nude, their clothes are scattered everywhere…
HN: I'm quite a tidy person. I would hate to live in disorder…. But this is interesting — I create that disorder — I want the model to take all her clothes off and just dump them.
— Newton talking to Carol Squiers, *Portraits*

Waste of time

If I say to a person, I want to see you naked, and in my head I say, Well I would like to fuck her but the reason I don't is because I'm scared to get AIDS or something…
— Newton, *Portraits*

The little boy thought he knew women, now he knows better. In this moment he has also learned that what exists can also *not* exist. The only find of comparable magnitude to the discovery of the reality of sexual difference is the discovery of the reality of death. Small children have a problem with death, the fact of death tends to disappear over their conceptual horizon. "Dead" to the child initially means "not here," which in

turn implies "elsewhere." Again, one only has to "keep looking" to restore what was lost. What was lost *can* be found; but every move repeats the discovery of loss. Observing a universal compulsion to repeat painful experiences, Freud was lead to posit a "death drive" alongside the libidinal drive. Much confusion surrounds this concept. I prefer the recent formulations of Jean Laplanche. There is only one drive, and it is sexual, but it has two aspects: one seeks to conserve the self and its object; the other seeks to destroy one or the other (or both, for in reality they are the same — read Freud on narcissism); hence sexual aggression and sadomasochism. Newton's joke at his own expense is self-destructive (the raincoat on this hunched figure, minia-turized by the object of his fascination, reminds me of the phrase — *King Lear*, I think — "a giant's robe on a dwarfish thief"). June's appearing in this picture in public is self-destructive, for she has now changed seats with the woman on the métro. The same "joke" of aging is being played on the shining woman at the center of this image; but only in reality, not in this photograph. Everything pivots around this naked figure (appropriately, we see her from both front and back). There to be admired simply because she exists, she need do nothing more than *be*. She is a statue in marble, like the *Venus Victrix* in Villiers de L'Isle-Adam's *L'Eve Future*, who is imagined to utter, "Moi, je suis seulement la Beauté même. Je ne pense que par l'esprit de qui me contemple" [I, I am simply beauty itself. I think only through the mind of the one who contemplates me]. Yes, I know. The model is a *real* woman, caught up in an economy in which her identity is reduced to that of a figment of a man's imagination. I understand why you think that that's the most important thing about this picture; but economies are not only mone-tary, they are psychical, and the psychical is worth more than a penny in our exchanges. This statue in marble, like so many of the women in Newton's photographs, is on a marble slab; the photograph, like so many photographs — which annihilate color, movement, and sound — leaves the detective an exquisite corpse. Back in the days of silent movies, Cocteau remarked that the camera "filmed death at work." Portraits are a by-product, a waste-product, of time at work — the waste of time.

All these young photographers who are at work in the world, determined upon the capture of actuality, do not know that they are the agents of Death. This is the way in which our time assumes Death: with the denying alibi of the distract-edly "alive," of which the Photographer is in a sense the professional....For Death must be somewhere in a society; if it is no longer (or less intensely) in

religion, it must be elsewhere; perhaps in this image which produces Death while trying to preserve life… Life/Death: the paradigm is reduced to a simple click, the one separating the initial pose from the final print.
— Roland Barthes, *Camera Lucida*

…I'm not at all interested in death. I'm not preoccupied by death. My wife, June, once said, Helmut, don't you want to discuss this subject? And I said, It doesn't interest me. I don't want to discuss it, it's a waste of time…. I don't care about it.
— Newton, *Portraits*

Perverse love

This is a photograph, not a movie; but nevertheless, this is a moral tale. I think of those allegorical paintings which show *Time ordering Old Age to destroy Beauty*. Why is there so often a *trio* of principal protagonists in these allegories of the human condition? If I had more time I might write about this. I immediately think of two images in relation to Newton's *Self-portrait with wife June and models:* Robert Doisneau's 1948 photograph *Un Regard Oblique*, which shows a middle-aged couple looking into the window of a picture dealer, the man's slyly insistent gaze on a painting of a seminaked young woman; and Balthus's 1933 painting *La toilette de Cathy*, in which a young man, seated in an attitude which reminds me of June's posture in Newton's picture, seems to take an anxious lack of interest in the seminaked young woman who is having her hair combed by a much older woman. ("It doesn't interest me… I don't care about it.")

In an essay about "The Perverse Couple," Jean Clavreul describes a complex system of relations which "nest" one inside the other, like "Russian dolls." First, there is the relation of the fetishist to his object; but the fetishist of whom Clavreul speaks can value this object only to the extent that *someone else* values it. Second, then, there is the relation of this second person to his object. Where this person is his wife, as it very often is, then there also exists the relation of this woman to her husband, in his relation to his (become "their") fetish object — as well as, of course, to her. A third person is now called upon as *witness*, as the "perverse couple" thus formed seek the recognition of an "external" other. Perverse? All human sexuality is deviant. Nothing about our sexuality belongs to anything that could be described as a "natural" instinctual process. In the natural world instinctual behavior is heredi-tary, predictable, and invariant in any member of a given species. In the human animal what might once have been instinct now lives only in

shifting networks of symbolic forms — from social laws to image systems. Human sexuality is not natural, it is cultural. The same movement which produces culture, in the broadest sense of the word, also produces the unconscious — psychoanalysis is the theory of this unconscious, and it was in the discovery of the unconscious that Freud first dismantled the barrier between "normal" reproductive heterosexuality and "perversions." At the end of the nineteenth century, Freud inherited comprehensive data on sexual perversions from the sexologists. For researchers such as Richard von Krafft-Ebing and Havelock Ellis, the behaviors they catalogued were viewed as deviations from "normal" sexuality. Freud, however, was struck by the ubiquity of such "deviations" — whether in dramatically pronounced form, or in the most subdued of ordinary "foreplay." (It was Freud who remarked that that mingling of entrances to the digestive tract we call "kissing" is hardly the most direct route to reproductive genital union.) In his 1905 *Three Essays on the Theory of Sexuality* he observed, "the disposition to perversions is itself of no great rarity but must form a part of what passes as the normal constitution. In opposition to the sexologists, who took socially accepted "normal" sexuality as inherent to human nature, Freud stated that "from the point of view of psychoanalysis the exclusive sexual interest felt by men for women is also a problem that needs elucidating and is not a self-evident fact." If the word "perversion" still has an air of disapprobation about it today, this is not the fault of psychoanalysis. Perversion is defined *only* in relation to social law, written or not. Robert Mapplethorpe could exhibit his most "perverse" pictures at the Whitney Museum of American Art only in exchange for the redeeming promise of his own impending death. Clavreul recognizes that the pervert within the perverse couple may receive public acknowledgment, even acceptance, of his perversion because it may be recognized as situated within the redeeming field of *love*.

Alice Springs: Portraits, **Pasadena: Twelvetrees Press, 1986**

Why is a young girl so pretty, and why does this state last such a short time? I could become quite melancholy over this thought, and yet, after all, it is no concern of mine. Enjoy, do not talk. The people who make a profession of such reflections generally do not enjoy. However, it can do no harm to harbor this thought, for the sadness it evokes, a sadness not for one's self but for others, generally makes one a little more handsome in a masculine way.

— Kierkegaard, *Diary of a Seducer*

...all men of my generation are concerned with this under their chins. I say I look like an old crocodile!
— Newton, *Portraits*

His mouth tired, tense — *Helmut Newton, Paris 1976.* Sitting for June; between his legs, his camera, exhausted. Sprawled on the bed behind him a woman's naked form, in one of those positions which in

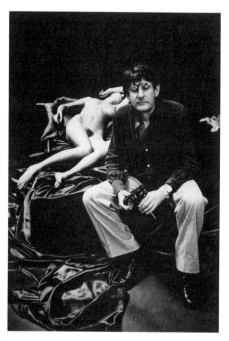

Alice Springs, *Helmut Newton, Paris 1976.* Courtesy of the artist.

painting would imply lascivious exhaustion (the "little death"). One of her arms hides her face, in a gesture reminiscent of Masaccio's shameful Eve being cast from Eden. At the same time, by one of those often absurd spatial collapses produced in the camera, she seems to be whispering in Newton's ear — the profound and dreadful secret of her body, a secret told to no man. In *Une Femme est une Femme*, Angéla, twenty-four, wants a baby. If Angéla had had that baby in 1961, the year the film was made, the year Anna Karina (Angéla) got the best new actress award at Cannes, Angéla's child would now be twenty-eight. Anna must now be fifty-two. Angéla works as a stripper. As she strips she sings, "Je ne suis pas sage, je suis trop cruelle"; but (she sings) all the men forgive her because (final line of the chorus) "Je suis *très* belle!" In his written outline where Angéla is called "Josette," Godard says, "Josette believes in her art and practices conscientiously in front of a mirror." But the only such scene I remember is when Josette/Angéla/Anna stuffs a pillow up under her jumper to see how she will look pregnant. When her frown of concentration departs her child's face, it will leave no more trace than does her perfect smile. My own reflection now always seems too tired, too tense. I look away. Newton looks down, into the mirror of his Rolleiflex. I see the words "Peau Saine" on one of those pots which show that a woman shares this bathroom. "Peau Saint," I think, and the image of the woman in Newton's mirror returns to me as a Sainte Sebastienne, waiting to receive time's arrows. June's (Alice's) book lies open on the floor of my office, alongside Helmut Newton's *Portraits.* Helmut is still receiving the young woman's confession. It is the anticipation of this confession — hoped for each time the shutter is withdrawn, exposing the tiny dark room to that which is hopelessly beyond it — that gives Newton's picture its gravity.

PHOTOGRAPHY AND AIDS

Simon Watney

Introduction

This is a revised version of an essay that appeared originally in *Ten.8*, no. 26.

The following article was first written and published in Britain in 1987 and concerns the significance of Acquired Immunodeficiency Syndrome (AIDS) as identified by the major public institutions of photography. It therefore speaks from a particular moment in the history of the epidemic — a history that should always include the active role of representation itself. Yet in spite of many changes and developments in biomedical knowledge and patient care and the emergence of organized cultural and sociopolitical responses, the overall "look" of AIDS has remained significantly stable and resistant to modification. I have added to the original article a new conclusion that considers some aspects of the continuing cultural and ideological resistances to acknowledging the actual complex, shifting realities of Human Immunodeficiency Virus (HIV) infection and its many possible consequences in the lives of individuals and communities. Sadly, most available images of AIDS continue to tell us rather more about the practices of professional photography than about the epidemic.

A friend of mine recently wrote an article for *Nursing Times* which included a reference to the situation of a woman whom she described as "living with AIDS." When the piece was published, it told of the woman "dying of AIDS." An anonymous subeditor had automatically "corrected" the original text in the light of the dominant agenda for thinking AIDS in contemporary Britain. It is this largely unconscious agenda which is my subject, and the role which photography has played in establishing its authority — the authority of *the morbid* which, as Michel Foucault has pointed out, "authorizes a subtle perception of the way in which life finds in death its most differentiated figure."[1] The absolute difference of death has by now become closely identified with the effects of HIV infection and the social groups in which it has emerged. AIDS has been widely interpreted as if it were an intrinsic property of these groups, which are seen as actively threatening rather than *vulnerable*, with the outward and visible signs of infection taken as evidence of their supposed inner and secret depravity. The representation

1. Michel Foucault, *The Birth of the Clinic: An Archaeology of Medical Perception*, (New York: Vintage, 1975), p. 171.

of AIDS gives the lie to any oversimplified assumption that the emergence of pathological anatomy and the modern medical sciences of virology and immunology have led to a complete transformation of the concept of disease "away from the metaphysics of evil, to which it had been relegated for centuries."[2] The most cursory reading of the history of sexually transmitted diseases, for example, demonstrates clearly that the tendency to regard illness as a sign of moral judgment has been displaced rather than replaced at the level of lay perceptions of health by the emergence of modern clinical medicine.[3]

2. Ibid., p. 196.

3. See Allan M. Brandt, *No Magic Bullet: A Social History of Venereal Diseases in the United States Since 1880* (Oxford: Oxford University Press, 1987).

In this respect the representation of AIDS is a site of complex struggle between rival and competing estimations of disease and, at a further extreme, of our very estimation of the range and meanings of human sexuality. The entire subject of AIDS has been used to shore up and reinforce the ideological fortresses of the Nation and the Family, as if they were under a state of unprecedented siege. In this respect we should pay particularly close attention these days to the twin rhetorics of Defense, which promise to protect the national family unit from both the powerful projective fantasy of imminent foreign invasion and the equally powerful introjective fantasy of sexual desire erupting in the bosom of the home with literally fatal consequences. The family is the central locus of concern in British AIDS commentary — but not the families of the more

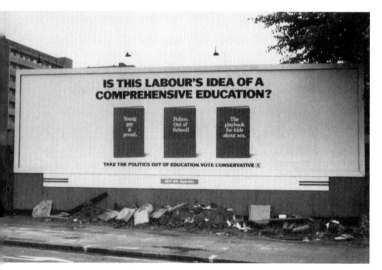

Simon Watney, Conservative Party election billboard, June 1987.

than 90 percent of people with AIDS, who are gay men or intravenous (IV) drug users. The family at the heart of AIDS commentary is an ideological unit, as yet supposedly unaffected, but held to be threatened by the "leakage" of HIV infection, which, like nuclear fallout, is widely and erroneously perceived to be everywhere about us, a deadly miasma of contagion and death.

The concept of the family enjoys absolute centrality for modern social policymakers and their enforcement agents. It is presented as that which precedes them — their object, that on which they work, invested with the full ideological weight of Nature. Yet the family is nothing of the kind, and its apparent stability in the field of public

representation only evidences its primarily *instrumental* role as a rigorously disciplinary and pedagogical environment in which subjectivities are shaped and molded, though not without resistance. As Gayle Rubin observes, a "domino theory of sexual peril"[4] ensures that anything which can be represented as a threat to the family can be used to justify punitive legislation and scandalized outcries "on behalf" of a general public which is universally represented as entirely and unproblematically heterosexual.

In the recent general election campaign, the Conservative Party published a poster which appeared throughout the United Kingdom. It showed three red books, lined up horizontally, with their titles on display: *"Young, gay & proud," "Police: Out of School!"* and *"The playbook for kids about sex."* Above them a caption asked "Is this Labour's idea of a comprehensive education?" while beneath them voters were earnestly exhorted to "Take the politics out of education" and "Vote Conservative." Three strands are densely woven together: in the center, the notion of official institutional support for challenges to the authority of the police, an unacceptable and horrifying threat to the central agency of Law-and-Order, which is simultaneously "our" most immediate and effective defensive recourse against those who threaten to corrupt and molest "our" children, who in turn are held rigidly as parental property rather than as individuals with their own rights. It is axiomatic to this position that "our" children are entirely nonsexual. This fashionable return to a pre-Freudian agenda for thinking childhood is entirely congruent with the dominant structures of The New Victorianism and the theory of sexuality which continually offers us the spectacle of a heterosexual population threatened from all around by the sinister specter of perversion, now equated with Labour Party policy, supposedly encouraging and promoting homosexuality.

We find just the same siege mentality at work in the government's AIDS information campaign, with its exclusive targeting of heterosexuals, despite the fact that at the time of writing there has still been only one definite case in the United Kingdom of AIDS caused by HIV infection contracted sexually between a man and a woman, neither of whom was bisexual or an IV drug user.[5] We cannot, however, afford to simply dismiss such fears as absurd, since they so evidently speak to and for the vast majority of the overall population. Behind the election campaign and the AIDS campaign lies a complex of anxiety which is both social and psychic: social in so far as it is culturally transmitted and expressed, and psychic in so far as it responds to deep levels of sexual repression and guilt. Nor is the mentality of modern familialism easily

4. Gayle Rubin, "Thinking Sex: Notes for a Radical Theory of the Politics of Sexuality," in *Pleasure and Danger: Exploring Female Sexuality*, ed. Carole S. Vance (London: Virago, 1984), p. 282.

5. *The Sunday Times* (London), 21 June 1987.

open to modification, since the central identity of the Parent is massively dependent on such fears and is largely stabilized by them. Hence the bizarre yet immensely powerful convergence of popular assumptions about AIDS, regarding it simultaneously as a blessing in disguise and at the same time a threat to the very fabric of society, if not the future of the species itself. We are dealing here with profound beliefs concerning pollution, beliefs which as Mary Douglas explains, "function to keep some categories of people apart so that others can be together. By preserving the physical categories, pollution beliefs uphold conceptual categories dividing the moral from the immoral and sustain the vision of the good society. Our analytic task is to unwind the causal theories until they reveal who is being kept out and who is being kept in."[6]

6. Mary Douglas and Aaron Wildavsky, *Risk and Culture* (Berkeley: University of California Press, 1983), p. 37.

The physical and conceptual categories constructed and defended by AIDS commentary are readily apparent from the second paragraph of the leaflet designed for national family consumption, which states that "AIDS is not just a homosexual disease." Note the "just," with its barely concealed note of regret. Seven years into the AIDS epidemic, we hardly need to be ordered not to die of ignorance: it is the nature of the carefully orchestrated and institutionalized 'knowledges' about AIDS that are most immediately threatening. These 'knowledges' constitute a level of general AIDS awareness achieved at *the direct cost* of accurate risk perception or any recognition of the enormity of human suffering already occasioned in social groups which familial ideology cannot perceive as fully human. Yet familialism is not without its own internal stresses, and the radical unsuitability of many biological parents to the responsibilities and difficulties of actual child-raising emerges from the dismal litany of examples of domestic child abuse and sexual molestation, most of which take place within the family. The grimly pathological nature of much family life, for adults and children alike, is impossible to square with the banal yet dominant cultural family-ideal of maximized gender distinctions and absolute paternal authority, exercised in a domestic space of pure and uncontaminated heterosexuality. According to this picture, it is the child's moral duty to replicate the parent of its own biological sex, before settling down to the given world of labor relations and the renewed task of sexual reproduction. In this Real-Life world of humanoid Action Men and Barbie Doll marriages, it is hardly surprising that we are constantly faced with stories like that of the "Toy Boy Love Massacre," which reveal the family in a very different light. What is most interesting here is the position of the imaginary spectator, which is highly ambiguous. We read of a wife who leaves her husband, an ex-policeman, for a younger "Toy Boy" lover. The husband finds out and murders his wife and entire family

before killing himself. Quite apart from the implied situation of domestic tension, it is far from clear whether we are intended to identify with the wronged-but-pathological husband, or with the faithless-but-independent wife. The viewing angle on such stories is as radically unstable as the dominant cultural fantasy of family life. Such instability is however immediately resolved in relation to AIDS. Thus we are unambiguously asked to sympathize with the vicar who proclaims that "I'd shoot my son if he had AIDS."

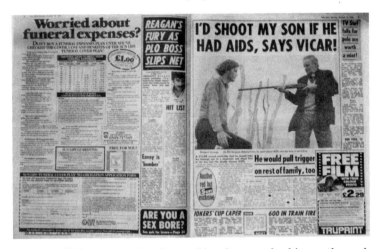

The accompanying photograph sets up the scene of such a crime, with the father pointing a shotgun at his son, above another caption which informs us that "He would pull trigger on rest of family, too." Let us consider this scenario. A father, who is also a priest, is saying

The Sun,
October 14, 1985.

that he would rather murder his son than acknowledge and accept the fact that the boy is gay and terminally ill. This is not held up as an example of psychotic barbarism, but on the contrary, is offered as an example of Christian moral probity. The familial message is clear: better to kill your own son than accept that he is "queer" and already dying. This is the domestic register of the morality which speaks of the *contras* in Nicaragua as "freedom-fighters" and which rushes to denounce "busy-body" social workers stepping in to steal children from their parents — unless it is denouncing the same social workers for their "irresponsibility" in failing to protect the same children from the same brutalizing and murderous families.

For more than five years, groups in the voluntary sector and on the fringes of the National Health Service, in the Family Planning Association, and elsewhere have struggled to achieve some kind of public recognition of the realities of AIDS. As ever, preventative medicine has been struggling against the priorities of clinical practice and the expectations of a "magic bullet" vaccine.[7] The AIDS agenda established right across the entire media industry, and backed up by massive recent government interventions, has now succeeded in creating widespread AIDS awareness — of a kind. This awareness has been constructed around a triad of terms which are every bit as medically inaccurate as they are

7. See Brandt, *No Magic Bullet.*

socially misleading and politically loaded. To begin with, we are end-lessly obliged to imagine "the AIDS virus," and by courtesy of the transmission electron micrograph we can even see it. In 1985 *The Face* referred to it as "the spectre of the decade."[8] In these circumstances it is absolutely crucial to distinguish between HIV infection and the various unpredictable consequences it may have in human subjects, including damage to the central nervous system, AIDS-related condi-tions (ARCs), total dormancy, and the wide variety of life-threatening conditions which result from damage to the body's immune-system, known collectively as AIDS. The collapsing together of HIV infection and AIDS ensures that AIDS takes up both meanings and is itself per-

8. "Panic," *The Face* 61 (May 1985).

ceived as a threaten-ing condition to other people, thus creating a totally unjustified fear of people with AIDS themselves. This in turn supports the routine descrip-tion of people with HIV infection *and* people with AIDS as "AIDS carriers," with the highly mis-leading implication that HIV leads automatically and inexorably to AIDS, together with the

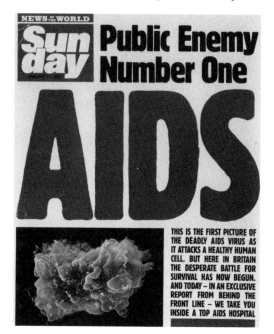

strong suggestion that both conditions are contagious and transmissible by casual contact, as the ancient connotations of "the carrier" so forcibly and mischievously imply.

 Once the "AIDS virus" and the "AIDS carrier" have been estab-lished as a couplet, it is an easy and seemingly logical move to think in terms of an "AIDS test," which completes the triad of terms which make up the AIDS agenda, and slide debate effortlessly from the domain of the medical to that of politics in such a way that specific social policies *toward* AIDS seem to derive directly *from* its medical nature. The central tragedy is that the social policies most frequently envisaged and enacted remain so hopelessly inadequate to the actual task of preventing the spread of HIV infection. It cannot therefore be

overemphasized that the so-called "AIDS test" is in fact nothing of the kind. No single test could possibly be sensitive to all the various conditions classified as AIDS, ranging from a huge array of distinct fungal, protozoal, bacterial, and viral infections to specific tumors and cancers. It is frankly astonishing that AIDS continues to be imagined and portrayed as if it were a discrete illness rather than a conceptual diagnostic category of opportunistic conditions, yet this is the inevitable result of the discursive framing of AIDS since the early 1980s in the terms of the agenda I have described. This remains as seemingly impervious to correction as ever, which strongly suggests the sheer strength of the ideological investment in the views of human sexuality and social relations it evidently protects. In this respect the notion of the "AIDS test" locks the supposed defense of the family back in line with the more traditional rhetoric and strategies concerning the defense of the realm against the threat of foreign invasion. The implication is clear — if AIDS can be detected, it can be kept out of Britain once and for all, like an illegal immigrant or a political "undesirable."

News of the World, Sunday Edition, January 11, 1987 (left), and June 8, 1984 (right).

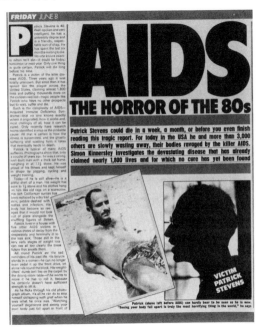

But the HIV antibody test, as it should *always* be described, records only whether or not an individual has produced antibodies in response to HIV infection. Since such antibodies are not necessarily produced for up to a year or more after initial infection, it is not necessarily a reliable index for HIV. Nor does it reveal if an infected individual will develop neurological damage, or an ARC, or AIDS — let alone which presenting symptoms might emerge, or when. Hence its total irrelevance to all aspects of travel and immigration policy, but its immense convenience to those who continue to think about epidemiology in militaristic terms and who wish to launch punitive campaigns against a virus and all those infected by it. This approach only encourages calls for the mass quarantine of people with HIV ("AIDS carriers") who appear as "aliens," an "enemy within" the social formation. This is hardly surprising, since this is precisely the way in which those social groups most devastated by AIDS — gay men, black Africans, IV drug users, and workers in the sex industry — have always been regarded

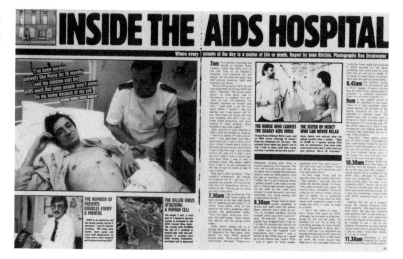

from the narrow, blinkered, and essentially frightened perspective of familial ideology, and the identities it sustains. Behind the pro-testing agenda lies the picture of a world carved up into "high-risk groups," endlessly threatening to overwhelm the rest of the population, in exactly the same way that the "menace" of black immigration and homosexuality are endlessly described in the familial imagination, which can no longer be easily ascribed to The Right alone. Perhaps the most frightening aspect of AIDS commentary is the fact that total misconceptions about the nature of the information provided by the HIV antibody test continue to inform and determine almost all public discussions of AIDS, from tabloid newspapers to medical journals, from the vocabulary of politicians of all persuasions to the general social level of gossip, hearsay, rumor, and jokes. It is in relation to this discursive formation that people with AIDS are forced to live their lives, and against which social policy on AIDS is debated and enacted. Given that the modes of transmission of HIV are now so well understood medically, it is equally extraordinary that public debate continues to be organized primarily in relation to HIV testing rather than to prophylactic education. Unfortunately safer sex information falls foul of the larger contemporary embargo on sex education as a whole, and it is impossible not to conclude that we inhabit a society which prefers to regard an inefficient and ambiguous test as a preferable response to the enormity of AIDS rather than a serious commitment to public education. Such education would have to acknowledge the actual complexity and diversity of sexuality, and this evidently presents familial ideology with an even far greater threat than AIDS. The refusal to accept that the localization of HIV infection among gay men is no more remarkable *per se* than the

localization of *any* viral agent in *any other* social group remains the central problem for health educators.

From the earliest days of this epidemic, it has been the original social positions of the groups most devastated by it that have determined the ways in which the whole subject has been understood and treated — though "treatment" in this case must also include the years of total inaction, and underfunding, as much as any actual policy decisions and their consequences. The HIV virus is thus made to appear to dictate social policy with the full authority of its medical and virological nature, and it is endlessly used as a kind of ideological glove-puppet — being made to speak on behalf of bigoted moralists of all political persuasions in a ventriloquistic performance of great ideological sophistication and complexity. Thus children themselves are frequently recruited to the cause of making the lives of other children with HIV infections ("AIDS Kids") that much more difficult than they need to be. Here at least we can clearly recognize the miserable and impoverished model of the family defended by familial politics — a model which hardly begins to deal with the actual diversity and complexity of human social, sexual, and parenting relations.

The photographic narration of AIDS reinforces the before-and-after conventions of traditional medical photography with the before-and-after conventions of standard photojournalistic practice. An emphasis is all but invariably placed on the question of fatality. This might not be so surprising, given that both HIV and AIDS remain currently incurable and irreversible, were it not for the fact that the vast majority of people with AIDS have a life-expectancy of years and spend most of their time much like everybody else, indistinguishable from the rest of the population. The AIDS agenda requires, however, that AIDS should reveal itself as the stigmata of the doomed and the damned, the concrete visible evidence of the deserts of depravity. Hence the tremendous emphasis on the physical transformation of Rock Hudson's face and body, when the entire story of his fight against AIDS was venomously constructed as the wages of sin and hypocrisy. What is at stake today is an ongoing struggle between the deeply embedded cultural picture of AIDS as retribution, and a model of health which suggests the possibility of individuals and whole social groups taking control of the circumstances and definitions of health and disease. The devastating silence which surrounds the lives of most people with HIV, ARCs, or AIDS suggests that the social constituencies which they are made to represent are officially regarded, in their totality, as disposable. Hence the fetishistic and obsessive concentration on death. Indeed,

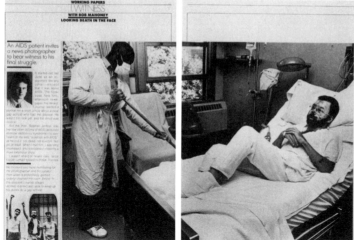

American Photographer,
April 1986.
Photo: Bob Mahoney.

there is no way in which a person with AIDS can hope to enter the public space of photographic representation save as a sign of mortality, regardless of their own responses to AIDS.

The correct site of AIDS thus emerges as the hospital or hospice, which join the prison as the just and proper latitude for the perverse.

At the same time people with AIDS with particularly disfiguring symptoms will be privileged above all others in so far as their features can so easily be made to relay the values of all the surrounding commentary. And as usual, the photojournalist is confirmed in his or her role as the "courageous" and "intrepid" explorer of secret and forbidden realms — even bearing the torch of humanism! Thus Bob Mahoney in *Looking Death in the Face* describes how, on an assignment to photograph a gay man with AIDS, "the job became painful, especially as Jenteel's appearance deteriorated. 'In the end I had to make myself take the pictures,' he said."[9] It is precisely that *compulsive* making of pictures, the sense of AIDS as "a good story," that photography has so firmly established. I am not aware of a single photojournalistic AIDS narrative published in the United Kingdom which does not collude in every respect with the overall discursive tendency to criminalize and stigmatize the hapless subjects. In another AIDS story we are told by an editorial voice-over:

9. David Schonauer, *A Way of Life,*
Introduction to Bob Mahoney,
"Looking Death in the Face,"
American Photographer, April 1986,
p. 97.

The mild-mannered detective pursuing the culprit in this mystery story is photojournalist Matt Herron. He's a good choice for the case, broadly expert where wide expertise is needed.... [What's he going to do after this article?] "I caught the intrigue of this bug," Matt says. "I'm devoting my time to uncovering the riddle of this puzzle, going to Central Africa if that's what it takes. Somebody should."[10]

10. Kevin Kelly on *Matt Herron,*
Whole Earth Review, Fall 1985,
p. 34.

Needless to say, there is no question of Mr. Herron lugging his Leica to London or Washington to explore the scandalous unavailability of drugs for people with AIDS, or to the head offices of the insurance companies which refuse insurance coverage to people with HIV infection, or to the streets of San Francisco and New York where hundreds of homeless people with AIDS sleep out rough every night of the week.

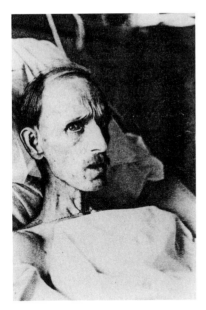

Jim Bell,
Whole Earth Review,
Fall 1985.

What we are shown is a face we already know and recognize from AIDS commentary — the face of death, staring out at us with an expression of unbearable intensity and complexity, and whatever this man, Joseph, might be thinking, it is silenced by the full weight of an agenda which constructs him simply and unambiguously as a morbid and above all *admonitory* sign of the deadly danger of sex outside the confines of the family. The unconscious of this photograph is brutally direct: Homosexuality = AIDS = Death. Whether we are shown black Africans or American gays, the person with AIDS is invariably imprisoned within the demeaning category of the "victim," in which he or she is stripped of all power and control over the actual complex meaning and dignity of an individual's life. In this manner the entire experience of living with AIDS is censored, and the diseased body is transformed into a signifying husk which is only there before our eyes to evidence the "knowledge" of AIDS commentary which both precedes and exceeds the life of the person in the photograph, whose living being is ruthlessly obliterated. Such images repeatedly reinforce the wider cultural and political victimization of people with AIDS by sentencing them to the black-and-white testimonial space of the "AIDS victim" — further validating the entire, monstrous agenda which requires that people with AIDS should always appear as monsters in order to satisfy the sickeningly brutal and thinly veiled revenge fantasies of the upright guardians of "public" decency.

This of course is precisely how particular groups have always been marginalized in the field of photographic practices — caught up in a documentary iconography which effortlessly transforms gay men into "tragic queers" or "dangerous perverts," just as blacks emerge as either docile and "childlike" or else sinister and "untrustworthy." Yet at the same time a new and aggressive identity is appearing among people with AIDS, especially in America, where more than 60,000 people are currently living with AIDS and over 300 are dying every month in New York City alone. But as photography transforms people with AIDS into "AIDS victims," they themselves are actively contesting and resisting the discursive structures which they have been made to embody. Sometimes the collision is dramatic, as in the recent case of *The Guardian*'s framing of the diary of a man who wrote clearly and positively of his rejection of the morbid fatalism surrounding his diagnosis as "The Diary

of a Condemned Man." It is critically important to recognize that the condemnation here is taking place on the "other side" of the lived experience of AIDS — among photographers, journalists, subeditors, and politicians. Beneath the text of the diary, a photograph appeared showing a group of men at a demonstration carrying the banner of New York's People with AIDS Alliance. This was clearly intolerable to the picture-editor of the day, who attempted to force the recalcitrant image back in line with his professional agenda by using a caption which read: "Immunised against embarrassment: American AIDS victims." Here once more we can clearly identify the unconscious of AIDS commentary at work, struggling to suppress the affirmative identities of groups such as the People with AIDS Alliance and ACT UP in America and Front-liners and Body Positive in Britain, forcing them back in line with the morbid and essentially silent role which is so obviously required and expected of them. The only "embarrassment" here is that of the AIDS agenda, faced with the truly terrifying spectacle of people with AIDS who calmly and confidently reject the entire pernicious ideological framework by which they have been hitherto contained. The "AIDS victim" is the final discursive product of the AIDS agenda. Crushed, submissive, mute, he or she accepts and justifies the "punishment" of AIDS for the unforgivable capital offense of daring to live beyond the narrow and sadistic intelligibility of familial consciousness. By contrast, the person with AIDS affirms and confirms the actual diversity and richness of human affectional and sexual experience. At this moment in time a great and historical struggle is taking place around the meaning of AIDS. Photography is one of the many cultural means by which it is being waged — challenging and interrupting the degrading spectacle of official AIDS photography. There should be no doubt in anyone's mind that the outcome of this struggle will ultimately decide who controls the most basic definitions of what it means to be a human subject — black or white, male or female, adult or child — in the modern world.

It is therefore absolutely imperative that we accept and celebrate the social, racial, and sexual diversity of our species, since it is at the level of the species that AIDS commentary offers its most extreme and apocalyptic vision. This involves devising cultural means to reinforce and encourage those behavioral changes which are the only effective means for minimizing the transmission of HIV. Unfortunately but revealingly the dominant AIDS agenda continues to imply that it is sex *as such* which is dangerous, rather than particular forms of unprotected sexual behavior, especially fucking. The great emphasis on so-called high-risk groups can serve only to distract and divert attention from

the real dangers of high-risk behaviors. It should go without saying that it is impossible to successfully persuade people to explore the multiple erotic possibilities of Safer Sex from a perspective which is radically anti-erotic. We have to establish Safer Sex as an enlargement of our lives, rather than a restriction. This is especially difficult among heterosexual men, whose identities seem so frequently to be confined by the most limited notions of "real" sex as unrestricted penetrative intercourse. The world does not divide up neatly between the chaste and the promiscuous, any more than it can be fully and humanely understood in terms of the Righteous and Damned. Those are *profoundly* damaging and degrading ways of thinking about human beings, and one of the many ways in which AIDS can make us all stronger is by forcing us to think more carefully and more *caringly* about ourselves and one another. The last thing we need at this of all times is an increase in the censorship of sexual materials which can help to promote the cause of Safer Sex. When sex is regarded as intrinsically dirty and degrading, it will undoubtedly become dirty and degrading, and those who continue to call for ever-increasing censorship of explicit sexual materials must ultimately shoulder a large part of the responsibility for the increase in HIV infection among those who use sex as a weapon because they have never been allowed or encouraged to explore and experiment with their sexuality in any other terms. In this respect lesbians and gay men continue to provide a more mature, and flexible, and above all honest model for social and sexual relationships than is currently sanctioned anywhere else in British culture. Which in turn is precisely why AIDS has come to seem a blessing in disguise to those who are most profoundly threatened by the promise of guilt-free consensual sexuality, since its emergence among gay men can ironically be used against us on the grounds that it is our sexuality *per se* which causes AIDS. This argument can prosper only among those who hold to the primitive belief that the social group in which a virus emerges is in effect its *cause*, a belief which is entirely in keeping with the overall tendency of familialism to think of the modern world in terms of almost medieval superstition and grotesquely oversimplified dogmatism. Viruses are not choosy about whose blood they infect.

It is these positions which guarantee the continual harassment and mistreatment of people with HIV and AIDS, causing them untold suffering in relation to housing, employment, and direct medical treatment. The systematic persecution of people with AIDS and the tenacity of an agenda which remains totally silent on the subject of their ordinary day-to-day lived experience will undoubtedly come to be

regarded at some later date as one of the most glaring and hideous indictments of late twentieth-century British culture. In the meantime, however, we have to work, especially at the level of representation, to transform an agenda which so belittles and impoverishes us all. We have to shift the terms of the entire AIDS debate now, before it is too late. For the sake of the thousands who have already died, and their families, and friends, we have to ensure that a whole new agenda for thinking AIDS is established, so that the morbid chorus which speaks in such gloating ways of "AIDS victims" and "AIDS carriers" will be fully and publicly exposed to the same contempt and humiliation which they reserve for those whose voices they have so far so effectively silenced. We will know that day has arrived only when a text which talks of people "dying of AIDS" is automatically corrected to read "people living with AIDS."

Conclusion

The changing imagery of AIDS is largely determined by the social history of the epidemic, which responds slowly and unevenly to new information concerning the biochemistry and natural history of HIV that has emerged in recent years.[11] For example, it is currently estimated by the Centers for Disease Control that the average time between infection and diagnosable AIDS symptoms is approximately eight years, though it should always be emphasized that such statistics are never predictive for individuals.[12] Moreover, this delay may be subject to upward revision.[13] At the same time a number of factors have effectively contributed to a significant increase in the average life-expectancy of people with AIDS in both Britain and the United States. First, it is clear that good standards of patient care, and the practice of patient-centered medicine, play an important role in improving the quality and length of life of people with AIDS. Second, the emergence of new treatment drugs has played a significantly positive role, though as Dr. Mathilde Krim, the founding chair of the American Foundation for AIDS Research (AmFAR) pointed out early in 1988: "Drug development has been very slow. We have tens of thousands of people sick… and only 2,900 of them are in government clinical trials."[14] Third, the Report of the U.S. Presidential Commission on AIDS and the emergence of effective activist organizations such as ACT UP have drawn attention to the gross inadequacies of the U.S. government's and the pharmaceutical industry's responses to the epidemic, as well as signaled the outrage of the most severely affected social constituencies.

11. For example, see the special issue of *Scientific American*, 259:4, October 1988.

12. See Simon Watney, "Introduction," in *Taking Liberties: AIDS and Cultural Politics*, ed. Erica Carter and Simon Watney (London: Serpent's Tail Press, 1989).

13. Tim Radford, "Estimated incubation period for AIDS rises to 10 years," *The Guardian* (London), 17 March 1989.

14. Philip M. Boffey, "Campaign to Find Drugs for Fighting AIDS Is Intensified," *The New York Times*, 15 February 1988, p. A14.

In sum, it is vital to understand that HIV was widely transmitted for at least a decade before its existence was even suspected, and that the profile of AIDS today closely reflects the transmission of the virus some ten years ago. Yet such relatively simple and intrinsically uncontroversial information is not widely known, or its significance appreciated. In the United States it would at least seem that a certain liberal consensus is now generally supportive of people with HIV or AIDS. It remains doubtful, however, whether popular medical or political understandings have significantly improved. In this context we should consider the active role played by frequent and widespread representations that construct and relay the supposed "meaning" of AIDS. In January 1988, the *The New York Times Magazine* could give over its main story to the subject, but only as a personalized and privatized account.[15] We are thus shown an image of free-lance journalist George Whitmore, who has HIV antibodies, relaxing with his cat: "I'm one of the lucky ones. I haven't even been hospitalized yet." Then Whitmore is seen again in another photograph, staring rather glumly at a large amount of high-tech equipment in the New York Medical Center, together with a research assistant who acts as a Virgil-like guide to the complex Underworld of biomedical information, while also asserting biomedical authority within the text. Both photographs emphasize Whitmore as an individual patient, facing a medical reality which is threatening and mysterious, and over which he exercises little or no control himself.

It is the cumulative effect of such "human interest" stories that remains so problematic, for they almost invariably abstract the experience of living with AIDS away from the determining context of the major institutions of health care provision and the state. By being repeatedly individualized, AIDS is subtly and efficiently de-politicized. For example, you would never suspect the existence of huge national support groups and other organizations created largely by and for people with HIV and AIDS, or the vast network of information and treatment drugs that they have developed for themselves.

The photographic iconography of AIDS in countless newspaper and magazine articles in the United Kingdom and the United States still massively conforms to what I have described elsewhere as "the AIDS diptych," which constantly narrates AIDS according to two sets of images: one focusing on color-stained electron-microscope — derived images of HIV, usually misdescribed as "the AIDS virus," and other signs of biomedical technology and authority; the other relentlessly constructing people with AIDS as "AIDS victims," physically debilitated and preferably disfigured.[16] Such images not only mystify the

15. George Whitmore, "Bearing Witness," *The New York Times Magazine*, 31 January 1988. See also more recently, Dena Kleiman, "Gay Men Find Sadness Colors Life as They Make the Most of Their Days," *The New York Times*, 7 February 1989.

16. See Simon Watney, "The Spectacle of AIDS," *in AIDS: Cultural Analysis Cultural Activism*, ed. D. Crimp (Cambridge: MIT Press, 1988).

actual complex history and reality of the epidemic, they also serve to naturalize some government and medical policies at the expense of others. We are thus invited to imagine a world of supposedly disinterested medical research, with patients' best interests always in the foreground. Yet in reality, research is generally dictated by the profit motive, rather than people's medical needs. This was brilliantly exposed by the Gran Fury collective in a parody of *The New York Times* entitled *The New York Crimes*, produced by ACT UP for a demonstration against the intransigent neglect of AIDS by New York's City Hall. Across a full-page image of a scientific petri dish, with an anonymous lab technician's hand clad in a rubber glove and holding out a pipette, we read a quote attributed to Patrick Gage, on behalf of the pharmaceutical corporation Hoffman La Roche: "One million [people with AIDS] isn't a market that's exciting. Sure it's growing, but it's not asthma." At the bottom of the page, we read the simple message from ACT UP: "This Is to Enrage You." The juxtaposition of words and image provokes us to think about how "science" may indeed be photographed, not simply as a field of incomprehensible yet heroic research, but as a site of complex conflicting values, beliefs, and methods. This is precisely the history that most AIDS photojournalism suppresses.

Much of the uncertainty and confusion surrounding most aspects of AIDS may also be attributed to the development of "official," and often state-funded, AIDS information materials. For example, the New York State and New York City departments of health have for several years distributed leaflets and posters that show a fairly wide cross-section of the population under a banner statement: "AIDS does not discriminate." Such an approach is to some extent understandable, given the dominant journalistic construction of AIDS as intrinsically connected to gay male sex or the sharing of intravenous drug equipment. Yet by showing a group of largely middle-class women and men, albeit of different racial origins, we are left with a new set of mystifications. For it is clear that HIV has, in fact, had an overwhelmingly disproportionate effect in population groups that were already profoundly marginalized long before the epidemic began — particularly lower-class African-Americans and the Hispanic community. Of course AIDS itself does not discriminate, but none the less discrimination in relation to the availability of adequate health care provision and health education remains a major factor in determining one's risk of HIV infection. This is especially true of societies such as the United States, which so conspicuously lacks the provision of socialized medicine: a lack that goes much of the way to explain the seriousness and extent of the national epidemic.

Having refused for years to heed the advice of AIDS service organizations in the voluntary sector, the British government's Health Education Authority (HEA) recently launched a new campaign of photo-based ads that seek to establish the distinction between HIV and AIDS. Yet the way in which the HEA has sought to clarify this important point still conforms to the larger ideological agenda of most public AIDS commentary in the west. Throughout the British press, for example, we were shown an image of a stereotypically glamorous young woman, with a caption underneath that reads: "If This Woman Had the Virus Which Leads to AIDS, in a Few Years She Could Look Like the Person Over the Page." Turning the page, we find exactly the same photograph, but this time with the terse caption: "Worrying, Isn't It." The implied meaning is clear: we are meant to be worried by the fact that a beautiful (and sexually available) woman might have HIV, "we" being heterosexual men. A woman with HIV would certainly not find it "worrying" that she looks perfectly well.

It is almost impossible to imagine any other group of people living with a manageable yet chronic disease who could be presented as a public problem for the simple reason that they look, and to all extents and purposes are, well and healthy. Moreover, such images demonstrate the long-term consequences of the confusion of HIV with AIDS, and the tendency to think of people with chronic disease in terms of infectious illness. Thus people with HIV are made to embody the powerful and deeply misleading notion of "AIDS carriers": well or ill, they are invariably portrayed as *deterrents* rather than as people. They are used to frighten people about sex, in a manner which taps into deep-seated misogynistic anxieties concerning female sexuality, and guilt about sexual pleasure. Thus people with HIV are tacitly understood to be in some way "guilty" for having been infected, while HIV is also understood as a reflection of excessive or immoral sexual behavior. In this way the fantasy that HIV affects only certain types of people — prostitutes, the "promiscuous," and the "unfaithful," and so on — is protected, and supposedly "ordinary" women and men are reassured that there is nothing for them to worry about. But HIV is not necessarily associated with particular types of people or any sexual acts except unprotected intercourse, and risk comes as one writer puts it, not from how you label yourself but from what you *do*.[17]

Many of the problems of the photography that I've discussed derive from ways in which the various institutions that generate photographs — from photojournalism to "art" photography — have traditionally represented lives and social groups that are usually culturally visible

17. Cindy Patton, "Safer Sex and Lesbians," *The Pink Paper* (London), Issue 14, 25 February 1988, p. 2.

only as "deviants" or "perverts." Thus the widespread notion that intravenous drug users constitute a recognizable type obscures the fact that many people may inject drugs at some time or other. Yet photography rarely attempts to explore the wide latitude of intravenous drug use, or of sexual practices, and instead seeks refuge in easily identified stereotypes — especially when it is employed by other institutions, including the press and the state, that have a major investment in just such stereotypes. As a result we rarely gain any real sense of the scale or complexity of the epidemic, for this would involve a visually immediate acknowledgment of the actual diversity of drug use and sexuality in everyday life, a diversity which is evidently very threatening to many institutions, especially those that have a major investment in policing and defining our perceptions of ourselves and the world we live in. Thus we also see little or nothing of the scale of community-based support and activism for people with HIV and AIDS, for such images would likewise threaten to interrupt the pious sentimentality with which this epidemic is quietly and tastefully celebrated. Instead we see "AIDS victims," isolated, often hospitalized, frequently near death, in the face of which they are shown to be meek and — most dishonest of all — accepting. It is in this context that we might usefully recall the words of Michael Callen, who has lived with AIDS for seven years. As he points out, this type of single-minded emphasis on fatality "denies the reality of — but perhaps more important, the possibility of — our survival."[18]

18. Michael Callen, "Not Everyone Dies of AIDS," *Village Voice*, 3 May 1988, p. 31.

In any case, photography's conventional eye has long fixed the look of disaster in the likeness of passive, suffering "victims," in both news and documentary images. Heroic or pathetic, the "victim" invariably waits, dependent on the faint chance of relief or remedy, understood to be beyond his or her personal control. Hence the "victim" is constructed as a universal category, constituted in images which are accepted because we recognize that we are all ultimately subject to the same common order of mortality. Yet as James Baldwin argues, this acknowledgment should be the source of our dignity as a species, rather than a pretext for oversimplification, since the awareness "that isolation and death are certain and universal clarifies our responsibility."[19] The photographic construction of the "AIDS victim" on the contrary depicts AIDS as always *someone else's* problem, rather than a *collective* social issue. Thus the regime of familiar AIDS-derived photographs functions to protect and defend audiences from recognizing that AIDS might ever be a reality for themselves. Nor is this specific to the signification of AIDS. For example, the image of a Sudanese child dying of starvation may be used to represent the failure of the rain season, or to embody

19. James Baldwin, *The Evidence of Things Not Seen* (New York: Henry Holt, 1985), p. 52.

the intractability of a "Marxist regime," but almost never to signify the direct social consequences of western capitalist financial and political policies.[20] Moreover, the chronically sick have generally tended to be presented as emblems of disease rather than as people who are often as much in control of most aspects of their lives as anybody else.[21]

Nonetheless there is growing awareness in both Britain and the United States of the yawning gulf between the political and psychic realities of this epidemic and the miserably impoverished and punitive imagery through which its public face is habitually registered. It is not surprising that this awareness has been keenest among those most deeply involved in the complex realities of AIDS, understood as a biomedical, political, and cultural phenomenon. In the United States, both Jan Zita Grover and Douglas Crimp have written eloquently of the emergent cultural response to AIDS among progressive artists and photographers, while others including Kristen Engberg have — like Grover — curated major exhibitions.[22] In Britain, a number of photographers are also working to establish an understanding of the wider network of social, economic, and political factors that play such a major role in determining the situation of people living with HIV and AIDS. For HIV-related disease is never "just an illness," as Susan Sontag has suggested.[23] On the contrary, throughout the west it has engaged the most vicious forces of racism, misogyny, classism, and homophobia, in ways that cannot be adequately explained by recourse to the history of medicine alone, as many commentators are now attempting to do.[24] At any given moment in time, the epidemic should, also, always be thought of as a still-life that is every bit as rich and complex as that of any seventeenth-century Dutch artist: a still-life that contains many bottles of drugs, together with the multinational pharmaceutical industry that generates and markets them, and the government agencies that regulate (and frequently inhibit) their availability. The imagery of AIDS includes keys to properties illegally reclaimed by fearful and bigoted landlords; job contracts terminated by prejudiced employers; interminable application forms for every aspect of welfare, social security, and sickness benefits; rejected health insurance and life insurance claims; travel-passes for the disabled; and the collective cultural, political, and personal achievements of thousands of groups and organizations around the world working on behalf of the rights and needs of people with HIV and its many consequences. Not least, the AIDS tableau should finally include some suggestion of the constant avalanche of photographs that continue to do so much to undermine the confidence and dignity of people attempting to live their lives with all the humor and courage that

20. See *Famine and Photojournalism*, special issue of *Ten.8* 19 (Birmingham, U.K.), 1985.

21. See Susan Scott-Parker, *They Aren't in the Brief: Advertising People with Disabilities*, (London: The King's Fund, 1989).

22. For example, Crimp, *AIDS: Cultural Analysis Cultural Activism*; and Jan Zita Grover, *Introduction to AIDS: The Artists' Response* (Columbus, Ohio: Hoyt L. Sherman Gallery, 1989); and *Bearing Witness: Artists Respond to AIDS*, curated by Kristen Engberg and Mary Ann Nilson, (Boston: Mobius/ICA, 1988).

23. Susan Sontag, *AIDS and Its Metaphors* (London: Allen Lane, 1989). See also, Simon Watney, "Guru of AIDS," *The Guardian* (London), 10 March 1989, p. 30.

24. For example, Sontag, *AIDS and Its Metaphors*; and Elizabeth Fee and Daniel M. Fox, "Introduction: Public Policy and Historical Enquiry," in *AIDS: The Burdens of History*, (Berkeley: University of California Press, 1988).

they can collectively muster. Writing as a woman who has used photography to explore her own situation as someone living with cancer, British photographer Jo Spence insists that "not only do we need to use photography to try to make visible what is not being talked about by those in power,...but the other side of the coin,...that only by using photography to ask new questions can we then begin to understand the systematic denial of the reality and fantasies of groups and individuals who have plenty to say, who have been silenced, or who are still fighting to speak."[25]

25. Jo Spence, "Questioning Documentary Practice?" (Paper given at the first National Conference on Photography, organized by the Arts Council of Great Britain, Salford, Lancashire, April 1987).

In all of this it is still important to avoid the conclusion that photography has simply "misrepresented" AIDS, with the implication that at the end of the day there is indeed a clear, unitary visual "truth" of the epidemic that might be directly accessible to the camera. AIDS-derived photography demonstrates with particular clarity the ways in which images plunder the visible world in order to construct their own distinct dimension of representations. It is at this level that photography is best equipped to intervene in the *ideological* processes by which certain definitions of health and disease are massively privileged and naturalized, to the virtual exclusion of all others. In the case of AIDS, photographers are particularly well positioned to interrupt the constant flow of images that conflate HIV and AIDS and to challenge the crude and cruel version of the epidemic that continues to regard AIDS as a moral verdict rather than a medical diagnosis. For if we accept that photography participates in the practice of representation that forges our identities, we should be as sensitive to its potential to produce subjects as we are to its undoubted capacity to define objects.

I would like to thank Jan Grover for bringing the articles in *American Photographer* and *Whole Earth Review* to my attention.

SELLING GREEN

Kathy Myers

In Britain, a new vogue in advertising appeared at the end of the 1980s. The words "nature" and "environmentally friendly" began to crop up with increasing frequency. New Zealand lamb is hand-reared by "Mother Nature." Timotei hair conditioner contains "natural" herbs, and woolen sweaters breathe "naturally." Nor is this phenomenon confined to "natural" products: AEG washing machines offer to look after our underwear and "the environment," and Subaru announces that its hatchback cars are "environmentally friendly."

How has this come about? Did advertisers discover a "back to nature" appeal two decades too late? Not quite, but what was once considered to be a parochial, folksy conservation movement is now being seriously reconsidered by advertisers faced with a western world in the process of "going Green." Green politics has suddenly become big business, and everybody from the Prime Minister to the industrial oligopolies of Lever Brothers and Proctor and Gamble wants to cash in on it.

How to sell Green politics is, however, a matter of considerable debate. Green pressure groups have never been at the forefront of the "image business," preferring to rely on old-fashioned forms of communication, like leaflet drops, pamphleteering, flyer-posting, and the occasional advertisement in a sympathetic magazine. These forms of communication are now regarded as quaint, out of touch with a modern world, where the medium is the message and the shoppers of tomorrow are weaned on high-tech video and Hollywood production values.

Most notably, Green publicity to date has been characterized by a remarkable resistance to the photograph. And, of course, it is the use of the photograph that characterizes much of contemporary advertising. The reasons for the resistance to photography as a legitimate form of expression in Green advertising are threefold.

First, many alternative groups believe that photography is a waste of economic resources. These groups have been hard pressed for cash, subsisting on voluntary donations and small local government grants, and advertisements featuring color photographs are expensive to make and to place in magazines.

Second, the photography and lush design associated with advertising are thought to run counter to the philosophy behind the Green

movement. Green sympathizers have always positioned themselves on the margins of the consumer economy. Green advertising reflects a preference for the natural and homemade through the use of simple type design and a recourse to graphics and line illustration rather than photography. Their belief is that a straightforward approach is more appropriate than the slick persuasion tactics associated with contemporary advertising.

Third, there is a belief that advertising should just "tell the facts." It should be a transparent and innocent form of communication. Unlike most contemporary advertising, Green publicity does not offer the advertisement as a source of visual pleasure in its own right. The photograph — tinted, teased, colored, and molded to sell a product — is seen as indulgent and dishonest.

Although this approach has served the Green movement well over three decades, a broader perspective is needed to reach a wider public.

Finding out how to talk to would-be-Greens, without alienating the die-hard Greens, was the subject of a unique conference held in London at the Marriott Hotel, January 1989. There, politicians and representatives from the government's Department of the Environment rubbed shoulders with delegates from Mobil Oil, ICI Chemicals, Coca-Cola, Saatchi and Saatchi Advertising, Greenpeace, Friends of the Earth, and a host of other ecology conservation groups.

The community of interest among these groups was described in the conference brochure as "The Eleventh Commandment — or how to search for and exploit Green Market opportunities." In one of the opening speeches, Dorothy Mackenzie from the Brand New Product Development Company clarified the issue: "Meeting the needs of the Green Consumer and exploiting the opportunities offered by a change in attitude and values represents [sic] for many companies the biggest challenge of the 1990s." According to the latest round of market research from "Brand New," there are at least three groups of Green consumers.

The smallest but most influential group is the Bright Greens. This group is made up of the original environmental political activists, people who either belong to the Green Party or to ecological organizations like Greenpeace and Friends of the Earth. The second, and by far the biggest group, is the Pale Greens. It accounts for the bulk of the British population and addresses ecological issues from a personal point of view. Pale Greens are concerned with family health, wholesome foods, and clean air and water.

Finally, Turquoise Greens represent the right wing of public concern. These are often affluent people interested in traditional values and

preserving England as a green and pleasant land. They include Mrs. Thatcher and NIMBYs (Not In My BackYarders), people who are against any infringement on their land, environment, and leisure pursuits.

Between them, these three groups are estimated to account for 70 percent of the British population. A recent survey indicated that, in addition, nine out of ten British citizens were at least "concerned" about the environment and ecological issues. As the "Who Is the Green Consumer" report concluded: "Manufacturers with brands which could have poor environmental consequences should not be panicked into action; however, ignoring the problem could be a risky approach.... The Green Consumer who is influenced by ecological concerns is very much with us and there will be more of them."

So how have manufacturers and advertisers set about talking to these important consumer groups? Agencies are well aware that invocations of social success and sex appeal simply will no longer do. Nor can they expect today's high-tech consumer to embrace the unsophisticated values espoused by traditional ecology groups. British advertising is still finding its way, but it is possible to detect certain trends in the efforts to target diverse Green interests.

Bright Green Advertising

What differentiates Bright Greens from other Greens is their attitude toward consumption, and their own advertising reflects this. Bright Greens who align themselves with active ecological groups like Greenpeace believe that we abuse the world's resources not only by the way we consume, but also by virtue of consuming too much. Bright Greens blame this "galloping consumption" for much of the world's problems. As the recently published *Green Consumer Guide* put it: "One area where we are spending increasing amounts of money is on consumer durables. They accounted for less than 4 percent of our expenditure in the early 1950s compared with more than 11 percent in the 1980s."

Bright Greens are anti-high-tech. They believe that even the paper used for advertisements should be recycled. They consider that advertising should be as straightforward and factual as possible and that fancy photographs and high production costs are a waste of raw materials. But it is also true to say that the activist ecological groups that Bright Greens belong to operate on a financial shoestring and of economic necessity must keep costs down. This style is exemplified by the Green and the Labour parties' own advertisements. An abrupt,

factual style of writing conveys the dangers facing the planet and invites readers to "do" something about it. Friends of the Earth ask "How many skin cancers must aerosols cause before you join us?" using typography and layout reminiscent of a war-time government information bulletin. A crude graphic montage depicts the "enemy" as an aerosol can. The heroes, Friends of the Earth, invoke our fear of illness and death to rally us to their sides. It is as if in the war of defending the planet, the advertiser has no time for the frills and flourishes traditionally used to make advertisements seductive. In equally polemical tones, the Labour Party says "Toxic waste, acid rain, sewage on the beaches. That's not what I want my children to thank me for."

Pale Green Advertising

How to combine a simple ecological message with sophisticated advertising imagery is the problem facing advertisers who wish to talk to the Pale Greens. The Pale Green Consumer, as far as market definitions go, comprises the majority of people in Britain. They are the sort of people who are "into" health but not into direct political action, who are worried about the ozone layer and skin cancer but find the greenhouse effect a difficult concept to grasp. *The Green Consumer*, a market-research guide, warned advertisers to produce "a more normal progressive, sophisticated image which can be communicated with easygoing entry points for action. Overt 'Green-ness' could become unattractive and undesirable."

The difference in Bright Green and Pale Green advertising statements can be seen by comparing two petrol ads. Both are for unleaded petrol, but each adopts a different tone. The first, "Caring for tomorrow's quality of life," appeared in *The New Statesman*, a newspaper that expresses overt liberal, left-wing, and Green Party sympathies. The do-it-yourself graphic style of the advertisement is in keeping with the Green Party and Labour Party advertisements in the newspaper. In this context, "graphic" and "home-drawn" symbolize a no-fuss, "responsible" attitude to advertising. It conveys the message that Esso understands the concerns of its target market.

The second ad — in which the phrase "Ecologically Sound" is conflated with "Economically Sound" — is reserved and conservative in its choice of image, typography, and design yet obeys many of the conventions of mainstream advertising. Because it appeared in a car magazine and was aimed at the "average" motorist, the ad does not address its reader from the point of view of ecology, but from the point

Detail:
Shell advertisement.

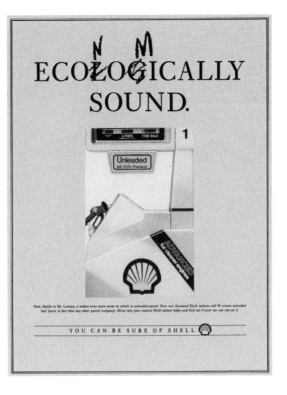

Detail:
Esso advertisement.

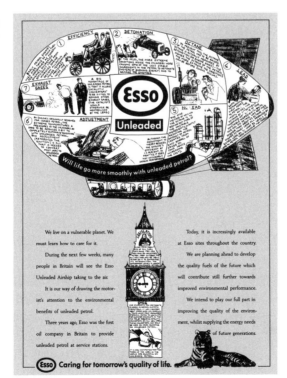

of view of thrift. Its message: "Now, thanks to Mr. Lawson [the Chancellor of the Exchequer for the British government], it makes even more sense to switch to unleaded petrol."

Advertisers were initially very tentative about addressing the Pale Green Consumer, although many have made concessions in this direction. Elida Gibbs, a company that makes a range of toiletries, has put a discrete "Ozone Friendly" sticker on its aerosol canisters. Tesco supermarkets, while still offering the traditional range of brands, offer the consumer a choice about whether to "Go Green" or not. This choice extends to recyclable packaging, chlorofluorocarbon gas–free aerosols, organically grown vegetables, and health-information packs. Tesco's competitor, Safeways, has produced its own range of information packs, such as a booklet warning consumers about food additives and pesticides. On the face of it, much Pale Green advertising looks like any other mainstream promotion. An ad for Sensiq makeup, for example, shows a beautiful model, rendered in sepia tones, reclining against a sunny rock. Against this brown-and-white world is a hint of color: the color of Sensiq. It could be any other fashion statement were it not for the discreetly printed copy that gives the brand its Green credentials: "Free of known sensitizers. No fragrances. No cruelty [to animals in testing]. And no inflated prices." Along these lines, ads for wool and New Zealand lamb emphasize the natural, the personal, and the body. The issue being addressed is what will this brand do for you: how can a "natural product" improve your life?

Turquoise Green Advertising

The address to the Turquoise Greens is quite different. Unlike the Bright Greens, who view ecology in terms of politics, or the Pale Greens, who see it in terms of personal health, the Turquoises see "Green-ness" in terms of conservation of comfort and privilege. Turquoises are by far the most affluent group. They buy expensive products and live in lavish houses in the professional belts around Britain's major cities. Turquoises have their roots in the mud of the home-county 'Shires, where an arcadian, almost pre-industrial vision of England can still be captured. Turquoise advertising is to be found in lush color magazines and in newspaper supplements like *The Observer*, *The Sunday Times*, and *The Independent*.

An advertisement for the Subaru Justy is a good example of Turquoise sensibilities. Parked outside one of Britain's country mansions, the Subaru is presented as a new thoroughbred among hatchbacks: "in

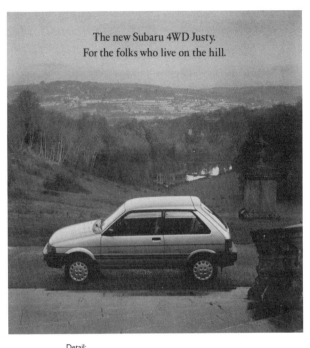

The new Subaru 4WD Justy.
For the folks who live on the hill.

Detail:
Subaru advertisement.

a class of its own." The sales pitch combines the performance of the car with its Green credentials. Running on unleaded petrol, this "environmentally friendly" little runabout won't pollute the pastures of your country estate.

Similarly, Bovis Homes appeals to the nostalgic arcadian fantasies that beat deep in the Turquoise heart. A large, traditional 1920s-style country house is juxtaposed with a "collectible" painting of innocent badgers — themselves an endangered species — at play. The ad sells the green magic of Britain that has been lost forever, a magic that was in reality the prerogative of the rich and privileged few. Bovis offers to reconstruct this green heritage: "We've also planted thousands of trees — mainly native British broadleaf species; we've been recreating village greens, encouraging butterflies, and preserving wildflower meadows." The title itself, "A badger doesn't know the Green Cross Code," is significant on three levels: The Green Cross Code is learned by British children at school; it explains how to cross the road safely. A green light also suggests progress as well as regulated access. And, of course, green refers to the countryside and to ecological issues. In one sentence, Bovis has harnessed its brand name to the values of care, modernity, exclusivity, and ecology.

Sporting Green credentials can be lucrative business, but how Green is Green? Should a company with only one ecologically responsible brand be allowed to call itself a Green company? It is very easy for advertisers to exploit the public's concern about the environment. For example, Cadbury Chocolate's only concession to Green-ness is putting endangered wildlife on its candy wrappers. This raises money for the Wild Life Nature Fund, and it encourages children who love animals to buy Cadbury's in preference to other brands. But only the packaging has changed; manufacturing, processing, and distribution techniques remain the same.

Even more pronounced are the efforts by some corporations — especially petrochemical companies — to make consumers feel good about the company concerned. A public relations booklet for Shell is a typical case. Entitled *Good Neighbors*, the booklet purports to describe "How the oil and petrochemical industry goes about its task of protecting the environment." A crucial part of this communication is the cover image, which is disingenuously spare. Amid a balmy glow of late spring sunlight, a clutch of fragile eggs nestle in the protecting shell of an oil worker's helmet. Lévi-Straussian in its opposition, nature and culture are harnessed: man is juxtaposed with the animals, wisdom with innocence, experience with new beginnings, and emotive values with big business. Indirectly we are invited to buy into this caring philanthropy by buying Shell products — although in the genteel world of corporate advertising nothing so vulgar as sales and profit are mentioned.

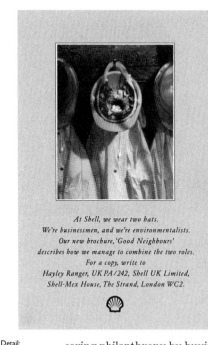

At Shell, we wear two hats.
We're businessmen, and we're environmentalists.
Our new brochure, 'Good Neighbours'
describes how we manage to combine the two roles.
For a copy, write to
Hayley Ranger, UK PA/242, Shell UK Limited,
Shell-Mex House, The Strand, London WC2.

Detail:
Shell advetisement.

The press advertising for AEG also sells a caring approach. Simple cartoon graphics and a photograph of a modern washing machine are accompanied by the line: "People don't buy AEG just to care for their clothes. Our Lavamat automatic washing machines are also designed to look after something much more delicate. The environment." Yet when *City Limits* magazine investigated the company, it found that AEG was supplying electronic systems for advanced weaponry, a fact not apparently shared with Friends of the Earth, who had been asked by AEG to enter into a joint promotion of "ecologically friendly" kitchen gadgets.

From the consumers' point of view, the Green upholstering of the planet is just part of a much more complex social and political issue. This move to "save our planet" coincides with a moment in late capitalism when even diehard libertarians are forced to check their zealous pursuit of the free market. What is the point of putting money by for a rainy day if the rain that falls is acid rain? Most people in Britain have been forced to take ecology seriously, motivated by fear, not benevolence.

To some extent, the consumer bubble has burst. We live in a time when even the poor of the western world have access to commodities that

only twenty years ago would have been considered luxuries. Most people now own a refrigerator; in 1955 that was the privilege of a mere 5 percent of the population. Similar figures apply to other domestic gadgets we take for granted: cars, washing machines, and electrical appliances of all kinds. We are saturated with consumer durables, and the question must be posed, how many more can we absorb? As we replace goods in our homes and on our person at an increasing rate, our relationship to these goods grows more tenuous and confused. Some advertisers have responded to consumers' anxiety that this pattern of consumption is itself a root cause of the ecological crisis.

Thus, the manufacturer of Pepe jeans has turned to the Native Americans for product endorsement. In place of hip teenagers lounging about in Pepe jackets and trousers are Native Americans performing a rain dance set to the sultry tunes of The Smiths. Nature-culture, paganism-modernism, youth-wisdom, pop music–ancient ritual, fire-rain, clothing-nakedness: a series of structural oppositions appear to harness the earth's elements at the behest of the brand. The Pepe TV commercial is, as it were, the flip side of Green advertising. For whereas Green environmental advertising presents the planet as vulnerable and in need of our protection, the Pepe jeans commercial depicts the elements as powerful, dangerous, and almost uncontrollable.

There is an increasing vogue for this sort of advertising, which depicts Mother Nature as a powerful force dictating our lives. And while the simple interpretation is that advertisers are enjoying a period when nature in all its manifestations is fashionable, there is clearly something more at play. When asked to predict the trends for the future, advertisers describe the same phenomena: ecology issues and the need to buy a "vision." On the simple level, this "vision" is a reassurance that England is still the green and pleasant land of tradition. On a deeper level, dissatisfaction with the relentless cycle of consumerism is producing a need to find something more than material goods. In the late 1980s, the metaphor used to describe that desire is The Earth or Mother Nature, the community from which we were born and to which we must surely return.

This "soft-sell" is a far cry from the harsh graphics traditionally associated with Green political propaganda. And within this transformation, the photograph has achieved an almost magical or mystical status. It has become the medium through which advertisers bid us to capture a glimpse of the future. If saving the planet cannot be left to the world's unscrupulous politicians, it is ironic that it should be advertising that now acts as the prophet of that better, brighter tomorrow.

MISSING WOMEN

Rethinking Early Thoughts on Images of Women

Griselda Pollock

1. Sheila Rowbotham, *Woman's Consciousness, Man's World* (London: Penguin Books, 1973), p. 40.

We learn ourselves through women made by men.
— Sheila Rowbotham, *Woman's Consciousness, Man's World*[1]

The political identity of the women's movement has been formed in large part by a critique of the representations of women that circulate through "high" culture and the media, including film, television, advertising, and pornography. These "images of women" have been denounced by some in the name of feminism. Yet they are difficult to disavow because of the potency of their formulations of femininity, their fascination, and their pleasures. We recognize a gap between idealized or debased versions of "woman" and the lives and identities we ordinarily inhabit, but in spite of the gap, we cannot but acknowledge that to a certain extent our identities are formed through such imageries.

Feminist cultural theories of the image have moved along a trajectory from an initial denunciation of stereotyped images of women to a more exacting assessment of the productive role of representation in the construction of subjectivity, femininity, and sexuality. In this paper I want to revisit an article I wrote in 1977, at the beginning of my political and theoretical engagement with feminist studies of the image, entitled "What's Wrong with 'Images of Women'?" in order to draw out more clearly what has been gained by the substitution of one paradigm, "images of women," for another, "representation/sexuality/femininity." As paradigms, they inhabit different theoretical universes, differently valorized by their advocates in terms of accessibility and relevance versus theoretical sophistication. My concern in 1977 was to establish a point of contact between women who had become conscious of the problem with "images of women" and the theoreticians who were attempting to work the problem through. That dialogue is ongoing and continues to be relevant.

2. The phrase is originally from Geoffrey Nowell-Smith. "I was a star-struck structuralist," *Screen* 14, no. 3 (1973), pp. 92–100.

Back then, I was a "star-struck structuralist."[2] During my formal training as an art historian, I had had little access to any of the currents that were so dramatically reshaping neighboring disciplines, such as literary criticism and film studies. New possibilities were opened up in journals such as *Screen* and *Screen Education*, which published seminal

texts in semiotic theory, particularly such works as Roland Barthes's "Rhetoric of the Image."[3] An equally important part of the *Screen* initiative of the early 1970s was the critical examination of structuralist developments in Marxist theories of ideology.[4]

My 1977 text was the result of the desire to enter the theoretical community associated with the *Screen* project, but symptomatic of the difficulties of doing so. Semiology and ideology, however crudely understood, were enough to make me worry about the term "images of women," which then served to advertise courses run by feminists about the representation of women in art and the media. While challenging social definitions of women's roles and spheres, feminists were also contesting socially accepted *images* of women: the limited repertory of dumb blond, *femme fatale*, homely housewife, devoted mother, and so forth, which were judged in a vocabulary of absolutes: right or wrong, good or bad, true or false, traditional or progressive, positive or objectifying. But as an organizing principle, the phrase "images of women" seemed to me then — and now — theoretically impossible. Claiming to be no more than the simplest of descriptions, it assumes a world already formed, defined, and meaningful, which "images" depict in a direct relation of picturing, figuring, visualizing. Hence, images are judged against the world they reflect or reproduce or, as feminists have claimed, distort or falsify. The *real* is always present as the criteria against which images are assessed, a real which is never interrogated as itself a product of representation. The image becomes the true or false reflex of the real, and thus, posed in a hierarchical relation, the real precedes and determines the image.

"Realism is a social practice of representation: an overall form of discursive production, a normality which allows a strictly delimited range of variations."[5] In his analysis of the historical developments of photography in the nineteenth century, John Tagg identifies the realist mode as the dominant mode of signification in bourgeois society. It operates by establishing a network of mutually referring references, which by constant repetition and cross-echoing create "a generally perceived picture of what may be regarded as "real" or "realistic," which is not recognized as such — as a picture — but presents itself as, precisely, the Reality."[6] The implication is that across any one society there are diverse discourses, some of which are specifically but never exclusively visual, each producing specific representations. These representations interact, cross-refer, and accumulate around certain fixed points to create a dense texture of meaning that then acquires the authority of the obvious, commonsensical, and self-evident to the point

3. Roland Barthes, "Rhetoric of the Image," reprinted in *Image-Music-Text*, ed. Stephen Heath (London: Fontana, 1977).

4. Anthony Easthope, "The Trajectory of *Screen*," in *The Politics of Theory*, ed. Francis Barker, Essex conference on Sociology of Literature, 1982 (Colchester: University of Essex, 1983), pp. 121–133. As I understand the position set out by *Screen* contributors, signification and ideology were seen as complementary, the one being the form of the other's existence. Ideology motivates and limits the potential polysemy of the sign. Signification generates the field of meanings that ideology organizes in the interests of the dominant social groups, be they of class, race, or gender.

5. John Tagg, "Power and Photography — Part I," *Screen Education*, no. 36 (1980), p. 53. Reprinted in John Tagg, *The Burden of Representation* (London: Macmillan, 1988).

6. Ibid., pp. 53–54.

that their status as *representation* is occluded. From this perspective we see that the phrase "images of women" obscures the issues of representation as a process that produces meaning and is inadequate to understanding representation as a process in history, society, and ideology. I want now to develop this argument by means of some examples.

In a photographic collage by the Hackney Flashers, a socialist-feminist photography cooperative active in London in the early 1970s, a contrast is made between a middle-aged female machinist who works in a north-London garment factory and the model used in a magazine advertisement for the kind of clothing produced by the first woman and now being sold by a West-End department store. This juxtaposition prompts the viewer to make a simple judgment about the two images, presented as exemplars of the good and the bad, the "real" and the glamorized, the positive and the distorted. One image is claimed to be closer to a truth in the "real" and the social, in the world of labor as opposed to that of consumption and/or fantasy. The recognition that both images are densely rhetorical products of material, social, and aesthetic practices is suppressed.

The advertisement is the result of a capitalized process producing high-gloss, airbrushed photography. Carefully composed, constructed, and selected from many shots, it is printed for mass circulation. The other image is a black-and-white photograph produced under artisanal conditions either at home or in a small-scale darkroom with limited resources. It takes its place in a tradition of documentary photography dating from the 1930s. Black-and-whiteness and the graininess of the image stand as signifiers for authenticity and directness, for closeness to the "real" of the working class observed by another class. Such codes and rhetorics are specifically classed and are associated with the treatment of the social problem, the life of labor, the urban poor. The high-gloss glamour photograph, with its selected bodies and lack of realized surroundings, also has a tradition, and a referent powerful enough to evoke and create a "reality effect" for its appeal to fantasy. It is by means of an address to the viewer through fantasy that the spectator is converted from casual witness to the desiring consumer. In the "realist" photograph, the signifiers (the grain, the black-and-whiteness, and so forth) are themselves signifieds. For the advertisement, the manufacturedness, the signifying process must be repressed so that the image seems a spontaneous and credible world in which money is the only mediator, apparently operating freely in a realm of commodities.

But we cannot simply ignore these specificities and compare some abstract common component called "images of women." The case to be

made is not that one kind of photograph is more real or more authentic or positive than another as a depiction of women. Rather, both are fictions that produce distinct meanings both for the term "woman" and through the inclusion of woman in their semantic field. Both deploy specialized and historically grounded rhetorics within economically and ideologically different practices.[7]

My 1977 text was an attempt to go beyond these confines. The first breakthrough was to attend to the internal organization of a visual field: the image is not simply an icon, dominated purely by a figurative element. To think of it as such, one would have to isolate one element from the totality of codes, rhetorics, devices, techniques, competences, and stylistics that make up the image. Color, focus, texture, printing procedures, airbrushing, grain, and so forth, all constitute signifying elements that must be scrupulously decoded in their interaction within a specific visual configuration. This requires an in-depth study of the internal organization of an image. But its decoding demands a constant comparison of the image to those like and unlike it across all the levels of its signification. What I am describing is fundamentally the semiotic procedures of syntagmatic analysis of all the elements within one statement, and the paradigmatic analysis of the relation of those elements to the "sets" or connotational groups upon whose existence any one item or technique relies for signifying at all.

Such paradigmatic analysis raises important questions about the specificity of sites of representation and about history. In my earlier article, I used examples from contemporary advertising, nineteenth-century painting, pornography from the 1890s and 1970s, and amateur photography. At that time, feminists were adamant about clearly showing that there were links between elite cultural forms legitimated as art and those generally agreed to deal with sexuality on the edges of the licit. The traffic between various sites and diverse forms of representation was a clumsy but politically significant exposé. Nonetheless, there was and is a danger in extracting "images of women" with a shared iconography from their specific system of production and consumption. The common ground is easily reduced to the observation of a general tendency to debase women, to exploit their bodies. If the unclothed female body turns up in high art in the guise of the nude and in pornography as a masturbating, voyeuristic turn-on, is anything gained by reducing their differences of effect and circulation to the fact of nudity and femaleness? The questions raised about their distance, difference, and reference are more important than the act of merely denouncing them. Undoubtedly there *is* traffic between different sites of representation.

7. But why then are female bodies so often figured as a component of these fantastic visions? I shall not try to answer this question here, but I will return to it later in the paper. In 1977, I rashly asserted that "woman" signified "sale"; that is, it was the presence of a female figure that converted a bunch of commodities from the status of still life into objects of desire and consumption.

But we have to make a crucial distinction, which comes back again to the trap laid down by "images of women." What we identified as the common link was something external to the representations, something signified by the image that has its cause and existence elsewhere — in ideology, sexism, the terms of patriarchy. Nudity and the recurrence of the female body were read as the result of the patriarchal system in which women were exploited by men, sexually objectified in images used by men for sexual pleasures.

But such generalizations have turned out to be far less useful than careful analysis of the specific constructions of the feminine body as well as of specific modes and sites of representation and discussion of address and the imagined spectator. Here, woman/women cease to be the topic of representation. Instead, it becomes possible to perceive that the function of representation is the production of sexual differentiation for which a certain body image is the signifier. Representation is one of many social processes by which specific orders of sexual difference (internally differentiated across the axes of class, race, sexuality, age, ability, and so forth) are ceaselessly constructed, modified, resisted, and reconstituted. The issue here is whether we can transcend the idea that representations are symptoms of causes external to them (sexism, patriarchy, capitalism, racism, imperialism) and learn to understand their active role in the production of those categories. Representations articulate/produce meanings as well as re-presenting a world already meaningful.

Ironically, one of the key texts for understanding the role of representation can be found at the heart of historical materialism. The Marxist concept of the base/superstructure seems to represent the cultural domain as a secondary structure, dependent upon an economic base that is both its cause and its content. In the essay *The Eighteenth Brumaire of Louis Bonaparte* (1852), Marx carefully studies the sequence of historical events that led from the defeat of the revolution in France in February 1848 to the coup d'état of Louis Bonaparte in December 1851. It is a narrative of a series of moments focusing specifically on the political machinations of various parties and interest groups in the struggle to control the state and the government, and the final withdrawal of all save Louis Bonaparte from the political stage.

The theoretical importance of this text is the understanding it produces of the domain of the political as a stage on which class struggles were acted out by representatives of diverse economic and social classes and class fractions. The text concludes by suggesting the relative autonomy, in modern terms, of the ensemble of social practices

that can be classified as "the political." Relative autonomy means that there is at some level a relation between the ultimately material determinants on social life — how and in what relations people work — and the concrete practices in which these forces and relations of production are articulated and acted out. What's more, it means that once this level of representation is in place, its goings-on obey internal pressures and limits and, in turn, act upon the economic and social relations that they articulate. Stuart Hall argues that the economic must pass through specific forms of representation that constitute the political:

And once the class struggle is subject to the processes of 'representation' in the theatre of political class struggle, that articulation is permanent: it obeys, as well as the determinations upon it, its own internal dynamic; it respects its own distinctive and specific conditions of existence.[8]

8. Stuart Hall, "The 'Political' and the 'Economic' in Marx's Theory of Classes," in *Class and Class Structure*, ed. Alan Hunt (London: Lawrence and Wishart, 1977), p. 77.

9. Ibid.

He goes on to note that once class forces appear as political forces they generate their own effects, which "cannot be *translated back* into their original terms."[9]

It is not difficult to extrapolate a theory about the effectivity of *the cultural* as an equally significant articulation of the social forces of a society after looking at the formative relation between the political and the economic in bourgeois society. Furthermore, we can adapt the theory to accommodate relations other than those of class, especially in terms of race and gender and their mutual and complex inflections. Such potentialities are even more obvious as a result of the actual terminologies that recur in Marx's writing.

As many commentators have noted, Marx's text relies upon numerous theatrical metaphors: acting out, masquerade, borrowed costumes, comedy, tragedy, and farce.[10] Representation should be understood through the metaphors of enactment, dramatization, performance, and masquerade. This displaces the typical notions of reflection or mirroring associated with the phrase "images of women." But feminist theory offers an even more radical reworking of ideas about representation.

10. John Coombes, "The Political Aesthetic of the 18th Brumaire of Louis Bonaparte," in *1848: The Sociology of Literature*, ed. Francis Barker (Colchester: University of Essex, 1978), pp. 13–21.

In 1978, Elizabeth Cowie published the essay "Woman as Sign," which provided an anatomy of tendencies within feminist film analysis, while at the same time offering parallels with other areas of cultural critique. Cowie states the problem of "images of women" succinctly: "What must be grasped in addressing 'women and film' is the double problem of the production of woman as a category and of film as a signifying system."[11] Both sides of the equation, be it woman and film, or "images of women," require analysis. In my first example above,

11. Elizabeth Cowie, "Woman as Sign," *M/F*, no. 1 (1978), p. 49.

I suggested how semiotics allows us to attend to the specificities of systems of representation (film, images, and the like). But what about the other term, "women"?

Cowie suggests that it is common for film analysis to treat "woman" as a category already constituted in society through social and economic roles that form the lived world of women. Film is representation and therefore a secondary, ideological process reworking what has been formed prior to filmic practices. On the other hand, Cowie notes that some semiotic analysts of film acknowledge the active role of film as a signifying system. It produces meanings by organizing signifying elements within a specific narrative or textual system. But even in this formulation, we are still left with the categories of "woman" or "man," assumed to have a meaning produced somewhere else before the film put these elements into play. It is, at one level, common sense to acknowledge that there are men and women outside of film. But the existence of "real" people of the female persuasion is not what is at stake here. More useful is to question how categories of difference, and specifically of sexual difference, are produced and persons are subjected to them, indeed are subjectified precisely by being thus placed.

Using structuralist readings of anthropology based on the work of Claude Lévi-Strauss, Cowie argues that society is a complex of signifying systems that establish both sexual divisions in the socioeconomic realm and sexual differentiation of the subject at the psychic level.[12] Cowie stresses that film is one such signifying system that actively produces definitions of difference within a network of signifying systems.

For Lévi-Strauss, society, which is synonymous with culture, is a series of systems of exchange and is defined by rules that produce meanings by constituting a grid of differences. The most significant are the rules governing kinship, for these define the social or cultural family group — kin — against the biological family by determining who may or may not be allied through marriage. Marriage is at once the site of economic, social, and sexual practices — the exchange of wealth, the establishment of reciprocal relations, and the regulation of sexuality and reproduction.

Kinship systems, then, appear to be systems in which men exchange women: woman is the currency, both the token of exchange and the sign of those relations and meanings. But that formulation, to which Lévi-Strauss himself was susceptible, obscures the radical implications of the thesis. The basic difference established by kin structures is between exchangers and exchanged: the system designates a set of positions as potential exchangers and receivers — husbands, brothers,

12. For a comparable attempt to think through the sex-gender system as a simultaneous formation at the cultural and psychic levels, see the highly influential essay by Gayle Rubin, "The Traffic in Women: Notes on the Political Economy of 'Sex,'" in *Toward an Anthropology of Women*, ed. Rayna Reiter (New York: Monthly Review Press, 1975).

13. Of course, it would be disingenuous to pretend that there is no significance in the fact that the founding difference is that which engenders and sexualizes us. But it is necessary to imagine a non-sexual division in order to overcome any residual naturalism with regard to the materialist and historical terms of difference, not as a logical system, but as the forms of existence of the organization of the reproduction of the population. In the same way historical materialism defines class as the form of existence of an oppressive and exploitative organization of the means of producing daily life and social subsistence.

14. Rubin, "Traffic in Women," p. 60.

fathers, uncles, brothers-in-law, fathers-in-law. These positions collectively constitute the signification "man." Those who are distributed to the places in this system as wives, mothers, daughters, and daughters-in-law, for example, collectively produce the term "woman." Thus, far from assuming that man and woman are given through biology, or some moment outside of social time, the terms are presented as the generalized designations of places assigned by a signifying system — no more inherently meaningful than the value of numbers one through ten, which only signify according to relative positions in a numerical system. To recognize the arbitrariness of the system, we need only image that the difference that could distinguish exchangers from exchanged could be size, hair, color, six-toedness, or any other feature.[13]

Cowie's thesis, that woman is a sign within a signifying system, has quite radical implications for feminist analysis. On the one hand, woman as a category is produced, and we must attend to the mode of its production in any system we are studying, for example, film. On the other hand, woman is produced as a sign central to key social systems; what is signified by "woman" has nothing to do with femaleness — lived, imagined, or denounced.

To talk of woman as sign in exchange systems is no longer to talk of woman as the signified, but of a different signified, that of the establishment/re-establishment of kinship structures of culture. The form of the sign — the signifier in linguistic terms — may empirically be woman, but the signified is not "woman."[14]

This is difficult to grasp. "Images of women" places the emphasis on the problem of the images vis-à-vis contested ideas about what women are or would like to be. The concept of "woman as sign" makes us doubt that images signify women at all, though they undoubtedly circulate the sign Woman incessantly — and with the purpose of seducing persons of the female persuasion to recognize themselves in these signs and places. Visual images that proffer iconic figurations of the feminine body through rhetorics technically and ideologically aiming at the "reality effect" — this is, the disavowal of their rhetorical character behind the illusion of direct reproduction, transcription, and replication — play a particularly important role in this masquerade. The visual signifier "woman" is potent precisely insofar as the forms of representation, especially those associated with photographic processes, naturalize their constituents, masking their constitutedness and presenting themselves as mere description of a neutral content. Woman can therefore simply be seen, that is, in "images of women."

Cowie qualifies her use of Lévi-Strauss carefully. The structuralist tends to seek for the structure, signaled by the interest in the rules of

formation of a given system. The rules do not limit, but are the very means by which social systems can be generated and modified. It is necessary, however, to lay much greater emphasis on any system as a process rather than a structure. For instance, if we perceive kinship as a structure, we may be tempted to conclude that it is the cause of women's seemingly universal position as exchanged, secondary, different. This would lead us to seek some cause for it — men are beastly and aggressive — or some originating moment that easily slipped into inevitability. The important methodological point is that in a signifying *process*, origins matter far less than actual effects. This is not to abandon history, or diachrony, in favor of abstracted conjunctures. It is to repudiate a narrative that binds any group of historical moments in a long-term chronology that easily supports some transhistorical tradition rooted in the mythicized past.

Cowie's turn to anthropology is not an attempt to discover founding systems that produce sexual difference, but rather to make us think about all social practices as signifying processes, which are productive of meaning. If one of the defining features of all societies is the ways in which they sex their populations and organize reproduction, and hence sexuality, definitions of sexual difference will be multiply produced across many signifying systems, though not in any necessarily corresponding manner. We can grasp the accumulations of meanings, the attempted fixities, and the recurring patterns, which are then mutually reinforced by repetition and circulation in diverse forms across many sites of signification.

In a sense, then, the identification of stereotypes is an important recognition of such patterning. Such overdetermined significations utilize the body of woman for the meanings they attempt to generate. But every time the body of woman is put on display, it raises the repressed question of what it is and what it signifies.

One of the major theories of meaning, subjectivity, and the relations between subjectivity and systems of signification, is psychoanalysis. But both the foundation and the failure of its discourse can be found in the question of what woman is. Posed as a science that can confirm that woman *is* (explicable, knowable, reassuring, definable), its discourse continually exposes woman as a sign for the phallocentric system of signification. For Freud, the body of woman can be imagined/imaged only in fetishistic form — she is lacking and can be viewed only by restoring this lack, which threatens the very possibility of masculinity. For Lacan, woman is phallus.

In Lacanian theory a series of lacks and losses, of the object in the drive, or the

subject in relation to language, are overlaid and signified by the phallus (always a signifier, not a signified) and by the woman in so far as she assumes the position of the phallus. As man's missing part, as a substitute for what he has had to sacrifice or mortgage to the Law, the woman-as-phallus comes to signify in Lacan's terms, "what he has to renounce, that is *jouissance*."[15]

15. John Fletcher, "Versions of Masquerade," *Screen* 29, no. 3 (1988), p. 52. I am indebted to this paper for its clarifications between the various interpretations of the masquerade of femininity.

Both Freud and Lacan pose woman as representation, as fetish or signfier. The body to which representation refers is always, however specific the representation, the maternal body. But it is important to realize that the maternal body itself is already representation; the body figures the place of the Mother, the desire of the Mother, the status of the formative Other in relation to which subjectivities are initially outlined. Despite the literalness of Freud's account of boys' shock at the sight of their mother's body, the whole theory of psychoanalysis functions as a study of representations — imaginary, in fantasy, symbolic. It is a theory of substitutions and the forms (literally) of figuration. Jacqueline Rose clarifies this when she writes that it is not that "sexual anatomical difference *is* sexual difference (the one as strictly deducible from the other) but that anatomical difference comes to *figure* sexual difference; that is, it becomes the sole representative of what the difference is allowed to be."[16]

16. Jacqueline Rose, "Introduction II," in *Feminine Sexuality: Jacques Lacan and the École Freudienne*, ed. Juliet Mitchell and Jacqueline Rose, (London: Macmillan, 1982), p. 42.

Any image of a feminine body is thus a trace of a body (the mother's), a memorial to it as lost, a sign of threat because of its seeming lack. This lack can be disavowed by making the body image a substitution for it and for what it lacks, necessary insofar as both viewer and viewed are captured in a system of sexualized and sexualizing difference enacted in a familial system in which the actors are named in accord with a familial script — mother, father, son, daughter. To call it the mother's body is to name a relation that is figured by an image, rather than to fall back on some final excavation and validation of the nurturing mother — though that haunts us all as a fantasy because of the very system I am describing.

In light of this somewhat abstract rereading of current positions for approaching "images of women," I want now to reconsider some of the examples I used in the 1977 article. In trying to get a distance from the overwhelming naturalism of photographic imagery and the ideologies of woman, I looked at an advertisement for a large chemical company, which featured a series of seven ads. One of them showed a photograph of a young girl, nude. What I noted at the time was the elision of nakedness, bodyness, and woman, a combination which the reversal — using a man's body — made strange. In subsequent considerations of the original advertisement, much more complex readings became

possible. The advertisement was composed of a large photograph accompanied by text which read:

Test-tube baby

Lichfield

Adolescence — a time of misgiving. Doubts about the site offered by parents to build a life on. Both head and heart subject to the tyranny of hormones. Youth under stress in search of an identity.

Bayer is there to help her through this period of self-seeking. With textile fibers and die stuffs for the fashionable clothes she needs to wear.... With raw ingredients for the cosmetics she uses to create her own personality. And simple remedies too. Like aspirin (a Bayer discovery) for the pain she will experience.

All of this was under two headings. The series was called the "Seven Ages of Man." This particular ad was labeled "Test Tube Baby."

My first impulse was to point out that this was not only the single nude in the series, but the only woman. The combination seemed significant and sufficient (denunciation of the exploitative use of the female body). But close scrutiny of the text and its relation to the image generates something quite different. The whole of the text produces a tension between inner and outer, organic and artificial. Adolescence is the key condition; it is a moment of lack, waiting to be filled with meaning. It oscillates between notions of emptiness, a *tabula rasa* onto which personality and identity will be inscribed, and an imaginary fullness, the menstruating, fully dressed, and made-up woman. Femininity is to be mapped onto the body by cosmetics, fabric, fashion, which echo definitions of femininity as "masquerade." The body is also subject to another signification of femininity in which the feminine body is pathological, ill, in need of drugs as a direct result of the reproductive function with which it is so often elided. This body is both a trace of that maternal body and its disavowal through the fetishes of costume and the mask of makeup. Adolescence is posited as a period of transition between the lack and the completion. But completion is a kind of masquerade, and it is presented here as depending upon external interventions in the form of manufactured products. This psychosexual formation is thus articulated with commodity circulation. Bayer makes all the things this body needs to achieve "her-ness."

Yet Bayer is posited not merely as a producer of chemical commodities, but as a kind of midwife to the "test tube baby." It is there to help and provide. There is an implied identification with the place of the mother, as that nurturing, formative Other. At this point it is important to connect this text with the image. We might simply describe the image as a figure without clothes, in a kneeling posture, hands crossed over the chest, head inclined. But these body gestures and postures and the lack of clothing signify connotationally, outside the image, within the culture. "Unclothed" is a willfully obscure way of not saying the obvious. This is a nude. The nude is a term of art (artifice, culture), but in that discourse, it is a signifier for an ideologically construed notion of a state of nature, innocence, ignorance. The term "baby" implies a state of nature too, but the pose suggests another metaphor of the body as an organic entity. The pose may suggest an unfolding flower or bud. The pose and gesture are intensely rhetorical: the inclined head and crossed arms are both demure and submissive. We tend to associate these postures with woman, yet this body cannot be easily sexed. Indeed, its obvious sexual identity is carefully concealed by the legs and even the arms. The body is hairless and has no obvious signs of female gender, but it would be hard to dispute that most viewers would see it as a woman. Where does its femininity come from? From its submissiveness, its suggestion of unfurling flowers, its silence and to-be-done to-ness? In some senses the visual image is the opposite of the image conjured up by the text. The connotations of nature oppose the notion of the body as the site of chemical, that is, cultural transformation. The image has to sell the idea that someone needs Bayer products, that becoming a woman is a matter of intervention, construction, and artifice accomplished by using Bayer goods. The image also has to portray Bayer as a mere helper on the way to a process that is as natural as childbirth, yet naturally uses Bayer's test tube products. These contradictory impulses are at one level signified by the opposition between image-iconic message, and text-linguistic message. I do not think it is as simple as image being woman and the text signifying man (Bayer). The advertisement as a semantic field tries to knit into its complex pattern associations of birth and its feminine sphere, medicine and its supporting role, femininity and its artifice. The nude body is not a stable signifier for a given, simple notion of woman. It introduces into the play of the semantic field of the ad as a whole a series of possibilities that include a momentary recognition by the viewer of this as a female body. But the image does not work to fix that recognition, but rather to invoke and then destabilize it so that it can signify a lack that only Bayer can make good. Yet to put that lack on

display involves defensive procedures to disavow that feminine body as a signifier of lack.

The text produces a body that lacks an identity, a self, and that needs Bayer to furnish those lacks, which will then produce "woman." Would there be pleasure in looking at a body signifying lack; does not the female body in Freud's schema represent lack in a most terrifying way, threatening the potential mutilation of that by which masculinity figures itself as lacking lack? It has been argued that woman's body is an extremely threatening sight, and that its visual display is conditional upon a series of defensive strategies by means of which the threat of lack this body evokes can be disavowed and allayed. Fetishism is the prime defense, turning from the lacking body to some comforting substitute for that which is missing. Indeed, under the regime of fetishism, the female body is converted into a sign for the phallus itself. When such fetishism is combined with a tendency to compensate for the fright the body could offer by building it up into an abstractly or formally beautiful object, the body we see can in no way be deemed to be a body of woman — rather it is a sign for phallus, an inscription of masculine anxieties and fears displaced by aesthetic beauty. Merely to denounce this body as impossibly glamorized is precisely to miss the conditions of its existence, which have nothing to do with women. It may, of course, address and solicit women viewers into complicity with the order of sexual difference that generated it, which it actively signifies to its viewers.

This suggests not only that we are not looking at an image of woman, but also that we are hardly looking at a body at all. We may be looking at traces of several body *signs*, which can simultaneously occupy the fictive space of the image — or perhaps we should now introduce the real site of meanings. The point at which all the traces and currents activated by the signifying elements in the text (iconic and linguistic or graphic) converge is the putative viewer, who carries with him or her the necessary baggage to move in and out and across the many dimensions of the image that such systematic decoding inevitably impoverishes. The viewer is the split subject of semiotics (since Kristeva) and of psychoanalysis. The split subject operates in two discontinuous fields. Both word and image must address the conflicting demands of conscious and unconscious registers. Photographic representation has particular potency in this field for it offers fictive fields for fantasy located in credible spaces, likely scenarios, and fantastic possibilities. It addresses the demand for the legible and visible while servicing the less prosaic signifying systems of the unconscious with its multiple displacements, substitutions, and playfulness.

Let me now turn to another example originally used in my 1977 article. It is an advertisement for Levi's jeans in which again an unclothed body appeared. Rather, I should be precise — the advertisement offered a *corps morcelé*, a body fragment. The best way to summon it up is to invoke the viewer. The viewer is presented with buttocks that are situated at eye level. One cheek is visible and the other cut off by the edge of the image. Also included is a section of the arm and half a hand. On the fully exposed buttock are drawn the outlines of the stitching of a pocket to which is attached the Levi's label. I assumed that this had to be read as a female body, until a colleague pointed out its clear references to one of art's most famous buttocks, those of *David* by Michelangelo.

The hand, then, is there to underline the quotation. Why then did I see it as female while my colleague saw it as male? Probably because I know this image in color and he saw only the black-and-white reproduction, which emphasized the sharp line that the divide and crease in the buttock make. The effect is obviously more like the masculine anatomy. In the color version, this perception is effaced by the golden glow that bathes and unifies the surface of the whole image. The light is softening and creates highlights that emphasize the curves. Softened forms and contours connote a difference in the sexually demarcated rhetorics of representation, a difference signaled by the term "woman." The body is not sexed by reference to genital difference. The reading depends on the way light and color gloss the forms to convey feminine connotations. But to anyone for whom the reference to Michelangelo is available and vivid, the body would read as "masculine." The ambiguity is wholly to the point of the advertising campaign, which is serviced by an image that sells Levi's jeans both to men and women and can offer them to both kinds of consumer by pitching their desirability through a narrative of men looking at women's bums and women knowing that men find pleasure in looking at women's bums in tight jeans and thus imagine them without jeans, and so on. Jeans, moreover, have the added *frisson* of disrupting difference through confusing fixed-fashion codes for men and women. Yet this image has to be about desire and has to invoke it — a desire that will become attached to the commodity, which is itself here attached to the body as the site and figuring of desire. Could this image be read against this grain according to the viewer's sexual orientation? Its ambivalent gender identity only enhances that wide range of consumers. Yet without denying the potentiality of the images to be read variously according to the position of its viewers, there is a pressure within it towards a preferred reading. Color is vital here.

Through it the body is drawn, photo-*graphy*. Yet at one point light signifies lack; between the legs there is a gap where the model's right thigh is clearly defined by the fall of light. The same lighting effaces the contours of the left buttock and thigh. In this dazzling brightness, form is obliterated. Does this create the void that signals a lack of masculine genitals, thus signifying a female body precisely as that which lacks? Does this bright shaft of light nonetheless stand in for what cannot be seen in its brightness? If it can erase the leg, what else has it merely erased?

More than a decade after writing my original essay, I still think that anyone brought up in western society would read the body in that image as a female body, an erotic proffering of a sexualized body part. But that hardly explains the success of this image or its possibility as an advertisement. The highly technical manufacture of this image, its management of scale and fragment, its play on disavowals and displacements, its use of saturated golden color, and the deployment of a phallic hand move us constantly back and forth over meanings generated by these specific elements in the image field and then out into a world of images, back across the fantasies of bodies and their sexualities and uses located in our psyches, in those unconscious formations of fantasy that are synonymous with the manufacture of sexuality and sexual difference itself.[17]

17. Jean Laplanche and Jean-Bertrand Pontalis, "Fantasy and the Origins of Sexuality," in *Formations of Fantasy*, ed. Victor Burgin (London: Methuen, 1986).

The point being made here is that there really is no body on show. There is nothing there except the signs generated in the process of reproduction, which constitute a semantic field for a viewer, who is the only body present. These signifying elements yield the possibility of reference for a viewer. But the reference is not to the certain category of man or woman, but to the process that is sexual difference. That process is always a fantasy, a psychosymbolic domain in which sex and gender are ceaselessly produced and negotiated. These fantasies are sexual/erotic even as they are about sexual formation. They are mobilized within the system of commodity production and exchange.

The process of the image and its viewer, and the commodity and its consumer, are elided through the effect of "woman-as-sign," which signifies the lost object of desire and lack, for which the commodity is the momentary compensation.

One final image will complete the move from the image of a whole body to body part. In this, the image content is radically reduced. Into a plain black field are cut two inserts, one of reddened and opened lips, the other of an upright, unsheathed, and extended lipstick. Again we must acknowledge that there is nothing in the image to sex the lips.

18. See Laura Mulvey, "You Don't Know What Is Happening, Do You, Mr. Jones?" *Spare Rib*, no. 3 (1973), pp. 13–16, 30. Reprinted in Rozsika Parker and Griselda Pollock, *Framing Feminism: Art and the Women's Movement 1970–85*, (London: Pandora Press, 1987) pp. 127–131. See also John Ellis, "On Pornography," *Screen* 21, no. 1 (1980), for further discussion.

Max Factor advertisement.

Redness, fullness, a suspicion of a tongue signify at the level of connotation, within a discourse associated with pornography. Its regimes of representation are typically fetishistic.[18] That is to say, that the representation of any body parts is subject to the process of conversion, displacement, and substitution for a viewer, who is both curious and afraid (to look at something that is not there) and who invents an impossible body that was never there (the phallic mother), in relation to which the viewer's own unstable sexual identity is being fashioned. This somewhat contorted formulation is necessary to undermine the common sense that we are, in fact, *looking at a woman's lips*. The signifier in the form of the photographed model may well have been a female person posing thus — but that does not determine the signifying effects of the image. The inset picture of the lips is at once a superimposed area of lightness and color on a black field and an opening framed by the surrounding blackness — a sense of exposure and revelation carefully controlled. The viewer can see but is safe, protected particularly from being seen, looked back at. The isolation of the lips from the totality of the face — a recurrent feature in many advertisements for food and drink — is so commonplace that it is hard to grasp the violation and terror it embodies. Why are our senses not deranged by the facelessness, especially when the formal order of the page puts the lip fragment precisely in the place of the head and face? Synecdoche, where the part can stand for the whole, is perhaps a reasonable but inadequate explanation. According to Lacan, subjectivity (the possibility of the ego) is precipitated by the encounter with an image that unifies the disparate drives and sensations playing over the infant body into a psychical image of the body. Western art — and, indeed, most cultures — maintain considerable respect for the human body and have made the body one of the central signifiers of ideals of humanity. To cut up the body is to enact both a symbolic and psychic violence upon that body as

imago, an ideal that is the basis of self. Since the later nineteenth century, and especially after Picasso had visually hacked up the body, we have been gradually accustomed to the cutting up of specifically feminine bodies; indeed, their cut-up-ness has come to be a sign of that femininity. This fetishistic regime of representation is not ahistorical. But we do not yet understand the way it was formed in the nineteenth century and came to be naturalized by photographic representation in film, advertising, and pornography, all of which are discourses about desire that utilize the dialectic of fantasy and reality effects associated with the hegemonic modes of photographic representation.

Displaced by the luminosity and lush color, reassuring because of the formal geometry of the layout, the image of the lips is nonetheless an image of violence. Keeping in mind that trace of a body provoked by the arrangement of the two inserted photographs, we come to the lipstick. It is phallic, but what does that mean here? Typically, the phallus can never be represented. The penis may figure it, but more often it requires a whole body, which, as in the extreme case of bodybuilders, is a composite of many phallic signifiers; the whole body is phallic, tense, tumescent, hard. But the lipstick is not merely a stand-in for a man's organ, or a reference to masculinity, which would make the ad a straight masculine/feminine opposition. It too is coded "feminine" in our culture, and a link with the lips is made by the use of color. Its strategic placing is a fantasy of restoration to the carefully screened body that is signified by the mouth, both a possible sign of the mutilated maternal genitals and a metonym for the mother's breast through oral associations of sucking.

At a literal level, this ad is selling us a lipstick. But at the structural level, it creates a relationship of need premised not so much on lack as on deficiency with regard to the female body as an object of desire. All cosmetic advertisements work to promote a sense of women's deficiency in relation to an ideal of desirability. We have to buy their commodities to make us beautiful. Building up the aesthetic beauty of an object by the mechanism of fetishistic scopophilia is one of the defenses Laura Mulvey identified in the star system of Hollywood cinema.[19] The commodity of lipstick not only is fetishized in Marxian terms, but is a fetish in the sexual economy as well. The signifying system of advertising as a specific point of production of signs and meanings is articulated with, but not reducible to, economic practices. The commodity is a sign, as an exchange value and token of exchange in which value is invested and by which it is realized. It is also a sign in the psychosymbolic domain where order is secured by the circulation of the phallus.

19. Laura Mulvey, "Visual Pleasure and Narrative Cinema," *Screen* 16, no. 1 (1975). Reprinted in Laura Mulvey, *Visual and Other Pleasures*, (London: Macmillan, 1989).

20. John Fletcher, "Versions of Masquerade," p. 52.

Attempting to deploy psychoanalysis, structuralism, and historical materialism in the service of feminist analysis of the image requires me to locate my speech within discourses that themselves are fetishistic.[20] Masculinity and femininity are produced as terms of a hierarchical difference premised on assigning a lack to a perfectly whole body. Women's bodies lack nothing, have not been mutilated or castrated. But their position in the world is constantly subject to castration, symbolically, as a denial of being, a denial of speech, a denial of the means to figure the subject by means of its body. Therefore, we must conclude that there are no "images of women" in the dominant culture. There are masculine significations figured by deployment of body signs. Yet I have suggested that any figured body is a complex of traces of fantasies of several bodies, bodies constantly oscillating between lack and plenitude, threat and restoration. *The* body of this scenario is the mother's body, the repressed body, and the one that obsesses the phallocentric system. Every image of the feminine coded body is at the same time an image of woman and not an image of woman. It is never simply fetishized and phallic, nor a memory trace of the *jouissance* imagined and desired in relation to maternal plenitude. Both and neither, the image is a field traversed by desiring subjects/viewers through whom meanings come into play only to be ceaselessly displaced by others. Advertising photography is a major scene of representation of sexual difference in this conjunction of two economies of desire, where commodity and psychic fetishism entrance us through their mutual investments in and constant trading of our subjectivities.

PRACTICING THEORIES

An Interview with John Tagg

Joanne Lukitsh

The text is an edited version of one first published in *Afterimage* 15, no. 6 (January 1988).

1. John Tagg, "The Currency of the Photograph," *Screen Education*, no. 28 (Autumn 1978), pp 45–67; reprinted in *Thinking Photography*, ed. Victor Burgin (London: Macmillan, 1982).

2. John Tagg, "Power and Photography–Part I. A Means of Surveillance: The Photograph as Evidence in Law," *Screen Education*, no. 36 (Autumn 1980), pp. 17–55; and "Power and Photography–Part II. A Legal Reality: The Photograph as Property in Law," *Screen Education*, no. 37 (Winter 1981), pp. 17–27.

3. John Tagg, *The Burden of Representation: Essays on Photographies and Histories* (Amherst: The University of Massachusetts Press, 1988), p. 3.

Writer and educator John Tagg has played an important role in the development of critically informed writing on photography since the 1970s. In "The Currency of the Photograph"[1] and "Power and Photography,"[2] Tagg has advanced the ideas that the photograph is neither a disinterested transcription of the "real" nor a pictorial form separable from the motives for its production and the institutions in which it functions. Instead, Tagg proposed that photography is "a material apparatus set to work in specific contexts, by specific forces, for more or less defined purposes."[3] The following interview took place in May 1987 at the State University of New York at Binghamton, where Tagg is associate chair of the Department of Art and Art History. He discusses with Joanne Lukitsh the progress of his thinking in regard to his own critical and institutional practice and some of the theories enlisted in the current rewriting of photography's histories.

Joanne Lukitsh: When questions of theory and practice are raised within college art departments, it is usually done within the art studio but not the art history classrooom. What are your observations on this split?

John Tagg: Well, there are ways one can open up the space between theory and practice from the point of view of art historians as well. Art historians are very good at meting out prescriptions to practitioners, but they are not very good at thinking of themselves as practitioners, thinking about the strategies they use, the spaces they work in, their own institutional base, their own implication in power. Art historians, like art critics, are comfortable telling practitioners what to do, how to operate — ticking them off for not connecting with new audiences, finding new spaces for practice — and they go on writing in journals, lecturing, sitting in universities — like me. But this is an area to look at, too. What about art history as a cultural practice? Because it's actually more and more significant economically. Agriculture is New York's biggest industry. The next biggest industry is tourism: which means selling what you and I do — selling "cultural heritage."

There have been few enough moments when art historians have tried to confront these issues: the *anti-catalogue*, for example, produced

at the time of the Whitney bicentennial show in 1976. Was it intervention-ist art? Was it art history? It is uncategorizable. And I would like my students to think about doing something besides writing a thesis — to have much more flexible ideas of what they could do as a historian-critic.

JL: I can appreciate the desire to create a generation of cultural historians, especially since that kind of training isn't widely available in art history departments in this country. But in terms of gainful employment, only certain people will end up occupying a very secure institutional space. Most of the B.F.A. students taught by these instructors will face very uncertain employment opportunities.

JT: The direction of your question suggests we can still speak from a voice of authority, a voice outside. But can we? There are two responses to your comment: either start worrying about how those students can operate with a B.F.A., what they can do; or else start challenging the position of art historians to adjudicate on this, making them think about their own practice. This is not, of course, something we might choose to do. In England, before I left, many of my graduate students were going to go on the dole. They were probably doing the course while picking up welfare, and there was going to be no work for them afterwards. Contrary to what you say, they haven't been hiring in universities in Britain since 1980. There are no jobs; there will be no jobs.

In the mid-1970s, by contrast, the debate had been focused on new methods in art history. No one ever thought about where they practiced because it was all going on OK, even if it was often marginal. Then the university cuts came. They cut right across the interests, security, and habitual concerns of what had then become established as "the New Art History." Art history students as well as art students had to ask: where am I going to go with these kinds of ideas about deconstructive practice, cultural politics, or whatever? And there was nowhere for them to go, unless they found spaces in community art centers, youth opportunities services, or the kinds of independent galleries and studios that were be-ginning to set up education programs. They weren't ever going to come back into academe: there was no space for them. They had to think about where, as well as how, an art historian could practice. They were more likely to find work in the areas of tourism, museums, and galleries. They had to create alternative institutions, set up workspaces, set up a gallery, education programs, seminars, or something like that. It happened in Leeds, Newcastle, Sheffield, Manchester, Liverpool, and so on, as well as in London. It cut against the process of metropolitan concentration.

Such projects are interesting in themselves. But they have also

pointed to a whole unchartered area: 95 percent of the art history that's consumed. What do people do on their day off? They go out and consume art history. They go out and visit a monument; they go to an open-air museum, a country house, a "national monument," site of "historical importance," or whatever. And the art history they consume plays a crucial role in the construction of a notion of the National Heritage. Yet, it seems that few of the radical art historians of the 1970s ever thought about this as an area of intervention, even though we were the people who were all in favor of interventionist art work, work on the streets, deconstructive work. But what would it be for art historians to do the same within their own practice? An example, as I have said, would be the *anti-catalogue* committee who sold a counter-catalogue on the steps of the Whitney that rewrote the museum's bicentennial show from which the committee's concerns and arguments had been excluded. So, if I agree, on one hand, I've got out of art schools with the problems they have, because I want to teach people who have a primary commitment to the area in which I work; on the other hand, there's this idea of shaking up art history as well, producing new kinds of art historians.

JL: Perhaps it's a dilemma many art historians don't want to face.

JT: It's difficult. It brings up the whole thorny question of "intervention." Anything I say is going to seem like bad faith because I have a job and so many people are unemployed. Nonetheless, I think the space between incorporation and intervention is not fixed but constantly negotiated. The mythology of the avant-garde is that there is a center, which is incorporated, and a middle-ground, which is kitsch or lower-brow culture or whatever the term is they want to use, and then there are the margins, occupied by avant-gardes and other heroes. So it's simple: there's a center — a dominant culture — and there's a margin. Cross that line and you're incorporated.

In fact, this whole representation of our culture is completely inadequate to understand how it is structured, where its centers are; for it may be subject to colonization and domination, at a number of different levels, but it is not a centered structure. Power doesn't operate in one way, through the "usual channels," or in a simple descending manner, however much we might have to calculate the effects of the emergence of certain forms of the modern, centralized state. For example, contrary to one kind of argument that often surfaces here, there is no such thing as a unified market culture, because there are whole areas that are highly capitalized and fully absorbed into commodity production, that are areas of great profit, that use the latest

technological means of cultural reproduction and are very powerful in some senses, yet are excluded from cultural privilege, where they are not sporadically repressed. Think only of the publishing, film, video, and tourist industries connected to pornography, for example. On the other hand, we have residual activities that would have died out long ago if it had been left to market pressures, yet which carry all the weight of cultural prestige: monumental sculpture, for example, or ballet, or opera with its 80 percent state funding, or military bands, which in Britain receive a bigger subsidy than all other "arts" put together. Dominant culture is not homogeneous, nor is domination a single kind of process, let alone a question of economic determinacy.

This is not to say I think there's any space outside our cultural order, but I don't think this order is a circle with a voracious center and a vulnerable periphery or margin. Thus the question of incorporation isn't one that's decided in advance, say, by where somebody is working — whether they are showing in a gallery or working on the streets, lecturing in the lecture hall or speaking from a soapbox, publishing books or producing pamphlets. It's a matter not of stark moral choices — a kind of Truman Doctrine of cultural practice — but of continual and provisional institutional calculation. So, there's no question of grand strategies either. I mean, along with the unified image of our culture as a series of concentric and involuting circles goes the whole avant-gardist fantasy of a grand strategy; a way to strike at the center from an uncontaminated space outside the circle, to effect a total revolution. The political resonances, here, are clear enough, but against the ambitions of totalizing theory, Michel Foucault's ideas of micropolitics make us think much more about how practices engage with specific kinds of institutional relations, power relations, ways of speaking, ways of prohibiting. I guess the whole seventies' radical fantasy of the big push, the answer, the strategy, is gone. This is supposed to be the index of my own "despair," and I suppose it is from some points of view, because we have no longer got the compensations, the self-heroization; we've seemingly just got little shuffling kinds of interventions that have no way of getting a bird's eye view of the field from which to judge every action against some grand map. There's no doubt this has created a kind of vertigo: where is the grand plan? For example, a book came out in the 1970s in England with the title *Beyond the Fragments*[4] that suggested the hope that eventually this fragmentary activity would all add up: we would all be shown to be in the same column, headed by the same vanguard. But it was a false and, I think, unnecessary hope. These struggles don't add up; they actually don't add up. There's no way you

4. Sheila Rowbotham, Lynne Segal, and Hilary Wainwright, eds., *Beyond the Fragments: Feminism and the Making of Socialism* (Boston: Alyson Publications, 1981).

can make a struggle over washing-up the same as the struggle in the classroom, or the struggle over deindustrialization. Acknowledging this is deflating, but I don't think disabling.

JL: Since you moved to the United States, in 1985, it seems that you've been less involved with activities dealing specifically with photography than you were in the 1970s in England.

JT: I've certainly never wanted to be a historian of photography as such. I've always tried to pose the issues more widely as those of visual culture, histories of representation, representational practices. It's true, however, that it was possible to talk about things in the area of photography it wasn't possible to talk about in the area of art history. But it's impossible to teach the history of photography as a canon, as a discrete and coherent field or discipline. I mean, how could one teach the history of photography without talking about family photography, without talking about the photographic industry, advertising, porno- graphy, surveillance, documentary records, documentation, instru- mental photography — whole areas of production in which there is no common denominator? There is no such thing as photography as such, a common medium. There are differentiated areas of production, differ- ently institutionalized practices, different discourses. One could, of course, raise the same issues in literature, but radical literature de- partments go on laundering the same canon, rereading the same texts: a new reading of Milton's *Paradise Lost*, another reading of Joseph Conrad, and so on. A course is offered, say, on "Writing and the Body"; but it turns out to be another Lacanian or Derridian resurrection of surrealism. "Writing and the Body": wouldn't that mean looking at medical reports; wouldn't it mean reading criminology and parliamen- tary records on public health; wouldn't it mean tracing the emergence of new forms of technical writing? Where is the body written? For so many literary critics, the body of Literature is too precious to be given up for this kind of inquiry. You could say the same about art history: it too thinks it knows where its objects are — because they are all in museums. But it is the historical emergence of this canonized archive in relation to others of a more lowly sort that constitutes the real problem.

These are the sorts of issues that could be opened up through the history of photography. So that now, if I was to look at the history of drawing, I would have to ask: where is the history of mechanical draw- ings or "working drawings," as opposed to "idle drawings" or "art" drawings? Where is the history of blueprints? Where is the history of cartography? (And cartography and photography have a crucial

relation.) I would have to ask a wholly different set of questions. There would be no assurance of knowing in advance where the archive was or, indeed, what drawing was. This is a line of questioning that has been pursued in the area of the history of photography; something which hasn't even been the case with film theory, where most people have taken the "corpus" as given.

Perhaps that's why so many people in the mid-1970s gravitated toward work in photography. I think a number of people did so precisely because it wasn't caught in the canon. And I think a related point at the level of practice is that it hasn't been successfully appropriated to a hierarchy of metropolitan institutions. In Britain, photography is a thoroughly devolved practice — you can't learn about British photography in London. It goes on in provincial towns and cities, in all kinds of galleries and workshops and evening classes, and so on, in devolved organizations — it's not London-based. I think, therefore, that a number of people went into this area of practice and theory because there was a space: it wasn't caught in the same institutional structure, or in the same paradigm, as Art. But then, having done that, and having made an intervention through this space, I don't want to get caught in it, because then I would be solidifying the very thing that I have sought to challenge: I'd be occupying and institutionalizing a contained space as a historian of photography who, paradoxically, writes all the time that there is no such thing as photography and so on.

JL: In the United States, you are strongly identified with the two "Power and Photography" articles, which are reprinted in *The Burden of Representation*. In general, what do you try to accomplish in the book?

JT: It's related to what we have been talking about, because what we've been talking about is, actually, how I could take the arguments of these articles and apply them to my own practice. So it folds back. If I'm going to ask questions about the relationship between power and representation, questions about institutional spaces, power relations and their implication in ways of speaking and ways of silencing, then I have to ask them in relation to the way I work as well as in relation to the things I look at. OK, it's a book. Perhaps, the best I can say about that is that it's a contribution to a series on cultural theory and cultural history; so it's a slightly different space.

All of the articles it includes were written with a project in mind, and it was useful to pull them together, though they don't add up. I mean, it was useful to see them together in an order that is not the order in which they were written, and then see how the project didn't add up at all.

I think the articles were each always speaking to a number of contexts, saying different things in a number of different contexts. For example, the original "Power and Photography" piece was given as a talk at the ICA in London in February 1979, where it was deliberately couched to follow a lecture by a photographer who taught at the Royal College of Art, in the photography department, but who was volubly committed to street photography, to the idea that Reality is out there on the streets and you've got to get out there, that's the radical thing to do. There is the Real, out there, it can be possessed and brought back, and the truth will blow apart ideology. I wanted not only to have a go at this theoretical conception of the Real-out-there and the conception of ideology that goes along with it, but also to suggest that surveilling the streets or getting on the road in search of the Truth were activities implicated in a sorry history and saturated in relations of power. This precipitated me into looking at other kinds of archives, other kinds of materials. But, at one level the impetus was an argument about contemporary left photography; something that takes us to the "Three Perspectives," show at the Hayward Gallery [London, 1979], because my selection there, the "socialist perspective on photography," deliberately refused to present a stylistic position but argued instead for a mapping of specific practices. It showed quite different kinds of activity, even including street realism or social realism, because what interested me about groups like the photo agency Report or the Hackney Flashers, a feminist collective, was that they were much more inventive and resourceful in the ways they organized themselves than photographers intervening in art institutions tended to be.

So there was an argument in the book with current practice, but there was also an argument with photo history, pointing to archives that hadn't been engaged with. And there was a further argument with art history; for example, with Tim Clark's seminal work on realism which, for him, focused on a study of Gustave Courbet.[5] What I wanted to suggest was that, if there is a crucial connection between debates about realism and an emergent social order, perhaps the significant debates on realism, on representations claiming the status of the real, don't go on in art criticism alone. Perhaps there are other levels of debate and negotiation that might take you to very different spaces: to manuals on police photography or psychiatric photography; to parliamentary legislation allowing a kind of photography to be used as evidence; to arguments about copyright law — about which image is real and therefore in the public domain, and which image is creative and therefore private property. In another sense, then, those two articles on

5. T. J. Clark, *Image of the People,* (New York: New York Graphic Society, 1973).

power and photography specifically engaged with Tim Clark's work by seeking to ask where else one might look to trace the emergence of new realist discourses and how else one might think through their relation to power.

Another area on which the articles focused was that of theories of the state and their relation to theories of representation. The first piece appeared in an issue of *Screen Education* that was subtitled "The Politics of Representation." I was on the board of *Screen Education* and was very much aware that the journal had an idea of cultural history and cultural theory that was, by then, much broader than the journal *Screen*'s idea of finding a methodology and a text to apply it to — a can opener to open the text. The board of *Screen Education* had tried to develop a notion of cultural politics that carried over into the journal's specific involvement with teaching and pedagogy. This was an intervention of which the articles became a part.

So I think these essays, like any others, have spoken a number of times, and when you say they fix me (though they are theoretically unfixed and incoherent in ways we could talk about), my reply would be that you are pulling these texts into a particular context, but beyond that, they require their own archaeology because their multiple and ununifiable concerns already seem elusive and strange.

JL: Do you raise the implications of changing the context of publication in the book?

JT: Yes, in the introduction. It seems to me now that these articles are both theoretically and historiographically incoherent in ways that are, perhaps, instructive. They also had their own contexts to which I wanted to point. These things run together: the kinds of context they came out of had to do with debates about cultural politics that were bringing together practitioners and theorists in new ways, that were not necessarily going on in academic spaces, and that were engaged in trying to think of new options for political change as well. This is a context that has come to seem so remote now — and of course in another country it seems even more remote — that it needed some explanation.

Part and parcel of this were certain marked theoretical ambitions, so that one could talk about the articles in another way: talk about the kind of political intervention being theorized, but also about the way the theoretical basis created excessive hopes for that intervention. Central to all the essays was the work of Louis Althusser and Michel Foucault. And there is clearly an attempt to read their theoretical programs as continuous: to argue that we could take Althusser's idea of the state and

Ideological State Apparatuses and that would explain where photography worked, why it was politically important, what political investment there was in it, how power operated in the representations and institutions of photography, and how they could be viewed as part of the state in this expanded form; and then, you could plug Foucault's account of specific institutions, discursive formations, and their power relations right into this model. And that would provide an alibi...

JL: An alibi?

JT: An alibi for cultural activism. Althusser's theory made a cultural politics possible because it said: cultural apparatuses are actually extended apparatuses of the state, invested with power relations that reflect relations of class domination in the society. It therefore became as valid to be working in a cultural arena as in a parliamentary or an industrial arena, or whatever. One could say, look, there's the Althusserian argument that explains that the way power works in a developed capitalist society resides in a whole network of cultural institutions that somehow secure social relations of production. That validated one's work. But at the same time, it invalidated it. Because, according to the theory, if cultural institutions were Ideological State Apparatuses, on the one hand they were valid areas of intervention; on the other hand, if those interventions didn't go beyond the cultural institutions themselves, ultimately to take on the state, then they were merely reformist. Cultural institutions were seen as extended arms of the complex modern state, so unless challenges went beyond them to engage in the supposed common struggle against the state, wherever it was found, they could be accused of merely collapsing back into reformism.

On the one hand, Althusser's seminal contribution, as it was debated in Britain, opened up the area of cultural politics for analysis and for practice and created an alibi: we could then have good political credentials for working on specific cultural institutions. On the other hand, at the same moment, it took away the ground from beneath us, because it was a view that was still implicated in a reductive idea of power as economically constituted class power, "expressed" in the entire range of cultural institutions that could then be viewed as apparatuses of the state. It still maintained an idea that cultural "apparatuses" reflected or represented power relations that were really and properly set in place elsewhere, in *production*. So we were given something on the one hand, only to have it taken away on the other.

If we take the articles in the book in the order in which they were written, beginning with "The Currency of the Photograph," we can

clearly see the ambition to try to build up from the Althusserian account of the state, to understand representational practices in the terms of that model, then to slot in Foucault's analyses of power/knowledge relations merely as a development or extension of Althusser. This would then be a way of analyzing the micro-level of photographic documentation, to blow apart the 1930s idea of radical documentary, to talk about the power relations involved in practice, and yet to maintain a claim to being engaged in a thoroughly politicized activity. This became a problem, because the idea that institutions reflected power that came from elsewhere ran against the very grain of the theory of power and discourse being invoked. Once one said that the kinds of power effects generated in cultural institutions or cultural practices are not representations or reflections, are not simply referable to a power given in advance, elsewhere — if, in fact, the power effects of cultural practices and institutions are not reducible to the replication of power relations created at the point of production — then, of course, the whole centralized model of the state begins to be decentered, begins to fall apart. We can retain an idea of cultural politics, by insisting on the power effects of cultural practices and institutions in themselves, only at the price of abandoning the idea of a necessary structural connection between these activities and some larger desire to overthrow the whole totality.

The worrying path trod by the articles is the loss of that sense of social totality. If they insistently hang onto an idea of cultural politics, it is only to see any notion of the pregiven place of cultural practices within a total structure receding fast. Hence the critique in the introduction of the notion of totality that is there in the first essays: the conception of society as a structure involving a number of functionally necessary levels of practice that interlock in certain ways, so that cultural practices can be seen to be as crucial as economic and political practices, though in the last analysis they do not have the same determinant weight. Because of the ways this model of the social totality has come under attack, it seems that we now have no clear way of siting the activities we're involved in as practitioners (theory practitioners, history practitioners, academic practitioners) or have studied (photographic practices, representational practices) within a pregiven structure or model of society.

This is what comes to be questioned in the articles in the book. Their ambitions are unfulfilled and unfulfillable. The ambition of the first articles was to elaborate a model of the social totality in which social practices would all lock together in this way and in which we could then begin to understand cultural apparatuses and how they work to

reproduce the relations of production. Having put together a book and tried to make it coherent only to find myself working against the grain of the very ideas being invoked, I'm now trying to argue that its incoherencies are actually useful, productive, or interesting.

In the introduction, I've tried to make an argument about the relation that is there to be explored between the development of forms of social governance and administration and practices of representation. This is crucial: the implication of photography in new forms of social administration in the nineteenth century. A number of the articles look at documentation, record keeping, and practices of surveillance in the nineteenth century and go on to ask about the relationship between these models and "documentary" practices, which constitute a quite different kind of discourse: a popular rhetoric addressed to a particular sector of the populace, speaking of an Other. This is quite different from nineteenth-century documentation, and the two cannot be run together. We have, rather, to map the moments in which these discourses were formulated, the currencies they had, the power effects they generated. But the relationship between instrumental representations and new forms of social administration cannot be seen in the way imagined at the start: in terms of a model of the state in the Althusserian sense.

So, I've tried to bring out both the historical argument about nineteenth-century documentation and 1930s documentary practices and the theoretical argument, whose direction points again to what we have discussed earlier in relation to seeing academics as "specific" intellectuals. Here, too, what is coming out is an insistence upon analysis of specific structures and specific practices; not an analysis premised upon a global model into which the particular is then fitted. This is deeply problematic if you have been working out of a Marxist tradition that has insistently revolved around a particular kind of topography of society in order to understand the cultural and its place in the overall social order.

JL: Would you like to elaborate on that?

JT: Marxisms have constantly negotiated around the idea of cultural practices as a superstructure, somehow linked to the other superstruc-tural and structural levels of society — the political and economic. For such theories to abandon the notion of social totality is fraught with problems. How could we then pose the relationship between one practice and another? Yet, I think we can pose the relationship between one practice and another without having to be dependent on a pre-given model into which they can be slotted. We don't have to have this

architectural model in which everything is fixed on the right floor, no matter how many mediatory staircases and elevators are built. We may be told that we have to choose between totality and chaos. But, in fact, thinking about specific structures, specific institutions, specific discourses doesn't shut us off from exploring specific relations between practices or between the conditions of existence of a particular practice and its effects. We simply don't have to choose between a global explanation — a notion of totality — and a chaotic conception of everything as simply being itself.

JL: Is the article about doing research in an archive, "God's Sanitary Law: Slum Clearance and Photography in Late Nineteenth-Century Leeds," an answer to that criticism?

JT: It is an essay precisely caught in the problems of the ambitions I am describing. It concerns an archive opened up to me by a local historian in Leeds, Janet Douglas, who used to conduct architectural walks in which she taught her classes a kind of literacy: how to read the streets. (Not just "high" architecture, though Leeds has a wonderful Victorian town hall and Corn Exchange. We'd walk around back-to-back housing and learn how to read the political-geographic formation of this town.) It was Janet Douglas who pointed out that historians of housing used these albums of photographs as illustrations allegedly showing us what nineteenth-century housing was like. None of these historians, however, seemed to have asked about the photographs themselves as a historical practice. As historians, they were caught in the notion of the photograph as evidence, which was precisely the notion these photographs tried to establish in their currency.

 Having found these photographs of slum housing in this way, I began to work on them, but I still had in mind that this would again slot into a particular conception of the local state: that one could look at this archive as an instrumentality of state power. The photographs were certainly part of a strategy in which the east end of the town, the literal environment and, of course, its occupants, were to be brought under control, spoken for, positioned, defined as Other. Within this strategy, photography operated as a means of surveillance, intruding, looking, searching out, but also as a means of evidence or incrimination. The interesting point is that these photographs were produced in Leeds to be shown in Parliament in London as part of the official case for an enabling bill allowing this area of Leeds to be knocked down. The photographs claimed, therefore, to speak the truth of an area that Members of Parliament had never visited. Of course, there are minutes of the

parliamentary committees, but in these we don't hear the photographs speaking for themselves. We rather find that the very readability of these pictures had be negotiated.

Here, then, we have photography as an instrumentality of power, mobilized by the local medical officer of health and the local engineer as a means of intruding into, of fixing, knowing, and controlling a no-go area, a working class, largely Irish and Jewish, slum. The very fact of medical officers and their photographers having intruded into the area was a trace of a kind of power — but it was not, however, entirely successful: the photographers never got into anyone's house, for example. The photographs were then to be used to gain the power literally to knock the area down, to unhouse the inhabitants. To do that, however, the photographs had to be established as real; they did not already possess an evidential value.

In *Camera Lucida*, Roland Barthes argues that the photograph's value as evidence is seared into it by its indexical nature.[6] I wanted to argue that its evidential value was something that was contestable and in fact, contested. It was something that was institutionally and historically produced; it had to be argued for. Otherwise, the photographs were just bits of chemically discolored paper or, more to the point in this case, just a bunch of postcards. Seeing a photograph as somehow having the clout of truth was something that had to be produced, argued for, institutionalized. And, given the fact that there were minutes covering the Select Committees that were shown these photographs, we could follow, here, the trace of a historical gaze; uncover, perhaps, the way that gaze was engineered and institutionally sanctioned, so that looking became caught up in the idea of the truth of the photograph and its evidential weight.

The investigation of how these pictures were used and looked at was, therefore, a way of developing arguments previously made, for example, in "The Currency of the Photograph," that rested on the view that we can't understand photographic meaning as an abstract system, as a *langue*, but only as a social practice involving specific institutional currencies, determining the way photographs circulate as social discourse. It was a chance actually to look at the historical negotiation of the idea that photographs are self-evident.

If fact, the minutes trace the photographs' disputability. It's largely the medical officer of health who takes them to London to do a number of things. He wants to build up his own credentials and the professional weight of his account of the area proposed for demolition. He has then to build up the professional status of his reading of the

6. Roland Barthes, *Camera Lucida*, trans. Richard Howard (New York: Hill and Wang, 1981).

photographs. He therefore has to contest the idea that photography is an entertainment, something associated with Sundays on the local common. He has to insist that photography is a specialized technology, like a theodolite [a surveyor's instrument], and that its images, like blueprints and maps, are materials that require professional scrutiny and interpretation. So he builds up his own credentials at the same time as he builds up the credentials of photography. This is what the minutes trace to a degree, though still not as one might wish, because even the minutes don't record how the committees, which might have thought they had been shown a postcard album, were schooled in the protocols of handling photographs as evidence. A similar question could be asked about the maps or architect's drawings that were on the table as well, and which the committees seemed to be much happier about accepting. Clearly, we are dealing here with specific representational conventions that are very much professionally controlled and have to be taught and learned, and not only by those who make the maps, because the enabling bill would never have been passed if the committee hadn't accepted those conventions and their reading. I was looking for a trace of how such literacy was engineered for photography. But it wasn't entirely graspable, because it wasn't even minuted. It had rather to do, one suspects, with the way the photographs were handled and handed round the room, the way they caught the gaze of the committee members and spoke for themselves wordlessly. What is recorded is the work that had to be done by the medical officer of health to make them speak in this way, by a legally sanctioned ventriloquy, by his insistently helpful translation of what they had already supposedly spoken.

JL: Given what we've already discussed, what would you add to your comments on "Power and Photography"? Also, do you anticipate becoming involved in arts administration in the United States?

JT: We were talking about the way the article tries to telescope a number of things: Foucault into Althusser, semiotics into discourse theory, the theory of positionality into a general theory of the social formation. There's an idea that, somehow, Marxism, feminism, psychoanalysis, and semiotics revolve around a theory of social subjectivity. And we discussed why those ambitions for an eclectic but unified theory have fallen apart. You could look at a whole range of journals from the late seventies, not only *Screen* but *Screen Education*, *M/F*, *Working Papers in Cultural Studies*, and *Block*, and find this momentary belief that these theoretical discourses could be sewn together. And it wasn't only a theoretical project.

But that was another moment: pre-1979, before Thatcher's first election. It was also another context. Not that it was a simple matter of taking theory onto "the streets," but there seemed to be enough connections, through involvement with arts administration, workshops, galleries, publications, and local politics, to make it feel like it wasn't isolated.

The major problem here in the United States is the corporate structure of cultural institutions and the much more developed professionalization and thus greater isolation of intellectuals. It's more than just being stuck out on a campus shaped like a brain, whose spinal cord is a post-urban parkway, with no connection to a (dead) town center. This is the most obvious part. But I'm so far from understanding the economic, cultural, political processes that make this place. I can't just "intervene." The whole theory of intervention isn't a paradoxical general theory for landing anywhere, helicoptering in the theory corps.

Perhaps an important part of what I'm saying is that I simply haven't done enough mapping to understand the cultural and institutional networks. I don't know enough to say what are the languages, institutions, spaces, or conditions here. What's different on the academic front is that a lot of what I'm doing is retrospective, informing people of debates that have gone on in Britain over the last ten years. Because it seems that American campuses have characteristically skipped a beat in the way humanities departments have come, recently, under the influence of a particular reading of Derridian deconstruction, in which Derrida is taken away from the way in which he was interrogated in France or Britain. There's little familiarity with the kind of questions associated with journals such as *New Formations*, *Screen*, and *Screen Education*, for example. To be coming out of certain traditions of French theory means something very different here. But I still think that there are crucial things going on in that tradition — its attack on authorship, or its attack on the closing of the text, for ex-ample — that can be brought into relationship with other areas of debate that aren't read here. For instance, with the work of Raymond Williams on the organization of cultural production, the technologies of cultural production, and the relations in which cultural production goes on. These are issues, like those of cultural practice, that tend not to be talked about here in theory departments dominated by deconstruction.

JL: You included a diaristic essay, "Contacts/Worksheets," in your book. Could you talk about it?

JT: Right, we haven't talked about that piece and its embarrassments and difficulties, even though it's very fashionable after Barthes and

Baudrillard to be writing diaristically: we're all supposed to be speaking the personal; it's all stream of consciousness now.

I should say that, if I find it embarrassing, it's embarrassing in precisely the way that I ought to be embarrassed. Two things are not being spoken in the rest of the book: the impact of feminism and the impact of psychoanalysis. One can, it's true, read "Power and Photography" as a kind of response to Laura Mulvey's article on power and looking,[7] to the great difficulty she has in trying to connect her analysis of a specific historical regime of representation and looking with the undefined temporalities of patriarchy and the Oedipal complex. Foucault's analysis of power and looking suggests that this universalizing of the look is inadequate, because looks have more complex histories. So one could regard "Contacts/Worksheets," like "Power and Photography," as written in response to certain debates in feminism, psycho-analysis, and representation. But it engages more directly, not only with this, but with feminisms of other sorts.

7. Laura Mulvey, "Visual Pleasure and Narrative Cinema," *Screen* 16, no. 3 (1975), pp. 6–18.

There was an interesting split in Britain between the kind of feminist cultural theory that was close to the theoretical concerns we've been talking about — semiotics, psychoanalysis, deconstruction — and the kinds of feminist practice they fostered (paradigmatically, Mary Kelly's; though the *Post-Partum Document* is still in a sense a diary of her losses in relation to her child), and other kinds of work that were regarded as theoretically reprehensible and labeled essentialist, but which often challenged relations of representation in other ways. This latter work, from the early 1970s, was frequently much more effective at finding other spaces in which to speak, as in the women's postal art event or Kate Walker's "Portrait of the Artist as a Housewife," which sewed up other connections, took itself elsewhere, and didn't operate in galleries or even in single spaces. Much of this work was also diaristic, as a means of retrieving subordinated genres and articulating other voices. Whereas that's now acceptable, after Derrida and after Barthes's last writings, it was greeted with much less enthusiasm in Kate Millet's earlier and much less comfortable work, from *Sexual Politics* to *Prostitution Papers*, *Sita*, and *Flying*.[8] Hers was a political and not purely textual questioning of the masculinized voice of authorial and academic authority.

8. Kate Millett, *Sexual Politics* (New York: Doubleday, 1970); *Prostitution Papers* (New York: Avon Books, 1975); *Sita* (New York: Farrar, Straus and Giroux, 1977); and *Flying* (New York: Knopf, 1974).

"Contacts/Worksheets," which was originally published in *Photography/Politics: One* was pushed by this into an effort to interrupt that voice, *my* voice, to give it a body, to catch it up in the personal, yet to find the personal not a comforting area of nostalgic truths, an area outside politics, but thoroughly implicated. So, there's a degree of

self-implication that, of course, can be misread; and there's irony, which can itself be a mechanism of disavowal. It was also an attempt to unsettle the voice of some of the other essays in *Photography/Politics: One*. I'm sure what the original editors wanted for their book was another theoretically brutal attack on left documentary practice, putting it in its place. But that would have been caught in the very problems that I thought I should be looking at: the authority of theory and its relation to my voice, my speaking, my writing. So I decided to do this. But it wasn't much liked. I think that it pointed to a great discomfort on all sides about men speaking, in however an academicized way, about the ways our own activities are implicated in power and sexuality. Perhaps there was also rightful offense at a man stealing the voice and colonizing the space of the Other again.

However, I wanted it in *The Burden of Representation* because I regard it as having come out of a difficult period of engagement with certain feminist practices and the women's art movement. But I didn't want to write *about* that; I wanted it to be ingrained across the voice, I wanted it to interrupt my speech. It's striking that what would have been better received would have been exactly the voice of violent authority, heavy theory. That's why I said it was embarrassing: it was meant to be disturbing of my Self, but I think many other people at the time just found it embarrassing.

JL: They were embarrassed for you?

JT: Yes. Which is interesting because, after all, it's only writing. It's a quite conventional article: there's a beginning, no end, but it occupies the pages, stays on the line. What is it? Is it autobiography? Is it confession? Is it a story about a character? Is it theory? It tried to occupy a space that wasn't criticism and shake up those comfortable and controlled genres. James Agee had already done it forty years earlier. And, just as much to the point, there were a whole lot of practitioners whose work had problematized categorization. Are they photographers? Photographers don't think they are. Are they theoreticians? They often can't get jobs in art history departments. Jo Spence, Mary Kelly, Marie Yates, Connie Hatch, Martha Rosler: it's intentionally difficult to define the status of what they do. So that was another reason to attempt to do something similar in the space of criticism as well.

I think I have similar thoughts about it now as about being involved in the Pavilion Feminist Photography Centre in Leeds between 1980 and 1984: perhaps the article claims a space and then is unable to deal with the consequences. But I still like it because it upsets the rest

of the book, which is in a very traditional mode of theory. It's a fly in that ointment.

Yet, I must say, I was also trying to open a space in *Photography/Politics: One*, as in my own work, for kinds of writing that are not there in other parts of the collection, with its very particular kind of theory. This was to be much more oblique.

JL: I found most of the articles in that book prescriptive: people telling us what practice ought to be.

JT: It's true. It was virtually proletcultist in parts. And, in that context, I certainly didn't want to be prescriptive, to lay down what photographic practice should be, or a theoretical line. I felt that I was being asked to contribute precisely to do that, to sew it up at the end, to write a theoretical conclusion. It was the same thing I refused to do in the *Three Perspectives* catalogue.[9] I'm sure that, for the editors, it made a very unsatisfactory ending, but that was my satisfaction, that was my point.

JL: Does your current work explore that approach?

JT: I kept up the notebooks from which this piece was drawn for another two years. I might do something with them, but that's not a theory book, it's not an academic book, it's not a photography book, it's something else.

It's very difficult to do something on the self that's not self-serving. It's bound to be — like this interview. Yet, I wonder about Millet: I think she genuinely did. Barthes's undoing of himself in *Roland Barthes by Roland Barthes* is now part of the poststructuralist canon.[10]

Still, we all have to work; we all have to eat.

9. Paul Hill, Angela Kelly, and John Tagg, *Three Perspectives on Photography*, (London: Arts Council of Great Britain, 1979).

10. *Roland Barthes by Roland Barthes* (New York: Hill & Wang, 1977).

Victor Burgin, artist and writer, was born in England and now lives in California. He is the editor of *Thinking Photography* and co-editor of *Formations of Fantasy*. A collection of his essays, *The End of Art Theory*, and a comprehensive book of his photographic work, *Between*, were both published in 1986; he is a member of the editorial board of *New Formations*. Burgin is chair and professor of art history at the University of California, Santa Cruz, where he teaches critical theory in the Art History and History of Consciousness programs.

Rosalyn Deutsche, art historian and critic, is a member of the editorial board of *October*. She is currently preparing a full-length study of public art and urbanism in New York City.

Andy Grundberg is an art critic whose reviews of photography exhibitions and books have appeared regularly in *The New York Times* since 1981. He is the co-author of the recent book *Photography and Art: Interactions Since 1946* (1987) and co-curator, with Kathleen McCarthy Gauss, of the exhibition of the same title, which toured American museums in 1987–88. He is also author of a book about a graphic designer, *Alexey Brodovitch* (1989).

Silvia Kolbowski, artist and writer, has contributed to *Blasted Allegories*, a book of artists' writings, *Artforum*, and *Parachute*.

Rosalind Krauss, distinguished professor of art history at Hunter College, City University of New York, is the author of *Terminal Iron Works: The Sculpture of David Smith* (1972), *Passage in Modern Sculpture* (1977), and *The Originality of the Avant Garde and Other Modernist Myths* (1986). She is editor and co-founder of *October*.

Joanne Lukitsh is a visiting assistant professor in the Department of Art History at SUNY Buffalo. She is author of the exhibition catalogue *Cameron: Her Work and Career.*

Christian Metz is director of research and director of the "Theory of Film" section at the Centre Universitaire Américain du Cinéma and the École des Hautes Études en Sciences Sociales, Paris. Three of his books on cinema have been translated into English.

Kathy Myers is a television producer and director for the British Broadcasting Corporation. She has written extensively on advertising and is the author of *Understains: The Sense and Seduction of Advertising*. She recently completed a six-part television series on advertising for the BBC.

Griselda Pollock is senior lecturer in the history of art and director of the Centre for Cultural Studies at The University of Leeds, England. She is co-author with Rozsika Parker of *Old Mistresses: Women, Art and Ideology* and *Framing Feminism: Art and the Women's Movement 1970–1985*. Her book *Vision and Difference: Femininity, Feminism and the Histories of Art* was published in 1988.

Fred Ritchin is the author of *In Our Own Image: The Coming Revolution in Photography*. He contributed an essay to *In Our Time: The World as Seen by Magnum Photographers* and he co-curated the accompanying exhibition. He was picture editor of *The New York Times* from 1978 to 1982.

Abigail Solomon-Godeau, photography critic, art historian, and curator, has published widely and curated shows on subjects as diverse as postmodernist art photography and the wartime devastation of Hiroshima. A collection of her essays entitled *Photography at the Dock* will be published by The University of Minnesota Press.

Carol Squiers, a writer and curator, is currently senior editor of *American Photo* magazine. She has written extensively on photography, was photography critic for *Vanity Fair* and *The Village Voice*, and is a regular columnist for *Artforum*. She wrote the introduction to Helmut Newton's book, *Portraits*.

John Tagg is associate chair of the Department of Art and Art History at SUNY Binghamton. Born in northern England and a resident of the United States since 1985, Tagg has written numerous articles on art history, photography, and cultural theory. He is the author of *The Burden of Representation: Essays on Photographies and Histories* and

the editor of Max Raphael's *Proudhon, Marx, Picasso: Three Essays on the Sociology of Art* and *The Cultural Politics of "Postmodernism."*

Carole S. Vance, an anthropologist, teaches at Columbia University and writes on issues of representation. She is also editor of *Pleasure and Danger: Exploring Female Sexuality.*

Simon Watney is a volunteer with The Terrence Higgins Trust, Britain's oldest and largest AIDS service organization. He was a member of the editorial board of *Screen* from 1982 to 1989 and has lectured and written widely about AIDS. He is author of *English Post Impressionism* (1981) and *Policing Desire: Pornography, AIDS and the Media* (1987), co-editor with Patricia Holland and Jo Spence of *Photography/Politics: Two* (1987), and co-editor with Erica Carter of *Taking Liberties: AIDS and Cultural Politics* (1989).